When we try to make sense of pictures, what do we gain when we use a particular method – and what might we be missing or even losing? Empirical experimentation on three types of mythological imagery – a classical Greek pot, a frieze from Hellenistic Pergamon, and a second-century CE Roman sarcophagus – enables Katharina Lorenz to demonstrate how theoretical approaches to images (specifically, iconology, semiotics, and image studies) impact the meanings we elicit from Greek and Roman art. A guide to classical images of myth and also a critical history of classical archaeology's attempts to give meaning to pictures, this book establishes a dialogue with the wider field of art history and proposes a new framework for the study of ancient visual culture. It will be essential reading not just for students of classical art history and archaeology, but for anyone interested in the possibilities – and the history – of studying visual culture.

KATHARINA LORENZ is Associate Professor in Classical Studies in the Department of Classics and Director of the Digital Humanities Centre at the University of Nottingham. Her main research interest is in the methodologies for the study of Classical art and their implications for historical understanding. She is the author of *Bilder machen Räume. Mythenbilder in pompeianischen Häusern* (Berlin, 2008) and has published widely on Greek and Roman visual narrative, Roman painting and the domestic context, art historiography and intellectual history, and digital heritage engagement.

Ancient Mythological Images and Their Interpretation

An Introduction to Iconology, Semiotics, and Image Studies in Classical Art History

KATHARINA LORENZ
University of Nottingham

CAMBRIDGE
UNIVERSITY PRESS

CAMBRIDGE
UNIVERSITY PRESS

University Printing House, Cambridge CB2 8BS, United Kingdom

Cambridge University Press is part of the University of Cambridge.

It furthers the University's mission by disseminating knowledge in the pursuit of education, learning, and research at the highest international levels of excellence.

www.cambridge.org
Information on this title: www.cambridge.org/9780521195089

First published 2016

Printed in the United Kingdom by TJ International Ltd. Padstow Cornwall

A catalogue record for this publication is available from the British Library.

Library of Congress Cataloguing in Publication Data
Names: Lorenz, Katharina, author.
Title: Ancient mythological images and their interpretation :
an introduction to iconology, semiotics and image studies in
classical art history / Katharina Lorenz (University of Nottingham).
Description: Cambridge, United Kingdom; New York, New York :
Cambridge University Press, 2016. | Includes bibliographical references and index.
Identifiers: LCCN 2016013373 | ISBN 9780521195089 (hardback) |
ISBN 9780521139724 (paperback)
Subjects: LCSH: Art, Classical–Philosophy | Art, Classical–History. |
Mythology, Greek, in art. | Mythology, Roman, in art. |
Visual communication–Philosophy. | Visual communication–History. |
Image (Philosophy) | Semiotics and art. | Classical antiquities. |
BISAC: ART / History / Ancient & Classical.
Classification: LCC N5613.L67 2016 | DDC 704.9/489213–dc23
LC record available at https://lccn.loc.gov/2016013373

ISBN 978-0-521-19508-9 Hardback
ISBN 978-0-521-13972-4 Paperback

In memory of my father, the scientist.

Table of contents

Figures

Preface

The book is indebted to the intellectual stimulus of the Karlsruhe research group Image – Body – Media of which I was an associate member from 2002 to 2004, especially the conversations with Hans Belting, Martin Schulz, Birgit Mersmann, and Jutta Held. My interest in the methods of art-historical interpretation and the historiography of classical archaeological study was and still is stimulated by Jaś Elsner, not least because of his suggestion to embark together on the adventure of translating some of Erwin Panofsky's writings, an experience that has greatly shaped this book. Peter von Möllendorff and Ivana Petrovic introduced me to the work of David Wellbery; our many discussions of pictures and narratives emboldened me and gave the book its framework. A first draft of this book was prepared with support from the Arts and Humanities Research Council. My warmest thanks to all.

The book has also benefited enormously from discussion and debates with numerous colleagues and friends, including Mont Allen, Ting Chang, Esther Eidinow, Tonio Hölscher, Andreas Kropp, Susanne Muth, Stephanie Pearson, Verity Platt, Michael Squire, Jeremy Wood, and Richard Wrigley. While working on the book I was fortunate to enjoy the hospitality of the Winckelmann Institut at Humboldt Universität Berlin – here, Nikolaus Dietrich, Arne Reinhardt, and Christoph Klose offered their time for discussion and made many useful suggestions. My thanks also go to the undergraduate and graduate student cohorts of the Nottingham–Humboldt Universität Berlin exchange, QKolleg, and those of my Nottingham module, Q83VIS Visual Mythology, who, mostly without knowing it, helped to shape the argument; I would like to thank especially William Leveritt and Jodie Martyndale-Howard, who read and commented on parts of the text.

I owe special thanks to Michael Sharp, Elizabeth Hanlon, and Marianna Prizio of Cambridge University Press for their enthusiastic support of the project. The anonymous readers for the press provided thoughtful and encouraging reports that have helped steer my revisions of the text. My sincere gratitude goes to Rona Johnston Gordon for her meticulous editorial scrutiny and her skill at stamping out linguistic vagaries and improving the text. My thanks are also due to several colleagues who helped with

illustrations: Tomas Lochmann and Laurent Gorgerat (Antikenmuseum Basel und Sammlung Ludwig); Martin Maischberger and Ines Bialas (Antikensammlung, Staatliche Museen zu Berlin); Elizabeth Saluk (Cleveland Museum of Art); Josephin Szczepanski (Arachne, University of Cologne); Anja Slawisch (German Archaeological Institute, Istanbul); Chris Sutherns (British Museum, London); Angelika Hildenbrandt (Badisches Landesmuseum, Karlsruhe); Claudia Wedepohl (Warburg Archive, London); Anne-Catherine Biedermann and Tiphaine Leroux (Réunion des Musées Nationaux et du Grand Palais); and, especially, Sylvia Diebner, Daria Lanzuolo, and Alexandra Busch (German Archaeological Institute, Rome).

Earlier versions of parts of this book have been published elsewhere. The sections on the Louvre sarcophagus are developed from 'Image in distress? The death of Meleager on Roman sarcophagi', in *Life, Death and Representation: Some New Work on Roman Sarcophagi*, eds J. Elsner and J. Huskinson, Berlin (2011): 305–32. The sections on the Pergamon frieze build on 'Der Grosse Fries des Pergamon-Altars: Das Stilmittel Metalepse und die Analyse von Erzählung in der Flächenkunst', in *Über die Grenze: Metalepse in Text- und Bildmedien des Altertums*, eds U. Eisen and P. von Möllendorff. Berlin (2013): 119–47. I wish to thank Mirko Vonderstein of De Gruyter for permission to republish material.

The experiment: methods – images – objects

> For this reason it is not only art theory that should have an interest in the continuing development of factual research (without which its terms, to use Kantian terminology, would be 'empty'), but empirical research on factual matters also has an interest in the prejudice-free development of art theory (without which its observations would be 'blind'); and in the end both have to come together to work collaboratively, ideally within the same person.
>
> <div align="right">Panofsky 2008: 66</div>

> Now we must always, when we find an answer, revisit the question that gave issue to it. We must never be satisfied with answers. Art historians who glibly dismiss 'theory' are actually dismissing, or rather expressing their dread of, the strange fact that questions can outlive answers.
>
> <div align="right">Didi-Huberman 2005: 33</div>

This book is an experiment. It places under the microscope the methods we employ to analyse mythological pictures, and also pictures more generally, and, in turn, the range of understandings that we can gain by different modes of analysis. The discussion starts where other discussions of ancient mythological imagery have ended. The central objective is broadly diagnostic, for this study is concerned not with *what* we can find out about Greek and Roman cultures by analysing their mythological imagery, but with *how* we approach their imagery and in what ways this *how* determines what we can find out about the cultures that produced these pictures.

The book stems from the notion that there is not one single way – the *right* way – of analysing and interpreting pictures. Its approach is driven by the assumption that analysing and interpreting pictures, and specifically ancient mythological imagery, is all about our stretching these objects out methodically, turning and twisting them so as to elicit historical knowledge while fully aware of what we are doing, for we must not break the wondrous material we are manipulating.

This book addresses these concerns by examining the relationship between primary evidence, analytical methodologies, and scholarly practice, using

the example of Greek and Roman mythological imagery. By design, this approach generates both a study guide and a critical analysis, for it provides an introduction to art-historical methods and the study of ancient pictures of myth and, at the same time, it presents fresh interpretations of three sets of ancient mythological imagery and an argument about the art-theoretical foundations of classical archaeological and art-historical scholarship and their role in shaping the discipline – past, present, and future.

This study has two distinct strands. The first encompasses three analytical methods of particular relevance in art-historical scholarship and, specifically, in the study of ancient mythological imagery: namely, iconology, semiotics, and image studies. In order to establish how these methods impact the meaning derived from individual artefacts, the second strand considers three well-contextualised and articulate case studies that can be plotted along three different axes in our proposed experiment. All three are monuments displaying mythological depictions of particular relevance for individual artistic genres, periods, and contexts of ancient art: an Athenian pot of the later fifth century BCE, the Great Altar in Pergamon, which is from the early second century BCE, and a Roman sarcophagus of the late second century CE.

To interweave these two strands, the investigation is laid out in three parts. Each part is devoted to one of the three methods and examines all three case studies by means of iterative analysis, drawing from the respective methodological toolbox. This unusual setup of juxtaposing diverse analyses of the same object facilitates direct cross-examination and highlights the dependencies between the individual strategies. Each part is introduced by a chapter on the functioning of the method itself and concludes with a critical appraisal of the method that includes a discussion of its use in classical archaeological and art-historical scholarship.

This design speaks to the key concern of my study, also expressed in the two quotations summoned above to launch the experiment: that is, the importance of a reciprocal relationship between the theory and the practice of interpretation, a relationship that recognises the interdependencies of method and knowledge.[1] This threefold experiment seeks to establish how – or by what analytical means – mythological imagery can be reliably used to write about ancient societies, and what questions pictures might be competent to answer. My aim is to rethink the study of familiar material on the level of method by focusing on a small sample of relatively well-processed data and by subjecting that sample to three distinct yet related approaches.

[1] Cf. Iversen & Melville 2010: 1–14.

The objective of this experiment is to contribute to a theory of ancient art by obverting those conventional procedures of classical art-historical scholarship that emphasise quantitative presentation over qualitative assessment.

Methods

This book arises from a desire for a theoretical reflection on how to study ancient imagery, with that study of ancient imagery undertaken in concert with approaches to imagery more generally, in other branches of art-historical scholarship. It is driven by the need for a systematic art-historical practice, informed by such reflection, for analysing and interpreting pictures. These aims are stimulated by the very evidence of ancient art itself. Ancient Greek and Roman art is prominent in the templates for Western visual culture and serves as a touchstone in discussions of the nature of art history and visual culture studies. Yet, as a product of diverse periods and societies – in both east and west and over a span of more than a millennium – ancient Greek and Roman art was generated and received variously, with different formats, social and political contexts, ideologies, functions, and types of viewer.

Ancient art can serve to unlock social and historical meaning. And yet, while on the one hand the evidence appears to provide a very rich picture, on the other hand that evidence always constitutes an equation with an infinite number of unknowns. Evidence is always only fragmentary, sometimes with regard to external particularities such as dates or contexts and sometimes, even more critically, with regard to the ways ancient viewers infused their visual worlds with meaning.

This incompleteness can lead historians of ancient art to adopt an attitude that Margaret Iversen and Stephen Melville, writing of the wider discipline of art history, have described as an 'impoverished sense of its own possibilities'.[2] This attitude can be expressed in a contemptuous distrust when the scholar is faced with such dubious things as pictures[3] and, specifically, in a disregard for theoretical reflection on the methods employed to elicit meaning from visual evidence. If one doubts that pictures can yield genuine meaning, then there is little point in one's considering how best to uncover that meaning.

[2] Iversen & Melville 2010: 3.
[3] Cf. Jay 1993: 588 for a similar phenomenon in twentieth-century French critical theory.

That attitude is also encountered beyond responses to imagery. In classical archaeological and art-historical scholarship as well as across art history more generally, it is found in the obsession with accumulating data about evidence without consideration of the principles according to which this data is collected and organised and without challenging its fragmentary state. Georges Didi-Huberman aptly describes the problematic nature of this process, which seems to aim for greater accuracy, even exactitude:[4]

> The history of art often ignores that, by its very nature, it is confronted by analogous problems: by choices of knowledge, alternatives that entail loss, whichever option is chosen. This is called, strictly speaking, an alienation. A discipline that is 'informationizing' itself throughout, that guarantees the 'scientific' basis of the world art market, that accumulates staggering amounts of data – is such a discipline ready to come to terms with itself as alienated, as constitutionally alienated by its objects, and thus inescapably subject to loss?

Georges Didi-Huberman was not the first to articulate doubts about the benefits of, indeed about the justifications presented for, replacing discussion with seemingly pure, quantifiable accumulations of data when it came to works of art. Already a much-disputed topic in art-historical scholarship as far back as the 1920s and 1930s, the issue was taken up and particularly fiercely fought out by Erwin Panofsky.[5] Panofsky and Didi-Huberman are concerned with the study of modern art, or, better, the study of art after the end of antiquity. But their comments not only hold equally true for any engagement with Greek and Roman art, but also are particularly pressing in this very area, where we are always faced with evidence in a state of considerable disintegration and where the fragmentary nature of our knowledge and our resultant alienation are therefore felt particularly strongly.

Panofsky and Didi-Huberman also set the tone of the present investigation in another way. Iconology, the analytical model for historical interpretation of pictures presented by Panofsky and strongly challenged by Didi-Huberman, not only is one of the three methods under scrutiny in this study, but also provides the central reference point for the discussion of the other two approaches. Its centrality has two reasons. The first, and more general, explanation lies in the attribution to Panofsky of a pivotal presence in all three of the approaches under investigation in this book:[6]

⁴ Didi-Huberman 2005: 32–3.
⁵ Panofsky 2008: esp. 66–8.
⁶ These diverse accolades are explained, first, by Panofsky's comprehensive theoretical ambitions with regard to the study of art and its meaning – inevitably resulting in many later attempts to deal with similar issues related to him, whatever their methodological allegiances. Another explanation lies in the openness of Panofsky's own approach and its changing scope from the

in addition to iconology, for the field of semiotics, he has been enlisted as 'grand structuralist'[7] and as the 'first semiotician',[8] while image studies put Panofsky (and the critical engagement with his approach) also at its centre, specifically in its permutation as a 'critical iconology'.[9]

The second reason – of particular interest in the present study with its focus on ancient art – is that Panofsky belonged to the last generation in which modern art-historical and art-theoretical scholarship had an impact on the study of ancient art and, vice versa, problems derived from the study of ancient art still substantially informed art-historical discussion and theory formation at large.[10] Such mutual exchange has since largely ceased, replaced by a unidirectional relationship dominated by modern art history. Since one of the objectives of this study is to reignite this discourse, Panofsky suggests himself as a starting point – and the engagement with his model of iconology connects all the strands of this book.[11]

In its execution, the iterative analysis, or comparative experimentation, at the heart of this books finds parallels in Edgar Wind's discussion of experimentation in the humanities,[12] along with projects such as David Wellbery's collaborative multi-perspective analysis of Kleist's novella *The Earthquake in Chile*,[13] and James Elkins' *Stories of Art*.[14] Wind's study is concerned with the relationship between the epistemological framework of the humanities and that of the natural sciences, from which he derives a definition of *experiment* not just as a testing ground for explanations, but also as their breeding ground.[15] Wind argues that the natural sciences and the humanities share an epistemological paradox: their respective tools of enquiry – mechanical instruments on the one hand, methodological reasoning on the other – have to presuppose the existence of the very world they set out

1920s to the 1960s – the different periods of his work facilitate relationships with all of the three methods under scrutiny here, despite their individual differences. Finally, the range of Panofsky's approach, and its logical rigour, exudes a spirit that seems to incite challenge: to get locked into combat with Panofsky appears *de rigueur* for any respectable analytical enterprise in the visual arts (see, for example, Mitchell 1986; Mitchell 2005; Didi-Huberman 1992; Didi-Huberman 2005; Belting 2011; Davis 2011: 234–74).

[7] Claude Lévi-Strauss' label for Panofsky; see Bredekamp 1995: 363–5.
[8] Argan 1975; Bal & Bryson 1991: 174. Contra: Hasenmueller 1978. Cf. below, pp. 32–3 n. 57.
[9] Cf. Bredekamp 2003: esp. 427–8.
[10] See below, pp. 19–20, 95.
[11] It is perhaps a testament to the thrust of Panofsky's work that it is employed in a similarly connective way in Iversen & Melville (2010: 10).
[12] Wind 2001.
[13] Wellbery 2001.
[14] Elkins 2002.
[15] Wind 2001: 52; see also Krois 1998.

to measure. The instruments have to embody this world in order to make sense of it. But because they embody an unapparent reality, they simultaneously also embody the questions of the researcher who strives to establish this already presupposed reality and can act as a corrective along the way of enquiry. The tools can themselves therefore produce answers to the researcher's questions, not just data pertaining to such answers.[16]

How does this relationship between tool and enquiry inform this book? The epistemological conditions of the humanities and the natural sciences can be paralleled, and therefore the concept of reason as embodied in scientific experiment must be equally valid for research in the humanities – not because here too data can be accumulated through experiment, but because the specific processes applied in gaining data and interpreting evidence are themselves prone to produce answers to the very questions that instigated the process of data collection.

Meanwhile, if the processing of data impacts the results of analysis, then in turn the instruments used for analysis – here, the methodologies of reasoning – need to be scrutinised in detail because their functioning determines the answers likely to be produced. Wind's hypothesis, therefore, is not appropriated here to introduce through the back door scientific positivism into the study of the humanities; on the contrary, it is adopted in order to throw into relief the importance of methodologies in the study of the humanities, in their role as analytical instruments in our disciplinary laboratories.

Wellbery and Elkins add to this framework derived from Wind: they approach the issue of methodology from a different but complementary angle. Both promote multi-perspective enquiry as a means of honouring the complexity of the evidence under scrutiny, along with the internal complexities of the disciplines dealing with it. Wellbery notes that while the discipline of literary studies presents itself as a homogeneous discourse domain, it is actually split into a wide array of sub-discourses, each of which uses a distinct methodological toolbox and which lacks the means to communicate across divides.[17] Again, the notion of alienation can be discerned in this description, in the discrepancy between the external homogeneity of a discipline and that discipline's inner warping.

The situation in the study of ancient art, and in modern art history more broadly, is not dissimilar. Elkins demonstrates these parallels in his *Stories of Art*, with different possibilities for looking at artworks shaping the design

[16] Wind 2001: 19–22.
[17] Wellbery 2001: 7.

of the study as whole. Elkins notes, 'As the new millennium gets under way, art historians find themselves spending nearly as much time puzzling over their theories and methods as they do looking at images.'[18] Meanwhile, both Wellbery and Elkins succeed in cultivating this method-focus – a multilateral approach juxtaposing analyses – as an asset for the understanding of their respective subject matters. Their approach deliberately draws attention back to the evidence and so facilitates deep analysis.

The evidence – in the present study mythological pictures – provides the core around which the analytical trajectories of the differing methods are projected and leaves no need for an additional layer of negotiation about the exclusive use of one particular method.[19] Thus, this type of approach overcomes the various traps of intuitive interpretation, which operates without specific methodological grounding, and by the same token it also overcomes the diametrically opposed tendency towards methodological exclusivity. Both these positions, as Wellbery rightly points out, suffer from a common problem: they negate differences – the former by levelling, the latter by excluding.[20]

Images

As we seek to understand pictures and the images they stimulate, we find ourselves eager to know of their producers and of their viewers, who seek to make sense of these pictures through processes of individual or collective symbolisation.[21] Images become part of a network of reciprocities, constituted between producers and viewers, between external pictures and internal images. These relationships render pictures a powerful device in the organisation and transmission of observations and thoughts, ideals, norms, and, finally, knowledge. This capability, and its potential, makes pictures indispensable for historical enquiry and, in turn, renders them a particularly promising object of historical and cultural study.

Talking about pictures means talking about people in the context of their visual environment, in particular because by their very nature pictures constitute simultaneously a time-outlasting object and a time-bound social process.[22] This dual nature of pictures sits at the root of the differences

[18]　Elkins 2002: XII.

[19]　Wellbery 2001: 8.

[20]　Wellbery 2001: 7.

[21]　Belting 2011: 9 (the English trans. renders the German 'Symbolisierung' as 'knowledge and intention').

[22]　Cf. Belting 2011 (2001: 7), who here reformulates Jean Paul Sartre's *Imagination*, 1962 (this passage from the German introduction does not appear in the English translation).

among the individual theories and methods employed in their study – such methods tend to give preference to one of these two parameters, rather than engage both.

The objects at the centre of this investigation – the pot, the altar frieze, and the sarcophagus – all yield pictures of a specific type that was immensely popular in antiquity: namely, mythological imagery. These pictures of myth present the essential image, for in conveying myths they transmit adventurous and exotic narratives and broadcast religious ideologies; they can become devices of self-representation, of power and hierarchies, and of allegoric reflection; they have the potential to narrate stories as well as to sublimate ideas and wishes.

The complexities of their internal functional structures and their frequent use throughout antiquity make mythological pictures an ideal case study for an experiment of the type proposed here. They form a representative and diverse grouping that allows for an in-depth examination of all the factors that constitute images and, in turn, of the capacity – and limitations – of the three analytical models.

Scholarship on Greek and Roman mythological imagery is vast.[23] And yet, most studies of ancient mythological imagery only account for the capacity of these pictures in a limited way. Susanne Muth has convincingly demonstrated this limitation in her exemplary study on the mythological mosaics of Roman Spain and Northern Africa. Muth differentiates between three strands in scholarship on Roman mythological mosaics – categories that can be equally well applied in research on ancient mythological imagery more broadly: the *associative-philological* approach, the *generalising* approach, and the *contextual-differentiating* approach.[24]

The *associative-philological* approach puts the myth in its literary manifestation at the centre. Any visual version of the myth, therefore, is deemed an illustration – of a specific literary version or a conglomerate of differing literary sub-narratives. The picture is taken as a reference to the myth in its entirety, disregarding the moment(s) actually captured in the visual manifestation. Any discrepancy between the depiction of the myth in the picture and the known literary versions is considered an error in the visual representation.

In the *generalising* approach, the physical context of the picture is under scrutiny, an aspect of no concern in the first approach. Within this strand,

[23] See Woodford 2003; Junker 2012; Giuliani 2013 for some of the most recent comprehensive treatments of ancient mythological narrative in the visual realm.

[24] Muth 1998: 38–45.

mythological pictures are studied in light of the atmosphere they might contribute to a certain setting by virtue of being a mythological depiction: for example, a sacral aura in the funerary sphere or a stimulus for entertainment in the domestic context. Meanwhile, their actual content – what they display and how they display it – is of no concern.

Only the *contextual-differentiating* approach explores the contextual framework of the picture, in a spatial, historical, and social sense, and also focuses on the actual form and content of the picture, its particular take on the myth it depicts, and its relation to other representations of the same narrative. The present investigation will map out the relationship of the three analytical models to these three strands of scholarship on mythological imagery and their standard practices of analysis and interpretation. It will examine how the three methods facilitate these practices, and indeed how they might help to reach beyond these practices.

Objects

The objects at the heart of the investigation, the late fifth-century BCE hydria, the second-century BCE frieze, and the late second-century CE sarcophagus, have been selected for three reasons. Together, the three case studies stake out the domain of ancient mythological imagery in its entirety, covering the Greek and Roman worlds (classical, Hellenistic, and High Empire, respectively); public and private contexts (domestic, funerary, and public-sacral); artistic practices (pottery painting, architectural sculpture, and relief); materials and scales (clay and marble; from an object that can be held in one's hands to a monument one has to walk around). Additionally, their treatment in existing scholarship tells of different academic practices ('armchair' classical art history in the case of the pot and the sarcophagus; archaeological fieldwork in the case of the altar).

Each case study presents a particularly complex rendering of a mythological narrative, with each also posing different challenges when we seek to understand the relationship between the depiction and its material carrier. Finally, each instance provides data of different types and in different quantities on the chronological and spatial context in which the object was experienced (with direct evidence in the case of the Great Frieze and indirect information in the case of the hydria and the sarcophagus). With this, the three objects present a set of case studies suitably complex and diverse not merely to serve as a demonstration of the three analytical models in

action, but also to facilitate an experiment that investigates how these models might be applied in varied circumstances, and with what results.

The diverse nature of the case studies leads this book to include a wide range of other material, beyond the three objects: other images of the same myth; similar representations of other myths; mythological pictures in the same and other contexts throughout the different periods of Greece and Rome; non-mythological representations from the same period or context or with similar characteristics. In this way, the study accounts for both ancient mythological imagery and ancient imagery at large.

The Karlsruhe hydria.

The hydria in Karlsruhe facilitates a representative case study of the genre of Greek vase-painting and modern scholarly engagement with that genre (fig. 0.1).[25] Attic red-figure hydriae are water containers conventionally associated with the Athenian female realm but also associated with symposia, the elite male drinking parties.[26] This hydria was one of many found in a tomb in the South Italian town of Ruvo.[27] And again, like many others, it was attributed by John Beazley to a fictive Athenian painter, whom Beazley named after this pot, the Painter of the Karlsruhe Paris.[28]

On the basis of formal stylistics, this painter can be related to the circle around the Meidias Painter.[29] This identification provides an indirect date

[25] RF Hydria, Karlsruhe, Badisches Landesmuseum B36; from Ruvo. Painter of the Karlsruhe Paris, *c.* 420 BCE. ARV² 1315.1 and 1690; Para 477; Add² 180; CVA *Karlsruhe* 1: pl. 22.4, 23, 24.1–2; Real 1973: 66–8; Burn 1987: 65–70, C1; LIMC VII 1994: s.v. *Paridis Iuridicum* no. 50; Borg 2002: 145. For the inscriptions: Immerwahr 1990: 117, no. 809.

[26] For the pot shape, see Diehl 1964.

[27] The hydria comes from tomb 152. It was found in 1835 together with an Athenian RF Squat-lecythus and a RF Panathenaic amphora, both attributed to the Meidias Painter, and a proto-Apulian crater; see Montanaro 2007: 639–50. The vessel might have been targeted at an Athenian audience (as a funerary container, or for another purpose), only later to be shipped to South Italy; or it might have been made specifically for an Apulian audience, as a funerary container or, again, only later recycled as such. For an overview of the site of Ruvo and the history of its exploration, see Gadaleta 2002; on the necropolis, see Montanaro 2007: esp. 75–90.

[28] For issues around connoisseurship, see below, p. 118 n. 1.

[29] The Meidias Painter is named after a potter's signature on a hydria in the British Museum (fig. 5.3), 'ΜΕΙΔΙΑΣ ΕΠΟΙΗΣΕΝ', 'Meidias made it': RF Hydria, London, British Museum E224. Meidias Painter, *c.* 420 BCE. CVA *London, British Museum* 6: 6–7, pls 91–2; ARV² 1313.5, 1690; Para 477; Add² 361; Burn 1987: 15–25, pls 1–9; Camponetti 2007; Lorenz 2007: 131–8, 141–3. He was first identified by Eduard Gerhard (Gerhard 1839), and is variously commented upon: ARV 831–3; ARV² 1312–3; Furtwängler & Reichhold 1904: 38–46; Nicole 1908 (for the Karlsruhe hydria, see esp. 65–9); Ducati 1909; Beazley 1925: 459–50; Hahland 1930; Becatti 1947: esp. 12–13; Real 1973: 57–71; Burn 1987; Isler-Kerényi 1985; Robertson 1994: 237–42; Couëlle 1998. See Tugusheva 2009; Kalkanis 2013 for the most recent

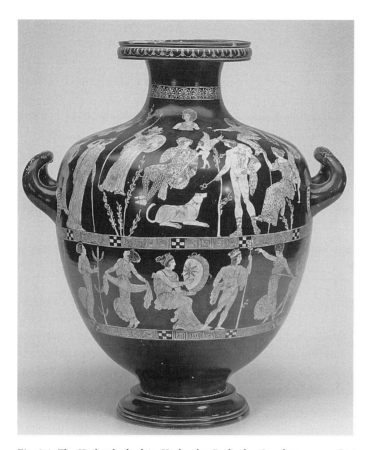

Fig. 0.1 The Karlsruhe hydria. Karlsruhe, Badisches Landesmuseum B36. *c.* 420 BCE.

for the hydria, based on stylistic sequencing, in the last quarter of the fifth century BCE. The style of the Meidias Painter is reminiscent of the ornate rendering so characteristic of the sculptural work on the Parthenon east pediment, of the 430s BCE,[30] and to a lesser extent of the frieze of the Temple of Athena Nike:[31] the garments fall in sharp-ridged, sweeping folds or form rubbery bulges; the male bodies have a squat frame but otherwise lean features.

The richness expressed in lavish garments is further elaborated by the use of white slip for the depiction of necklaces, bracelets, earrings, and floral detail. Again, the colouring, along with the use of gold plate, is a characteristic feature of the Meidian circle; it can be found throughout the range of products of the workshop and in the work of its successors. The abundance

assessments. This flourishing style shows in vase-painting first in the works of the Eretria Painter; for example: RF Squat-lecythus, Berlin, Staatliche Museen F2471; from Attica, Eretria Painter, *c.* 440 BCE; ARV 1247.1.

[30] Kelperi 2007.

[31] On the Athena Nike frieze, see Mark 1993; Giraud 1994; Harrison 1997; Schultz 2009.

and vividness expressed in the use of colour is perfected by the indication of a lavish landscape, with shrubs, contour lines, and rocks creating an amiable nature setting in both picture fields.

The hydria poses a challenging case for analysis with regard to mythological narrative because it combines two picture fields and different mythological stories and characters, with only the figures in the upper picture field named by inscription. We are left to wonder what information the painter intended to convey, and how. Context provides further challenges. First, the hydria's potential use within two diametrically opposed contexts – one exclusively female and one exclusively male – renders any conclusions derived from the function of the container problematic. Second, the production of the pot during a time of crisis – the Peloponnesian War – raises questions about how wider historical developments can be employed to guide the interpretation of specific artefacts.

The Pergamon frieze.

The Great Frieze of the Pergamon altar enables an assessment of Hellenistic architectural sculpture and the problems it poses for modern scholarship (fig. 0.2). Architectural sculpture adorned many Greek public and religious buildings, frequently reflecting civic aspirations. The Great Frieze depicts the battle of the gods against the giants.[32] It adorns the Great Altar, erected on the acropolis, the civic and religious centre of the city.[33] The date and function of the Great Altar are fiercely contested: most likely, it was constructed during the first half of the second century BCE, during the reign of Eumenes II (197–159 BCE).[34] It served as a monument both to the gods revered by the city and to Pergamon's royal family.[35]

[32] For discussions of the frieze, see Puchstein 1888; Puchstein 1889; Winnefeld 1910; Robert 1911; Kähler 1948; Smith 1991: 158–64; Ridgway 2000: 32–42; Kästner 2003; Heres & Kästner 2004.

[33] The most recent summary of the features of the Great Altar is Kästner 2011a. Radt & De Luca 1999: XV–XIX provides a comprehensive bibliography with commentary.

[34] The precise date is fiercely debated. For an overview, see Callaghan 1981; Ridgway 2000: 21–2; Stewart 2000: 39–41. For the two fragments of the dedicatory inscription that name a royal patron and make reference to the gods who granted Pergamon its greatness, probably placed on the east flank, see Fränkel 1890: 54–5, n. 69; Stewart 2000: 34–9.

[35] Identifications reach from an altar – in the sacrificial sense, or merely as prestigious marker – for Zeus (a summary of the history of this identification in Kunze 1996: 79), for Athena (a summary in Stewart 2000: 35–9), for both, or for the Twelve Gods (La Rocca 1998); or as Eumeneion, in celebration of the Attalid dynasty (Queyrel 2002: 561–90; Queyrel 2005: 112–47). For the most recent discussion of the function of the altar, see Webb 1998; Ridgway 2000: 25–32; Stewart 2000: 46–9; Massa-Pairault 2007a: 7–24; Scholl 2009. A few ancient reports exist that might refer to the Great Altar (John Rev. 2.12–13 and Paus. 5.13.8); only Lucius Ampelius, *Liber memorialis* 8.14 identifies the monument specifically among a list of forty

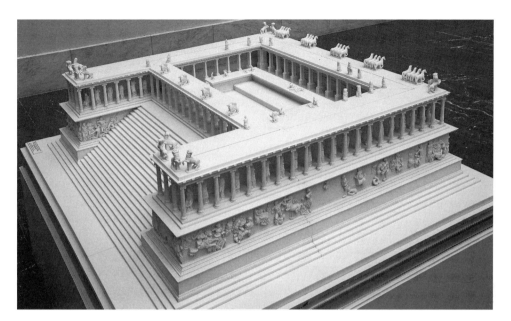

Fig. 0.2 The Pergamon altar (model), seen from the south-west corner. Berlin, Staatliche Museen. First half of the second century BCE.

The Great Frieze was presented atop the altar's podium, which stood at 5.37 m high. Wrapped around the three long sides of the altar, the frieze was originally 113 m long. The frieze followed the structure on the west side, then ran around the frontal projections on each side of the great stairway and up the stairs to the colonnade and courtyard of the complex, inside which a second frieze, the Telephus Frieze, was presented.[36] Carved in exceptionally high relief, the Great Frieze consists of 118 individual marble slaps, each 2.3 m high and between 0.7 m and 1.5 m in width, their appearance enhanced by painting and metal appliques. The figures of the frieze are all named: the gods with inscriptions on the cavetto moulding above, the giants on the base moulding below,[37] where the names of some of the executing artists are also placed.[38]

wonders of the world: 'Pergamo, ara marmorea magna, alta pedes XL cum maximis sculpturis; continet autem gigantomachiam.' In addition, a set of Severan coins seem to show the altar; see Rohde 1961: 43, fig. 19; Kästner 1997: 78, fig. 2.

[36] On the Telephus Frieze: Stähler 1966; Pollitt 1986: 198–205; Dreyfus & Schraudolph 1996–7; Stewart 1996; Heres 1997; Queyrel 2005: 79–101.

[37] Exceptions are: the label for the mother of the giants, Ge, is set next to the figure, into the frieze itself; and the same applies to the label of one giant, Bro[nteas], which again sits on the relief ground, on the south projection.

[38] The named artists are Theorretus, Dionysiades, Orestes, and Menecrates; among the inscribed ethnics are three Pergamenes, two Athenians, and one sculptor from Tralleis. See Fränkel 1890: 70–85; Kästner 1994: 126–34.

When the Pergamon altar was discovered in 1864, the Great Frieze in particular was hailed as representing an artistic period previously unknown.[39] That period was subsequently labelled 'Hellenistic Baroque' because of the emphatic pathos the figures on the Great Frieze – the giants in particular – exuded. That verdict was influenced in no small part by the impact of Heinrich Wölfflin's study of modern Baroque art on German art-historical circles towards the end of the nineteenth century.[40] In contrast, the Telephus Frieze displays an entirely different formal language: where on the Great Frieze all the figures are arranged on a common base line, on the Telephus Frieze they are staggered on top of each other, reaching into the space of the frieze. This highly illusionistic rendering supports a very different type of narrative –the Great Frieze is predominantly monoscenic, but the Telephus Frieze features a continuous narrative, telling the story of the local hero from his birth to his end.

Indicative of the use of myth in the Hellenistic world and of the appropriation of mythological stories for specific functional contexts, the Great Frieze raises questions about the ideological deployment of mythological imagery and its spatial display. At the same time, with specific styles employed for specific types of content, the Great Altar encourages us to recognise that dependencies of form and meaning also require analytical attention.[41]

The Louvre sarcophagus.

Through the Louvre sarcophagus we can address the use of myths in the Roman funerary context of the High Empire and the academic practices of the analysis of these myths (fig. 0.3). Sarcophagi were the costly burial containers of the Romans. They became increasingly popular from the first half of the second century CE onwards, with a change in burial customs. They were usually displayed in burial chambers open to the family of the deceased, where they were either on their own or part of larger ensembles.[42]

[39] Gaehtgens 1996; Koester 1998; Raeck 2010; Kästner (U.) 2011.
[40] For an assessment, see Payne 2008. Wölfflin's study was published in 1888 (Wölfflin 1964).
[41] The role of style on the Great Altar is interesting particularly because the monument is sited firmly in the contested ground of what should be defined as an artwork in the ancient world. Its production date in the second quarter of the second century BCE puts it within the period labelled by the influential Roman polymath and art critic Pliny as one 'without art' (Plin. *Nat.* 34.53): 'Cessavit deinde ars; ac rursus Olympiade centesima quinquagesima quinta revixit'; on Pliny's assessment, see Rouveret 1989: 454–6; Hafner 1990; Isager 1991: 97–8.
[42] Koch & Sichtermann 1982: 20–3. Examples for such settings: D'Ambra 1988; Bielfeldt 2003; Zanker & Ewald 2012: 21–30; Borg 2013: 213–40. On the lack of textual sources mentioning sarcophagi, see Gessert 2004: 218.

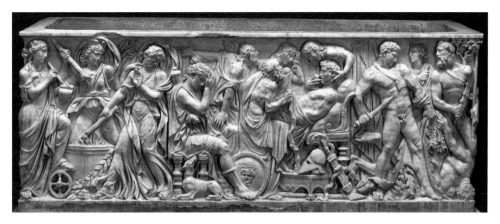

Fig. 0.3 The Louvre sarcophagus. Paris, Musée du Louvre MA 539. *c.* 190 CE.

The sarcophagus in the Louvre depicts Meleager on his deathbed,[43] an episode featuring the aftermath of the Calydonian boar hunt. This subplot of the myth, depicted only on Roman sarcophagi, was secondary in both reach and significance to depictions of the actual hunt and Meleager's falling in love with Atalanta.

On stylistic grounds the sarcophagus is dated to *c.* 190 CE – a period in which the appropriation of myth was particularly diverse and widespread,[44] but also a period that marks the end of an intensive use of myths in this specific genre, the sarcophagi.[45] The rendering of the figures and the composition more generally show characteristics of both the classicising style prevalent in relief sculpture of the middle of the second century and formal features related to the stylistic changes of the late Antonine period. Whilst squat in shape as on earlier sarcophagi, the individual figures are here stacked on top of each other. Sweeping drapery and dynamic action, especially towards the edges of the relief, add to a crowded feel and emphasise the energy of the scene overall.

The depiction must have been further enhanced by the colouring of the relief:[46] a torch depicted in the scene bore traces of red, as did the hair of one of the female characters on the left. In the central scene, the seat as well as

[43] Paris, Musée du Louvre, Inv. MA 539. 190 CE. L 2.05 H 0.74 D 0.98. Robert 1904 no. 277, pl. 91; Koch 1975: 38–47, 120–1, no. 116, pls 103b, 106–11, 113a, b; Baratte-Metzger 1985: 97–9 no. 37; LIMC VI 1992 s.v. *Meleagros* 428 no. 155, pl. 223 (S. Woodford); Zanker & Ewald 2012: 62–70; 364–6, figs 44, 51–2. The side panels depicting a sphinx on either side still form part of the casket, but the lid is missing.

[44] Koch & Sichtermann 1982: 89; Zanker & Ewald 2012: 30–2, 245–9.

[45] Zanker & Ewald 2012: 254–60.

[46] Carl Robert still saw traces: Robert 1904: 337 no. 277.

the handle of the sword and the spear showed red colour. On the far right, the sword handle and spear of the bearded male were painted red, as were the branches of the tree in the background.

The function of the sarcophagus as a burial container might mark a context and thus present an asset for interpretation – yet again, this context is only general in character. Whilst the casket must have been designed for and displayed in a tomb, no information about that specific context exists. The sarcophagus also poses another challenge on the level of context, this time regarding its relationship to other contemporary visual art. Private art is usually analysed within a framework defined by prominent contemporary public monuments: formal and stylistic features along with subject choice are assessed with regard to how they compare to public art, on the assumption that the latter set the pace for visual presentation at any one time. However, the second half of the second century CE provides many sarcophagus reliefs aimed at audiences in the somewhat semi-private context of the tomb but only a few state monuments for comparison – in fact, the modern understanding of the late Antonine period is largely based on sarcophagus reliefs. Our challenge, then, is avoiding this circularity whereby the sarcophagus is interpreted within parameters that are seemingly derived from state art yet actually rest on the evidence of sarcophagus reliefs.

Iconology

1 | Introducing iconology

> This 'as if from an observation point' obviously implies that Lucian
> himself was uncertain whether this figure was positioned further back,
> or was at the same time on higher ground. We need to recognise the
> logic of ancient bas-reliefs where figures further to the back look over
> those at the front, not because they are actually positioned above them
> but because they are meant to appear as if standing behind.
>
> Lessing 1768/1769[1]

From its first, formative stages, iconology has been closely intertwined with
the study of ancient art. This relationship distinguishes iconology from the
other two methods discussed in this book, while underscoring the role of
ancient art as a fundamental reference point for art-historical endeavours.[2]
In the 1932 article that was the first to sketch out the iconological enterprise,
Erwin Panofsky borrowed the observation by Gotthold Ephraim Lessing
cited above, on how the ancients approached art, to drive his argument dir-
ectly at the core of the heuristic problems he intended iconology to solve.[3]

Lessing had used Lucian's somewhat clumsy description of Zeuxis' famed
masterpiece of the fifth century BCE to pinpoint the fallacious nature of vis-
ual art, incapable of providing unequivocal information.[4] Panofsky turned
Lessing's ridicule of the medium the eighteenth-century scholar so deeply
despised into evidence that no such thing as *pure* description of an artwork

[1] Cited after Panofsky 2012: 467.

[2] It is worth noting that this mapping of art-historical phenomena onto what is perceived as the
blue screen of ancient art is as popular as it is highly problematic for the study of ancient art
itself: if ancient art is employed as an example of in effect *a priori* validity, the methods of its
investigation are also easily taken as a given. Potential friction between the two – the material
and the methods of its exploration – is thereby overlooked, leaving a false sense of security that
no methodological scrutiny is needed for the monuments of Greek and Roman antiquity to be
treated meaningfully.

[3] Panofsky 2012: 467–9.

[4] Lucian, *Zeuxis or Antiochus* 3–7. Lucian describes a copy of the painting (according to him an
exact one), stating that the original had been lost by his time. On the painting and its literary
documentation: Kraiker 1950; Tanner 2006: 178–9. Lessing's choice of source is smart: Lucian's
comment is primarily concerned with the stylistic features of the painting, and yet he fails
to capture its take on perspective. On Lessing's difficult relationship with the visual arts, see
Mitchell 1986: 95–115; Squire 2009: 97–111; Giuliani 2013: 1–18.

can exist. That Lucian of Samosata (120–80 CE), the learned polymath of the second century CE, had difficulty understanding the rules of perspective at play in a painting produced some centuries earlier – and during the classical period, a period seen as the epitome of artistic activity, and one understood to be accessible to all because of its ideal-typical character – was evidence enough for Panofsky to showcase that description is impossible unless based on an understanding of the workings of styles and artistic types at the time the artwork was created. And if description without such familiarity is impossible, the very process perceived as the unmediated part of any engagement with an artwork, then so too must be interpretation. In short, Panofsky held that one needs to be familiar with the artistic conventions of a period before one can attempt to interpret its artworks.

1) What is iconology?

Iconology in its contemporary codification, i.e., reading visual images as historical documents, connotes directionality, coherence, and lack of fragmentation.

Holly 1993: 17

Panofsky drew on antiquity to provide his argument with general significance, a clever trick to authenticate the otherwise simple assumption that artworks do not merely showcase sets of isolated aesthetic phenomena. Panofsky could claim that artworks also facilitate a better understanding of culture(s) and they do so because there exists an intimate relationship between an artwork and the period in which it is created. This idea sits at the core of iconology, as the method is based on the fundamental proposition that the objects that surround us, including artworks, reflect propensities of the human mind, and that they do so in ways specific to the individual cultures that produce them.[5]

But iconology as sketched out by Panofsky goes further, constructing a fully integrated epistemological framework, with the artwork as its ontological centre. It supports the idea that artworks – better than other cultural products – can portray the mind's exploration of reality, that they can show how the mind organises and conceptualises the world, displaying notions of space as expressed in the positioning of objects, or notions of volume in their rendering, and that they document how these formal articulations are combined to shape content.[6] By studying works of art, an iconologist would argue, we are able to track the workings of the mind within specific historical settings.

[5] Panofsky 2012: 479.
[6] Panofsky 2012: 480–2.

Object of interpretation	Subjective source of interpretation	Objective corrective of interpretation
1. Phenomenal meaning (to be separated into factual and expressive meaning).	Vital experience of being.	History of styles (the quintessence of what it is possible to represent).
2. Meaning dependent on contact.	Literary knowledge.	History of types (the quintessence of what it is possible to imagine).
3. Documentary meaning (intrinsic meaning).	Worldview Ur-behaviour.	General intellectual history (the quintessence of what is possible within a given worldview).

Fig. 1.1 Erwin Panofsky's three-step model of iconology (1932).

With this latter claim Panofsky propelled iconology into the realms of philosophy: no longer simply an analytical device to appropriate pictures as historical evidence, the method appears equipped to monitor the relationship between mind and world, thereby affording engagement with such cardinal issues as aesthetics, perception, and causality. This, in turn, raises the stakes for art history as a discipline. By reconciling empiric art-historical endeavour and deductive philosophical thought, Panofsky introduced a refreshed sense of the importance of artworks as evidence on par with that tackled in other fields of scientific pursuit. But by the same token, that reconciliation put a considerable obligation on the discipline as envisaged by Panofsky, for it must not be content with collecting observations on form and style, but must pursue truth itself.

Panofsky devised iconology as an interpretive process consisting of three steps (fig. 1.1),[7] but he attested that during interpretation those distinct

[7]　Panofsky's model undergoes considerable changes: voicing his ideas for a methodological interpretation of works of art first in the introduction to *Herkules am Scheideweg* (Panofsky 1930), his 1932 article based on a paper delivered to the Kant Society in Kiel the previous year presents a tripartite interpretive model (Panofsky 2012). After emigration to the United States in 1933 Panofsky published an English version of this paper as the introduction to *Studies in Iconology* of 1939; in this version, the model retains its tripartite structure, with similarly spirited categories, but the argument is more pragmatic and notably toned down with regard

levels are amalgamated to form one undividable process, a circle of inter-
pretation.[8] The first level, that of *primary or natural subject matter*, or *phe-
nomenal meaning*, incorporates everything that a viewer can identify in the
lines and colours of the artwork based on his or her own experience. This is
the level of pre-iconographic description.

On the second level, that of *secondary or conventional subject matter*,
or *meaning dependent on content*, specific identification of these natural
objects takes place. Panofsky's classic example for this step is that a dinner
table with thirteen guests is likely to represent the Last Supper. This level,
with the correct identification of the natural subject matter, the second-
ary or conventional meaning of which is unveiled, is that of iconographic
analysis.

On the third level, that of *intrinsic meaning or content*, or *documentary
meaning*, Panofsky hoped to capture within the work of art the principles
that unveil the attitudes of 'a nation, a period, a class, a religious or philo-
sophical persuasion'.[9] The exploration and interpretation of these sym-
bolic values is positioned in contrast to *iconography* and, consequently,
labelled *iconology*. The activity that leads to iconology is re-creative, with
the intuitive synthesis of a multitude of information, whereas iconography
is achieved by analysis. In the 1955 iteration he explained the relationship
between the two more fully:[10]

It is because of the severe restrictions which common usage, especially in this
country, places upon the term iconography that I propose to revive the good old
iconology wherever iconography is taken out of its isolation and integrated with
whichever other method, historical, psychological or critical, we may attempt to
use in solving the riddle of the sphinx. For as the suffix 'graphy' denotes something
descriptive, so does the suffix 'logy' – derived from logos which means 'thought' or
'reason' – denote something interpretive.

Only in this latter version did he use the term *iconology* for this level, which
previously he had labelled 'iconographical interpretation in the deeper
sense'.[11]

Panofsky distributed specific requirements to each of the three levels, as
correctives for the interpretive process. For the first level the interpreter

to its theoretical trajectory. Yet another English version, similar to that of 1939, was published
in 1955 (Panofsky 1955). On the different versions and their origins: Holly 1984: 158–93;
Davis 2011: 234; Elsner & Lorenz 2012: 495–506.
[8] Panofsky 1939: 16–7.
[9] Panofsky 1939: 7.
[10] Panofsky 1955: 32.
[11] See Schmidt 1993: 17–18.

needs to have an awareness of the history of styles, in order to be able to recognise different objects in their period-specific manifestations. For the second level, a thorough familiarity with literary predecessors, with themes, thoughts, and ideas of a specific period, is required. Here, the interpreter has to have an awareness of the history of types. For the third, the toolbox is even more varied: here, Panofsky relies on the synthetic intuition of the interpreter, and on 'a familiarity with the essential tendencies of the human mind, conditioned by personal psychology and *Weltanschauung*'.[12] To gain a corrective for this last step, the interpreter has to have an awareness of the history of symptoms or symbols, and thus an insight into how these tendencies can be expressed throughout world history.[13]

Very much in line with the approach of the whole Warburgiana, for Panofsky the formal aesthetics of an art object and the layers of meaning added to that object by its relation to a specific iconographic tradition and historical context are not captured by two distinct modes of perception, but come together to form one holistic experience. Historical baggage does not taint the aesthetics of an object but enhances and adds depth. To capture this wholly integrated aesthetics, Panofsky's model throughout its three stages favours an interdisciplinary approach, incorporating different methods and heuristic remits.

2) Iconology: premises, positions, and problems

'It is not true,' he [Panofsky] said, 'that the art historian first constitutes his object through a re-creative synthesis and then begins his archaeological research, as one first buys a ticket and then boards the train. Actually, the two processes do not occur successively, but rather proceed in an interwoven manner; not only does the re-creative synthesis serve as a basis for the archaeological research, but the latter in its turn serves as a basis for the process of re-creation. Both qualify and correct each other in a reciprocal relationship.' The work of the iconologist is completely different from that of the iconographer; the latter describes the connotations of the figure as an entomologist describes the characteristics of an insect; the former synthesizes, not analyzes, because he reconstructs the previous existence of the image and demonstrates the necessity of its rebirth in that present absolute which is the work of art.

Argan 1975: 300

[12] Panofsky 1939: 15. For the origin of the concept of *Weltanschauung*, see below, p. 31.

[13] In his later writings, Panofsky ventured so far as to proclaim a 'disguised symbolism' in works of art, identifying a process by which the artists would deliberately weave doctrinal and other ideological messages into their images for the viewer, and subsequently the art historian, to decode; he exemplified this interpretation in his study of Netherlandish painting (Panofsky 1953).

The methodological sweep of iconology as originally devised by Panofsky is considerable, and it is therefore not surprising to find its positions, and post-Panofskyan repositioning, both wildly applauded and heavily contested down to the present day. A closer look at the method's founding father, Erwin Panofsky (1892–1968),[14] should ease our way into the hotly debated issues. A characteristic feature of his oeuvre is a penchant for combining close autopsy of an artwork, the traditional analytical technique of art history, with an interest in the wider cultural impact of art and, more broadly, the philosophical concepts to which it pertains. Employing astute logical argument, his analyses seek to bring out the assumed meaning(s), historical and philosophical, behind what is on display. Following his dissertation on Albrecht Dürer's theory of art,[15] Panofsky produced a series of articles in which he argued fiercely for a more methodologically aware discipline of art history, attacking the most prominent products of art-historical scholarship at the time: initially the work of the Swiss art historian Heinrich Wölfflin (1864–1945),[16] then, and vociferously, the studies of Alois Riegl (1858–1905).[17]

Riegl and Panofsky: an overture to iconology.

In three seminal studies, first *Problems of Style*, then *Late Roman Art Industry* and *The Dutch Group Portrait*, the Austrian art historian Riegl sketched out his model of a new type of formalist art history (*Problems of Style*, originally published in 1893).[18] Whilst following ideas formulated by Gottfried Semper (1803–79) and Wölfflin on the evolution of ornament and the interconnectedness of visual phenomena within one period,[19] Riegl forged a new line of argument by turning the attention away from the artwork and onto the forces, artistic and attitudinal, that impact its creation. He summarised, and classified, these forces under the heading *Kunstwollen*, translated as *artistic volition* or *the will to art*.[20]

[14] On Panofsky and his work: Podro 1982: 178–208; Holly 1984; Hatt & Klonk 2006: 96–119; Davis 2011: 234–74.

[15] Panofsky 1915a.

[16] Panofsky 1915b.

[17] Panofsky 1981; Panofsky 2008.

[18] Riegl 1985; Riegl 1992; Riegl 1999.

[19] On Semper, see Podro 1982: 44–55. Wölfflin's *Sehformen* ('forms of seeing') had particular relevance for Riegl: Wölfflin 1932; Wölfflin 1964. For a critical discussion of Wölfflin's work, see Podro 1982: 98–116; Schwartz 2005: 1–36; Hatt & Klonk 2006: 71–80.

[20] For a critical appraisal of Riegl's approach, and particularly the concept of *Kunstwollen*, see Pächt 1963: 190–1; Alpers 1979: 139–48; Panofsky 1981; Sedlmayer 2001; Podro 1982: 71–118; Holly 1984: 69–96; Olin 1992: 148–53; Iversen 1993: 3–18, 149–66; Wood 2000: esp. 26–30;

With *Kunstwollen*, Riegl set into place a framework for the scrutiny of the artistic output of a period beyond its aesthetic substance. Its aim is to carve out the conceptual attitudes of a period as evident through its artworks, and to do so by dissecting the typological development of the artworks' individual features. Riegl argued with notably non-hierarchical thrust that any artistic output, and any artistic period, is driven by intentionality and purpose, regardless of that output's aesthetic achievement. He thereby opened the way for the study of artistic material hitherto neglected or pigeonholed as undeserving of art-historical study, such as decorative embellishments, alongside products of *high art*, the traditional domain of art history, including sculpture, painting, and architecture. And he directed the scholarly focus to periods previously regarded as merely troughs between peaks of artistic production.

Riegl was interested in the perceptual world as it finds itself organised in the artworks of any one period,[21] assuming that differing stylistic periods are characterised by differing *artistic vision*, by distinct ways of seeing the world. Hence he set out to map the internal causality that shapes the stylistic development of individual forms – for example, how the Egyptian motif of the lotus flower undergoes transformation in Greek architectural art to become the acanthus leaf.[22] Similarly, his reassessment of the Arch of Constantine, which forms the core of his study of late antique art, is fuelled by a comparison with Egyptian relief sculpture that captures its character as constituted by its tactile rather than optical nature.[23] Traditionally regarded as a monument documenting the beginning of the decline of Roman art during late antiquity, the arch in Riegl's analysis, which is complemented by the discussion of a vast array of other artistic material, provides the scaffolding for a commanding counter-narrative of artistic development in Italy from the fourth to the ninth centuries, with the arch presented not as an end, but as a beginning of art.[24]

Sedlmayer 2001; Crowther 2002: 22–35; Reichenberger 2003: 17–28; Schwartz 2005: 137–45; Elsner 2006; Gubser 2006: 153–61. The influence of Riegl's *Kunstwollen* reaches as far as the Marxist philosopher Ernst Bloch (Bloch 2000: 18–20 and 94–6, turning to *Kunstwollen* as an example of how to capture social affectivity), Mikhail Bakhtin (Bakhtin 1981, criticising material aesthetics; further on Bakhtin, see below, p. 115), and not least Walter Benjamin (Benjamin 2002); see Kemp 1973; Kemp 1978.

[21]　Hatt & Klonk 2006: 82.

[22]　Riegl 1992; Hatt & Klonk 2006: 85.

[23]　Riegl 1985. Cf. Riegl's discussion of two Mycenean drinking vessels, the Vapheio cups: Riegl 2000. The binary terms used for discussion are mostly adopted from Wölfflin's fundamental terms for art history; see Wölfflin 1932.

[24]　Brendel 1953: 21–7.

From the vantage point of *Kunstwollen*, artworks serve as historical documents. On first sight, Riegl's approach seems therefore closely in line with the method of iconology as described above. And indeed, in his 1925 essay on the relationship of art history and art theory, Panofsky appropriated this aspect of Riegl's concept, the formal and stylistic appearance of the artwork as a means to unlock historical knowledge, to argue for a concept he refers to as *Kulturwollen*, a 'will to culture'.[25] This assessment seems to sit somewhat uncomfortably with his earlier, and later, charges against Riegl's model, and those of the New Vienna School, which followed in Riegl's wake.[26] There, Panofsky attacked *Kunstwollen* for its psychologising nature and engrained concept of history, admonishing its tendency to act as a levelling tool in interpretation, with any discrepancies in the evidence trimmed to fit predetermined historical analogy.

The essence of Panofsky's vision for iconology, and the reason for both his compliance with and objection to Riegl's approach, lies in the way in which the two approaches negotiate empiricism. Riegl understood *Kunstwollen* as a supra-individual dynamic force that determines the formal appearance of the artwork and can be captured through its erudite formal analysis, and therefore by empirical means, while Panofsky propagated a metempirical approach: for him, artworks – along with any other cultural artefact – pertain to discourses around fundamental (philosophical) problems, problems that are specific to their period and in need of elucidation.

Panofsky thereby unmasked Riegl's approach as simplistic and as playing into the hands of those who held that art history developed linearly[27] because it was founded on the unreflective assumption that artistic form could directly explain history.[28] Panofsky aimed to overcome this 'merely causal account of art'.[29] In its stead, he introduced a system of fundamental concepts, a set of *a priori* antithetical categories within which, he argued, the mind operates and with which it infuses experience with causality.[30] His interest was not in changes in mode of vision, à la Riegl, but in the symbolic function of artistic expression – a difference that was manifest in Panofsky's disregard of the viewer, whose presence was firmly integrated in Riegl's model. Panofsky's approach superseded Riegl's supra-individual concept of *Kunstwollen* and

[25] Panofsky 2008: 65–6. See Lorenz & Elsner 2008: 37.

[26] Cf. Panofsky 1981; Panofsky 2012. The protagonists of the New Vienna School were Otto Pächt and Hans Sedlmayer. For Sedlmayer's approach, see Sedlmayer 2001; Schwartz 2005: 146–51. For the Vienna School now Rampley 2013.

[27] Podro 1982: 97, who discusses the Hegelian influences of Riegl's model.

[28] On Riegl's failure to explain art as a 'metempirical object': Holly 1984: 147–9; Panofsky 2008.

[29] Podro 1982: 178–9.

[30] Panofsky 2008: 47–56.

model of accessing history through the artwork, by locating the driving force behind artistic expression explicitly in the human mind, which was to be understood by an analytical synthesis of artwork and history.

Panofsky between Kant and Warburg: the shaping of iconology.

Iconology's subscription to the metempirical, and to pictorial signification as its facilitator, differentiates it from formalism as propagated by Riegl, despite the approaches' shared interest in stylistic form. Panofsky's investment in conceptual theory grew out of an entirely different allegiance, to reasoning as expressed by Immanuel Kant (1724–1804) in his 1781 work, *Critique of Pure Reason*.[31] In his fundamental concepts, Panofsky adopted from Kant the idea of an *a priori* system that organises the relationship between mind and world, as he strived to satisfy Kant's model of scientific judgement. The result was an analytical framework that is not empirical but exists above experience: it is structured around the duality of what is determined *a priori* and of sensual perception organised in relation to this.[32]

Panofsky was not the first in this period to adopt Kantian philosophy for cultural study. Through the 1920s the philosopher Ernst Cassirer (1874–1945), Panofsky's colleague at the University of Hamburg,[33] completed his seminal work on the philosophy of symbolic forms,[34] a study developed out of Kant's assumption, as expressed in his *Critique of Pure Reason*, that reason can produce knowledge of things but cannot create these things as objects. Cassirer argued that in compensation symbols act as navigational devices for humans: they organise the multifarious approaches devised by the mind in its attempt to relate to the world – effectively, what we perceive as our knowledge of the world – into a coherent system. And he examined the processes by which these symbolic forms are constructed within different fields of cultural activity: language, the production of scientific knowledge, myth, religion, and art.

With this wide sweep, Cassirer cultivated the Kantian judgement of reason into a fully-fledged critique of culture.[35] Panofsky harnessed both, the Kantian foundation and its cultural appropriation by Cassirer, to devise his

[31] Most recently on Kant's *First Critique*: Guyer 2010.

[32] Podro 1982: 181, 202; Ferretti 1989: 182–4; Neher 2004: 45–6.

[33] Cassirer had joined the university upon its foundation in 1919, Panofsky in 1921. See Podro 1982: 181.

[34] Cassirer 1955. Bayer 2001 provides a commentary on the philosophical consequences of Cassirer's work.

[35] Cassirer lay down here the foundations for his later work in the field of cultural anthropology: Cassirer 1944; Cassirer 2000. A concise assessment of his work can be found

Fig. 1.2a Mnemosyne, the motto over the entrance to the Kulturwissenschaftliche Bibliothek Warburg (K.B.W.) in Hamburg (1920s).

own interpretational model.[36] He applied the idea of the symbolic forms and on that basis argued that the study of a visual representation with regard to its iconological emergence allows direct access to the mental dispositions that shaped it. He thus opened up a way for visual analysis to reach beyond the manifestation of the object and towards the capture of reality, a reality mediated by psychological dispositions as they show themselves in the visual.[37]

Further influence on Panofsky's iconology came from another circle of scholars, again based in Hamburg: those related to the Kulturwissenschaftliche Bibliothek Warburg, including its patron, Aby Warburg (1866–1929).[38] Warburg's interest in the visual aspects of culture

in Holly 1984: 114–30; for a more detailed discussion: Skidelsky 2008: esp. 100–27 on the symbolic forms.

[36] On Panofsky's relationship with Cassirer, see Holly 1984: 114–57; Ferretti 1989: 97–8, 158–9; Crowther 2002: 36–68.

[37] Moxey 1993: 27.

[38] Founded in 1901 and funded by his family's bank business, the library was established as an important resource for culture-historical study and included a large collection of pictures. On the library: von Stockhausen 1992; Raulff 1997; Schäfer 2003.

Fig. 1.2b The reading room of the K.B.W. with Warburg's picture boards (1920s).

interlocked most helpfully with Cassirer's understanding of symbols.[39] In his 1893 dissertation on Botticelli, which launched the Renaissance reception of classical antiquity as the key interest of his scholarly career, Warburg introduced the term *iconology* as an analytical index, making recourse to its original meaning, as constituting an explanatory guide to allegory.[40] He drew on the term again in a paper presented at the International Congress of Art Historians in Rome in 1912, on the depictions of the months in the Palazzo Schifanoia in Ferrara.[41] Here Warburg conducted a discussion of the frescoes on an entirely new conceptual level, examining visual evidence and contemporary textual evidence – in this case, on astrology – alongside

[39] On Warburg, his life and work: Gombrich 1970; Hofmann & Syamken & Warnke 1980; Bredekamp & Diers & Schoell-Glass 1991; Schmidt 1993; Didi-Huberman 2002; Russell 2007: esp. 20–55; Michels 2007. On the parallels and differences between Warburg's and Cassirer's work: Ferretti 1989: 142–56; Habermas 1997; Raulff 1997; Skidelsky 2008: 74–5, 89–99.

[40] Warburg 1893. Cesare Ripa had first used *iconologia* as the title for his collection of emblems with explanatory texts of 1613. For further discussion, see Gombrich 1970: 43–66; Schmidt 1993: 9–12, 21–32; Didi-Huberman 2005: 118–21; Hatt & Klonk 2006: 98.

[41] Published as Warburg 1999c.

each other, with considerable repercussions for the discipline of art history.[42] He claimed the pictures could unlock layers of the cultural subconscious and thereby turned them into a unique historical source.[43]

Warburg's approach, and his interest in social memory in particular, was steeped in the psychological scholarship of his time.[44] He strove for what he labelled a 'psycho-history', to be achieved by analysing pictures in order to capture emotional and social mentalities, entities that Warburg referred to as 'pathos formulae'.[45] The most striking example of Warburg's approach is his picture atlas *Mnemosyne*, devised to explore the reception of ancient artistic elements in Western art since the Renaissance,[46] the concept manifested also over the entrance of the Warburg Library in Hamburg (fig. 1.2a). Warburg used a series of wooden boards covered in black cloth in the reading room of this library to pin up all sorts of visual evidence and so create 'visual clusters' (fig. 1.2b). The arrangement allowed for continuous regrouping, and thereby was able to accommodate changes in question or perspective.[47] The three simple principles inherent in this configuration constitute the kernel of Warburg's approach to pictures: to place the visual evidence at the centre of any argument; to present different pieces of evidence simultaneously alongside each other; and to use the relationality of this arrangement as a device to forge an analytical argument that can account for multiple relationships and so distil the meaning(s) inherent in what is on display. This championing of relationality as a basis for analytical endeavour contrasts profoundly with the linearity inherent in Riegl's *Kunstwollen*. Conversely, it serves – along with both Panofsky's and Warburg's interest in the work of Cassirer – as a precursor for the synthesis that sits at the heart of Panofsky's model of iconology.

Panofsky had met Warburg at the 1912 conference in Rome, and his work on Dürer and his move to Hamburg in 1921 brought him steadily closer to the Warburg circle. He even became Warburg's replacement in the project on Dürer's *Melancholia*.[48] And yet it would be wrong to see Panofsky

[42] For an assessment of its standing in the history of the discipline, see Gombrich 1970: 186–205; Schmidt 1993: 21–32.

[43] Earlier examples of this approach are his 1902 article on the pictures of the Florentine bourgeoisie and the 1907 piece on Francesco Sassetti, both republished in Warburg 1999a: 184–221 and 222–62.

[44] A central influence was Richard Semon (Semon 1920), and also the philosopher Friedrich Theodor Vischer (Vischer 1887). See Gombrich 1970: 25–36; Ferretti 1989: 14–16, 112–15. For Warburg's influence on the concept of collective memory, see Assmann 1995: 128–9.

[45] Warburg 1999b. Gombrich 1970: 177–85, esp. 179–82 on the birth of the term 'pathos formula'.

[46] Warburg 2003. For a critical discussion, see Gombrich 1970: 283–306 and Bredekamp 1995: 365–7; the latter labels it a 'psycho-motorical history of images'.

[47] Gombrich 1970: 283–306. Cf. Lorenz & Bligh 2013.

[48] Panofsky & Saxl 1964. See Gombrich 1970: 31–4.

as simply a satellite of Warburg. Panofsky may have shared Warburg's interest in the symbolic content of visual presentation, its value for sociological study, and, more generally, the ways in which cultural conditions are registered in artworks, and certainly he chose the same field for his own work, the reception of ancient iconography in Renaissance art. In contrast to Warburg, however, Panofsky analysed pictures not in order to extract constituents of social memory but to determine the production of knowledge and prevalent social ideologies in any one period.[49]

This differing scope was facilitated by Panofsky's adherence to the work of the philosopher and sociologist Karl Mannheim (1893–1947) and his model of *Weltanschauung*, part of his 'sociology of knowledge'.[50] Opposed just as much to Warburg's psychology-informed cultural history as to the psychologising aspect of Riegl's *Kunstwollen*, Mannheim provided Panofsky with the methodological toolbox that would enable him to synthesise findings made in differing fields of culture and establish 'documentary meaning'.[51]

But also, and perhaps more importantly, Panofsky's iconology was shaped by an appropriation of Kantian metaphysics different from that of the Warburg circle: while Panofsky argued on the basis of the existence of an *a priori* truth to which any actual visual manifestation can and must be related, setting out to capture the *a priori* objective, Warburg instead aimed to explore the social conditions of this relationship.

In this context Panofsky made a somewhat surprising attempt at conciliation with a conceptual camp intrinsically opposed to Kantian ideas, that of Martin Heidegger (1889–1976), a move that once more contrasts him with the Warburg circle. In a 1932 article on iconology, Panofsky chose a passage from Heidegger's 1929 discussion of Kant's *Critique of Pure Reason* to demonstrate the dependency between interpreter and interpretation of works of art:[52]

Nevertheless, an interpretation limited to a recapitulation of what Kant explicitly said can never be a real explication, if the business of the latter is to bring to light what Kant, over and above his express formulation, uncovered in the course of his laying of the foundation. Surely, Kant was not in a position to state this himself, just like it is in all philosophical discourse not essential what is found in the specific propositions of which it is composed but in that which, although unsaid as such, is

[49] Cf. Podro 1982: 205.

[50] Mannheim 1971. For a critical discussion see Hart 1993: esp. 545–59. On the relationship of art history and sociology in the early twentieth century, see Tanner 2003: 8–17, esp. 10–12.

[51] Panofsky makes various uses of Mannheim: Panofsky 1981; Panofsky 2008: 65–6; Panofsky 2012: 478.

[52] Panofsky 2012: 476, quoted from Heidegger 1962: 206–7.

made evident through these propositions … It is true that in order to wrest from the actual words that which these words 'intend to say', every interpretation must necessarily resort to violence. This violence, however, should not be confused with an action that is wholly arbitrary. The interpretation must be animated and guided by the power of an illuminative idea. Only through the power of this idea can an interpretation risk that which is always audacious, namely, entrusting itself to the secret élan of a work, in order by this élan to get through to the unsaid and to attempt to find an expression for it. The directive idea itself is confirmed by its own power of illumination.

Heidegger marked the process of interpretation as characterised by violence, which can only be justified if driven by an 'illuminative idea'. While in this passage Heidegger refuted the possibility of reaching anything along the lines of a Kantian truth,[53] Panofsky employed this very passage in order to reach a middle ground,[54] arguing that an objective description, and subsequent interpretation, of a work of art is impossible if it is not based on a coherent methodological thread, a clearly defined method of enquiry. Panofsky thereby turned Heidegger's illuminative idea into a means of achieving the condition of *a priori* truth, and he forged a direct link between philosophical and art-historical argument.

In the reinvention of Heidegger's critique as a starting point for arguing for the method of iconology, and with it for a falsifiable, coherent system of art-historical interpretation that tracks the steps of any one interpreter, Panofsky's methodological eclecticism is apparent.[55] But it also demonstrates his profound investment in the concept of knowledge, which differentiates his approach decisively from Warburg's. In employing Heidegger's statement, Panofsky purged iconology of anything that could appear as empiricism,[56] and he sacrificed any interest in socio-historical experiences in favour of what he declared to be *scientific synthesis*.

Iconology after Panofsky: simplification and iconoclasm.

Panofsky's model of iconology bears elements that can be found in later semiotics,[57] which feed off Panofsky's interest in the coding of knowledge

[53] Heidegger and Cassirer stood for opposing concepts, ontology vs Kantian metaphysics, and their debate culminated in a showdown in Davos in April 1929; see Friedman 2000: 1–9, 129–44; Skidelsky 2008: 195–219.

[54] Elsner & Lorenz 2012: 488–90.

[55] Cf. Hasenmueller 1978 with regard to the relationship between iconology and semiotics.

[56] Bredekamp 1998: 208.

[57] Panofsky was hailed as the first semiotician: Argan 1975: 299, 303; Bal & Bryson 1991: 174. For a detailed discussion of this claim, which draws the conclusion that Panofsky shared with

and also in visual culture studies,[58] exploiting those passages where Panofsky operates close to Warburg. The modern shape of iconology is accordingly varied, as is the criticism it has encountered. Two aspects, however, stand out: iconology's reliance on the capabilities of the interpreter, and its abstinence from the category of the viewer.

The method of iconology requires considerable ingenuity and historical understanding on the part of the interpreter in order that he or she can execute the type of informed scientific synthesis Panofsky demands. In its application, however, interpreters frequently fall short of this ideal, falling victim to an endemic danger of mistaking cause and effect.[59] So the lack of skill on the part of the interpreter can result in behaviour of which Panofsky was himself frequently accused and which favours one type of evidence over another,[60] for example when the interpreter explains a picture unidirectionally through the textual sources instead of using the visual manifestation as a source in its own right. A vicious cycle forms, with knowledge of general cultural developments in a particular period put before the actual object,[61] which renders iconology a merely tautological device, deployed to find exactly what the interpreter set out to look for. This failing also underlines the inherent problem that any number of texts might support any number of interpretations rather than produce a better understanding of the historical period in question.[62]

In recent years, Georges Didi-Huberman has introduced an alternative to iconology by launching a fresh attack on the failure to consider the viewer. Applying Heidegger's critique of Kant, Didi-Huberman tackles Panofsky's reliance on Kantian philosophy,[63] and he thereby argues against the notion of *intuitive synthesis* so central to Panofskyan iconology:[64]

The history of art, by adopting the schema or more loosely the tone of the Kantian doctrine, made itself directly subservient to the constraints that Heidegger, as early as 1927, recognized at the heart of Kantism. On the one hand, its metaphysical character: thus did the history of art become married without knowing

semiotics only an interest in deep meaning: Hasenmueller 1978: esp. 297; cf. also Bredekamp's comparison of Panofsky and Claude Lévi-Strauss (Bredekamp 1995).

[58] For the relationship between Panofsky's iconology and media studies: Schmitz 2000.

[59] Hatt & Klonk 2006: 115.

[60] Wood 1997: 24; cf. Arnulf 2002: 103.

[61] Mitchell 1986: 42–6; Harbison 1989: 198–205; Preziosi 1989: 111–21; Bedaux 1990: 10; Cassidy 1993: 6–7; Belting 2011: 12. Contra: Bredekamp 1995: 365–7.

[62] Baxandall 1985: 132. Baxandall has himself been accused of similar failure: see Didi-Huberman 2005: 40–1; cf. Squire 2009: 79–83; see also below, p. 158 n. 26.

[63] Didi-Huberman 2005. Previously, Donald Preziosi had advanced another fierce critique (Preziosi 1989). Cf. Mitchell 1994: 16–19.

[64] Didi-Huberman 2005: 137.

it (rather: actively denying it) to a movement, a method aiming to reground metaphysics, and more exactly to make metaphysics into science. By doing so the history of art made its own desire to become a science subservient to the neo-Kantian formula of a science spontaneously conceived as metaphysics. On the other hand, Heidegger articulated very well the logical limit of this whole system: a limit in accordance with which Kant, likewise spontaneously, reshuffled his transcendental logic into the customary procedures of simple formal logic.

According to Didi-Huberman, Panofsky propagates a metapsychology of symbolic forms[65] to solve the conundrum that artworks mime both what can be seen and what cannot, but, following Kant, deals with this metapsychology as if it were metaphysics,[66] concentrating only on what is shown and how it relates to truth. Didi-Huberman argues that Panofsky thereby actively impeded the phenomenological approach needed to unlock the full visual potential of artworks,[67] and he implicitly accuses iconology of the same offence. Indeed, in his view, the discipline of art history as a whole has fallen victim to glossing over the alienation and fragmentations of its objects. Yet, according to Didi-Huberman, iconology does so not by accumulating data, as do the other approaches,[68] but by employing a false sense of reason, a levelling tool that can only ever produce an overly homogenised picture of the past.

Calling for an engagement with those layers outside reason that govern art, with 'life in its subterranean routes' as propagated by Warburg,[69] Didi-Huberman directs the focus instead onto processes of viewing and their psychological condition, the metapsychology of the artwork, an area left untouched by Panofsky's iconology because he had seen imminent in it the threat of simplistic subjectivism and circularity.[70] Didi-Huberman's critique is thus a prompt to acknowledge the network of viewers and artworks as constituting the meaning of the artwork within the cultural setting which it shapes and to which it contributes. He ventures even further, declaring this network the means by which any interpretation of an artwork is made valid, because by exploring processes of individual symbolisation

[65] Didi-Huberman's use of the term metapsychology is appropriated from Sigmund Freud's and Jacques Lacan's work, see Didi-Huberman 1992: 11–18, 64–7.

[66] Didi-Huberman 2005: 170. For his own approach, see below, pp. 181–2.

[67] Mitchell 1986: 42–6; Belting 2011: 12–13.

[68] Didi-Huberman 2005: 33. See also above, pp. 4–5.

[69] Cf. Wind 1931; Gombrich 1960: 19–20; Holly 1993: 18.

[70] Panofsky argued that concentrating on the viewer would stand in the way of the establishment of *a priori* principles. He had accused Riegl of circularity on the same grounds, since Riegl put considerable emphasis on the artists' intention when creating their works (Hatt & Klonk 2006 : 101–2; Panofsky 2008: 58–9).

the dangers of tautological interpretation are avoided.[71] Didi-Huberman hereby forges a link with critical iconological approaches.[72]

This criticism also helps to bring out an inconsistency in Panofsky's method. Panofsky acknowledged that the process of perception was determined by viewers,[73] but his iconological model was only concerned with acts of collective symbolisation. Or, to put it in another, semioticised, way: his goal was to establish the cultural code to which any artwork pertains, with the existence of such a code testified by *a priori* necessity, by the *a priori* compulsion of the human mind, as Cassirer defined it, to render things intelligible.[74] But for the sake of one paramount reading within a unified creative process, that method is not concerned with the multitude of different decodings by viewers. And in bypassing this metapsychological side of the artwork, Panofsky's unidirectional approach towards knowledge returns with a vengeance:[75] his *intuitive synthesis* is nothing but an anthropocentric corrective conducted by a scholar who, after all, is always himself a viewer, even if a hyper-informed one. By excluding the viewer Panofsky manoeuvres himself into conflict with his own method.

And yet reconciliation between these two camps, Panofsky's iconology and Didi-Huberman's phenomenology, is not impossible. If the category of *intuitive synthesis* is accepted as an anthropocentric corrective that includes the viewer, a pragmatised version of the iconological model becomes a possibility[76] and a means of mapping contrasting and even opposing expressions and perceptions. With aspects of metapsychology thus introduced through the back door, the divide between Warburg's and Panofksy's approaches

[71] Didi-Huberman 2005: 192–4.

[72] For critical iconology, see below, pp. 175–6.

[73] Panofsky 2012: 469. Holly 1984: 153.

[74] Holly 1984: 121.

[75] Cf. Holly 1984: 161–2.

[76] This possibility is anticipated in Edgar Wind's solution for the Kantian antinomy, based on the assumption that all science is metaphysics rather than that metaphysics is also a science: Wind 2001: 19. Contra: Belting 2011: 12–13. This new potential inherent in intuitive synthesis seems also to be a product of a certain mellowing in Panofsky's own methodology that took place between the 1932 article and its reworked version that appeared in 1939 in the English publication of *Studies in Iconology*. In 1939 Panofsky selected a different object to showcase his method, replacing Grünewald's resurrection with his famous example of meeting a man on the street who lifted his hat. In doing so, Panofsky did not simply opt for a more mainstream, less elitist image, but rather introduced as a measurement tool a commonsensical corrective that is not so far from Wind's anthropocentric pragmatism; Panofsky would later describe this development as the product of a need for clarification that arose from the new idiom in which he was now working (Panofsky 1955: 329–30; Elsner & Lorenz 2012: 498–9). While Panofsky had always assumed that the scholar would take on the role of corrective for irrational interpretation, in this example that role is made more explicit than in his earlier take.

towards pictures dwindles, and iconology emerges as a method capable of generating a homogeneous, but not homogenised, analytic narrative.[77] In this sense, then, Panofsky's iconology already offered scope for a critical iconology, as has been propagated by Tom Mitchell and Hans Belting.[78]

[77] Cf. Bredekamp 1995: 365–7.
[78] Mitchell 1986: 47–150; Mitchell 1994: 11–13; Schulz 2005: 91–6; Belting 2011: 9–36. Cf. below, pp. 175–6, 178–80.

2 | Iconology in action

The analysis here proceeds in two stages that encompass the Panofskyan three-step model.[1] At the iconographic stage, the focus is first on the depicted characters, their attire, and their relation to each other and to other pictorial elements, and then, in a second step, these elements are compared with other visual and textual versions of the myth. At the iconological stage, the specific rendering of the mythological story as presented in the pictures is contextualised within its historical setting.

1) The Karlsruhe hydria: conflict, consolation, and Athens

An iconographic analysis.

The figure of the Trojan prince Paris (Alexandros) in the upper picture field, the character judging over the fairest of the Olympian goddesses, is at the centre of the hydria's iconographic peculiarities requiring explanation (fig. 0.1). He is dressed in Oriental clothes, with soft cap, richly patterned tunic and trousers,[2] and with a dagger featuring a bird's head hilt hanging from a baldric across his upper body. The *lagobolon*, a hunting utensil, in his left hand identifies him as a figure of the outdoors and as a shepherd,[3] as do also the landscape setting and the dog at his feet.

The picture's nucleus shows Paris in negotiation with Hermes and Eros (fig. 5.1).[4] The prince's hand gesture towards Eros, with thumb and index

[1] Elements of Panofsky's first, pre-iconographic stage are covered in the introduction, see above, pp. 10–12.

[2] His cap is Phrygian, his tunic a Persian *ependytes*, and he wears Persian trousers (*anaxyrides*). See Miller 1989; Miller 1997: 153–87, esp. 180, 184–6; Leland & Davies & Llewellyn Jones 2007: 6 (s.v. *anaxyrides*), 58 (s.v. *ependytes*), 138 (s.v. *parakymatios*), 145–7 (s.v. *Persian dress*).

[3] *Lagobolon*: Martini 2003: 189 s.v. *Lagobolon*.

[4] For the iconography of Paris, see LIMC I 1981 s.v. *Alexandros* (R. Hampe); see also below, pp. 39–42. The label aside, Hermes is identified by the messenger staff, the *kerykeion*, and his travel hat. On the iconography of the god, see LIMC V 1990 s.v. *Hermes* (G. Siebert); Clairmont 1951: 106. Eros is characterised by his puerile appearance and the wings on his back, see LIMC III 1986 s.v. *Eros* (A. Hermary); Clairmont 1951: 122–3.

finger of the right meeting, seemingly expresses approval.[5] The three god-
desses are arranged around this group. Athena is on the left in full armour,
including an Attic helmet with horse protomes and the aegis.[6] The woman
standing further to the left is Hera, here lifting her garment in a way remin-
iscent of the *aidos* motif.[7] Aphrodite, in contrast, is depicted seated towards
the right of the nucleus;[8] she is accompanied by another Eros, who mimics
the stance of the Eros standing next to Paris.

The scene on the Karlsruhe hydria differs in two aspects from earlier
representations of the Judgement, which enjoyed considerable popularity
in sixth- and fifth-century black- and red-figure Athenian vase-painting.[9]
The first contrast concerns the characterisation of the participants, their
appearance, and their actions. In archaic and early classical versions, the
three goddesses were distinguished, if at all, by their attributes. Hermes was
shown leading them onto Mount Ida in a procession to meet the prince.[10]
Throughout the fifth century and particularly in the last quarter of the fifth
century, the goddesses became differentiated more clearly by dress, not
just attribute.[11] Also, on the Karlsruhe hydria they are depicted as having
arrived at Paris' post[12] and are no longer in procession.

[5] Lucilla Burn identifies this as an 'OK gesture' (Burn 1987: 67). Cf. Morris et al. 1979: 100–5.

[6] On the iconography of Athena, see LIMC II 1984 s.v. *Athena* (P. Demargne); Clairmont 1951:
108.

[7] On the *aidos* motif: Ferrari 2002: 55. For the iconography of Hera, see LIMC IV 1988 s.v. *Hera*
(A. Kossatz-Deissmann); Clairmont 1951: 107.

[8] LIMC II 1984 s.v. *Aphrodite* (A. Delivorrias); Clairmont 1951: 108–10.

[9] There exist 147 black-figure representations of the Judgement, and 71 in red-figure (figures
based on the material included in the Beazley Archive). For the treatment of the myth in art:
LIMC VII 1994 s.v. *Paridis Iuridicum* (A. Kossatz-Deissmann); Harrison 1886; Clairmont
1951; Raab 1972; Raeck 1984: esp. 14–5; Burn 1987: 65–8; Burn 1991: 118–22; Borg 2002:
101–2, 159–60; Woodford 2003: 89–94, 278–84; and cf. below, pp. 187–92. For the Judgement
in literature, see Reinhardt 1938; Stinton 1965; Davies 1988a: 5–11, 31; Davies 1988b; Davies
2003; Dodson-Robinson 2010; see also below, pp. 40–1, n. 22.

[10] Aphrodite can carry an Eros or a lotus flower, Athena her helmet, and Hera, who usually leads
the procession, a lion or a box for cosmetics. Borg 2002: 101–2. This type of composition
emulates Hermes leading the procession of the Charites, see Harrison 1886: 211–18; cf.
Clairmont 1951: 91–3. For example: BF Pyxis, Brussels, Musées Royaux A3; from Thebes/
Boeotia. Painter of London B76, *c.* 550 BCE. ABV 87.21; CVA *Brussels, Musées Royaux d'Art et
d'Histoire* 3: III.He.14, pls 22.1a–e; LIMC VII 1994 s.v. *Paridis Iuridicum* no. 18.

[11] This process began in the last quarter of the sixth century (Lemos 2009: 136) and continued
throughout the fifth, with a wholly new type of differentiation occurring in full elaboration
first on a pyxis: RF Pyxis, New York, Metropolitan Museum 07.286.36; from Cumae.
Penthesilea Painter, *c.* 450 BCE. ARV² 890.173, 1673; Para 428; Add² 302; Clairmont
1951: K149; Mertens 2010: 19 fig. 9; LIMC VII 1994 s.v. *Paridis Iuridicum* no. 46.

[12] On the tableau character of the later Judgement scenes see Real 1973: 64; Burn 1987: 65–70.
Cf. Harrison 1886: 204, 209–10 (her Type D).

In the archaic depictions, the Trojan prince appeared as a bearded older male (fig. 2.1),[13] but from the late archaic period onwards, he was presented as a youth, as is prominently documented on a classical cup in Berlin (fig. 2.2).[14] In addition, from the middle of the fifth century Paris can appear in Orientalising dress, first only with a Phrygian cap,[15] then in full attire, as on the Karlsruhe hydria. This outfit is at variance with earlier efforts, in the later sixth century, to display him as an Oriental, where he was shown in a distinctly ethnic-specific way as a Scythian, probably to emphasise his skills as an archer.[16] And while in the later fifth century the goddesses are depicted as more static, Paris' role and the act of choosing are now executed as the central elements.

The second contrast concerns the introduction of figures extending the core narrative: after the middle of the fifth century, characters such as Eris,[17] Zeus and Themis, Helius, Selene and Eos or Priam and Hecuba, and female personifications such as Eutychia and Clymene, enter the scenes.[18] Their presence instils greater complexity in the narrative: without them, the Judgement constitutes a negotiation of ideal female qualities; with them, and in parallel with the shift in focus away from the goddesses and onto Paris, who is frequently missing in the early depictions, the ethical behaviour of the individual participants in the Judgement is underscored, and so too are the wider implications of their actions for the course of (mythological) history.[19]

[13] BF Hydria, Basel, Antikenmuseum und Sammlung Ludwig BS 434. Antimenes Painter, *c.* 510 BCE. ABV 268.32; Para 118; Burow 1989: n. 115, pl. 104. Whilst particularly popular in the circle around the Antimenes Painter at the end of the sixth century, the aged Paris could also be found earlier, for example on the pyxis in Brussels (see above, p. 38 n. 9); cf. also: BF Amphora, Florence, Museo Archeologico 70995. Lydus, 560/550 BCE. ABV 110.32; Para 44; Add² 30; LIMC VII 1994 s.v. *Paridis Iuridicum* no. 12.

[14] RF Cup, Berlin, Staatliche Museen F2536; from Nola. Painter of Berlin F2536, *c.* 440 BCE. ARV² 1287.1; CVA *Berlin, Antikensammlung* 3: pl. 118.1; LIMC VII 1994 s.v. *Paridis Iuridicum* no. 39. He is presented with emphasis either on his musical skills, on the Berlin cup, or on his duties as a herdsman.

[15] Paris in Phrygian dress appears first here: RF Scyphus, Syracuse, Museo Archeologico Regionale Paolo Orsi 2406. Danae Painter, *c.* 440 BCE. ARV² 1076.16; LIMC VII 1994 s.v. *Paridis Iuridicum* no. 103. Cf. Clairmont 1951: K154. For literary descriptions of Paris as an Oriental, see Eur. *IA* 71–9; *Cyclops* 182–5.

[16] Depictions of Scythians, the then Athenian police force, were popular in the later sixth century: Vos 1963; Shapiro 1983: 111–12. Cf. Ohly 1977: 63; Raeck 1981: 263–4; Castriota 1992: 106 n. 22; Ivanchik 2005.

[17] For Eris, see below, pp. 119–20.

[18] LIMC VII 1994 s.v. *Paridis Iuridicum* nos 22–54. Harrison subsumes these under her Type D (Harrison 1886: 204, 209–10). For the additional figures, see below, p. 43 n. 35). For Themis, see p. 193 n. 35); for Eutychia: LIMC IV 1988 s.v. *Eutychia* (A. Shapiro); Shapiro 1993: 86–8, 169, 232–3; Borg 2002: 145. On personifications in the second half of the fifth century BCE in general see Osborne 2000; Borg 2002.

[19] Other additions to the Judgement scene in the later fifth century include Priam and Hecuba, for example: RF Hydria, Palermo, Museo Archeologico Regionale 2366; from Chiusi. Nicias

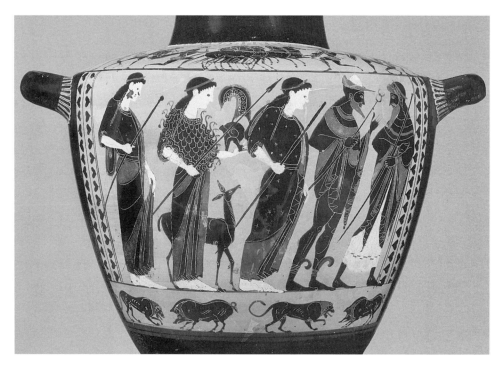

Fig. 2.1 Paris as a bearded, older male. Black-figure hydria by the Antimenes Painter. Basel, Antikenmuseum und Sammlung Ludwig BS 434. *c*. 510 BCE.

With the act of choosing between the goddesses taking centre stage on the Karlsruhe hydria, Paris stands out as protagonist. This portrayal follows a narrative concept similar to the plot developed in Euripides' *Alexandros*, who depicts Paris as an active arbitrator in the contest, which will result in the Trojan War.[20] And it presents a notable twist on other treatments of the myth by Euripides himself[21] and in previous versions,[22]

Painter, late fifth century BCE. ARV² 1334.29; Paribeni 1996: 89–91. For additional characters in the scene see also below, pp. 193–5.

[20] TrGF V 373–9; Snell 1937; Stinton 1965: 64–71; Kovacs 1984. Euripides explores a similar angle in his *Hecuba* (629–56).

[21] Eur. *Andr.* 274–92, 293–308; *IA* 573–85; *Hel.* 23–4 (premièred in 412 BCE, together with *Andromeda*); *Troades* 913–1042. Euripides identifies the incident as the cause of the Trojan War, and portrays the Judgement as a debate about the powers of the three goddesses, sidelining Paris' role.

[22] The Judgement is mentioned by Homer (*Il.* 24.28–30), whose plot rests on it. The story as a whole appears first in the *Kypria*, as part of the Homeric Cycle (Procl. *Chrest.* III 5.84–90): Zeus and Themis scheme a war to reduce the population of the world, and Eris throws an apple for the fairest into the audience at the wedding of Peleus and Thetis, to cause strife between Athena, Hera, and Aphrodite. Paris is enlisted by Zeus to decide between Athena's

Fig. 2.2 Paris as a youth. Red-figure cup by the Painter of Berlin F2536; from Nola. Berlin, Staatliche Museen F2536. *c.* 440 BCE.

where Paris serves merely as a small cog in the wheel of various divine schemes.[23]

What is more, whilst Eris and Zeus ensure reference to the imminent war is present, the Eros close to the Trojan prince puts emphasis on the theme of love, which, judging by Paris' gesture, is the quality for which the prince

military prowess, Hera's kingship of Asia and Europe, and Aphrodite's love and beauty. Stinton is correct to point out that the first textual evidence for the apple is Hygin. 92 in the second century CE (Stinton 1965: 7) (cf. Apollod. *epitome* 3.2; see Lugauer 1967). In visual representations, however, the apple appears as early as the last quarter of the seventh century BCE (see below, p. 41 n. 23) and then more frequently in vase-painting from the second half of the sixth century, for example: BF Neck-amphora; New York, Metropolitan Museum of Art 98.8.11; from Castel Campanile. Swing Painter, *c.* 550 BCE. ABV 308,65. 693; Add² 82; CVA *New York* 4: 20, pl. 22.1–4; Böhr 1982: 97, n. 115, pl. 115; cf. Lemos 2009: 136; LIMC VII 1994 s.v. *Paridis Iuridicum* no. 13. The fifth century witnesses a renewed interest in the story, notably with Sophocles' satyr play *Krisis*, which features Eris and identifies Aphrodite as a *daimon* or divine personification of *hedone*, pleasure, while Athena serves to present *phronesis, nous,* and *arête* (wisdom, reason, and virtue) (Athenaius 15,687c; TrGF IV F 360–1; Reinhardt 1938: 5–6; Stinton 1965: 7; Burn 1987: 67; Seidensticker et al. 1999: 356–62). Contemporary with the Karlsruhe hydria, the comic playwright Cratinus gives yet another spin on the story: in his comedy *Dionysalexandros* the god Dionysus takes over Paris' role and secures Helen for himself (PCG IV F 39–51; Ghali-Kahil 1955: 143–4; Ebert 1978).

[23] The visual tradition deviates from this: in one of the earliest depictions of the myth, on an ivory comb from Sparta, Paris hands Aphrodite the apple, past the other two goddesses: Athens, National Museum 15368; from Sparta. *c.* 620 BCE. LIMC VII 1994 s.v. *Paridis Iuridicum* no. 22; Hampe 1954.

displays a clear preference. Indeed, the whole composition on the right marks Aphrodite's imminent success: Paris turns to her; she is accompanied by an Eros, as is Paris. One member of the pair jointly labelled as Eutychia holds a laurel wreath above Aphrodite, as if indicating victory.[24] The other reaches with a garland towards Paris, thus establishing yet another link between the prince and the goddess.[25] Other contemporary vessels display a similar exposition, for example a hydria by the Modica Painter and a bell-crater in Vienna, where again Paris and Aphrodite are each accompanied by an Eros,[26] or a hydria by the Nicias Painter that depicts an Eros with a garland who is floating towards Aphrodite (fig. 8.2).[27]

By tapping into a potential source of allegory, the action depicted in the nucleus might also provide a cross-reference to another aspect of the story. Helen, Paris' reward for choosing Aphrodite, to be given to him by the goddess, is frequently referred to by Homer as 'bitch', *kynopidos*. On occasion, for example when admitting to her guilt regards the war, she refers to herself as such.[28] The dog in the picture displays no obvious gender characteristics but is strongly present in the dynamics of the nucleus: the Eros next to Aphrodite coaxes the dog, and the animal in turn looks towards the goddess, and to Hermes, who points his *kerykeion* towards the dog's head.[29]

[24] RE XI.2 1588–1607 s.v. *Kranz* (R. Ganszyniec). For the duplication of positive aspects in Greek religious thought (focusing on the example of female terracotta figurines) see Hadzisteliou-Price 1971: esp. 67–9.

[25] Contra Shapiro (Shapiro 1993: 86–7), Eutychia's reaching towards the left of the picture could equally hint at the benefits of choosing one of the goddesses there, thus enriching the figure with a further layer of meaning.

[26] RF Hydria, Syracuse, Museo Archeologico Regionale Paolo Orsi 38031; from Modica. Modica Painter, late fifth century BCE. ARV² 1340.1; CVA *Syracuse* I pls 26–7; LIMC VII 1994 s.v. *Paridis Iuridicum* no. 49; RF Bell-crater, Vienna, Kunsthistorisches Museum IV 1771; from Orvieto. Painter of the Athens Wedding, early fourth century BCE. ARV² 1318; Add² 363; CVA *Wien, Kunsthistorisches Museum* 3: pls 120–1; Burn 1987: 65; LIMC VII 1994 s.v. *Paridis Iuridicum* no. 59.

[27] RF Hydria, once Cancello; from Suessula. Nicias Painter, late fifth century BCE. von Duhn 1887: pl. 12; ARV² 1334.28; LIMC VII 1994 s.v. *Priamos* no. 13 (J. Neils); Lorenz 2007: 121–8. Another hydria by the Nicias Painter shows Paris gesturing his consent and a Nike approaching to indicate the outcome of the Judgement, but otherwise is less conclusive with regard to the theme of love: RF Hydria, Palermo, Museo Archeologico Regionale 2366; see above, pp. 39–40 n. 19.

[28] For example, Hom. *Il.* 3.180; *Od.* 4.145. My thanks to Ewan Bowie for his lucid observation. For Helen, see LIMC IV 1988 s.v. *Helene* (L. Kahil); for her characterisation in literature see Loraux 1989: 232–52; Meltzer 1994; Voelke 1996. On the depictions of Paris and Helen, see Ghali-Kahil 1955: 61–5, 157–89; Bron 1996; Shapiro 2005; Meyer 2009: 90–3.

[29] In the period from the early fifth century and into the fourth century, Paris was not normally accompanied by a dog; but the animal, frequent in black-figure vase-painting, made some notable appearances in the last quarter of the fifth century, in particular on the following,

These internal exchanges could be read simply as elements of bucolic playfulness, underlining the joyful nature of Eros, the general pastoral character of the scene, and, not least, Paris' role as a shepherd. And yet the incorporation of Helen in the guise of a dog would chime well with the other analeptic and proleptic pointers towards destiny embedded in the scene, with Zeus and Eris in the upper register, for example, who point to the origins of the Judgement and to the repercussions of Paris' choice.[30] In addition, Aphrodite is repeatedly shown in vase-painting of the last third of the fifth century ensnaring Helen into agreeing to a relationship with Paris, as on an amphoriscus by the Heimarmene Painter in Berlin.[31] Here again, a contingent of personifications underscores the ambivalent emotive atmosphere, including Himerus, desire;[32] Peitho, persuasion;[33] Heimarmene, destiny;[34] and Nemesis, retribution.[35]

If the dog symbolises Helen, then the two aspects of her story, the Judgement of Paris and her seduction by Aphrodite, appear combined on the Karlsruhe hydria.[36] In addition, this novel appropriation of the dog, both as an attribute of Paris and as the trigger of his destiny, would provide testimony of a strong interest in responsibility. And it would also keep to the characterisation of Helen prevailing in contemporary visual representations, where the heroine appeared as a victim, and specifically a victim of

where the prince is surrounded by two dogs: RF Pyxis lid, Copenhagen, National Museum 731; from Piraeus. *c.* 430 BCE. CVA *Copenhagen* 4: 125–6, pl. 163; Clairmont 1951: K160 pl. 35; LIMC VII 1994 s.v. *Paridis Iuridicum* no. 40.

[30] Zeus shares the side with the two goddesses set to loose, and Eris turns towards them. The element of narrative time is also quite literally embodied by Helius on the far right, ascending to the skies. The sun god appears only in one other instance in the Judgement, on a bell-crater in Vienna (see above, p. 42 n. 26). The depiction of stellar constellations grew in popularity in later classical Athenian and South Italian vase-painting: Schauenburg 1962. Contra Clairmont 1951: 111, who understands the combination of Helius and Selene as a reference to the Parthenon east pediment. Again different, and from a literary perspective, is Reinhardt's emphasis on dawn and sunset as providing a framework, assembling the events into an epic day (Reinhardt 1938: 7). For Helius, see LIMC V 1990 s.v. *Helios* (N. Yalouris). For Eos: LIMC III 1986 s.v. *Eos* (C. Weiss). For Selene: LIMC VII 1994 s.v. *Selene, Luna* (F. Gury).

[31] RF Amphoriscus, Berlin, Staatliche Museen 30036; from Greece. Heimarmene Painter, *c.* 430 BCE. ARV² 1173.1; Para 459; Add² 339; LIMV IV 1988 s.v. *Heimarmene* no. 1 (L. Kahil); Ghali-Kahil 1955: 59–61 pl. 8.2–3; Shapiro 1993: 194–5; Shapiro 2005: 50–2; Woodford 2003: 172.

[32] Himerus: LIMC IV 1988 s.v. *Himeros/Himeroi* (A. Hermary); Shapiro 1993: 110–19; Borg 2002: 132–4, 168–71.

[33] Peitho: LIMC VII 1994 s.v. *Peitho* (N. Icard-Gianolio); Shapiro 1993: 186–207.

[34] Heimarmene: LIMC IV 1988 s.v. *Heimarmene* (L. Kahil).

[35] Nemesis: LIMC VI 1992 s.v. *Nemesis* (P. Kasanastassi); Shapiro 1993: 173–7.

[36] A similar depiction of the Judgement scene on a pyxis lid in Copenhagen, again prominently including a dog coaxed by Eros, further supports this interpretation. RF Pyxis lid, Copenhagen, see above, pp. 42–3 n. 29.

love[37] – a view also propagated in contemporary literary treatments, notably Gorgias' *Encomium of Helen*,[38] and emphasised in this rendering by the subordination of the dog to those surrounding it.[39]

One further iconographic element of the scene on the Karlsruhe hydria is noteworthy: the rendering of Athena (fig. 5.1). Not only does Athena appear entering the contest on her own, while both Hera and Aphrodite are accompanied by an entourage, but – and this element sets this representation off from other treatments – she also appears with explicit reference to Athenian art, for her helmet with the three plumes on horse-shaped attachments and the decoration of the inner part of her shield, with what appears to be a warrior fighting in a rocky landscape, recall characteristic elements of the chryselephantine statue of Athena Parthenos on the Athenian acropolis.[40] Athena is thus presented with a focus on her military prowess, which is enhanced by the Attic helmet on her head.[41] And with the outside of the shield of Athena Parthenos displaying the battle against the Amazons on the slopes of the acropolis,[42] the choice of this particular iconographic type could also underscore the antagonism between the goddess and the Trojan prince, who is dressed in Oriental garments, a potential embodiment of the forces of the East, on a par with the Amazons.

An iconological synthesis.

The Judgement of Paris on the Karlsruhe hydria stands out from earlier visual treatments of the story in two respects: first, the scene itself, composed to foreground the outcome of Paris' decision and enriched with pointers to symbolise events to come; then, second, the choice of material carrier, the

[37] Cf. RF Hydria, Athens, Ceramicus 2712; from Athens. Meidias Painter, 420/410 BCE. ARV² 1313, 6, 1690, 1708; Add² 362. Burn 1987: 76–8, M6, pls 44–5; Schöne 1990; Shapiro 2005: 56–8. Helen, again in conversation with Eros, is here paralleled with Clytaemnestra, with emphasis on the ramifications of their actions for their offspring, see Braun 1982; MacDowell 1999; Shapiro 2005: 53–5.

[38] Braun 1982; Porter 1993; Borbein 1995: 444; MacDowell 1999; Shapiro 2005: 54–5.

[39] It is noteworthy that in the Homeric hymn to Hermes the god is given dominion over all dogs by Zeus: HH 4.570. My thanks to William Leveritt for pointing me to this.

[40] Schuchhardt 1963: esp. 31–46; Leipen 1971; Ritter 1997: 53–6; Hurwit 2004: 146–54. The Varvakion statuette, a scaled copy of the original Parthenos: Athens, National Museum 129; from Athens. Second century CE.

[41] On the different implementations, and meanings, of the helmet types in depictions of Athena see Ritter 1997: esp. 23–4, 53–4. At that time in vase-painting, Athena is otherwise more frequently seen with a Corinthian helmet.

[42] On the shield in particular see Harrison 1966; Harrison 1981; Strocka 1967; Strocka 1982. More generally on Amazons in classical Greek art: LIMC I 1981 s.v. *Amazones* (P. Devambez & A. Kauffmann-Samaras); Bothmer 1957; Tyrrell 1984; Hardwick 1996; Muth 2008: 329–412.

hydria, and with it the combination of the Judgement with those scenes in the lower frieze – the assembly of a Dionysian thiasus on the front, including the god himself and maenads, and other scenes of female activity on the back.[43] This compilation of specific myths and more generic scenes of Dionysian or Aphroditean character was popular towards the end of the fifth century, particularly on hydriae (for example fig. 5.3).[44] On the Karlsruhe hydria, that trend resonates with the similar landscapes that appear in both picture fields, with rocks, shrubs, and trees filling the scenes,[45] surroundings associated with the Gardens of Aphrodite on the north slope of the Athenian acropolis and therefore potentially yet another indicator of the importance of the goddess on this vessel.[46]

The depictions on the Karlsruhe hydria bring both religion and politics into focus. First, the concern with the psychological states of the individual characters, expressed by the moment of action chosen and the use of commentating figures, points towards forms of individualisation and intimisation that underwrite many accounts of the cultural history of the late fifth century BCE.[47]

[43] Dionysian scenes were popular on pots of the later fifth century, starting with the works of the Eretria Painter; among the followers of the Meidias Painter, about 10 percent of all the vessels display a theme related to the god. See Paul-Zinserling 1994: 12; Carpenter 1997: esp. 84, 103. On the general popularity of Dionysus and his entourage in this period see Hamdorf 1986; Moraw 1998: 93–9; Lissarrague 2013. The scenes of female interaction on the back of the Karlsruhe hydria are symptomatic of a shift in content that took place in the second half of the fifth century: vase production moved away from symposium pottery with its very male-related scenes and towards smaller pot shapes used to store perfume oils and cremes, for example pyxides and squat-lecythoi; numerous of these latter vessels, then, depict the female realm; see Williams 1983; Burn 1987: 81–6; Robertson 1994: 237–42; Borbein 1995: 442; Lissarrague 1995.

[44] Cf. RF Hydria, London, British Museum E224 (fig. 5.3); see above, pp. 10–1 n. 29 (Rape of the Leucippides and Heracles in the Garden of the Hesperides, both charged with generic Aphroditean elements); RF Hydria, Athens, Ceramicus 2712, see above, p. 44 n. 37; Burn 1987: 77; Shapiro 2005: 56–9 (Greek heroines in a boudoir setting are combined with a thiasus scene, and one with a mythological dimension, the death of Pentheus). On visual representations of the death of Pentheus: Greifenhagen 1966; LIMC VII 1994 s.v. *Pentheus* (A. Kossatz-Deissmann). On Euripides' tragedy (produced posthumously in 405 BCE) see Oranje 1984: esp. 167–75; Segal 1997.

[45] This predilection for nature emerges from the new use of pictorial space on vases introduced by the Niobid Painter and his followers, who started to adopt techniques used in contemporary wall- and large-scale painting: Burn 1991: 120–1; Robertson 1994: 236–7; Boardman 2005.

[46] Paus. 1.27.3; Burn 1987: 26–30. Cf. Broneer 1932; Langlotz 1954: esp. 8–15; Delivorrias 1987; Rosenzweig 2004. This would add another aspect of Atticisation, along with the appearance of Athena in the Parthenos type. More generally, the use of laurel bushes connects the scenes with Apollo and the victory at his games at Delphi (Plin. *Nat.* 15.127), and also with Dionysus (Eur. *Fr.* 480). The peaceful and pleasant sacral atmosphere has been interpreted as recalling a dream world, a paradise, in both the conceptual and literal senses, as the Greek *paradeisos*, or garden (Burn 1987: 19–21).

[47] Cf. Euripides' psychagogic renderings; for an overview see Sullivan 2000: 113–21. The renewed interest in the funerary sphere would also fall into this category: the legislation on luxury

Indeed, together with the representation of the Aphrodisian and Dionysian lifestyle so popular on the vessels of the Meidian circle, this interest seems to be symptomatic of a wider shift in Athenian approaches to religion. The gods, and particularly those divinities related to issues of individual well-being and fortune, were no longer approached solely in terms of their purposeful divine powers; instead, the conditions of their existence were drawn into the lime-light, along with their impact on individuals:[48] Dionysus was rejuvenated on the Parthenon; statues such as the Aphrodite Fréjus drew unparalleled atten-tion to divine bodily features; and Asclepius, the god of health and healing from Epidaurus, was introduced to Athens in 420/419 BCE.[49]

Second, and directly connected with this shift, the depiction of the Judgement informs an understanding of the socio-political environment at the time that reaches beyond the prevalent modern interpretation of the Meidian scenes. Conventionally, the amiable topics and pleasant surround-ings of the Meidian scenes have been taken as having provided an escapist outlet, a means of forgetting the horrors of the Peloponnesian War.[50] On closer inspection, however, the emphasis in this depiction of the Judgement seems to be not so much on diverting themes such as love and a decision in favour of pleasure as on the fateful consequences of Paris' choice, which leads to war. In that analysis, the scene on the hydria follows an interpret-ation of the myth also found in Euripides' *Hecuba*, where he explicitly iden-tifies the Judgement as the cause of the Trojan War:[51] 'Paris sat as a judge / over three goddesses. His verdict was war.' Euripides here connected the Judgement of Paris with the Peloponnesian War, both of which, he held, had their origins in moments of vanity. In the context of Athens in the last quarter of the fifth century, the Judgement emphasised how catastrophe can result from decisions led by desire, and a presentation such as that found on the hydria highlighted that interdependency precisely through its juxtapos-ition of peaceful atmosphere and virulent conflict.[52]

One iconographic element, however, appears more difficult to synthesise in this way. Paris' dress is Oriental, adopted in the wake of a general change

introduced in the sixth century was abandoned in the last quarter of the fifth century, and the tombs were once more lavishly monumentalised with sculpture; see Clairmont 1970: 41–71; Clairmont 1993: 180–90; Bergemann 1997: esp. 7–34; Engels 1998: 113–20.

[48] Borbein 1995: 446, 468–71; Parker 1996: 185–98.

[49] *IG* II².4960. Garland 1992: 116–35, esp. 128–35; Parker 1996: 175–85; Mitchell-Boyask 2008: 105–21; Wickkiser 2009; Lawton 2009. Rather tellingly, the cult itself was introduced by an individual, Telemachus; for his monument, see Beschi 1967–8: 381–436; Garland 1992: 118–21.

[50] Burn 1987: 66–8; Burn 1989: 122. In a similar vein see Pollitt 1972: 123–5.

[51] Eur. *Hec.* 644–6.

[52] On the relationship between vase-painting and the theatre in this period, see Lorenz 2006.

in Athenian art that saw various non-Greek entities appear in Oriental out-fits, including the Trojans and the Amazons.[53] How could an Oriental in any way serve as a representation of the Athenian struggle with the impact of the Peloponnesian War? The explanation seems rooted in two characteristics fre-quently associated with the figure of Paris, no matter what his attire: overin-dulgence and desirability. The prince appears with notions of these qualities in contemporary depictions that feature him outside the Judgement. On a squat-lecythus in Berlin, Paris is depicted as nude, and therefore without men-tion of the East, and together with Helen;[54] both, Paris and Helen, are here linked to Habrosyne, the personification of decadence and luxury (fig. 2.3).[55]

If the body of Paris, depicted by the Pronomus Painter as a Greek athlete, can be linked to *habrosyne*, then dressing the prince as an Oriental amplifies this characterisation, and it does so while adding lure and fascination, for the Eastern cover-up increases the element of decadence by hiding the body and all markers of its physical fitness. But here decadence is not dressed as damnable; on the contrary, Oriental garments in this period exude lux-ury and sophistication.[56] They might flag indulgence, but that indulgence is of a kind regarded as desirable. They render their wearer irresistible,[57]

[53] The earliest evidence of this use of Oriental costume are the paintings of Polygnotus shortly before the middle of the fifth century, in the Stoa Poikile and the Nekyia painting in the Knidian Lesche at Delphi, which have been taken as evidence of this generic Orientalisation (Raeck 1981: passim; Castriota 2005: 106–9, 111–27), even if entirely circumstantial. For the two monuments, see Robert 1892; Robert 1893; Stansbury-O'Donnell 2005. The development runs in parallel with changes in the appearance of the Persians: in the earlier fifth century, in the direct aftermath of the battles against the Persians, they were presented in great ethnic detail in vase-painting; from the 460s, however, this detail faded, and a new type of generic Oriental dress was more widely used. Cf. Raeck 1981: 214–31; Castriota 1992: 102; Borbein 1995: 438; Miller 1997: 170–83; Hölscher 2000a: 306–8; DeVries 2000; Erskine 2001.

[54] RF Squat-lecythus, Berlin, Staatliche Museen 4906. Pronomus Painter, *c.* 400 BCE. CVA *Berlin, Antikensammlung* 9: 66; ARV² 1336.4; Add² 366; LIMC IV 1988 s.v. *Helene* no. 88; Böhr 2000; Shapiro 2005: 52–3. Other representations of a 'Greek' Paris include the amphoriscus by the Heimarmene Painter; see above, p. 43 n. 31.

[55] On the use of the concept as pejorative, cf. Eur. *Or.* 485. See also Kurke 1992.

[56] This is documented by textual evidence, including Aristophanes' comedy *Acharnai*, produced in 425 BCE (*Ach.* 71–104): the ambassadors returning from the Persian court deliver a survey of all the riches to be found there to Dicaiopolis, who struggles to appear underwhelmed. More generally, see Miller 1989: 319–20, 323–7; Miller 1997: 153–83, and especially 183–7; Pekridou-Gorecki 1989 : 73, 116–17; Leland & Davies & Llewellyn Jones 2007: 58 (s.v. *ependytes*). Persian lifestyle is also showcased in the visual arts as lavish and desirable, especially in scenes of hunting and the symposium: cf. Miller 1997: 153–83. Hunting: RF Volute-crater, Naples, Museo Nazionale H3251. Schauenburg 1975: 116–17, pl. 42; Raeck 1981: P576. Symposium: RF Column-crater, Salerno, Museum T228; from Paestum. Suessula Painter. Napoli 1970: 197, figs 115–16; Schauenburg 1975: 114–15, pl. 38.2; Raeck 1981: P592.

[57] Added attraction could derive from the fact that Paris' dress shares its features with contemporary theatre costume. See Pickard-Cambridge 1988: 177–209; and also Miller 1989:

as the scene itself attests, with Paris attracting the undivided attention of three goddesses. This type of fashion statement was entirely compatible with Athenian identity, indeed was cultivated in late fifth-century Athens as a way to express prosperity and luxury. A pelike in the Louvre from the last quarter of the fifth century provides an example of such articulations (fig. 2.4),[58] showing a warrior in Oriental costume between two women in Greek dress in a scene of warrior farewell, a popular template in Athenian vase-painting.[59] Here, the discrepancies between the ethnicity of the actors and the action do not serve as a critique of foreign cultures, but rather reappropriate an Athenian practice within a more dazzling context.

Paris therefore represents both a character particularly susceptible to the scheming of Aphrodite because of his general proneness to debauchery, and a desirable Greek über-male. And he presents more than simply an enhanced version of the Athenian everyman whose indulgences have a detrimental effect on the whole polis.[60] Edith Hall has pointed out that Euripides in his tragedies of 415 BCE, in particular *Alexander*, *Palamedes*, and *Troades*, turns Oriental figures into 'surrogate Athenians' to raise empathy for the fate of those who have suffered at the hands of the Spartans.[61] Perhaps, and to this end, Euripides even overrides the antagonism of Greeks and barbarians.

Viewed from this perspective, Paris could be taken not as a role model of the decadent and doomed, but as a victim of Spartan forces, represented by the dog in front symbolising Helen. This interpretation would render the Judgement scene on the Karlsruhe hydria as concerned with the dichotomy between Athens and Sparta, rather than as an exploration of the divine powers that induce fate. The representation of Athena here, which is linked explicitly to the acropolis, along with the other elements of Atticisation, would then contextualise the scene appropriately and not introduce a contrast to Paris' Orientalism.

The Judgement scene on the Karlsruhe hydria, produced during the latter part of the Peloponnesian War (431–404 BCE),[62] draws attention

314–19; Leland & Davies & Llewellyn Jones 2007: 178–9 (s.v. *Stage Costume*); Wyles 2010: 241–8, with a critical discussion of what can and cannot be classified as Oriental in stage costume; cf. also Sourvinou-Inwood 1997: 281–94.

[58] RF Pelike, Paris, Musée du Louvre, CP 10830/CP 11164. Schauenburg 1975: 115–16 pl. 40.1; Raeck 1981: P585 fig. 42. Schauenburg 1975; Raeck 1981: 105, 147.

[59] Spiess 1992: 158; Lissarrague 1990a: passim; Matheson 2005.

[60] Cf. Shapiro 2009b: 252–5; he connects the representations of the Orientalised Paris, along with his effeminate traits, to the invective against Alcibiades.

[61] Hall 1989: 213–29.

[62] It is worth noting here that the Peloponnesian War was anything but one continuous conflict: it fell into two main periods of military aggression, the Archidamian War (431–421 BCE)

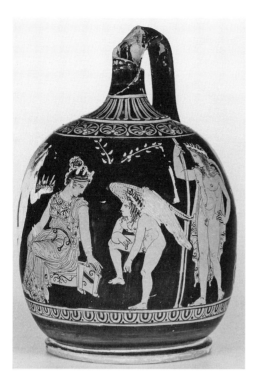

Fig. 2.3 Paris and Helen with the personification Habrosyne. Red-figure
squat-lecythus by the Pronomus Painter. Berlin, Staatliche Museen 4906. *c.* 400 BCE.

to military conflict, with explicit reference to Athens. It thereby serves as
an image of agitation,[63] not escapism. This function is tied to the role of

and the Deceleian War (413–404 BCE), divided by an eight-year period of relative quiet, the
so-called Peace of Nicias, when Athenian confidence was greatly renewed, leading to their
disastrous Sicilian Expedition (415–413 BCE). These extended periods of conflict see various
successes by both the Athenian and the Spartan sides, with the latter eventually gaining the
upper hand, not least by destroying the Athenian fleet at Aigospotamoi in 405 BCE. The
Spartan raids on the Athenian countryside during the Archidamian War, and the plague
which struck Athens repeatedly between 429 and 425 BCE, must have had a considerable
impact on the city and its inhabitants, both physically and psychologically; however, cultural
and artistic activity did not cease in this period, and it is debatable whether all of it is of
escapist nature. With regard to the vases of the Meidian circle, the crucial problem is that
they cannot be dated with such exactness as to establish whether they were produced during
a time of heightened conflict, or rather during the Peace of Nicias. On the lack of evidence
for perception of the Peloponnesian War as continuous conflict: Strauss 1997; Osborne 2007:
8–10. On the Peloponnesian War more generally see Kagan 1969; Kagan 1974; Kagan 1981;
Kagan 1987; Cawkwell 1997; Hornblower 2002: 150–209. On the social, political, and cultural
developments in this period see the contributions in Osborne 2007.

[63] I am here using a term introduced by Hornblower to differentiate between types of
propagandistic behaviour: OCD³ 1257–8 s.v. *Propaganda*.

Fig. 2.4 A warrior in Oriental costume between two women in Greek dress in a scene of warrior farewell. Red-figure pelike. Paris, Musée du Louvre CP 10830/CP 11164. *c.* 420/410 BCE.

Paris as 'Dys-Paris',[64] the quintessential luckless victim – a role designed to offer consolation. The scene reflects on the situation of war by functionalising, and overturning, the most pervasive antithesis in Greek thought, that between Hellene and barbarian, with its objective the symbolising of compassion. In this sense, then, all figures – Paris and the three goddesses – act as surrogate Athenians, and the picture mediates their stake in contemporary reality rather than offering a gateway into a dreamscape, as one would expect from an escapist scene. The Judgement on the Karlsruhe hydria expresses an interest in conflict, not in the escapist other. The image bears the tension of potential counter-interpretations of its characters and actions deliberately, to state this point even more profoundly.

This interpretation is not an over-intellectualisation of the scene; far from it. Similar thoughts and comparable arguments about human fallacy as a

[64] On this expression, see Reinhardt 1938: 18.

cause of conflict were frequently expressed in contemporary writing, found in the work of sophists such as Hippias and Plato,[65] and in Euripides.[66] In these texts, similar strategies are adopted to create a dense psychological panorama that introduces a debate concerning issues of war and personal responsibility. Whether the Karlsruhe hydria was originally intended for use in a *gynaikeion*, at a symposium, as a funerary container, or to be sold to the Etruscan market,[67] with its display of emotion and individual psychological states and its mixture of melodramatic effect and irony, the vessel reflects essential currents in Athenian thought and artistic culture, most prominently the new use of myth in Athenian tragedy and comedy.[68] The hydria thereby gives evidence of a society that, while expressing pride about itself, was also confident and strong enough to explore its own ambiguities and therein find consolation.

2) The Pergamon frieze: culture, cosmos, and family politics

An iconographic analysis.

The scenes of Zeus and Athena in the northern corner of the east flank of the Great Frieze serve up a range of iconographic elements that are both characteristic for the frieze and highlight the exceptional role of these two gods within the composition as a whole (fig. 2.5, 2.6). Athena is on the right, fighting against the youthful giant Alcyoneus (fig. 2.6).[69] The goddess is dressed in a thick peplos, with a feathered aegis over her left breast and a shield over her left arm, its inside opened to the front.[70] Whilst rushing towards the right, she turns to the left and, with her right hand, pulls the giant by his hair, for the only means of killing him is to lift him from the ground and break the connection to his mother, Ge, depicted to the right of Athena and shown pleading.[71]

[65] Hall 1989: 215–16.

[66] Sullivan 2000: passim.

[67] Reusser 2002: esp. 16–27, 204–6; Reusser & Bentz 2004: passim; Osborne 2004: esp. 33–6 on the diversity of uptake regarding different media. More generally on the problem cf. Gaifman 2009: 581–2.

[68] Seidensticker 1995: 194.

[69] No name label exists for this figure, but only the giant Alcyoneus, otherwise immortal, has to be defeated in this way, see Simon 1975: 22.

[70] On the iconography of Athena see LIMC II 1984 s.v. *Athena* (P. Demargne).

[71] Ge is shown in her usual iconography here, half-hidden in the ground, her mediating role between gods and giants emphasised by her name label placed directly next to her on the frieze ground, and not on the bordering mouldings. On Ge, see LIMC IV 1988 s.v. *Ge* (M. B. Moore).

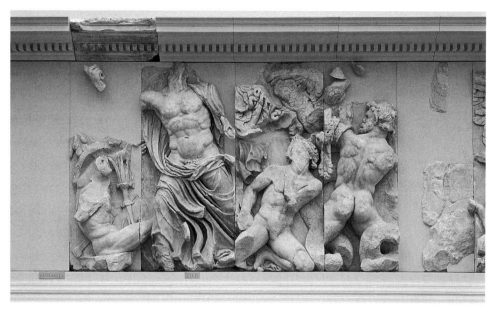

Fig. 2.5 The Great Frieze, east: Zeus. Berlin, Staatliche Museen.

The body of the giant is spread out in front of Athena, his left arm and leg stretching towards his mother and his right arm clutching Athena's arm to release her hold. Alcyoneus' large wings, screening the joined up arms, provide a dramatic backdrop to the V-shaped arrangement of goddess and giant. Poised for take-off, Athena's imminent success is evident. That outcome is aided by her snake, which is winding around the right leg and the left arm of the giant, as if to aid the process of hoisting him up. The Nike who is hovering in the air above Ge emphasises Athena's victoriousness by placing a wreath over the goddess' head.[72]

Following on to the left, a dead giant lies next to Alcyoneus; then comes Zeus, who is fighting against a diverse set of three giants. On his left, he has sent a thunderbolt piercing through the thigh of a youthful giant depicted in profile, leaving him on the ground screaming in agony. A second young giant has fallen down onto his knees in front of Zeus, mirroring Alcyoneus' stance; his left arm reaches over his right shoulder, assessing the damage inflicted there.[73] Only the third, Porphyrion, the elderly leader of the giants, counters the challenge of Zeus, who is about to hurl a second thunderbolt

[72] For Nike, see LIMC VI 1992 s.v. *Nike* (A. Moustaka & A. Goulaki-Voutira).

[73] Simon argues convincingly that this giant is wounded from an arrow sent by Heracles (Simon 1975: 18), not by Zeus' aegis (e.g. Winnefeld 1910: 53).

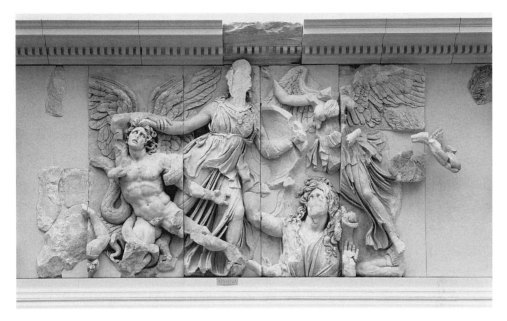

Fig. 2.6 The Great Frieze, east: Athena. Berlin, Staatliche Museen.

in his direction:[74] with his back to the front, he raises his left arm, protected by a fleece, against the god and against his eagle, which is hovering above the bearded giant. In addition, one of Porphyrion's snake legs is pushing upwards to bite the eagle, while the other – no longer fully preserved – must have been engaged in action further to the right.

Zeus and Athena are the tallest figures on the frieze, and their section involves the largest accumulation of giants, thus emphasising their decisive role in this battle. Compositionally, however, the drama unfolding in the north of the east frieze is matched by that on the south flank, where Apollo and his family are encountering the giants.[75] Those two groups frame the now mostly destroyed centre. Here, Hera was shown steaming towards the right in a four-horse chariot, followed by Heracles, who was further to the right and next to Zeus.[76]

The depictions on the east frieze form the overture to a gigantomachy wrapped around the Great Altar. This gigantomachy has the largest cast of

[74] For Porphyrion, see LIMC VII 1994 s.v. *Porphyrion* (F. Vian). On allocating a name inscription to this particular figure, see Kästner 1994: 126–9.

[75] Michael Pfanner argued convincingly for a set of compositional principles underpinning the Great Frieze, which work around Zeus and Apollo as the focal figures of the east frieze (Pfanner 1979: esp. 50–1, fig. 2).

[76] The figure is mostly lost, with only a fragment of a lion paw and the name label remaining; see Kähler 1948: 42–3 for a reconstruction.

all preserved gigantomachies from antiquity, on the sides of both the gods and the giants. The forty-nine gods still extant enter the battle in family units, thematically distributed along the sides of the altar. Considerable effort was made to continue the compositional units around the corners of the building: for the Olympians in the south-east with Asteria and Hecate (fig. 2.7) and in the north-east Ares and Aphrodite (fig. 2.15); for the eastern gods with Rhea and Semele in the south-west (fig. 8.6a); and for the maritime gods with Poseidon and Triton in the north-west (fig. 5.5, 2.14).[77]

From an iconographic perspective, the length of the cast list and the emphasis on family connections are the most prominent aspects that differentiate the depiction on the Great Altar from other versions of the gigantomachy, both textual and visual. The myth of the wild and uncontrollable giants, the sons of Ge, put into the world to threaten a freshly instituted cosmic order, first appeared in the eighth century BCE, in Hesiod's *Theogony*, the general guide to the Greek gods,[78] but accounts of the battle in which the gods defeat the giants did not appear in texts until much later.[79]

In contrast to the scarcity of the textual sources, visual evidence detailing the myth from the archaic period onwards is ample.[80] It adorns, for example, the north frieze of the Siphnian Treasury and the pediment of the Alcmaeonid Apollo Temple at Delphi.[81] The myth also plays a notable role in Athenian ritual and iconography: the myth appears on the Old Temple of Athena, in the inner part of the shield of the Athena Parthenos, on the east metopes of the Parthenon, and on the pediment of the Temple of Athena Nike,[82] all possibly influenced by the peplos carried in the Panathenaic

[77] The most recent discussion of the compositional principles is Pfanner 1979, with an overview of earlier arguments. He locates the Olympians in the east, chthonic and underworld gods in the north, maritime gods around the north projection, eastern gods around the south projection, and the gods of day and night in the south.

[78] Hesiod *Theog.* 50–2, 183–6, 954–5. Erika Simon argued for a direct relationship between the Great Frieze and Hesiod (Simon 1975); cf. Pollitt 1986: 107. With a more critical stance: Pfanner 1979: 46. See also below, pp. 67–8.

[79] Pseudo-Apollodorus' account (1.6.1–2) from the fifth century CE remains the main textual source; earlier mentions include Pseudo-Hesiod Fr. 43a (Merkelbach & West), see West 1985: 130–6; Pindar *Nem.* 1.67–72; and compare the account of the choir describing the depiction of a gigantomachy at Delphi in Euripides' *Ion* 205–18. See also Vian 1952: 169–222; Giuliani 2000: 263–7 on the different strands in the textual tradition.

[80] For an overview, see LIMC IV 1988 s.v. *Gigantes* (F. Vian & M. B. Moore); Kähler 1948: 107–9; Vian 1952.

[81] For the Siphnian Treasury, see Simon 1984; Neer 2001; on the inscriptions, see also Brinkmann 1985: 87–105, 121–30. For the Temple of the Alcmaeonids, see Picard & de la Coste-Messelières 1931: 15–74, figs. 32–6; Barrett 1979: 61–98; Childs 1993.

[82] On the Old Athena Temple, see LIMC IV 1988 s.v. *Gigantes* no. 7; Moore 1995. On the shield of Athena Parthenos see LIMC IV 1988 s.v. *Gigantes* no. 40. On the Parthenon see LIMC IV

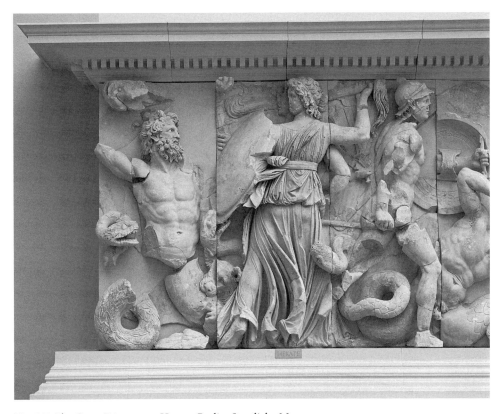

Fig. 2.7 The Great Frieze, east: Hecate. Berlin, Staatliche Museen.

procession, which was also decorated with the subject.[83] In addition, numerous Athenian black- and red-figure vases from the second quarter of the sixth century BCE onwards give visual accounts.[84] Yet after considerable popularity into the fourth century, the myth vanished from the visual record – until its reappearance on the Great Altar.[85]

1988 s.v. *Gigantes* no. 18; on the Temple of Athena Nike see Despinis 1974: 8–24; Brouskari 1989: 115–18.

[83] On the peplos, see LIMC IV 1988 s.v. *Gigantes* no. 32. For the link between the earliest vase pictures and the peplos, see Shapiro 1989: 39 and Giuliani 2000: 270–2, who emphasises that the black-figure vase pictures do not necessarily rely on Hesiod because of the names provided for the giants. However, the frieze composition of the earliest gigantomachy pictures remains puzzling, for I would agree with Simon that the depiction on the peplos likely consisted of individual metope-like picture fields, as does the depiction on the archaistic statue of Athena in Dresden: Simon 1975: 41.

[84] Giuliani 2000; Muth 2008: 268–328.

[85] The Great Frieze in turn influenced the appearance of other monuments, such as the relief frieze from the Sanctuary of Athena Polias at Priene, dating to 158 BCE (LIMC IV 1988 s.v. *Gigantes* no. 26; see Carter 1979: 139–51), and the gigantomachy slabs from the Sanctuary of Athena Nikephorus at Pergamon of the second quarter of the second century BCE

Fig. 2.8 The hoplite giants of the sixth century. Fragment of a black-figure cup. Athens, National Museum, Acropolis Collection 1.1632. 560/550 BCE.

An iconographic comparison throws into relief two further peculiarities of the Great Frieze. The first concerns the giants, whose iconography underwent significant modifications from the sixth to the fourth century. In the first generation of pictures, they were depicted as standard hoplite warriors, fighting with normal weapons (fig. 2.8);[86] from around 500 BCE they could acquire wilder accessories such as animal skins, and increasingly frequently hurled stones at their opponents or approached them with fire (fig. 2.9);[87] and finally, from the fourth century and into the Hellenistic and Roman periods, they could be shown with animal traits such as snake legs (fig. 2.10).[88]

The giants were gradually redefined in their iconography from powerful hoplites to unpredictable monsters. On the Great Frieze, these differing

(Berlin, Antikensammlungen PM 868. LIMC IV 1988 s.v. *Gigantes* no. 25; Queyrel 2005: 101; Kästner 2011b: 537–8, no. 6.24). von Salis notes the similarity in the composition of this small Pergamene frieze and the gigantomachy on the Great Frieze and argues that both are dependent on pediment art, even if here executed in a novel way (von Salis 1912: 52). For the Hellenistic and Roman versions of the gigantomachy, see Maderna-Lauter 2000; Maderna 2008; see also Massa-Pairault 2007b.

[86] For example: BF Cup (fragmentary). Athens, National Museum, Acropolis Collection 1.1632. 560/550 BCE. Graef-Langlotz 1925, pl. 84; LIMC IV 1988 s.v. *Ge* no. 4. Moore 1979; Giuliani 2000: 267–8; Muth 2008: 271–99.

[87] For example: RF Cup, London, British Museum 1894,0314.1; from Orvieto. Onesimos, 490/480 BCE. ARV² 319.3; LIMC IV 1988 s.v. *Gigantes* no. 301. Vian 1952: 26; Giuliani 2000: 277–9; Muth 2008: 300–28.

[88] For example: RF Lecythus, Musée du Louvre K509. Workshop of the Painter of Capua (or Foundling Painter), third quarter of the fourth century BCE. LIMC IV 1988 s.v. *Gigantes* no. 400.

Fig. 2.9 'Wild' giants dressed in shaggy fleeces and hurling stones appear from the fifth century BCE. Red-figure cup by Onesimos; from Orvieto. London, British Museum 1894,0314.1. 490/480 BCE.

iconographic solutions are newly recombined and significantly extended. Close to the centre of the north frieze fights a giant dressed in full military costume, including cuirass, and thus reminiscent of a traditional hoplite warrior giant of the archaic period. More common among the human-oid giants on the frieze, however, is a youthful nude type with helmet and sword, most prominently represented by Artemis' opponent (fig. 2.11, see also fig. 2.7). Among the monster giants, those with snake legs and wings appear throughout, both young and old.[89] But more notable are those who combine different animal features to display monster iconographies that are otherwise unknown: on the south frieze, two giants combine snake legs and a human body with, in one instance, a bull's neck and horns and, in the other, a lion's head and paws.[90]

This spectrum of both wild and civilised giants clashes with the gods, who generally bear common characteristics and attributes. And yet this trad-itional iconography makes for the second peculiarity of the Great Frieze, for here well-known templates are used to create meanings that are new within the context of a gigantomachy. The section with Zeus and Athena provides powerful examples of this innovation. Zeus' preferred mode of

[89] A third of the extant giants have snake legs; five have wings; and only two giants, the opponent of Dione and Bronteas, have both.

[90] See also below, pp. 134–5.

Fig. 2.10 Giants with snake legs appear from the fourth century BCE. Red-figure lecythus by the Workshop of the Painter of Capua (or: Foundling Painter). Paris, Musée du Louvre K509. Third quarter of the fourth century BCE.

combat is attack with his thunderbolt, and most pictures show him about to strike an opponent broken down to the ground and waiting to receive the final blow. The Great Frieze both embraces and diverts from this tradition (fig. 2.5): Zeus is attacking Porphyrion, who is defending himself from an unpromising position, but in addition, the presence of two wounded giants in Zeus' immediate vicinity emphasises the god's might and brutality. Together with Porphyrion, the giants form a synoptic panorama of

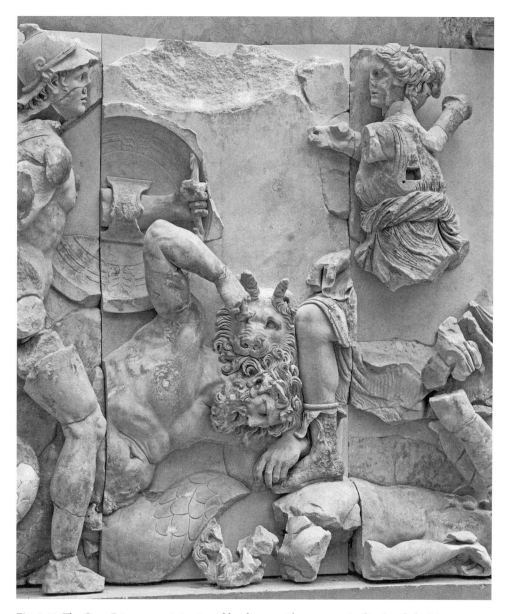

Fig. 2.11 The Great Frieze, east: Artemis and her humanoid opponent. Berlin, Staatliche Museen.

different stages of defeat. So, whilst Zeus is shown in a traditional template of combat, the tableau created by the extension of the number of his opponents and their respective states produces an unusually compact synopsis of the battle: one of total power (of the gods) and total destruction (of their opponents).

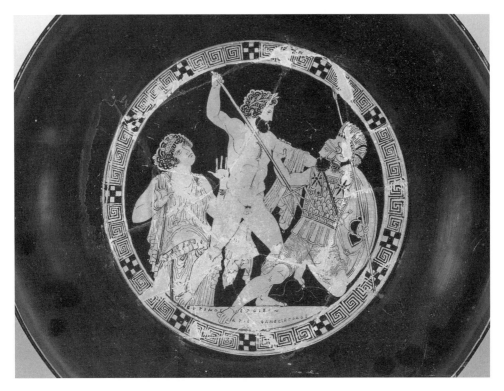

Fig. 2.12 Ge watches the demise of her son. Red-figure cup by the Aristophanes Painter; from Vulci. Berlin, Staatliche Museen F2531. *c.* 410/400 BCE.

Something similar can be said of Athena (fig. 2.6). Aspects such as her fight against an almost defeated giant and the presence of Nike, who flags the outcome of the battle synoptically, can also be found in her earlier iconographic portfolio.[91] But whereas her previous opponent – frequently called Enceladus – could be killed with the goddess' usual weapons, her opponent here can only be defeated by her lifting him off the ground and away from his mother, Ge. This portrayal puts the emphasis on Athena's sheer physical power and, at the same time, on her ability to counter the deeply magical elements surrounding the giants, which defy their elimination by the usual means of war.

Equally significant is the appearance of Ge. Instances of the mother of the giants taking part in the battle are few and far between.[92] But when she

[91] For occurrences of Nike with Athena in the classical period, see LIMC VI 1992 s.v. *Nike* nos 182–201.

[92] See Vian 1951: nos 104–6, 111; Vian 1952: 93, 96–7. LIMC IV 1988 s.v. *Ge* (M. B. Moore) nos 1–9.

appears, she either simply accompanies her children or, as is prominent on the Aristophanes cup in Berlin (fig. 2.12), is begging Zeus or Poseidon, but not Athena, to relent.[93] Interaction between Ge and Athena is more commonly known from the iconography of another story, that of the birth of Erichthonius, where mother earth hands the baby and future king of Athens to the goddess (fig. 5.4).[94] The scene on the Great Frieze reappropriates this iconographic motive, indeed inverts it to enhance the drama of the scene and display Ge's desperation. It provides the whole with a distinctly Pergamene twist: whereas in an Athenian context mother earth might happily and willingly pass on her offspring to support the prosperity of the city, here Athena has to annihilate the offspring of mother earth to preserve cosmic order.

Finally, the combination of the scenes of Zeus and Athena as a whole in this section of the frieze adds significant meaning. Whilst the appearance of Zeus and Athena alongside each other fits within the framework of the family units displayed on the Great Frieze, iconographic scrutiny reveals their pairing to be not at all common. Other sculptural presentations of the gigantomachy do not show Zeus and Athena in proximity to each other.[95] Even in vase-painting such instances are rare.[96] Presented alongside each other as they are here, the two gods symbolise more than merely family relationships. Zeus' mastery of the art of total destruction and Athena's supremacy over the dark powers of the earth come together to reach yet another level of panegyric in celebration of the powers of the gods.

[93] RF Cup, Berlin, Staatliche Museen F2531; from Vulci. Aristophanes Painter, *c.* 410/400. ARV² 1318.1; Para 478; Add² 363; CVA *Berlin, Antiquarium* 3: 18, pls 119.1–4, 120.1–3, 121.2–4, 133.10; LIMC IV 1988 s.v. *Gigantes* no. 318. Vian 1952: 145.

[94] For an overview, see LIMC IV 1988 s.v. *Ge* (M. B. Moore) nos 13–27. For the specific rendering of the story on the Cleveland lecythus, see below, p. 128 n. 32.

[95] The depiction on the pediment of the Megarian Treasury in Olympia, where Athena battles to the left of Zeus, but without any further interaction between the two, forms an exception: Olympia, Museum. *c.* 510 BCE. LIMC IV 1988 s.v. *Gigantes* no. 6. Notably, the two fight side by side in the relief slab from the Pergamene Sanctuary of Athena: Zeus to the right and Athena to the left, but again striding away from each other in a V-shape; see above, pp. 55–6 n. 85.

[96] On the vases of the second quarter of the sixth century they fight only occasionally together with Heracles, channelling their efforts against one enemy. In these pictures, Zeus and Heracles stand together on a chariot with Athena at their side. See LIMC IV 1988 s.v. *Gigantes* nos 104–23 (560–500 BCE); cf. also BF Pinax, Athens, Agora AP2087. Lydus, 560/550 BCE. ABV 112,53.57; LIMC IV 1988 s.v. *Gigantes* no. 177. In the second quarter of the sixth century these scenes were less popular than scenes of Athena and Heracles: LIMC IV 1988 s.v. *Gigantes* nos 151–69. A red-figure hydria by the Tyskiewicz Painter comes closest to the composition on the Great Frieze because it presents the two gods each duelling a giant on the shoulder of the otherwise black vessel: RF Hydria, London, British Museum E165; from Vulci. Tyskiewicz

What is more, viewed as a whole, the section on the east frieze featuring Zeus and Athena can be understood as a deliberate counterpoint to Athenian imagery. It has been frequently noted that the V-shaped composition in which Athena and Zeus appear on the Great Frieze shows similarities with the arrangement of Poseidon and Athena in the west pediment of the Parthenon (fig. 5.6).[97] There, Poseidon and Athena fight each other for cultic domination of Attica, each offering a unique gift: Poseidon a spring, Athena the olive tree. On the Great Frieze the situation is different: here, the gods do not battle against each other but seek to combat a common enemy, the giants. Whilst the principal theme of the Parthenon pediment is divine competition and what might best be termed innovation, the myth of the gigantomachy – here and elsewhere – stresses restoration, with marked emphasis on a highly specialised divine collective as the guarantor of success.[98]

Thematically, therefore, the Parthenon pediment and the Great Frieze are clearly distinct. This variety warrants closer inspection of the compositional structure of the two depictions, to enable differences to be mapped. First, and most notable, is that whilst reappropriating the motif of the steaming horses, on either side of the two gods, the Great Frieze inverts the positioning of male and female deities: where on the Parthenon Athena is to the left of Poseidon, on the Great Frieze she is to the right of Zeus. Second, the distance between the two deities on the Great Frieze is significant, making space for the bodies of dead or defeated giants that are piling up between them.

The compositional schema of the Parthenon pediment is thus modified into what could perhaps best be called a triple-V composition. The effect of this extension is that the drama and dynamic inherent in the Parthenon template is here conserved, but in a way that pinpoints not the moment of the gods' struggle, as on the Parthenon, but the drastic results of their

Painter, *c*. 480 BCE. ARV² 294.62; Add² 211; CVA *London, British Museum* 5: III.Ic.11, pls 71.3, 72.4; LIMC IV 1988 s.v. *Gigantes* no. 329. Two later vessels display iconographic parallels on the level of engagement with the opponents: on a cup by the Aristophanes Painter Zeus strikes against Porphyrion, who is seen from the back; and Athena is about to kill Enceladus, who is shown frontally, forced down onto his knees: see above, p. 61 n. 93. On an amphora by the Suessula Painter the two gods are arranged along a diagonal axis running across the centre of the picture field and fight giants who are positioned in the same way: RF Amphora, Paris, Musée du Louvre S 1677. Suessula Painter, *c*. 400–390 BCE. ARV² 1344.1, 1691; Para 482; Add² 367; LIMC IV 1988 s.v. *Gigantes* no. 322.

[97] Winnefeld 1910: 235; Kähler 1948: 118–19; Queyrel 2005: 157–8. Kähler also emphasises that the giant between Zeus and Athena looks like the opponent of Zeus on the inside of the shield of Athena Parthenos.

[98] Giuliani 2000: 274–7.

power – the annihilation of the giants. The four dead or dying giants depicted in the interim space between Zeus and Athena form the largest continuous group of giants on the frieze.

The differences from the Parthenon composition render the section with Zeus and Athena on the Great Frieze not so much a reference to one of the cornerstones of Athenian art, but an explicit statement of diversification from its predecessor, if, indeed, this is what the Parthenon is. Whereas in Athens the two central gods of the city are immersed in a petty quarrel over local domination, in Pergamon the gods work together to engage issues on a cosmic scale. And where in Athens the outcome of the power struggle is left tantalisingly open, here the domination of the gods is confirmed beyond any doubt.

The full thrust of this composition with regard to its content can be determined all the more clearly by a comparison with another instance in which two gods are presented in a V-shaped composition on the frieze, opposite on the west side, in the stretch of the frieze around the north projection that follows the steps up the altar.[99] Here, another pairing of father and daughter, the marine divinities Doris and Oceanus, is ensconced in battle with two giants in a manner reminiscent of that shown on the east frieze (fig. 2.13):[100] Doris holds onto the hair of her opponent,[101] a snake-legged young giant, who, on his knees, tries to fend off her grip; Oceanus, probably helped by his wife, Thetis, behind him,[102] is about to hurl something against two giants, both shown in a futile attempt to flee up the stairs, one seen from the front and one from the back, and one entirely human and one with snake legs. Another eagle of Zeus, similar to the eagle fighting with the god on the east frieze, concludes the scene in the upper corner.

Notwithstanding the obvious similarities between the two sections of the frieze with regard to composition and content, the gods on the projection are characterised differently. First, they fight in pairs, not on their own and supported only by animal satellites, as is the case for Zeus and

[99] Cf. Kähler 1948: 124–5.

[100] This section seems indeed to show features of an internal quotation of the sequence on the east frieze, as Winnefeld noted (Winnefeld 1910: 89). See Junker 2003: esp. 435–43 for the most recent interpretation of this part of the frieze. See also Schmidt-Dounas 1992, who discusses the scenes on the front of north and south projection.

[101] Her name is not confirmed by an inscription, but the identification is supported by the presence of her husband Nereus to her left, whose name label is extant (Fränkel 1890: nos 63, 87a).

[102] For Oceanus' label, see Fränkel 1890: n. 105; for Thetis, dressed in a chiton and armed with a thick branch, no label is preserved. Robert interprets the male figure as Hephaistus (1911: 218–19); in the accompanying female deity he sees Eurynome, who welcomed Hephaistus in the sea.

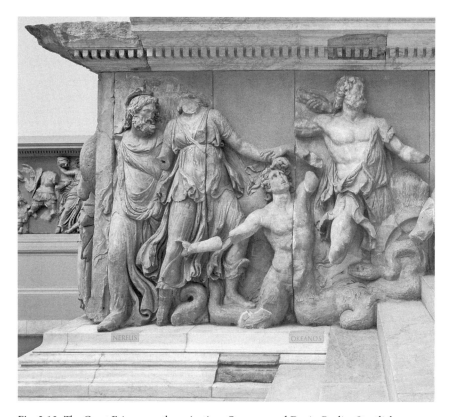

Fig. 2.13 The Great Frieze, north projection: Oceanus and Doris. Berlin, Staatliche Museen.

Athena, who are accompanied by an eagle and snake respectively. Second, whereas Athena and Zeus together take on five giants, the ratio here on the inner flank is considerably more favourable to the gods, with four gods facing three giants. This contrast renders their achievement considerably less noteworthy than that of the two Olympians, and indeed underscores the power of the latter: whilst Zeus can take on three giants on his own, here four gods are needed to achieve the same.

Such differentiation between forms of engagement with the enemy and their number underwrites the compositional structure of the Great Frieze more generally. Some gods fight in close combat, such as Hecate on the east frieze or Dione on the north; others appear more aloof, such as the gods in chariots – Hera, Ares, Poseidon, and Helius – or those riding on an animal, such as Rhea, Eos, and Semele on the south frieze; some fight across a sequence of other combatants, such as Themis on the south frieze. Artemis (fig. 2.11) and Triton (fig. 2.14) are distinguished, as is Zeus (fig. 2.5) in that

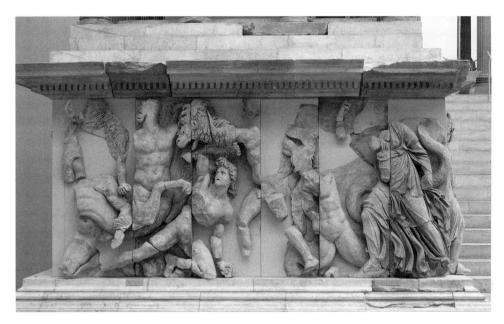

Fig. 2.14 The Great Frieze, north projection: Triton and his opponents. Berlin, Staatliche Museen.

they each take on not one or two giants, but three: all three gods are shown with a defeated giant, one already wounded and a third in attack.[103] And, finally, Aphrodite is the only god among those extant who presides over two dead giants; but her active involvement is limited to stamping her foot on one of their faces and pulling her lance from his breast (fig. 2.15).

Such accentuation as a whole is missing from other representations of the gigantomachy, although they do highlight individual aspects, as on the Siphnian Treasury, where Athena is singled out by virtue of taking on two enemies. In its effect, the compositional arrangement of the Great Frieze breaks up the battle into a series of units rich in variety, but does so without compromising cohesion. This dual character in turn underscores the unity of the gods whilst at the same time presenting them as part of distinct family groups, and the panorama of different forms of fighting paints a picture of the all-encompassing brutality of the gods and their supremacy.[104]

[103] The fragmentary state of the frieze does not allow this description to be developed further, but it is possible that more gods were displayed as fighting in this way, e.g. either Dionysus or Semele on the front of the south projection.

[104] Comparison with other Hellenistic battle scenes demonstrates that in the Great Frieze the destruction of the enemy is the clear focus: see Osada 1993: 86.

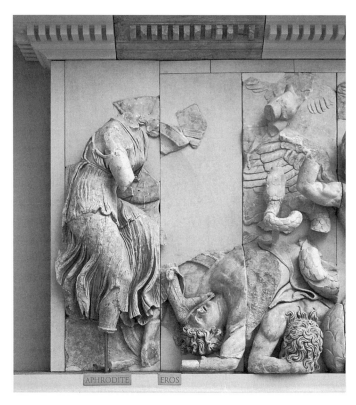

Fig. 2.15 The Great Frieze, north: Aphrodite and her opponent. Berlin, Staatliche Museen.

An iconological synthesis.

The Great Frieze stands out because of the complex nature of the gigantomachy depicted here, both with regard to the number of participants on the sides of gods and giants and with regard to the arrangement and compositional rhythm chosen for the different groups of gods. It alternates scenes of mass combat and individual encounter and puts particular emphasis on divine family ties.

These features have paved two broad avenues in scholarship, at times intertwined, with one emphasising the Great Frieze's cultural and political significance, and the other its philosophical, cosmological, and astrological dimensions. These interpretations are informed by what is known of the main influences on Pergamene culture and politics, especially the city's close ties with Athens and its image as a place of learning and knowledge production.[105] They are based on the assumption that a monument of

[105] For the Pergamene investment in learning, see Hansen 1971: 390–433; Gruen 2000; Massa-Pairault 2007a; Massa-Pairault 2010. For the Great Altar's intellectual stake, see also

such complexity must have derived its meaning from beyond the representation itself.

Various scholars have linked the depictions with a range of literary sources. Most prominently, Erika Simon read the Great Frieze as manifestation of Hesiod's *Theogony*.[106] She, like others, has connected the depictions with Stoic thought, and specifically with the Stoic idea of the cosmos' being divided into four parts. A central aim of these types of allegorical interpretation is to anchor the Great Frieze in contemporary philosophical thought, such as that championed by Crates of Mallos, the head of the Pergamene library, active throughout the second century CE,[107] or by Cleanthes of Assos in his treatise *Peri giganton*.[108] The depictions are then understood as a token of Pergamon's aspirations as a knowledge economy as well as of its political achievements in instating order over chaos.

Whilst there is no reason not to believe that the Pergamene academy around Crates might have had input into the design of the altar, there is also no evidence to support this claim. The connection with Hesiod, by contrast, is so general that it can merely attest that both the author and the monument map the Greek pantheon in family units.[109]

While accounts such as Hesiod's *Theogony* disentangle the family relationships of the gods, the Great Frieze is concerned with the intertwining of different characters and actions, as can be seen from the compositional set-up that leads around the corners and from one divine family unit to another, and as is reflected in the formal link between the Zeus–Athena group in the east and Doris and Oceanus on the northern projection.

Ridgway 2000: 34, who parallels it with monuments such as the Homeric bowls or the Tabulae Iliacae. For the Gymnasium specifically, see Mathys et al. 2011 with further bibliography.

[106] Simon 1975: 56–9; cf. Pollitt 1986: 107; Massa-Pairault 2010: 87–104. In addition, Queyrel traced a relationship between the depictions and Orphic hymns found in Pergamon (Queyrel 2005: 175–8). For a more critical assessment, see for example Pfanner 1979. Simon argues that on the three long sides the three divine families are depicted as described by Hesiod (Hesiod *Theog.* 105–7): in the west and on the north wing the descendants of Pontus; in the north the descendants of Nyx; and then the descendants of Ge and Ouranus, the Titans in the south, the Olympians in the east.

[107] In antiquity Crates was especially famous for his work on Homer ('Homerikos'). On Crates see Hansen 1971: 409–20; Simon 1975: 56–9; Porter 1992; Prignitz 2008: 12; Massa-Pairault 2010: 39–60. Simon argues that the Great Frieze is a reflection of Crates' geographical and cosmological work, depicting the cosmos organised into four parts, with Eos on the south frieze, Nyx on the north frieze, and the four eagles of Zeus; Massa-Pairault identifies individual characters as star signs, as Carl Robert had done previously (Robert 1911: esp. 236, linking the depiction to the writings of Aratus); Prignitz argues that the gods represent *dike*, the giants *Ihybris*, and the whole depicts the victory of order over chaos.

[108] On Cleanthes' alleged influence on the Great Altar, see Pollitt 1986: 109: Massa-Pairault 2010: 91–4.

[109] Cf. Pfanner 1979: 46.

Rather than necessarily following a Stoic blueprint, this composition seems arranged according to principles parallel to those advocated in Hellenistic literary studies and rhetoric. The layering of compositional, stylistic, and iconographic features in order to trigger complex associations, as can be observed in the group of Zeus and Athena, has shared stakes in the organisational principles for which Crates of Mallos argued in his literary criticism, where he distinguished three strands of enquiry that need be to be brought together for analysis: grammar in its narrower sense (the logical), phonetics and style (the practical), and the historical, the study of the use of ideas in the poets and historians.[110]

This composition is also in line with the choppy oratory style of Hegesias from Magnesia ad Sipylus, active around the middle of the third century BCE in a town not far from Pergamon, who employed unusual syntax and bold metaphors to give his speeches greater effect.[111] Hegesias strove for effects that bear resemblance to those associated with tragic historiography of the type pursued by Duris of Samos, the historiographer and art critic active in the late fourth and early third century.[112] That historiography fed on the generation of empathy in its audience, achieved in the case of Hegesias by forcing the audience to reposition itself continuously in relation to his account.

In its composition and iconography and when viewed through the prism of literary criticism and rhetoric – more so than in reference to specific philosophical thought – the Great Altar shows itself to be a highly intellectualised monument, an iconological musing on the myth of the gigantomachy and its previous depiction that brings together formal and iconographic components in order to produce the most substantial depiction of gods and giants in battle ever to be displayed.

The Great Frieze's collapsing of layers of reference also might help to explain the ambiguities of its depictions' relationship to classical Athenian art, a feature highlighted in the iconography of the group containing Zeus,

[110] Hansen 1971: 410; cf. also Wachsmuth 1860: 9–10.
[111] Reifferscheid 1881/2: 7; Brunn 1884: 27–32. For Hegesias, see FGrH 142; Dion. Hal. *Comp.* 18.125–7 (Usener-Rademacher); Cic. *Brut.* 286; Cic. *Att.* 12.6.1. See also Kennedy 1963: 301–3. Cicero describes his style as 'crumbling and hacking' (Cic. *Or.* 230). Dionysius of Halicarnassus provides a vivid example of Hegesias' style by juxtaposing a Herodotean sentence with a reworking of it as if delivered by Hegesias (*Comp.* 18.125–7 (Usener-Rademacher)): 'Croesus, by birth a Lydian, son of Alyattes, was lord of all the nations to the west of the river Halys, which separates Syria from Paphlagonia, runs with a course from south to north, and finally falls into the Pontus Euxinus' (Herodotus *Hist.* 1.6). 'Son of Alyattes was Croesus, a Lydian by birth, of all the nations to the west of the river Halys lord, which runs with a course from south separating Syria and Paphlagonia to fall to the north into the Pontus by the name of Euxinus.'
[112] Most recently on Duris, see Gattinoni 1997; on his art criticism see Tanner 2006: 2012–19.

Athena, and Ge (figs 2.5, 2.6). Since the time of Pergamon's discovery, shortly after the Pergamene sculptures went on display in Berlin,[113] modern scholarship has celebrated the cultural axis Athens–Pergamon.[114] Indeed, Pergamon demonstrates straightforward reverence for the Athenian heritage, be it by virtue of the display of Athenian masterpieces in the Sanctuary of Athena Polias/Nikephorus;[115] the dedication of monuments at Delphi to celebrate victories over the Gauls as if they were in line with the Persian Wars;[116] bold interventions such as the Pergamene pillar monuments dedicated on the Athenian acropolis, the Lesser Attalid Group,[117] the Attalus Stoa on the Agora, matched by a similar structure on the theatre terrace; or the Athenisation and/or Pergamenisation of the urban images of the two cities achieved through the buildings of Eumenes II and Attalus II.[118]

Meanwhile, on the Great Frieze a counterpoint was set to this Athenian über-template in the reappropriation of the representations of Athena and Ge and of the Parthenon west pediment. The Pergamene imagery shares sufficient features with its Athenian predecessor to be able to refer back, but at the same time it also displays significant difference that enables it to enter

[113] Slabs of the Great Altar were displayed in the Rotunda of the Altes Museum from 26 November 1879. See Payne 2008, 170–1; Fendt 2011: 379–80.

[114] Kähler 1948: 118–19 argues particularly forcefully in favour of the relationship; see also Holtzmann 2003: 140. For recent discussions of the Parthenon and the Great Frieze, see Queyrel 2005: 157–8; Junker 2012: 182–7. The earliest and most influential eulogy is that of Ulrich von Wilamowitz in his *Antigonos von Karystos* (von Wilamowitz 1881: 159): 'Das Hellenische als solches festzuhalten und zur Herrschaft zurückzuführen, das war das Zeichen in dem Pergamon allein siegen konnte und gesiegt hat. Das spezifisch Hellenische ist Athen. Athen war in einer Stunde ähnlicher Gefahr rettend gewesen; an die nationalen Gedanken, welche einst im attischen Reiche, in der attischen Weltsprache, in der attischen Religion sich verkörpert hatten, galt es anzuknüpfen. Dieselbe Göttin, der Pheidias Nike in die Hand gegeben, hält als Nikephorus Wacht auf der pergamenischen Burg. Dieselbe religiöse Geschichtsauffassung, die in dem Aischyleischen Drama und in den Metopen des Parthenon zum Ausdruck kommt, liegt den Kampfgruppen zugrunde, mit denen der Eponymos der Attalis die Südmauer der athenischen Burg ziert, und es ist geschichtlich im höchsten Sinne, daß die Athena der Gigantomachie des großen pergamenischen Altares die Gestalt hat, die ihr ein attischer Künstler in einem attischen Werk gegeben hatte, und daß ihr die Erechtheusschlange den Asterios bezwingen hilft.' His assessment seems primarily informed by observations with regard to the antiquated Atticisms that can be found in Pergamene state documents; cf. von Salis 1912: 22–4.

[115] Weber 1993: 100–5; Wolter von dem Knesebeck 1995; Mielsch 1995; Strocka 2000; Hoepfner 2002; Tanner 2006: 222–33.

[116] Hansen 1971: 292–5; Schalles 1985: 104–26.

[117] On the Lesser Attalid Group, see Schmidt-Dounas 2000: 232–44; against the late dating: Stewart 2004: 218–20.

[118] On the Pergamene dedications in Athens, see Hansen 1971: 295–8; Schalles 1985: 136–42; Schmidt-Dounas 2000: 34–9. On the Pergamene use of art and space, see Kohl 2007: esp. 117–22. On urban design, see Schmidt-Dounas 2000: 209; Radt 2011: 23–5; Schalles 2011: 120.

into competition with that predecessor – a visual competition from which Pergamon emerges as a city concerned with problems of the cosmos, in the solution of which they are supported by the gods. Classical Athens is thus rendered merely interested in local issues and sufficiently arrogant to let two gods struggle for her stewardship.

This simultaneous bow to and invective against classical Athens is achieved by the layering of formal and iconographic components. Such sophisticated emulation of the artworks of previous periods, turning a celebration of classical learning into a powerful political statement,[119] is not at all out of place at Pergamon, given that some of the leading art critics of the time were working there: Antigonus of Carystus and Polemon, the Periegete, active in the second half of the third century and the first half of the second.[120] This type of appropriation of the gigantomachy was not new: Diodorus and Plutarch report cases of rulers aligning themselves with the gods fighting against the giants in order to present themselves in a positive light, as is also the thrust of the depictions on the peplos of the Athena Parthenos celebrating the deeds of Demetrius Poliorcetes and Antigonus.[121]

At Pergamon, the Attalids continue this tradition, and that of their dynasty, in a celebration of victory. The Great Frieze is modelled both on previous Attalid victory monuments and on the Athenians' use of grand mythological battles against opposing forces as they can be found depicted on and in the Parthenon. With regard to the former, a significant change brought about by the Great Frieze is the move away from an explicit depiction of the Gauls: while the monument of the Large Gauls of *c.* 220 BCE focused entirely on these enemies, and the Lesser Attalid dedication on the Athenian acropolis at least included them, on the Great Frieze explicit reference to any specific military struggle has been abandoned in favour of the depiction of battle on a cosmic scale.

In light of this reworking, it would have seemed fitting to use the Athenian template to produce a mythologised eulogy, whether to celebrate the Pergamenes' struggle against the Gauls,[122] or, more likely, to applaud Attalid political and military strategy, dynastic planning, and intellectual

[119] On Pergamon's use of learning as a political tool, see Hansen 1971: 397–433; Gruen 2000.

[120] Hansen 1971: 397–402; for Antigonus and the problems around identifying him, see also Wilamowitz 1881; Tanner 2006: 212–19.

[121] Diod. 20.46; Plut. *Dem.* 10. Cf. von Salis 1912: 22.

[122] Kähler 1948: esp. 144–9 understood the Great Frieze as directly referring to the battles against the Gauls, alongside celebrating Eumenes' victory against Prusias and Ortiagon. For the gigantomachy as allegory of the Gallic wars, cf. also Hoepfner 1993. For the Great Frieze as more generic reference to Attalid wars, see Knell 1990: 170; La Rocca 1998: 25; Radt & De Luca 1999: 125; Marszal 2000: 1976; Junker 2003. Contra such specific interpretations:

prowess more broadly.[123] At the same time, the statement of the Great Frieze is rendered even more ostentatious and confident by being so explicitly devised in competition with and in contrast to Athens – an attitude that also emanates from Pergamon's celebration of herself as saviour with the defeat of barbarian forces in Asia Minor, as is documented in the letter of Eumenes II to the Ionian Alliance of 167.[124] While the Athenian template is deployed, here again the reach and significance of Pergamene actions are presented such that they outshine Athens.

3) The Louvre sarcophagus: why a hunter needs a sword

An iconographic analysis.

The depiction of Meleager's fate in the aftermath of the Calydonian boar hunt dominates the casket (fig. 0.3). The hero appears twice across the three loosely juxtaposed scenes. In the large scene in the centre, he is depicted on his deathbed, covered by a blanket. His weapons – sword, Corinthian helmet,[125] spear, and shield – are displayed around a footstool next to the bed. His family surrounds him, all in a state of frantic grieving: two young women, perhaps Meleager's siblings, stand behind him; to the left, an old woman and an old man, possibly his *nutrix* and *paedagogus*, nurse and teacher, move towards the bed;[126] further to the left sits Atalanta, the only figure in this scene not interacting with Meleager, her head buried in mourning.[127]

Maderna-Lauter 2000: 455–6; Michels 2003: 10–28; Massa-Pairault 2007a: 125; cf. also Ehling 2000, who demonstrates convincingly that the shield on the east frieze is not Macedonian. There is no arguing that the various battles Pergamon had gone through against the Gauls, Seleucids, and Macedonians throughout the course of the third and into the second century had provided the foundations for the city's prosperity; and they had linked her closer and closer with the force of Rome emerging in the West. For Pergamon's military campaigns, see Habicht 1956; Hansen 1971: 26–129; Allen 1983: 79–81; Moreno 1994: 430–2; Strobel 1996.

[123] For the different potential roles of the altar, cf. Webb 1998: 244–50.

[124] Dittenberger 1905: n. 763; Bringmann et al. 1995: 349–53 n. 285; Bringmann 2000: 74; Schmidt-Dounas 2000: 293–312. For Pergamon's intricate culture politics, see Schalles 1985; Gruen 2000; Michels 2003: 34–7.

[125] In Roman depictions the Corinthian helmet generally exudes notions of *arete* and *vetustas*, frequently appearing in mythological depictions or those, such as the late Antonine battle sarcophagi, intended to convey universal military messages: see Faust 2012: 193; for the Greek background of the iconography see Schäfer 1997: 43–70; Laube 2006: 129–30.

[126] Robert takes the two elderly characters to represent Meleager's parents (1904: 338); Koch refers to them as *nutrix* and *paedagogus* (1975: 38, 42), as does George (2000: 195). For *nutrix* and *paedagogus* characters, see Schulze 1998: 55–60, 61–72; George 2000: 194–7.

[127] For the iconography of Atalanta, see LIMC II 1984 s.v. *Atalante* (J. Boardman).

In the shorter scene on the far right Meleager is shown in the quarrel with his uncles, the Thestiadae, over the boar hide – an episode that takes place immediately after the successful hunt for the Calydonian boar and thus before the scene presented in the relief's centre. Meleager is here characterised as initiating the attack: he is approaching one uncle with his drawn sword whilst his opponent, holding a spear in his left hand, is only about to pull his sword from its sheath. The second uncle already lies on the ground; his twisted pose indicates he is dead, but his left hand still clutches the boar's hide, thereby engaging Meleager in a tug of war, for he too is holding on to the hide with his left hand.

Episodes from the life of Meleager enjoyed great popularity in imperial Roman domestic and funerary art – more than in Greek art, where only the episode of the Calydonian boar hunt is featured on occasion.[128] Among the Roman mythological sarcophagi, some two hundred caskets depicting Meleager constitute the largest group of reliefs devoted to one hero.[129] The hunt for the Calydonian boar itself forms the most substantial group of Meleager sarcophagi, with seventy-two pieces, all from Italic workshops (e.g. fig. 2.16); this grouping covers the longest chronological span of all Meleager sarcophagi, reaching from the middle of the second century to the end of the third.[130] Other episodes featured on the sarcophagi include the gathering for a meal after the hunt[131] and the recovery of Meleager's body from the Battle of Pleuron, a conflict between the Calydonians and the Curetes (fig. 2.17).[132]

The Louvre sarcophagus belongs to a fourth group, the deathbed sarcophagi, a relatively small group of sixteen sarcophagi, all from Italic workshops and primarily confined to the second half of the

[128] For the iconography of Meleager, see LIMC VI 1992 s.v. *Meleagros* (S. Woodford). For depictions outside the funerary sphere, see Lorenz 2008: 55–83, Lorenz 2011: 324–7.

[129] See Robert 1904: 221–311; Robert 1919a: 573–6; Koch 1974; Koch 1975: 3–6; Fittschen 1975; Brilliant 1984: 145–65; Lorenz 2011; Borg 2013: 172–5.

[130] See Koch 1975: 7–28.

[131] The meal is depicted on fifteen pieces, many of them lids, from the period from the second half of the second century into the third century. See Koch 1975: 48–50.

[132] The recovery is extant in thirty-eight pieces, from between 150 and 200 CE. See Koch 1975: 28–38. The Pleuron episode is a version of the Meleager story that is used in Homer's *Iliad* to lure Achilles back into battle (*Il.* 9.529–99): after the hunt for the Calydonian boar, Artemis' wrath has still not ceased, and she incites a conflict over the hunting haul between the Aetolians based at Calydon and the Curetes from Pleuron. In the resulting war, Meleager kills his uncles. The curse his mother subsequently puts on him makes him avoid further fighting, but when his city is threatened, he enters the battle again and is then killed by Apollo (according to the versions in the Minyas and Hesiod; see Paus. 10.31.3). Bakchylides has Althaea burn the log and thus cause Meleager's death: Bakchyl. 5.138–50; Apollodorus also mentions that she then kills herself: Apollod. 1.8.3); Robert 1904: 275–6 presumes this version to be older than the other one.

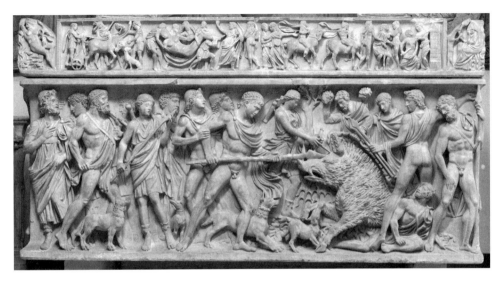

Fig. 2.16 Meleager in the Calydonian boar hunt. Rome, Palazzo Doria. 180/90 CE.

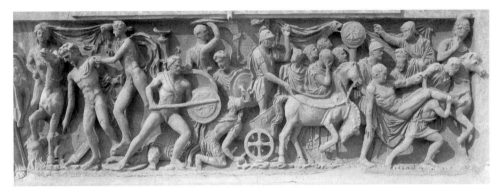

Fig. 2.17 Meleager with a sword at the gates of Pleuron. Rome, Villa Doria Pamphili. 190/200 CE.

second century CE.[133] These pieces detail the events around Meleager's death, which can also be found in Ovid's account of the hunter's life, the most prominent ancient textual version of the myth and probably

[133] See Koch 1975: 38–47; cf. also Traversari 1968. Alongside the Louvre sarcophagus, the group includes:
(1) Ostia, Museo Archeologico 101; from Ostia. 160 CE. L 1.37 H 0.40 D 0.36. Robert 1904 no. 282 fig. 575; Koch 1975 no. 112 pl. 96a. See here fig. 8.8.
(2) Paris, Musée du Louvre MA 654. 160 CE. Robert 1904 no. 279 pl. 93; Koch 1975 no. 113 pl. 95a.
(3) Rome, Villa Albani, Galleria del Canopo. 170 CE. L 1.89 H 0.43. Robert 1904 no. 278 pl. 92; Koch 1975 no. 114 fig. 8.
(4) Rome, Museo Capitolino 623. 170 CE. L 1.95 H 0.385. Robert 1904 no. 281 pl. 93; Koch 1975 no. 120 pl. 96c, 98–101. See here fig. 8.9.

appropriated from a tragedy by Euripides.[134] According to Ovid, after
the killing of the Calydonian boar Meleager courted Atalanta with the
hide, slaughtered his opposing uncles, was surrendered to his destiny
by his mother, Althaea, who burned a log that safeguarded his life, and
then succumbed to a fever in his bed. The reliefs of the deathbed group
detail these events in two, three, or four scenes, with almost all sharing
depictions of the hero on a bier surrounded by mourners and the fight
against the Thestiadae.[135] Some include a scene of Althaea burning the
log,[136] and one casket displays a scene in which Meleager and Atalanta
are depicted as a couple.[137]

Meleager's characterisation on the Louvre sarcophagus and some of the
other caskets in the deathbed group differs in two aspects from other rep-
resentations of the hero across Greek and Roman visual art, at points also
deviating from Ovid's account. The first concerns Meleager's armour: the
sword in the scene of the fight against the Thestiadae and the weapons sur-
rounding the bed appear on another five of the deathbed sarcophagi[138] but
not elsewhere: the hero is usually depicted in the nude and equipped only
with one or two spears, sometimes with a sword strapped to his torso, but

 (5) Milan, Torno Collection. 170/80 CE. L 2.20 H 0.65. Robert 1904 no. 282 pl. 93; Koch 1975
 no. 117 pl. 102a.
 (6) Rome, Studio Canova. 180 CE. L 0.48 H 0.55. Robert 1904 no. 280 pl. 92; Koch 1975
 no. 115 pl. 95b.
 (7) Wilton House, Wiltshire, from Rome. 180 CE. L 2.15 H 0.65. Robert 1904 no. 275 pl. 89;
 Koch 1975 no. 122 pls 103a, 104, 105, 113e.f.
 (8) Castel Gandolfo, Villa Barberini, once Vatican. Around 230 CE. L 2.06 H 0.47. Robert
 1904 no. 276 pl. 90; Koch 1975 no. 121 pls 96d, 112.
 (9) Florence, Museo Archeologico 1911. Koch 1975 no. 118 pl. 102b.c.
(10) Rome, S. Giovanni in Laterano. Koch 1975 no. 123.
(11) Rome, Palazzo Giustiniani, lost. Koch 1975 no. 124 pl. 113g.
(12) Side panel, lost, once Rome, Villa Borghese. Robert 1904 no. 225b pl. 77; Koch 1975
 no. 125 fig. 9.
(13) Side panels, Rome, Vatican, Museo Gregoriano Profano 10568. 10569. Koch 1975 no. 126
 pl. 113c.d.
(14) Ostia, Store 857, 845 (possibly two different pieces). Koch 1975 nos 196, 197.
(15) Lost, once Rome. Robert 1904: 282 pl. 93; Koch 1975 no. 119 pl. 96b.

[134] Ovid *Met.* 8.267–546. Euripides' drama is only extant in fragments: Cozzoli 2009. Other
 versions of the myth include Homer *Il.* 9.529–99; Stes. (Davies 1991: frgs 221–2); Bakchyl.
 5.93–174; Paus. 10.31.3–4. cf. Robert 1904: 268–77; Koch 1975: 38–9. Both associate the
 depiction on the sarcophagus with Euripides' account. For a comprehensive analysis of the
 narrative structure of Book 8, see Tsitsiou 1990.
[135] The only exception is the piece in Villa Albani, see above, p. 73 n. 133 (3), which leaves out the
 fight.
[136] See above, pp. 73–4 n. 133 (3); (4); (5), but only on a side panel; (7); (8).
[137] See above pp. 73–4 n. 133 (8).
[138] See above, pp. 73–4 n. 133 (1); (4); (5); (7); (8).

not engaging this weapon.[139] In this respect, the visual record is close to Ovid, who also has Meleager fight the Thestiadae with a spear.[140]

Across the Meleager iconography the only exception to his fighting with spears is found in the scenes of the Battle of Pleuron, another story exclusive to sarcophagi. Here, on occasion Meleager is shown with more weaponry, when he attacks his enemies with spear and shield, a sword around his torso, as in the centre of the relief in the Villa Doria Pamphili (fig. 2.17),[141] or when he is slaughtered by Apollo, then dons sword, shield, and helmet, for example on the far left of the same sarcophagus.[142]

With a close-combat weapon such as the sword and military armour so prominently featured on the Louvre sarcophagus, an intermingling with this other narrative strand of the Meleager myth as featured on the so-called recovery sarcophagi might have been intended.[143] These two strands can appear together on sarcophagi (fig. 2.16)[144] even though they present distinct narrative alternatives, each of which excludes the other, because one links the hero's end to the figure of Atalanta and an unheroic death in his bed, whereas the other has Meleager die on the battlefield.

[139] None of the hunters in the scenes of the Calydonian boar hunt on Roman sarcophagi is depicted with a sword strap around his torso, with two exceptions (of course, more might have been added in paint): on a relief in St Peter's Meleager is depicted with a sculpted sword strap (Rome, S. Pietro in Vaticano. 180/90 CE. H 0.70 L 2.06 D 0.60. Koch 1975 no. 146 pl. 121); and the two bearded characters who appear for example on the casket in Palazzo Doria sport sword straps (Rome, Palazzo Doria. 180/90 CE. L 2.47 H 0.94 D 1.10. Robert 1904 no. 231 pl. 79; Koch 1975 no. 8 pl. 10): Carl Robert interpreted the one on the left, who carries a double axe into the hunt, as the death demon Orcus (Robert 1904: 273–5; Koch 1975: 8); Bernard Andreae suggests Ancaeus / Hercules (Koch 1975: 8).

[140] Ovid *Met.* 8.437–44.

[141] Rome, Villa Doria Pamphili. L 2.05 H 0.70. 190/200 CE. Robert 1904: 283 pl. 94. Koch 1975 no. 84 pl. 89a. On the relief, the hero's hunting prowess is alluded to by the decoration on a shield that shows him advancing against the boar. Two other versions of this episode are extant: Rome, Vatican, Museo Gregoriano Profano 3098. L 0.665 H 0.28. Mid-Antonine period. Robert 1904: 284 pl. 94; Koch 1975 no. 85 pl. 80c; Istanbul, Archaeological Museum 2100, left side panel. L 2.41 H 0.57. Early Antonine period. Koch 1975 no. 81 pl. 78a.

[142] The hero is nude except for a shield, but a sword, helmet, and cuirass lie on the ground next to him. The head is modern, and Koch has identified traces of a plume in the background, which would indicate that the figure was also wearing a helmet: Koch 1975: 112. Four other versions of this episode are extant (including two caskets now lost: Koch 1975 no. 65 pl. 79g (left side panel); Koch 1975 no. 82 pl. 88b): Perugia, Museo Archeologico Nazionale dell'Umbria 1886. 190/200 CE. L 2.12 H 0.92. Robert 1904: 285 pl. 95; Koch 1975 no. 83 pl. 90b; Rome, Vatican, Museo Gregoriano Profano 10487. Mid-Antonine period. L 0.26 H 0.60. Robert 1904: 303 pl. 97; Koch 1975 no. 94 pl. 79e.

[143] For the term *intermingling*, see Koortbojian 1995: 58–9. For similar strategies in the shaping of different stages of life for the Orestes iconography, see Bielfeldt 2005: 265–70.

[144] As on Rome, Palazzo Doria (fig. 2.16). *c.* 180/90 CE. L 2.47 H 0.94 D 1.10. Robert 1904 no. 231 pl. 79; Koch 1975 no. 8 pls 10, 13b–c, spread across the lid (recovery) and sides (Atalanta, and the fight against the Thestiadae).

Another iconographic parallel to consider is the depiction of a proper mythological warrior, namely Patroclus, whose death is rendered on the Pianabella sarcophagus in a comparable way.[145] Patroclus also lies on a bier surrounded by weeping women and grieving men; at the foot of his bed are a Corinthian helmet and a sword, and a comrade holds his shield and rests on his cuirass. Interestingly, the weapons are also anomalous, for in the mythological story Patroclus' weapons, those he took from Achilles, are lost on the battlefield at the point when he is killed; where, then, have the weapons depicted here come from? The representations of Meleager and Patroclus are aligned in that both figures are shown with weapons that according to the underpinning myth they should not have.

Whatever the iconographic source of the sword as an attribute of military combat, the resulting mixture of hunt and warfare on the Louvre sarcophagus generates an image of the deceased's *virtus* that invites comparison with the message of the *Vita Romana* lion hunt sarcophagi, which became popular later, from the middle of the third century CE.[146] The latter sarcophagi depict a hunter on horseback, spear at the ready, but frequently also carrying a sword around his body. This riding hunter shows close parallels with the depictions on Roman battle sarcophagi of generals and other soldiers, as portrayed increasingly from the later second century onwards.[147] The amalgamation of the realms of hunt and war on the lion hunt sarcophagi is underscored when the hunting scene is combined with a 'commander' episode, showing the deceased as a general surrounded by his soldiers.[148] Also, the hunter can be accompanied by Virtus herself, with the personification emphasising his hunting abilities (fig. 2.18).[149]

[145] So Giuliani 1989: 35–7. For the Pianabella sarcophagus: Berlin, Antikenmuseum 1982.1 (now on permanent loan as Ostia, Museum 43504). 160 CE. L 2.01 H 0.55 D 0.48. Koch 1983; Giuliani 1989; Gallina 1993; Grassinger 1999: 204–5 no. 27 pls 28–31; Huskinson 2011: 58–61; Zanker & Ewald 2012: 287–91.

[146] Andreae 1980: 42–8; Andreae 1985. Cf. the earliest lion hunt sarcophagus in Paris: Musée du Louvre 1808; from the Borghese Collection. 230/240 CE. L 2.28 H 0.58. ASR I 2, 65 pl. 1.3; Andreae 1980 no. 65 pls 24–30; Koch & Sichtermann 1982: 93–4 pl. 82; and Rome, Palazzo Mattei II. 250 CE. L 2.14 H 1.33. Andreae 1980 no. 65 pls 24–30; Koch & Sichtermann 1982: 93–4 pl. 82. For the positive connotations around hunting in Roman society since the Hadrianic period, see Zanker 1999: 133–4; cf. also Zanker & Ewald 2012: 222–9.

[147] Faust 2012: 197–212.

[148] For example Rome, Palazzo Mattei. 250 CE. L 2.14 H 1.33 D 0.14. Andreae 1980 no. 128 pl. 13.1; Koch & Sichtermann 1982: 94 pl. 84. Cf. also the largest extant Roman hunt sarcophagus: Rome, Palazzo Rospigliosi-Pallavacini. 240–50 CE. L 2.90 H 1.40. Andreae 1980 no. 131 pls 43–5.

[149] For example Reims, Musée de Saint Remi 932, 14. *c.* 260 CE. L 2.83 H 1.46 D 1.30. Andreae 1980 no. 75. For Virtus, see LIMC VIII 1997 s.v. *Virtus* (T. Ganschow).

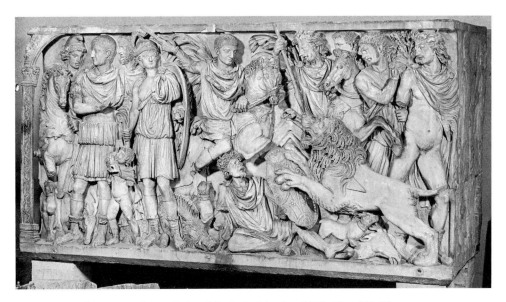

Fig. 2.18 Lion hunt sarcophagus. Reims, Musée de Saint Remi 932, 14. *c.* 260 CE.

The second aspect of Meleager's characterisation that deviates from the other representations of this figure in Greek and Roman visual art concerns his relationship to other characters on the casket. Whilst in the depictions of the hunt and the Battle of Pleuron, Meleager is singled out by his proactive manner, here he is only shown taking action in the scene with the Thestiadae, and that action is a perversion of his usual mode, for in order to secure the boar hide he has to kill humans, not an animal. And the other scenes on the casket show Meleager as dependent on the actions of his family.

As the deathbed sarcophagi deviate from the binarism of previous iconographies, Meleager's connection with Atalanta is difficult to pinpoint. Whilst Ovid's account refers to their loving relationship, a divergence from the earlier epic narrative,[150] the scenes of the deathbed group do not display the intimacy or physical eroticism featured on the Pompeian walls, for example in a Fourth-Style fresco from the Casa delle Danzatrici (fig. 2.19),[151] but neither do they confine Atalanta to the simple role of a fellow hunter, as she is rendered in scenes of

[150] Koch 1975: 39 and as described in Hom. *Il.* 9.529–49. Still, Ovid's narrative is, in the context of his oeuvre, surprisingly terse on the romantic element of the Calydonian hunt, and instead dresses the adventure in epic terms.

[151] Pompeii, Casa delle Danzatrici (VI 2,22). Lorenz 2008 no. K24a. For the iconography of the Pompeian scenes, see Lorenz 2008: 70–5; cf. also Lorenz 2011: 324–7.

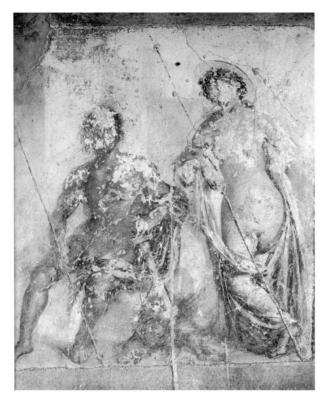

Fig. 2.19 Meleager and Atalanta. Pompeii, Casa delle Danzatrici (VI 2,22). 50/60 CE.

the hunt on sarcophagi and mosaics, for example in a mosaic from the Villa del Nilo in Leptis Magna (fig. 2.20).[152] Instead, Atalanta is singled out by her restrained sorrow as she guards over Meleager's shield and

[152] Tripolis, Museum; from Leptis Magna, Villa del Nilo. Second to fourth century. Muth 1998: 371–2 no. A19. For Meleager and Atalanta on mosaics, see Raeck 1992: 71–6; Muth 1998: esp. 217–18. These depictions can sometimes take an erotic flavour, especially towards the third century CE, as in scenes of counsel before the Calydonian hunt, where Atalanta puts her arm around Meleager (for example Rome, Museo Capitolino, Atrium. H 0.56 L 2.22. Mid-Antonine period. Robert 1904: 226 pl. 77; Koch 1975: 85 no. 1 pl. 2a). Another group is formed by the scenes of the meal after the hunt, where Atalanta lies with Meleager (for example Rome. Robert 1904: 273 pl. 88; Koch 1975 no. 139 pl. 116e). The iconography here is close to the presentation of husband and wife in *Vita Romana* consecration scenes on funerary monuments, for example on a *loculus* plaque in Rome, where husband and wife are depicted together on a couch while being attended by a maid and a torch-bearing Eros on either side (Rome, Museo Nazionale 114174; from Ostia, Isola Sacra. Last quarter of the third century CE. L 0.23 H 0.23 D 0.78. Koch & Sichtermann 1982: 111 pl. 107; Amedick 1991 no. 176 pl. 10.6). On images of consecration in the Antonine period see Wrede 1981: 125–57. Towards the end of the third century more scenes appeared, including Campanian, Attic, and Gallic sarcophagi, which in the context of the hunt render Meleager and Atalanta in the guise of bride and groom

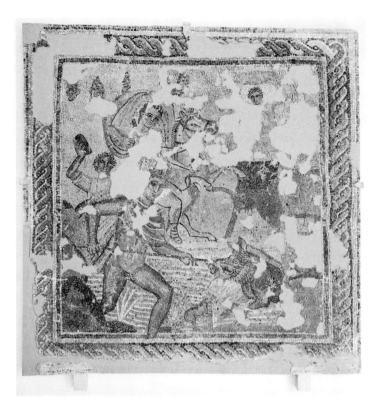

Fig. 2.20 Meleager and Atalanta. Tripolis, Museum, from Leptis Magna, Villa del Nilo. Second–fourth century CE.

its apotropaic powers, which are implicit in the shield sign featuring a gorgoneion.[153]

Atalanta's silent mourning aligns her with figures such as Achilles, seated at the bed of Patroclus, and a standing male comrade on the Pianabella sarcophagus,[154] emphasising her role as an equally virtuous, loving partner

or husband and wife: Woburn Abbey, Bedfordshire 59. Tetrarchic period. L 2.25 H 0.95. Robert 1904: 224 pl. 76; Smith 1900: 34–7 no. 59; Koch 1975 no. 71 pl. 63; Portici, Park. Late third century CE. H 0.60 L 2.13 H 0.60. Rodenwaldt 1943: 15; Koch 1975: 133 no. 150 pls 124a, 125b; Chicago, Alsdorf Foundation, from Antiocheia Orontes. First half of the third century CE. L 1.20 H 0.95. Vermeule 1971: 176; Koch 1975 no. 168 pl. 133a. Autun, Musée Rolin no. 66, from Arles. Third century CE. H 0.85 L 2.25 D 0.86. Robert 1904: 219 pl. 72; Koch 1975: 136–7 no. 159 pl. 133b. On relief sarcophagi, this trend had already started in the later second century: Rome, S. Pietro in Vaticano. 180/90 CE. H 0.70 L 2.06 D 0.60. Koch 1975 no. 146 pl. 121; Wilton House, Wiltshire. From Columbarium of the liberti of Livia/Via Appia. Mid-third century CE. L 2.08 H 0.46 D 0.58. Robert 1904: 311 pl. 98; Koch 1975 no. 147 pl. 122a.

[153] For the gorgoneion as shield sign, see Howe 1954. On the meaning of gorgoneia more generally see Mack 2002: esp. 575–6, 596–8; Hedreen 2007: 221–7.

[154] See above, p. 76 n. 145.

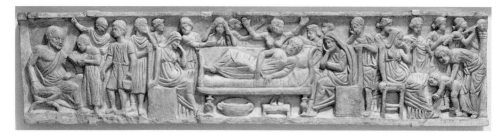

Fig. 2.21 *Conclamatio*: parents seated around the deathbed of their child. Paris, Musée du Louvre MA 319. Mid-Antonine period.

of Meleager. The pose is also comparable to the depiction of parents seated around the deathbed of their child in *conclamatio* scenes, popular on *Vita Romana* sarcophagi of the mid-Antonine period (fig. 2.21).[155] In these scenes elderly figures of the *nutrix* and *paedagogus* type also appear.[156]

In addition, *conclamatio* scenes can also feature the three Moirai/Parcae, providing a framework of fate and destiny, as we see, for example, on a casket in Paris that depicts Lachesis with the globe, allotting the length of life, Clotho with the wool thread, weaving the course of life, and Atropus with the lyra, ending life.[157] On the Louvre relief, these demons are deployed across the scenes of Althaea and the Thestiadae but are fashioned more generally as demons of fate and vengeance, a redressing that is achieved by blending the iconographic features of the Moirai/Parcae with those of figures such as Nemesis or the Eumenidai/Furiae, who are Alecto, Megaera, and Tisiphone.[158]

The three demons, alongside Atalanta's parental pose and the pairing of teacher and nurse, complete the threefold link of the Louvre relief to the *Vita Romana* versions of premature, ill-fated death and family grief. But the role of the three demons extends further: they also form part of a deviation from Ovid's account that channels the relief towards the presentation of a

[155] Toynbee 1985: 44 fig. 10; Amedick 1991: 72–4, 79–81; Huskinson 1996: 95–9, 101–4; George 2000: 202–5; Dimas 1998: 16–22. For example Child's sarcophagus, Musée du Louvre MA319. Mid-Antonine period. With regard to the children's sarcophagi the term *Vita Humana* is usually used rather than *Vita Romana*; however, the latter appears suitable here with regard to the marriage/commander sarcophagi; for a discussion of the terminology, see Reinsberg 2006: 17.

[156] For example Rome, Museo Torlonia 414. *c.* 200 CE. L 1.57 H 0.36. Koch & Sichtermann 1982: 109 no. 7 fig. 115; Dimas 1998 no. 392; cf. George 2000: 195.

[157] Paris, Collection Dresnay. 120/30 CE. Brendel 1977: 70–85 pl. 10; Amedick 1991 no. 122 pl. 77.1. For the Moirai/Parcae, see LIMC VI 1992 s.v. *Moirai* nos 38–44 (S. De Angeli); Brendel 1977: 70–85; Giannoulis 2010.

[158] Nemesis: LIMC VI 1992 s.v. *Nemesis* (P. Karanastassi, F. Rausa).

set of very specific values. In Meleager's story Ovid has Althaea interact twice with three female demons but leaves the identity of these demons somewhat fuzzy – the first interaction is at Meleager's birth with what might be the Parcae, the Fates;[159] the second is with what Ovid refers to as the Eumenidai, the Furies, at Meleager's death.[160] Whilst the iconographic blend served up on the Louvre casket might constitute an attempt at capturing aspects of both these points of Ovid's narrative, two of the demons frame a scene different from that reported by Ovid: in the Louvre relief, and indeed across the other versions of the deathbed group where the scene appears, Althaea burns the log sealing Meleager's fate not on a pyre, as recorded by Ovid, but on an altar (fig. 2.22).

What Ovid refers to as Althaea's *officium* towards her brothers[161] – her familial duty – and an act of *iustitia*, of just punishment,[162] is here displayed as if an official sacrifice, an *immolatio*,[163] an act of *pietas* of a type that can be found yet again on another group of *Vita Romana* sarcophagi, not on this occasion the *conclamatio* reliefs, but the biographical 'marriage' or senatorial 'commander' sarcophagi. On reliefs such as one now in Los Angeles,

[159] Ovid *Met.* 8.451–7 (trans. D. Raeburn, London, 2004): 'At the time when Althaea was giving birth to her son Meleager, a fragment of wood had been cast in the fire on the hearth by the Three Fates. Spinning with thumb and finger at destiny's threads, the Sisters uttered these words: "We assign the same life-span to this wooden log as we do to this new-born child." The spell was cast and the goddesses made their departure. At once the mother extracted the burning branch from the flames and doused it in running water.' ('Stipes erat, quem, cum partus enixa iaceret Thestias, in flammam triplices posuere sorores staminaque inpresso fatalia pollice nentes "tempora" dixerunt "eadem lignoque tibique, o modo nate, damus". Quo postquamque carmine dicto excessere deae, flagrantem mater ab igne eripuit ramum sparsitque liquentibus undis.')

[160] Ovid *Met.* 8.481–4 (trans. D. Raeburn, London, 2004): 'Eumenides, three dread sisters, powers of punishment, turn your gaze on these sacred rites of retributive fury! Vengeance is mine by sin, and death is atoned for by death; crime must needs be added to crime, and a body to bodies.' ('"Poenarum" que "deae triplices, furialibus" inquit "Eumenides, sacris vultus advertite vestros. Ulciscor facioque nefas. Mors morte pianda est, in scelus addendum scelus est, in funera funus."')

[161] Ovid *Met.* 8.488–90 (trans. D. Raeburn, London, 2004): 'I pray to the shades and the newly departed sons of my brethren: take regard of the honours I show you; accept my sacrifice, offered at such dear cost, the evil fruit of my own womb!' ('Vos modo, fraterni manes animaeque recentes, officium sentite meum magnoque paratas accipiter inferias, uteri mala pignora nostri.')

[162] That the scene might hold notions of punishment is supported by Carl Robert's interpretation of the additional female character on the Villa Albani casket, whom he takes to be Poena, a variation of Dike or Iustitia. Robert 1904: 339–40. For the relief, see above, p. 73 n. 133 (3). For depictions of Dike, see LIMC III 1986 s.v. *Dike* (A. Shapiro). For depictions of Iustitia, almost exclusively on coins, see LIMC VIII 1997 s.v. *Iustitia* (M. Caccamo Caltabiano). For depictions of Poena, see LIMC VII 1994 s.v. *Poina* (C. Lochin), who lists no Roman representation.

[163] For *immolatio*, see Brendel 1930.

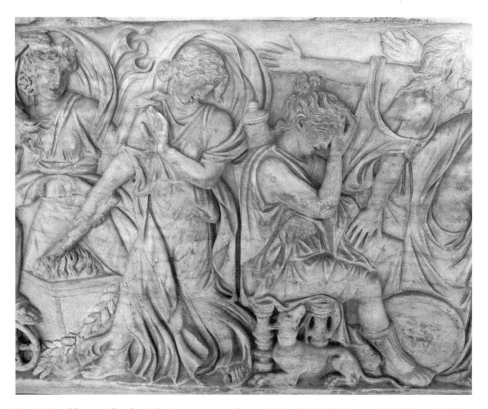

Fig. 2.22 Althaea at the altar. The Louvre sarcophagus. Paris, Musée du Louvre MA 539. *c.* 190 CE.

the military commander readying himself for departure for war conducts a sacrifice and thereby signifies his *pietas.*[164]

Along with Althaea's *sacrificium*, another element can also be aligned with the biographical sarcophagi. The torch wielded by the demon behind the altar, an attribute of vengeance, could be a reference to the torch carried by Phosphorus in the scenes of *matrimonium*. This interpretation, in turn, runs up against the figure of Atalanta. In the earliest relief of the deathbed group in Ostia, Atalanta is not part of the scene around the bier, but she is shown as mourning in the scene with the Thestiadae, where she appears as the hunting partner, her honour reinstated by Meleager's actions, which bring those who compromised it just punishment (fig. 8.8). On the Louvre

[164] Los Angeles, County Museum 47.8.9; from Rome, Villa Borghese. 170/80 CE. L 2.35 H 1.00 D 0.74. Reinsberg 2006 no. 29. This casket displays a further parallel with the Louvre sarcophagus: on the right side panel, the Moirai/Parcae are depicted. The other biographical sarcophagi show not a permanent marble altar, but rather portable versions, more in line with the situation for a departing army.

sarcophagus, in contrast, Atalanta has taken the place of the parents, whilst Meleager, on the left, is still doling out *iustitia*, but no longer exclusively linked to the figure of Atalanta. Atalanta is not marriage material, as the character of Phosphorus-turned-Nemesis underscores, but the two partners – Meleager and Atalanta, fighting and mourning – act in a way entirely appropriate to marital *concordia*, even if here shown as a *matrimonium interruptum*.

With these depictions of *pietas, iustitia, matrimonium*, and *concordia* the Louvre sarcophagus conjures up a series of virtues that can also be found on the senatorial biographical sarcophagi.[165] Scholarship originally assumed that the four cardinal Roman imperial virtues – *virtus, clementia, iustitia, pietas* – are depicted on these sarcophagi, as documented on the *clupeus virtutis* for Augustus, along with *concordia*, which is not recorded on the *clupeus*.[166] More recently, these sarcophagi have come to be seen as representing not so much acts of these virtues but rather a more generalised tableau of *imperium*, of social prestige as indicated by certain *imperii insignia*, indicators of public office, such as holding court and receiving expressions of power and victory. Overall three areas of life are encompassed, as depicted, for example, on the Mantua commander sarcophagus from left to right: the public, the gods, and the private (fig. 2.23).[167]

That interpretation has repercussions, too, for assessment of the Louvre sarcophagus, for its scenes can be aligned in a similar way:[168] the scene with Althaea can be understood as referring to the sphere of the gods, the scene around the bier to the private, and the scene with the Thestiadae to the public. The deviations from the senatorial templates are then more striking. Indeed, they even stand out as problematised inversions of this senatorial template, as a devious act of piety is executed by a torn Althaea; a virtuous woman is not marrying, but rather mourning the loss of her partner/comrade-in-arms/surrogate son; and *virtus* and *iustitia* are executed against unruly forces, whose identity questions the legitimacy of that act.

[165] On biographical sarcophagi: Rodenwaldt 1935; Geyer 1978; Kampen 1981; Whitehead 1986; Wrede 2001: 21–43; Muth 2004; Reinsberg 2006: 19–32. With a critical discussion of the notion of biographical depiction: Reinsberg 2006: 170–3; Zanker & Ewald 2012: 224–9.

[166] For the *clupeus virtutis* and its role in imperial self-representation, see Hölscher 1967: 102–8; Zanker 1988: 95–7. On the predilection in sarcophagus studies of focusing on these so-called cardinal virtues, or *exempla*, see Gessert 2004: 218–19. For the individual virtues as personified: LIMC III 1986 s.v. *Clementia* (T. Hölscher); LIMC V 1990 s.v. *Homonoia/Concordia* (T. Hölscher); LIMC VIII 1997 s.v. *Iustitia* (M. Caccamo Caltabiano); LIMC VIII 1997 s.v. *Pietas* (R. Vollkommer); LIMC VIII 1997: s.v. *Virtus* (T. Ganschow).

[167] Mantua, Palazzo Ducale. *c.* 160 CE. Muth 2004: esp. 269–70.

[168] For similar strategies in the depiction of Orestes on sarcophagi, see Bielfeldt 2005: 265–70.

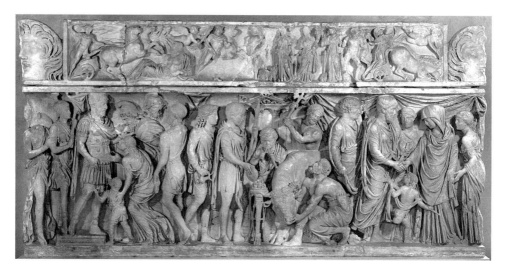

Fig. 2.23 The commander and his virtues. Mantua, Palazzo Ducale. *c.* 160 CE.

The Louvre sarcophagus thus presents two different life trajectories. The first is concerned with stages in the life of Meleager and has analogies to the *Vita Humana* sarcophagi, which celebrate social prestige achieved through holding public office. The second starts from a diametrically opposed premise: by emulating elements from the *conclamatio* scenes, it displays its concern for *consolatio* not by celebrating achievements, but by mourning a life cut short before such achievements could be made.

The two trajectories come together in the figure of Atalanta. The theme of *matrimonium* and *concordia* so characteristic for the biographical sarcophagi is re-sited within the framework of the *conclamatio* scenes, establishing a reference to childhood (by virtue of *nutrix* and *paedagogus*, and the log wielded by Althaea) but letting Atalanta take the place that on the child sarcophagi is allocated to the parents. Thus, *matrimonium* and *concordia* find themselves replaced by a different type of bond between man and woman, a bond that is at least equally strong, because it merges *concordia* with *virtus*, but that highlights that the chance of marriage has been forfeited.

An iconological synthesis.

Meleager's life, his military *virtus*, and his connection to Atalanta along with his role within the family are at the core of the depiction on the Louvre sarcophagus. The scenes stand out from other visual versions of the myth in charging Meleager's character with attributes of military conflict and aligning the episodes from his life with two types of biographical depiction on

Vita Romana sarcophagi, thereby highlighting two areas: war and the cycle of human life, as constituted by achievements and abandoned opportunities.

At the heart of the design is an investment in mashing up different, at times even contradictory, iconographic strands.[169] But the choices made with regard to the intermingling of traditions all serve to voice content – specifically the emotional bonds between the characters – *ex negativo*, at the point where they have been either compromised, as in the case of Meleager, his uncles, and his mother, or entirely cut off by external forces, such as death in the case of Atalanta. Fate and destiny are thus carved out as factors dominating human existence.

With its focus on war, loss, grief, and the power of fate, the Louvre sarcophagus conjures up themes that seem to be at the core of Roman life in the second half of the second century CE. This period was challenging for Rome: from 166 CE the empire suffered epidemics and enemy assault, and faced multiple military commitments and general insecurity, with detrimental economic and social effects that lasted for decades. The quick succession of rulers after Commodus is testimony to these problems. The situation only stabilised when Septimius Severus was confirmed as emperor, in 193 CE.[170]

The period also saw significant changes in artistic style and content, noticeable from around 170 CE, which Gerhard Rodenwaldt categorised as the 'late Antonine stylistic change'. These aesthetic transformations occurred on two levels: in the rendering of figures, and in the overall composition.[171] These stylistic innovations led to elongated figures, slimmed down and sculpted with an emphasis on the effects of light and shadow,[172] and to key characters being placed in the middle of groups. In addition, scale was employed to bring out hierarchy, with important figures appearing larger than secondary characters.

[169] For other examples of mashing up contradicting storylines on Roman sarcophagi, see Zanker 1999; also Bielfeldt 2005: 25–7, 278.

[170] For an overview of the late Antonine and early Severan periods, see Hannestad 1988: 239; Strobel 1993: 39–48. Cf. Zanker & Ewald 2012: 250–1.

[171] Rodenwaldt 1935; Rodenwaldt 1940; Jung 1984; Reinsberg 2006: 24–6. For a lucid assessment of the shaky methodological grounds on which the arguments of Rodenwaldt and others have been built, see Elsner 2000: esp. 261–2. Elsner's argument follows on from Brendel (1936, 1953). Elsner argues that either the argument that Roman art is characterised by a dualism of Greek and Roman elements is correct, or the argument that Roman art is characterised by a move from classical to medieval style – it cannot be defined by both models at the same time, as a dualism and on a scale, as style art history has it.

[172] Elsner 2000: 261–2 argues convincingly against the alleged compositional emphasis on frontality and centrality during this period.

The Louvre sarcophagus shares some of these stylistic features – centrality and hierarchisation by means of size, and light-and-shadow effects – with the *Vita Romana* marriage sarcophagi, on which Rodenwaldt's argument is based, and with the Column of Marcus Aurelius,[173] to which Rodenwaldt applied his observations in order to show their applicability to state art, usually regarded as the driver of stylistic development.

The Louvre sarcophagus also shares some of the adjustments to content that can be observed in state art with regard to military roles and the inclusion of allegorical and magical elements. The few, but highly significant, state monuments of the period – the base of the Column of Antoninus Pius (after 161 CE),[174] the reliefs from a monument for Marcus Aurelius (after 176 CE),[175] and the Column of Marcus Aurelius (around 190 CE, but already commissioned at the end of the Marcomannian Wars in 180 CE)[176] – are concerned with the life and roles of the emperor, specifically his military activities: the base shows the imperial apotheosis and cavalry manoeuvres; the panel reliefs display various imperial acts around warfare; and the column documents the military endeavours of the Marcomannian Wars.

In state relief, the amalgamation of the real and the allegorical gained momentum from the Flavian period onwards, mainly by means of the inclusion of personifications as characters – and actors – within the narration. In the apotheosis scene of Antoninus Pius this amalgamation is manifest in the Genius carrying the imperial couple into heaven; on the Aurelian panel reliefs it is particularly prominent in the *adventus* scene, where the emperor is accompanied by Mars and Roma; on the Aurelian column, the rain miracle especially characterises the situation in a way that goes beyond summarising the activities taking place.

The Louvre sarcophagus also has a stake in this new dramatic insistence, in the heightened emotional atmosphere shaping state relief that was underpinned by stylistic development.[177] On the base of the Column of Antoninus Pius, this emotionality is tangible in the contained forcefulness that drives the *decursio* scenes; on the panel reliefs and the Column of Marcus Aurelius, it is displayed in the way in which the defeated are openly

[173] For a stylistic comparison of the Column of Marcus Aurelius and the reliefs of the deathbed group, see Traversari 1968.

[174] Vogel 1973.

[175] Angelicoussis 1984.

[176] Wegner 1931; Pirson 1996; Elsner 2000; Hölscher 2000c; Beckmann 2011; Faust 2012: 92–121; Griebel 2013.

[177] Cf. Bianchi-Bandinelli 1970: 320–1; Pirson 1996: 169.

showing their grief and desperation,[178] not to elicit empathy and compassion but to highlight the power of the opposing forces.[179]

And yet, whilst the Louvre sarcophagus might share certain features with contemporary state art, imperial templates have not simply been adopted for private self-representation here to fuel internalisation and enhanced emotionalism – two aspects of central interest in Roman funerary art of the later second century CE.[180] True, the casket makes reference to individual virtues also presented in state art, but, again, it does so only by inverting those virtues into a tableau of systemic breakdowns. In its result, we may find parallels with the ideological rhetoric of punishment that shapes the Column of Marcus Aurelius,[181] but these similarities were not achieved by the adoption of imperial templates.

Just as the senatorial biographical sarcophagi adopt imperial virtues in order to showcase social prestige in various spheres of life,[182] so too the Louvre sarcophagus appropriates this senatorial self-representation, along with the template of child death, to shape a particularly drastic image of personal effort and loss. This combination, of senatorial virtues and the pains of losing a child, throws into relief that towards the end of the second century appropriate funerary commemoration was found not in depictions of people performing the traditional Roman rites of mourning at the tomb or in a straightforward adoption of imperial templates for virtues and values, but in carving out a middle ground between these strands.

The result is a particularly sophisticated tableau of the interdependencies of private and public life and their numerous psychological and social pressures. But that outcome was not necessarily a product of a time of crisis. Just as the drastic depictions of the Column of Marcus Aurelius provide a visual of Roman confidence,[183] so too here the engagement with death tells of a culture confident in facing up to the twists and turns of life,[184] a life in which even those more usually engaged in virtuous, if leisure-based, pursuits such as the hunt were required to take up the arms of a warrior but still might end up dying in their own bed from some ominous illness.

[178] Hamberg 1945: 149–61; Pirson 1996.

[179] This is analogous to the interpretation of brutality on the Pergamon altar, see below, p. 200.

[180] Zanker & Ewald 2012: 185–90, 222–9; cf. also Russenberger 2011: 153–5.

[181] Hölscher 2000c: 97.

[182] Muth 2004: 271.

[183] Griebel 2013: 203.

[184] Zanker & Ewald 2012: 109 on the relative security of the last decades of the second century, providing the necessary leisure to engage with questions around death.

The Louvre sarcophagus manages to provide a combined message of consolation and commemoration. It follows the traditional templates of *consolatio*, most prominently preserved in Cicero's *Tusculan Disputations*, in which death is displayed as a release from the toils of life.[185] At the same time, it also conveys the concept of *mors permatura*, a virtuous life brought to a halt by an untimely end, thereby commemorating past achievements. With that multifold message, which has resonances with depictions of Alcestis on the sarcophagi,[186] different types of mourning rhetoric detailed by Menander Rhetor in his writings on epideictic rhetoric of the later third century CE find themselves emulated in the sarcophagus frieze:[187] the mourning (*monodia*) of a life cut short, zeroing in on the deeds of the deceased and the deceased's role in the community and bodily features; consolation (*paramythetikos logos*), which drives up the pathos by emphasising the deceased's lucky escape from mortal struggles; and the funeral oration (*epitaphios*), which highlights both the role of demonic forces in plucking a worthy life from amidst a caring family and the efforts of the family in raising the virtuous deceased, now taken away.

[185] Cic. *Tus.* 3.76–82. Gessert 2004: 236; cf. Zanker & Ewald 2012: 37, 103–4.

[186] For Alcestis on Roman sarcophagi, see Blome 1978; Wood 1993; Grassinger 1999: 110–28; Zanker & Ewald 2012: 306–10. The myth was similarly popular on the deathbed sarcophagi of the second half of the second century, see Zanker 2005: 245 fig. 1.

[187] Soffel 1974: esp. 155–269. For Menander Rhetor beyond epideictic rhetoric, see Heath 2004. For ancient consolatory poetry, see Gessert 2004: 236–42; Zanker & Ewald 2012: 103–4, with reference to Sullivan 1936; Lattimore 1942: esp. 172–214; Esteve-Forriol 1962.

3 | Narratives of object and meaning

1) Iconology as experiment: the results

Iconology is concerned with the picture as a thing. The method as applied here, based on the Panofskyan model, focuses the interpreter on the depiction and its artistic background. The objective is to synthesise as historical evidence the individual elements that shape the picture. In praxi, as the case studies demonstrate, the interpretive framework of iconology allows for a range of questions, their substance dependent on the character of the picture under scrutiny.

At the pre-iconographic stage iconology is concerned with translating the elements constituting the visual into the verbal. This process results in a detailed report on the characters, their attire, and their relation to each other and to other pictorial elements that otherwise might easily be overlooked – but without qualitative judgement. Such an exercise in structured viewing is devised in order to avoid the pitfalls of the *associative-philological* and the *generalising* approaches frequently found in the study of Greek and Roman representations of myth.[1] It ensures a focus on the depiction alone, setting to one side what one would expect the picture to represent on the basis of textual versions of the myth.[2]

A significant problem arises here, for structured viewing does not translate well into written argument. If an exercise in structured viewing is presented prior to iconographic assessment, redundant data, perhaps in significant quantity, might be put in front of the reader.[3] The present study therefore amalgamates the pre-iconographic and iconographic stage. But does then the *associative-philological* approach appear to prevail, with the decision to focus on Paris, Zeus and Athena, and Meleager in the three case studies apparently driven by knowledge of the myth and pre-existing assumptions about how the picture might emulate that myth?[4]

[1] See above, pp. 8–9.
[2] See above, p. 33.
[3] I owe this observation to an anonymous reader for the Press, who commented unfavourably on an earlier draft of the present study that kept these stages separate.
[4] A criticism also validated by the fact that the subsequent treatment of the same objects through the lenses of the other two methods throws into relief significantly different aspects of the

The case studies are revealing at the iconographic stage the potential existence of correctives that will enable us to avoid slipping back into the vicious circle of the *associative-philological* approach, which comes with the threat of tautology. These correctives are provided by other materials that are to be compared with the picture under scrutiny, making up for the fact that when faced with a narrative picture, iconology presupposes a narrative, but without investigating either its actual formation within the picture – as happens in semiotics – or how that narrative might be shaped by the picture's materiality, its shape, location, and function – as happens in image studies. Iconology is concerned with content, not with the processes of production. This narrow focus is accompanied by an indifference towards the viewer and other phenomenological aspects.

The method specifies the roles of individual characters and the characters' relations to each other, but it undertakes no analysis of the narrative structures. Or, more precisely: the method is concerned with elements in a picture that deviate from how a given storyline is rendered in other sources, taking these elements to constitute the storyline of the picture.[5] In order to facilitate a *differentiating* approach within such a framework, the comparative approach needs to maintain an unbiased criticality and must not presuppose a hierarchy of evidence, most commonly by placing the textual before the visual.

Previous treatments of the Pergamon altar and the Louvre sarcophagus in particular have demonstrated the potential pitfalls at this stage. Rather than discuss two types of source comparatively, these studies use external evidence as a blueprint for the image under scrutiny: for the Great Frieze, exegesis of Hesiod and Stoic philosophy subjugates the depictions to a cosmological interpretation;[6] in the case of the sarcophagus, Ovid's rendering of the myth serves as a foil for interpretation.[7]

Meanwhile, the rich history of research on the Great Frieze provides an example in which the picture itself strikes back against the subjugation of

respective images, highlighting, for example, the importance of Eris and Triton (semiotics), or Atalanta and Bronteas (image studies).
[5] Cf. Panofsky's analysis of Judith: Panofsky 1939: 12–14.
[6] See above, pp. 67–8. Some of the earlier treatments of the Great Frieze retained a critical focus with regard to comparison with other evidence: Hermann Winnefeld refuted Otto Puchstein's claim that the presentation must be based on Apollodorus' account of the myth (Winnefeld 1910: 137–8; contra Puchstein 1889: 323–5. Cf. von Salis 1912: 40–1). However, these approaches were quickly replaced by interventions that assumed a written source of some kind behind the design: either a literary source (Carl Robert is the first to place the depiction in connection with Hesiod: Robert 1911: 217–49); or a compendium of ideas formulated in writing to guide the artistic execution (von Salis 1912: 43).
[7] See above, pp. 72–5, 77–9, and 80–2.

image to text. Based on Apollodorus' account of the gigantomachy, Erika Simon argued that the older giant fighting Zeus could not be Porphyrion because the text describes Porphyrion as killed by both Heracles and Zeus,[8] whilst the figure on the Great Frieze is shown fighting only the latter;[9] Simon therefore identified this giant as Typhon.[10] However, the recent discovery of the organisational system for the giants' name labels and the allocation of label fragments to individual figures have confirmed the figure as Porphyrion.[11]

The case studies demonstrate that a critical comparison of visual and textual parallels ensures a *differentiating* approach. In the case of the Karlsruhe hydria, this approach reconsiders Paris' seemingly unambiguous Oriental clothing, previously read pejoratively, and reels off a complex set of positive meanings.[12] Similarly, with the Louvre sarcophagus such counter-comparison brings out the significance of the appearance of Meleager's sword and Althaea's altar.[13]

At the iconological stage, the picture is contextualised within the historical, that is, the cultural, political, and intellectual. Rather than merely confirm externally established historical information in a tautological manner,[14] the cases studies exemplify how here additional historical value can be gained. Once more, with this critical alignment we see the interpretation emanating from the contextualised object, which is allowed to speak for itself rather than being forced into a part in a script dictated by external sources. The picture directs what is to be employed as its explanatory tool.

In the case of the Karlsruhe hydria, such an approach liberates the depiction from its conventional assessment as symptomatic of the period's seemingly escapist character and installs it instead as a visual of agitation and consolation, sporting content geared towards exploring ambiguities. In turn, such an assessment then has repercussions for our understanding of Athens in the later fifth century at large – which appears not simply as a society shaken to the core by the Peloponnesian War, but as a stable and reflective community.

[8] Apollodorus 1.36.

[9] Simon 1975: 18–19. He had been interpreted previously as Porphyrion: Puchstein 1902: 27; Kähler 1948: 115; Bieber 1961: 115; Rohde 1961: 72; Schefold 1981: 107 n. 221.

[10] Simon 1975: 19, 43–5.

[11] Kästner 1994: esp. 126–9.

[12] See above, pp. 46–8.

[13] See above, pp. 74–6, 81–2.

[14] For these two positions – surplus value vs tautology – see Argan 1975: 300 and Wood 1997: 24.

The iconological synthesis of the Great Frieze and the Louvre sarcophagus produces similarly transformative results: for the former, insights into the competitive relationship of Pergamon with Athens; for the latter, instead of a narrative of crisis, a self-reflective celebration of the course of life. Pursued as critical alignment, then, the iconological synthesis produces results that can provide a basis for assessment of other types of historical evidence.

2) Iconology and ancient art scholarship

The results of the iconological analysis of the three case studies require contextualisation within the wider field of classical archaeology. The following will concentrate on the core trends in the use of the iconological model in classical art-historical study. A significant challenge in surveying iconological practice across classical art history arises from individual studies' implicit employment of iconological method without explicit reference to their drawing from this analytical toolbox. Conversely, some studies claim an iconological framework but lack the execution that justifies that label.[15] Scholarship of ancient art is full of studies that dilute Panofsky's iconology, that adopt iconology in name but not practice. Notwithstanding these limitations, exemplary probing of existing scholarship from two perspectives – from the vantage point of the current status quo in the study of ancient mythological imagery and in light of the historiography of ancient art more generally during the post-Panofskyan twentieth century – brings out prominent trends in the application of iconological methodology, past and present.

Discussions of the method.

Among the sizeable range of recent studies on ancient imagery, two works stand out for engaging deeper methodological discussion. Mark Stansbury-O'Donnell provides the most vivid account of the method's use,[16] putting it to the test by discussing narrative pictures specifically according to Panofsky's three-step model, with the pediment decoration of

[15] Take, for example, Paul-Zinserling 1994, titled: *Der Jena-Maler und sein Kreis: Zur Ikonologie einer attischen Schalenwerkstatt um 400 v. Chr.* (The Jena Painter and His Circle: On the Iconology of an Attic Vase-Painter's Workshop around 400 BCE), a connoisseurship study of the oeuvre of the Jena Painter.

[16] Stansbury-O'Donnell 2011: 58–60; another description of the individual stages of the model: Squire 2009: 77–9; for an exclusive focus on iconology's alleged logocentrism and its approach towards the image-as-if-a-text see Junker 2012: 124–5.

the Siphnian Treasury at Delphi as his subject.[17] He also points to the two most common characteristics of the application of iconology in classical art-historical studies: first, the conflation of pre-iconographic description and iconographic analysis;[18] second, the creation of a 'programme' on the level of iconological interpretation, in which the iconographic elements and their meaning are drawn together.[19]

In his recent discussion of the interpretation of Greek mythological images, Klaus Junker has opted for a different approach to iconology, which he examines not in action, but instead conceptually. Junker works from a literal translation of the method's name, 'picture text', to conclude that this approach is well suited to Christian art, the pictures of which are derived from a master *logos*/text, the Bible,[20] but not to ancient imagery, where the relationship between text and picture is much looser.

The state of ancient art scholarship reinforces Junker's assessment because Panofskyan iconology is more frequently (and more explicitly) employed in the study of early Christian imagery than in other fields of ancient art study.[21] Nevertheless, while Junker's leaning towards the visual over the textual is laudable, his assessment reflects a selective understanding of Panofsky's approach[22] and, more generally, a narrow view of Christian art.[23] More importantly, by presenting iconology in this way, Junker essentially redresses it as a form of textual semiotics clothed in Kantian metaphysics, with its quest for *a priori* truth.[24] In iconology's stead, Junker proposes a type of contextual hermeneutics as the most appropriate analytical tool, a 'hermeneutical spiral',[25] a type of iterative, contextual analysis inspired by Hans-Georg Gadamer's philosophical, anti-Kantian concept and built on semiotic theorems.[26]

[17] Stansbury-O'Donnell 2011: 63–5.

[18] Stansbury-O'Donnell 2011: 62.

[19] Stansbury-O'Donnell 2011: 59–60. For a distinctly different take – a search for ruptures, not harmonisation – see Giuliani 2013: xvii.

[20] Junker's assessment is here probably based on Panofsky's involvement in Princeton's Index of Christian Art, initiated in 1917 by Panofsky's mentor, Charles Rufus Morley.

[21] Engemann 1997: esp. 35–43; Engemann 2007.

[22] Notably, Junker refers only to Panofsky 1955 and not the earlier elaborations of his approach.

[23] Christian imagery might be primarily concerned with the exegesis of the Bible, but – as the numerous waves of iconoclasm document – many other factors worthy of study impact the relationship of Christian imagery and text. See e.g. Bredekamp 1998; cf. also Belting 1997 on the impact of artistic appreciation on Christian art.

[24] Junker 2012: 126: 'iconology which inevitably brings up the association with a "theory of images", as if it were possible to "read" every visual representation like a text, as long as certain rules are sensibly obeyed'.

[25] Junker 2012: 120–31, esp. 126–31.

[26] See below, pp. 98–9, 178. See also Stansbury-O'Donnell 2011: 93–4 for hermeneutics in ancient art scholarship.

Junker's assessment of iconology is a direct result of the patterns that have been observed by Stansbury-O'Donnell which form as iconology is applied in classical art-historical scholarship. The conflation of pre-iconographic description and iconographical analysis, also employed in the present study, can lead to the application of a pre-existing understanding of the subject matter at the first stage of analysis, when the diagnostic assessment of the visual evidence should be at the centre. This false step then leads precisely to the logocentric approach for which Junker reproaches iconology, even though that approach is not inherent in the Panofskyan model, as its application in the interpretation of the case studies in the present study demonstrates.

Rather than being informed by iconology, the logocentric approach tackled by Junker follows traditional positivist modes of enquiry, as are most prominent in the work of Carl Robert.[27] These approaches are driven by an investment in the search for an *a priori* truth that is similar to iconology's remit, but work from a diametrically opposed understanding of the role of the picture in establishing this truth. Generally, these approaches assume that an external text holds the key to what is regarded as its illustration, the picture text.[28] This understanding assumes a hierarchy of text and image of the type described by Lessing,[29] and comes with all the detrimental

[27] Most prominently Robert 1881. Robert presented a practical, purely empirical guide to the interpretation of ancient mythological pictures, in which he advised his readers of the great importance of meticulous viewing, facilitated by drawing and describing (Robert 1919a: 14). He also argued for antiquarian knowledge as a corrective for the act of interpretation, in his case primarily derived from ancient literature (Robert 1919a: 15; trans.: author): 'A good description should itself already produce the interpretation … And yet, one has to acknowledge certain restrictions. If I want to understand or interpret a picture, I need to have a certain conception of the characters depicted and the action presented, a conception that frequently I will not be able to extract from the depiction alone. That means, when dealing with an ancient picture, in most cases a larger or lesser degree of antiquarian knowledge is required, except for those cases where the characters are not individuals but types, and the actions are of such a nature that they could still occur today in the same or a similar manner; a situation which, as is easily understandable, only ever applies to genre scenes.' German original: 'Aus einer guten Beschreibung muß sich die Deutung von selbst ergeben … Und doch bedarf es gewisser Einschränkungen. Wenn ich ein Bildwerk verstehen oder deuten soll, muß ich von den dargestellten Personen und dem vorgestellten Vorgang eine gewisse Vorstellung haben, die ich in den meisten Fällen aus der Darstellung allein nicht gewinnen kann, d.h. wenn es sich um ein antikes Bildwerk handelt, wird in den meisten Fällen ein größeres oder geringeres Maß antiquarischen Wissens erforderlich sein, es sei denn, dass diese Personen keine Individuen, sondern Typen, und dass die Vorgänge solche sind, wie sie auch heute noch in derselben oder ähnlicher Weise vorkommen, was, wie man leicht einsieht, eigentlich nur auf Genreszenen zutrifft.'
[28] Junker 2012: 125.
[29] See above, p. 19 n. 4, and below, pp. 164–5.

results that can be observed in the case of the Great Frieze and the Louvre sarcophagus.[30]

The second characteristic of iconological scholarship described by Stansbury-O'Donnell, the iconological synthesis turned into a quest for a programme, can lead the iconographic analysis at stages 1 and 2 to disappear into the background, thus subordinating the visual evidence to a pre-existing understanding of the historical context within which the picture was created. The picture does not generate the analysis; instead external information is imposed on the picture. Junker points to this inflexibility as a trademark of iconology. Again, however, as the iconological interpretation of the case studies in this work demonstrates, this practice is not inherent in the Panofskyan model; on the contrary, the critical alignment of picture and historical context serves to avoid such pitfalls.

A historiography of iconology in ancient art scholarship.

The engagement with Stansbury-O'Donnell's and Junker's discussions provides a sound sense of the main patterns of use of iconology in ancient art scholarship. And by zeroing in on two moments in the history of iconological interpretation, in the 1930s and the late 1970s, we see in even sharper relief the issues at stake when iconology is applied in the field of ancient art.

Where the protagonists of art-historical iconology had ties to ancient art scholarship –Panofsky engaged critically with Rodenwaldt,[31] and Warburg had trained in classical archaeology[32] – scholars of ancient art engage with iconology through an indirect route. In the 1930s, Panofsky's methodological considerations entered the field of ancient art, but with important modifications: the emulation takes place not via Panofsky's theoretical discussion of the model of iconology but via its application in allegory study, narrowing iconology's remit but at the same time widening it to include the work of Warburg scholars in the field of cultural history.

Based on a lecture series presented to the Warburg Institute in 1935, Roger Hinks' book entitled *Myth and Allegory in Ancient Art* starts from Cassirer's and Wind's writing about symbols. It also operates close to Panofsky and

[30] See above, pp. 90–1.
[31] For example Panofsky on Rodenwaldt's model of the classical element in ancient art (Rodenwaldt 1916), in Panofsky 2008: 143.
[32] See Gombrich 1970: 37–8. Warburg studied at Bonn with Kekulé von Stradonitz. Among other things, he prepared papers on the stylistic development of the Centaur–Lapith battle, from the Olympia pediment to the Parthenon. Gombrich noted how the detailed scrutiny of the classical archaeological approach later helped Warburg in his work on the Renaissance.

Saxl's *Melancholia* I,[33] which it employs for the study of the visual representation of the three Greek concepts of Dike, Themis, and Mnemosyne, in an attempt to differentiate between mythological storytelling and allegorical meaning production.[34] In line with Panofsky and Saxl, Hinks relied primarily on textual documentation to explain the development of the pictures, but he faced the added difficulty that in his case the textual sources were not dated at all close to the period of the pictures that he sought to understand. Thus, whilst Panofsky and Saxl employed the textual in order to open up pictures in a new way, Hinks merely subdued his pictures under the textual yoke, thereby fuelling accusations of logocentrism.[35]

Much more successful in establishing a communication between the visual and the textual along the lines of Panofsky's iconological model was Otto Brendel, in his 1936 study of the symbolism of the sphere.[36] Brendel combined a meticulous formalist approach with a wider interest in issues of religion and philosophy and thus strove to unearth deeper meanings in art, much as had Panofsky, even if Brendel showed no inclination to dig as far towards the epistemological conditions of knowledge as the latter.[37]

Also, Brendel appears to have been uneasy about subjecting works of art to a methodological system, even though he was invested in *a priori* truth, or so his words in a letter to Edgar Wind of 1936 suggest:[38] 'I sometimes think about the possibility of a (phenomenological) philosophy of art, but more as a last resort because of the fact that my circumstances deprive me of actual visual engagement. In the end, I find consolation in the fact that every true work of art constantly rebuts everything one could possibly say about it; multiplex opinio, veritas una.'

[33] For Cassirer and Wind: see above, pp. 27–30, 5–6; for *Melancholia* I, see above, p. 30.
[34] Hinks 1939: 1–21, esp. 1, 3–5.
[35] Hinks' work goes some way towards providing a stepping stone for an understanding of the different approaches towards ancient art at play in British scholarship during this period: that is, text-dominated classics, material-oriented dirt archaeology, and connoisseurship studies, from the 1970s to be gradually replaced by the anthropocentric, sociology-infused 'New Art History' and notions of the 'period eye', especially in the work of Michael Baxandall (see Baxandall 1972). For an account of the history of British ancient art scholarship, see Elsner 2007b.
[36] Brendel 1977. Brendel's review of Panofsky's *Pandora's Box* provides insight into Brendel's self-perception of the relationship between his own work and that of Panofsky, along with a critical review of the iconological method: Brendel 1958.
[37] For Brendel's work, see Lorenz 2012.
[38] Letter, Otto Brendel (Newcastle) to Edgar Wind (London); 24 November 1936. London, Warburg Archive – Brendel (trans.: author): 'Ich denke manchmal nach über die Möglichkeit einer (phänomenologischen) Philosophie der Kunst, aber mehr als Notbehelf aus Mangel an Anschauung, die mir meine Umgebung vorenthält. Am Ende tröste ich mich damit, dass doch jedes wirkliche Kunstwerk unaufhörlich alles widerlegt, was man darüber aussagen kann; multiplex opinio, veritas una.'

Brendel's stance is characteristic of the field of ancient art scholarship, which at that time was torn between a positivist reconstruction of the past, interwoven with notions of Riegl's *Kunstwollen*, and engagement with artworks that would unlock their historical value on a level beyond mere reconstruction. Such torment was not confined to allegory study and the representation of myth, for it permeated the discipline as a whole, including formal and stylistic analysis. The contested ground with regard to the latter is well documented in Panofsky's unfavourable comments on Gerhardt Rodenwaldt's 1916 paper on classical Greek art, which Panofsky repeatedly referred to in the context of his refutation of *Kunstwollen*.[39]

Brendel eventually shed some of his scepticism and engaged in a more cultural history of ancient art with borrowings from iconology, an approach that would inform the work of a string of scholars such as Jerome Pollitt, Richard Brilliant, and Natalie Kampen.[40] In contrast to this American school of thought, German scholarship on ancient art retained its investment in seemingly ideology-free formalist study, especially in the aftermath of World War II, when the earlier adherence to Riegl's *Kunstwollen* was replaced with Sedlmayer's work-immanent approach, in which the artwork was stripped of its historical context.[41]

In Germany, changes were again afoot from the late 1970s onwards, marking the second milestone in the application of iconology under scrutiny here. The research group Römische Ikonologie (Roman iconology) emerged, with amongst its members scholars such as Bernard Andreae, Klaus Fittschen, Tonio Hölscher, and Paul Zanker.[42] The common denominator for the diverse research output of this group, including Paul Zanker's *The Power of Images in the Age of Augustus* (German original: 1987), Tonio Hölscher's *The Language of Images in Roman Art* (German original: 1987) and Richard Neudecker's or Christa Landwehr's discussion of Roman ideal sculpture,[43] is that they all broke away from post-war formalist study, directing attention instead to issues of social history as expressed through artworks.

[39] Rodenwaldt 1916; see Panofsky 1981: 22–3, 26 n. 10; Panofsky 2008: 56.
[40] See in particular Kampen 2003: esp. 371–2. For a history of ancient art scholarship in the United States, see Dyson 1998.
[41] For Sedlmayer, see above, p. 26 n. 26. Cf. Altekamp 2008: 189–90, which does not mention Sedlmayer, but does mention the prevalence of this type of approach in classical art-historical scholarship.
[42] Maischberger 2001: 19–22; Altekamp 2008: 207. One core objective of the group was to publish previously understudied groups of material in order to facilitate new, society-focused questions, e.g. Cain 1985; Grassinger 1991.
[43] Neudecker 1988; Zanker 1988; Landwehr 1998; Hölscher 2004.

The methodological toolboxes they employed, however, ranged from traditional formalism to Panofskyan iconology, but that iconology was incorporated in a semioticised socio-political perspective, with pictures universally defined as signs and analysis of form and meaning functionalised as a prerequisite for an interpretation of these signs.[44] These tools were introduced during the 1970s and 1980s. This infusion of iconology with semiotic and sociological approaches made for the most significant innovation within the subject area. It facilitated an exploration of the power and processes of ideologisation as expressed by visual media. In so doing, in some ways, this approach instated precisely the type of grand structuralist enquiry for which Panofsky was hailed by Claude Lévi-Strauss.[45]

Tonio Hölscher explains this appropriation: on the semiotic level of semantics, he explicitly equals Panofsky's second and third steps, iconography and iconology, with denotation and connotation.[46] Here, then, is an exercise not unlike Roland Barthes' attempt to synchronise Panofsky's iconology with his own semiological systems, in which iconology's iconographic level was set on a par with the primary semiological system, and the iconological level with the secondary semiological system.[47] Overall, however, this semioticised version of iconology was derived from the writings of Umberto Eco,[48] who was himself influenced by French structuralism as well as by the move against Kantian epistemology found most prominently in the work of Richard Rorty.[49]

The work of the philosopher Hans-Georg Gadamer also provided inspiration for this revised form of iconology that finds its application in the field of classical archaeology.[50] Influenced by Heidegger, and in turn subsequently decisively influencing Rorty, Gadamer argued against a single unmoveable truth and in favour of a hermeneutics that concentrates on discourses and their relationship to each other in order to extract arguments and meaning.

This semioticised, hermeneutics-infused form of questioning has also benefited from the sociological approaches of Pierre Bourdieu (1930–2002) and Niklas Luhmann (1927–98).[51] Interestingly, this association has not gone as far as adopting Bourdieu's appraisal of Panofsky, despite the

[44] Hölscher 2000b: 160.
[45] Bredekamp 1995: 363–4.
[46] Hölscher 2000b: 161. Cf. also Settis 1992 for another take on a semioticised iconology. Cf. also Hasenmueller's differing parallelisation: Hasenmueller 1978: 290–4.
[47] Barthes 1972: 110–26.
[48] Eco 1968. For Eco, see below, p. 113.
[49] Rorty 1979.
[50] Gadamer 2004. For Gadamer, see below, p. 178.
[51] Bourdieu 1984; Luhmann 1995; Luhmann 2000.

potential links between the iconological and semiotic models, for it was Bourdieu who hailed Panofsky for refuting the myth of the pure eye.[52] Bourdieu emulated Panofsky's approach in order to develop a model for extracting social rituals and habitus out of aesthetic discourse.

The resulting methodological hybrid is constituted by elements – the anti-Kantian line of Gadamer, and Panofsky's Kant-infused iconology, which strives for the one *a priori* truth inherent in all cultural activity – which could be mutually exclusive. To resolve that dilemma, art-historical approaches such as those found in the field of classical archaeology include a hefty dose of Charles Sanders Peirce's pragmatism. This approach provides the necessary catalyst to let the two different methodological strands interact with each other simply because it runs through both iconology and semiotics,[53] although its share in both these models is not usually acknowledged.

Still, one crucial difference between this hybrid model and Panofskyan iconology remains: the emphasis on the human factor. In the semioticised, ultimately Heidegger-infused approach that human factor is far greater, for it is not just confined to the corrective interpreter, as defined by Panofsky, but is part of the process of meaning production itself. Considerable attention is therefore given to artists and recipients, categories Panofsky deliberately left out in order to maintain what he regarded as a scientific approach.

3) Conclusions

Iconology is concerned with placing the picture within the external world as a means of exploring its share in what can perhaps best be described as the 'cultural atmosphere'. Where semiotics deal with the internal operational structures of the picture, and image studies with the internal and external implications of the picture's physical presence, iconology focuses on the external relevance of the internal elements constituting the picture.

This function draws attention to the picture itself – with the obvious advantages of such an approach over those of an *associative-philological* and a *generalising* nature, where the picture is only secondary to textual evidence. When this approach is adopted for the analysis of mythological

[52] Bourdieu 1970: esp. 243–5. See Schmitz 2000: 87–8.

[53] Bal & Bryson 1991: 188–91; Hatt & Klonk 2006: 208–12; see also below, pp. 108–10.
Pragmatism affects the formulation of semiotics, particularly in its dynamic form as embedded in Gadamer's approach, and it leads to Wind's formulation of experimental reasoning, steered by an anthropocentric corrective, the repercussions of which can be felt in Panofsky's model.

images, it leads to an assessment of the visual rendering of a particular myth, to consideration of the cast, the characterisation of the individual cast members, and their relationships with each other. It also sets the stage for a critical comparison of the picture and other representations, textual or visual, of the same story. As the present study demonstrates, this stage of iconographic analysis is crucial to all three methods under scrutiny here – without it, the historical assessment of pictures, and specifically mythological pictures, would be impossible.

Iconology's focus on the picture and its constituting elements renders the method equally applicable to pictures from different genres and contexts and with heterogeneous intent. Its application across the different branches of ancient art scholarship, across Greek and Roman as well as public and private art, documents this broad relevance.

Iconology is almost exclusively applied to figural art – despite its potential for accounting for abstract elements. And it is primarily applied to figural scenes that depict what is also recorded in other media, such as mythological narrative or historical events, and therefore not to depictions of everyday activity.

This narrowing of the focus is a symptom of the central problem for the application of iconology, in that external evidence – and primarily, textual evidence – is imposed in order to explain individual pictures without critical comparison of the different types of evidence. In light of this problem, pictures for which no external textual evidence exists are not popular with this line of (pseudo-)iconology.

But even where pictures are studied on their own account, a problem arises. In contrast to semiotics and image studies, iconology has no investment in the operational processes by means of which pictures convey their stories and produce content. Iconology cannot trace the mixing of mythological and everyday discourse in a representation because it concentrates only on what characters are presented and not on how they are displayed.

This limitation is a crucial obstacle for analysis of ancient mythological images, which, as the three case studies demonstrate, always have a stake in two discourses, as a narration of mythological stories and a commentary on contemporary life outside the picture. But as the three case studies also demonstrate, iconology provides some ways around this issue at the stage of iconographic analysis, for through a comparison of one picture with other similar representations, some progress towards the 'how' of the presentation can be made.

Semiotics

4 | Introducing semiotics

The contemporaries and rivals of Zeuxis were Timanthes, Androcydes, Eupompus, Parrhasius. This last, it is recorded, entered into a competition with Zeuxis. Zeuxis produced a picture of grapes so dexterously represented that birds began to fly down to eat from the painted vine. Whereupon Parrhasius designed so lifelike a picture of a curtain that Zeuxis, proud of the verdict of the birds, requested that the curtain should now be drawn back and the picture displayed. When he realised his mistake, with a modesty that did him honour, he yielded up the palm, saying that whereas he had managed to deceive only birds, Parrhasius had deceived an artist.

<div align="right">Pliny, HN 35.64–6</div>

The enduring relevance of Pliny's anecdote is remarkable: indeed, unless art history finds the strength to modify itself as a discipline, the anecdote will continue to sum up the essence of working assumptions still largely unquestioned.

<div align="right">Bryson 1983: 1</div>

Norman Bryson's use of the anecdote about the contest between the Greek painters is indicative both of the relationship of the study of ancient art and the method of semiotics and of the functioning of semiotics more generally. Bryson's summoning of an ancient analogy for his argument is rather exceptional in semiotics studies: in contrast to iconology, the field of semiotics exists quite happily without reference to, or reverence for, antiquity. Semiotics does not require the legitimisation Panofsky had sought by enlisting antiquity as a passepartout,[1] for the simple reason that it lacks any investment in a single, irrefutable truth – the search for which is at the heart of iconology.

More crucially, the anecdote throws into relief the problems that arise from this disinvestment from truth for the study of ancient art and art more generally. On the surface, Bryson employs the anecdote to argue that no such thing as a natural attitude exists,[2] a claim that is central to the turning

[1] See above, pp. 19–20.
[2] Bryson 1983: 1.

away from the concept of a single truth. But dig deeper and Pliny's anecdote highlights how the methodological framework of semiotics raises the stakes for interpretation: we have only Pliny's word for both the contest and the pictures involved in it. Our relationship to a picture is therefore analogous to that which exists between what Zeuxis thinks he sees – a curtain – and what Parrhasius actually shows him – the representation of a curtain.

For a semiotic approach to succeed, the relationships between the individual sources of evidence need to be probed and evaluated with regard to their hierarchies and their perception, unmasking in that process any disguise of the type found in Pliny's anecdote as exploited by Parrhasius. In short, one needs to be familiar with conventions of communication and patterns of display in order to interpret artworks.

1) What is semiotics?

In the humanities, the success of structural semiotics, first developed by Saussure, who argued that the linguistic sign or word bears only an arbitrary relation to the thing to which it refers, has posed a decisive challenge to the notion that knowledge might somehow be guaranteed by direct appeal to experience. Deconstructive criticism, inspired by Derrida, has gone even further by analyzing and revealing the ways in which language itself affirms presence or being while relying on its absence for its capacity to function. Thus the very means by which knowledge is constructed, and on which truth claims depend, has been found intrinsically unable to afford assurances of finality or certainty. The result of these historical developments is that the type of epistemological idealism, the belief that mind and world are bonded by means of mental structures, on which Panofsky's enterprise depended, has been largely discarded.

<div align="right">Moxey 1993: 27–8</div>

Bryson's choice of anecdote pinpoints what shapes semiotics as an analytical framework: it is concerned with individual perceptions, in how meaning and understanding are scaffolded in a reciprocal process that takes place in the in-between of recipient and object. Whether the meaning derived from the object is factually correct is of little relevance – indeed, Zeuxis' mistaking of the painted curtain for an actual curtain says more about the conditions of viewing that bear upon him at this point than if he had not fallen for Parrhasius' illusionistic trick.

The central axiom of semiotics, no matter its many permutations, is that no naturally attributed, or *a priori*, meaning exists. Therefore, the method is

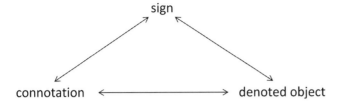

Fig. 4.1 The semiotic triangulation.

not interested in meaning as such, but in the processes of its creation, and in the possibility of meaning more generally.[3] The objective of semiotics is the study of conventionally communicated systems such as languages, pictures, or any other compilation of signs carrying content. In semiotics, these systems are studied with a view to the relationship of the object, thought, or concept that is denoted by the sign (including both its generic idea and the actual instance), the sign itself, and the connotations a recipient could derive from the sign in its relationship with what it denotes, the object. In the Pliny anecdote, the object would be a curtain covering a painting, the sign would be the curtain painted by Parrhasius, and the denotations here would be, on the part of Zeuxis, the expectation that his painting of the grapes was better than the painting by Parrhasius covered by the curtain, and, on the part of Parrhasius, his ability to deceive a fellow artist with his own art.

In semiotics, meaning is always derived from, and is relative to, this triangulation of denoted object, sign, and connotation (fig. 4.1). The primacy of this triangulation furnishes semiotics with two characteristics. First, cultural utterances – no matter whether oral, textual, or visual – are studied not in isolation, but as embedded in reciprocal relationships of meaning production. This focus on the production process replaces the focus on the historical and social context of the artwork that is so central to iconology. Second, and tied in with the focus on the processual, in semiotics it is assumed that cultural utterances can be understood only from the recipient's perspective, not from that of the originator. The intentions of the sender – the speaker, author, painter, or sculptor – are secondary; what counts from a semiotic perspective is how what is sent is turned into meaning by the listener, reader, or viewer.

In order to unpack this triangulation, semiotic analysis requires that codified, connoted meanings be captured and interpreted by unravelling the processes of denotation between object, sign, and recipients. In short,

[3] Bal & Bryson 1991: 175; Hatt & Klonk 2006: 200.

semiotic analysis functions as an assessment of the instant cultural associations that come with recognition. Again, Pliny's anecdote about two of the greatest Greek painters is exemplary: Zeuxis' reaction to Parrhasius' curtain provides an insight into artistic practice, in that the combination of curtain and wooden frame leads Zeuxis to believe he must be seeing only a protective cover, not the picture itself, whilst Parrhasius' choice of an illusionistic topic, which contrasts with the topic chosen by Zeuxis, indicates that visual artists of the period might expect a competition to involve fauna and flora but not the products of mundane human craftsmanship.

The example also demonstrates that the course of semiotic analysis consists of a chain of interpretations, or 'unlimited semiosis'.[4] Navigation of the evidence must take a variety of tacks in order to assess the scope and characteristics of meaning production related to the object under scrutiny. Potentially, the possible routes are infinite in number. In practice, therefore, the interpreter needs to strike a balance between, on one hand, exploring meaning in both traditional and unchartered territories of interpretation and, on the other hand, keeping the interpretation within clear boundaries to ensure the relevance of the potential findings.

With its interest in meaning production in the widest sense, semiotics is not limited to visual artefacts, in contrast to iconology. Within the concert of academic disciplines, its trademark is its trans-disciplinarity, or, as identified by Mieke Bal and Norman Bryson, its supra-disciplinarity.[5] Additionally, its interest in the possibilities of meaning renders semiotics ideal for mediating between different media, genres, and types of content. And yet the domain in which it is used most often, and most successfully, is that of linguistics and literary studies, the area for which it was conceived.

2) Semiotics: premises, positions, and problems

Lévi-Strauss' position finds its theoretical pendant in Martin Jay's raid on this century's French gaze and image theories. Jay's conclusion strengthens the impression that, to date, not even the most sophisticated semiological models have managed to refute the suspicion that their results could have been reached equally well by means of established art-historical methods. This is because they do not actually develop a new method, but merely apply new vocabulary.

Bredekamp 1998: 7 (trans.: author)

[4] Potts 2003: 24.
[5] Bal & Bryson 1991: 175.

Semiotic analysis is concerned with the production and circulation of signs and, in its post-structuralist revision, the multi-stability of signs and their involvement in processes of recirculation.[6] In the case of semiotics, in contrast to iconology, it is not so much its methodological depth, but its wide reach – across all types of communication processes – that poses problems. The methodological differences between individual approaches add to these problems but do not necessarily alter their quality. Focusing on three aspects will give us a grasp of the width of the semiotic enterprise without losing sight of the specific issues that emerge from semiotics' application in art-historical analysis: the linguistic and philosophical beginnings of semiotics; semiotics' structural and post-structural reworkings; and the study of the visual by means of semiotics.

Saussure and Peirce: the foundations of semiotics.

Semiotic analysis begins with the work of two scholars, the Swiss linguist Ferdinand de Saussure (1857–1913) and the American philosopher Charles Sanders Peirce (1839–1914), who operated within distinct epistemological frameworks and considered different applications. Saussure developed his theory of signs as a basis for modern linguistics, essentially as a structuralist theory of language.[7] His model rests on the differentiation of two types of language, *langue* and *parole*: the former the individual units of a language, its words; the latter, the changes that occur over time and in the expression and performance of these words.

Saussure targeted the *langue*, taking every language to represent a complete system of signs, and then explored these signs by focusing on the aspects that shape them: the *signifier*, the *signified*, and the *referent*. The *signifier* is the verbal utterance that denotes objectified meaning. The word F-R-A-M-E, for example, is the *signifier* for the pieces of wood that surround a painting, thus rendering the frame the *signified*. This *signified*, however, represents not any individual frame, but rather the concept of frame at large. Together, *signifier* and *signified* are the two internal components constituting a sign and its meaning. The *referent* presents the actual object that embodies the concept expressed in the *signified*. It is the external

[6] For post-structural semiotics, see below, pp. 110–4.

[7] For most of the twentieth century Saussure's thoughts were only available in the form of a volume published posthumously in 1916, compiled from lecture notes collected by his students (Bally & Sechehaye 1916). A manuscript of his lectures, handwritten by Saussure himself, was discovered in 1996 (Bouquet & Engler 2006). On Saussure, see Culler 1976. Saussure is rightly regarded as one of the founders of structuralism, see Bal & Bryson 1991: 191–5.

component of the sign. Or, as Saussure exemplified: the concept of horse is what is *signified*; the *referent* is what kicks its rider.

The central axiom of Saussure's model is that the relationship between *signifier* and *signified* is entirely arbitrary and is not constituted by a natural connection: every language employs different words for one and the same *signified*: P-F-E-R-D or C-H-E-V-A-L for horse, R-A-H-M-E-N or C-A-D-R-E for frame. No natural relationship exists between *signifier* and *signified*, not even in the case of onomatopoeic words, which again work only within the same system of signs, i.e. within one language, and not across different sign systems. Saussure's model operates as a differential system:[8] the quality of a sign as constituted in the relationship between *signifier* and *signified* can only be established by differentiating it from other signs. This differential approach has significant consequences. Essentially, Saussure argues that language, organised as a system of signs, creates reality – because it is the signs, not the actual objects (*referents*), that embody the concepts that populate and shape reality.[9]

In Saussure's model the relationship between *signifier* and *signified* is static, and the *referent* only forms an external token joined with the two by an equally static, if arbitrary, connection. In contrast, Peirce – a pragmatist philosopher – proposed a more dynamic system of signs.[10] He was interested not in the general rules governing a system of signs, but in the signs and their reception as the means of generating meaning, and thus engaged the general view that human knowledge is always linked to experience or practice.

The basis of Peirce's model is a process he labelled *semeiosis*, which consists of three components:[11] the sign or *representamen*, describing the unit which is perceptible; the *interpretant*, the label for the mental image of the object that the recipient – a reader or viewer – generates; and finally the unit that is referred to by the sign, the *object* or *referent*.[12] Mieke Bal and Norman Bryson aptly describe Peirce's system using the example of a painting depicting a fruit bowl:[13] 'The interpretant points to an object. The object is different for each viewer: it can be real fruit for one, other still-life paintings for another, a huge amount of money for a third, "seventeenth-century

[8] Hatt & Klonk 2006: 203.

[9] The referents prove the existence of the formal sign system only on the level of performance.

[10] For Peirce, see Iversen 1988: 84–6, 89–91; Misak 2004: esp. 1–26. For his influence on Edgar Wind, see above, p. 35 n. 76.

[11] Peirce 1977; Peirce, in: Innis 1985: 1–23; Short 2004, with an overview of the various changes Peirce devised for his own approach.

[12] Hatt & Klonk 2006: 210.

[13] Bal & Bryson 1991: 188.

Dutch" for a fourth, and so on.' Peirce put considerable emphasis on the mental image, the *interpretant*. In contrast to the Saussurean *signified*, this *interpretant* does not constitute a concept but – generated by the recipient – it defines the *referent* in a dynamic way: based on subjective perception, it can change continuously. And this mutability also renders the relationship between *representamen* and *referent* dynamic.[14]

Where Saussure's model was differential, Peirce opted for a referential approach. In addition, he identified different classes of *interpretants* and *objects*, continuing his triadic model. Signs can have three different shapes: *qualisign*, *sinsign*, and *legisign*.[15] *Interpretants* can be of three different qualities: emotional-unmitigated, energetic-dynamic, and logical-normal-final. *Objects* can take two different qualities: immediate (internal to the sign) and dynamic (external to the sign). Based on this organisation, the triad of *representamen*, *interpretant*, and *object* can generate three modes of meaning production. And with regard to the *object* element of this triad, Peirce differentiates between three types: *icon*, *index*, and *symbol*. He explains:[16]

An *icon* is a sign which would possess the character which renders it significant, even though its object had no existence; such as a lead-pencil streak as representing a geometric line. An *index* is a sign which would, at once, lose the character which makes it a sign if its object were removed, but would not lose that character if there were no interpretant. Such, for example, is a piece of mould with a bullet-hole in it as a sign of a shot; for without the shot there would have been no hole; but there is a hole there whether anybody has the sense to attribute a shot or not. A *symbol* is a sign which would lose the character which renders it a sign if there were no interpretant. Such is any utterance of speech which signifies what it does only by virtue of its being understood to have that signification.

With these types, Peirce accounts for differences in the way the sign is related to the object. In contrast to Saussure's static model, in Peirce's model the sign can be diversified, and it can be characterised by more than one of the modal qualities:[17] the *icon* refers to the object by a quality internal to itself; the *index* is constituted by means of a connection to the object; and the *symbol* links to the object through an acquired habit or rule that shapes its *interpretant*.

[14] Cf. Bryson 1983: 79 who re-enacts this argument to vindicate Saussure's approach.

[15] Signs can also be referred to as *tone*, *token*, and *type* or *potisign*, *actisign*, and *famisign*.

[16] Peirce, in: Innis 1985: 9–10.

[17] For a critical comparison of Saussure and Peirce see Iversen 1988.

When these early beginnings of semiotics are compared with iconology, we see that Saussure proposed a concept of the sign that is diametrically opposed to the idea of the symbol that serves as the foundation of the approach chosen by Cassirer and Panofsky.[18] In their model, symbols are shaped by humans, following *a priori* principles based on how the human mind organises and conceptualises the world. The link between sign and concept is characterised by necessity. In Saussure's model, symbols shape humans, and the relationship between sign and concept is arbitrary, not governed by *a priori* principles.[19] Saussure would argue that, as Hatt and Klonk put it, 'how the world is depends on how it is perceived'.[20] But whilst he put the onus in the process of meaning production on reception, Saussure was not interested in the actual recipient or in acts of individual symbolisation, unlike later forms of semiotics, assuming those acts under the rubric *parole*. His concept of the relationship between *signifier* and *signified* is entirely focused on the *natural* rules of the system above the level of performed language, an area outside even the realm of collective symbolisation.[21]

Peirce's model, by contrast, shares certain properties with iconology. Both were devised as relational systems, pursuing an analysis of reality. Where iconology sought to unearth *a priori* principles, Peirce used empirical experiment. But while these approaches share an investment in truth and reality, Peirce identified the recipient as the key pathway to this objective, whereas iconology steers clear of any such investment. And where iconology deals only with acts of collective symbolisation, and Saussure refused to account for either individual or collective symbolisation, Peirce embraced and pursued both, as is manifest in the range of sign-types he devised.

Semiotics, structuralism, and post-structuralism: from Roland Barthes to Jacques Derrida.

The reception of Saussure's and Peirce's semiotic advances started in the wider field of cultural studies in the 1960s.[22] It was fuelled by the desire to counter the human-centred notion of phenomenology and existentialism that had previously dominated the field.[23]

[18] Cf. above, pp. 27–8.
[19] Hatt & Klonk 2006: 219.
[20] Hatt & Klonk 2006: 203.
[21] For a critique of Saussure's approach see Bryson 1983: 77–80. For *individual* and *collective* symbolisation, see above, pp. 7, 34–5.
[22] Iversen 1988: 82–4.
[23] Hatt & Klonk 2006: 204–5.

Influenced by the work of Claude Lévi-Strauss (1908–2009),[24] Roland Barthes (1915–80) extended Saussure's model, specifically by adopting its conceptual strength to explain structural similarities across systems.[25] Barthes followed Saussure in abandoning the idea of realism.[26] He differentiated between two layers of meaning: a Saussurean primary level of *signifier* and *signified*, and a secondary level that he labelled *myth*, a category concerned with issues of political and social ideology.[27] In line with Saussure, Barthes initially assumed a static connection between *signifier* and *signified*. Because of his interest in visual evidence, Barthes' work is particularly relevant for the art-historical field, and specifically for analysis of visual media as used in advertisements, for which his approach with its investment in the ideological is particularly well suited.

A classic example for Barthes' approach is provided by his analysis of a French advertisement for Italian food.[28] He separated the picture into one linguistic sign (the denotational French writing, which, by including an Italian name, also connotes Italianicity), and four visual signs: the half-open bag; the choice of vegetables and colours for the representation; the comprehensive choice of foodstuffs; and the composition of the picture. These visual signs, in turn, signify freshness and domestic preparation, confirm Italianicity, signal 'total culinary service', and add gravitas to the whole by evoking traditional still-life painting. In this example, the linguistic and visual signs work together – in part to articulate the same message (Italianicity), in other aspects to complement and help interpret each other to communicate the nexus of food, traditional cultural values, and the desirability of a lifestyle that puts both in easy reach even of the less culinary savvy.

Barthes separated the individual units of meaning shaping the picture and analysed their functioning. This example demonstrates the key advantages of this type of analysis. As it is invested in unearthing structures, it allows visual evidence to be assessed alongside other types of media. In addition, it is not restricted to visual products of the fine arts and is particularly suited to tackling the potential subversiveness of cultural utterances.

[24] Lévi-Strauss 1963.

[25] Barthes 1967; Barthes 1972. See Bal & Bryson 1991: 191. Another influence on Barthes' work is that of the Danish linguist Louis Hjelmslev (1899–1965): Hjelmslev 1953.

[26] Barthes 1982; Bal & Bryson 1991: 195. In its abandonment of realism, Barthes' approach is comparable to that of Nelson Goodman (1906–98): Goodman 1976: 225–32; see also Mitchell 1986: 54–74.

[27] For Barthes' engagement with Saussure and his semiotic approach more generally, see Barthes 1977b; for myth, see also Barthes 1972: 131–56.

[28] Barthes 1977a: 33–7.

And yet there are also disadvantages. Barthes' approach presumes that the relationship of signifier and signified is stable, with each signifier denoting a specific signified. While this position works fairly well for advertisements and other types of allegorical imagery, it lacks the flexibility that is needed to account for more complex visual representations.[29]

A way around this limitation is offered by an analytical framework already prefigured in Saussure's differentiation of *langue* and *parole*, and also applied by Barthes.[30] At the core of this framework is a differentiation between paradigmatic and syntagmatic forms of meaning production. These forms are applied to the visual as follows: the paradigmatic is used to define the specificity of a picture in relation to other representations of a similar kind; the syntagmatic is appropriated for the study of the relationship of the individual signs constituting the picture. When analysis follows these two axes, looking also for where they intersect, complex representations can be more easily tackled.

The application of shifting analytical frameworks puts emphasis on the different meanings of an artefact. In his 1970 book, *S/Z* Barthes explored this aspect further, introducing five codes tasked with characterising types of signifier–signified relationship.[31] Mieke Bal and Norman Bryson describe the codes as follows:[32]

The *proairetic* code for Barthes is a 'series of models of action that help readers place details in plot sequences: because we have stereotyped models of "falling in love", or "kidnapping" or "undertaking a perilous mission", we can tentatively place and organize the details we encounter as we read.' In a way this is a narrative version of an iconographic code. The *hermeneutic* code presupposes an enigma and induces us into seeking out details that can contribute to its solution. Although this code may seem less relevant for visual art, we claim that there is a hermeneutic code at work for the viewer, precisely when an image's subject is hard to make out. The *semic* code inserts cultural stereotypes, 'background information' that the viewer brings in to make sense of figures in the image in terms of class, gender, ethnicity, age and the like. With the help of the *symbolic* code, the viewer brings in symbolic interpretation to read certain elements, e.g. 'love', 'hostility', 'loneliness', or, for that matter, 'theatricality', 'vanitas', or 'self-referentiality'. Finally, the *referential* code brings in cultural knowledge, such as the identity of the sitter for a portrait, the program of an artistic movement, or the social status of the figures represented. Together, these (and other) codes produce a 'narrative', a satisfying interpretation

[29] Held & Schneider 2007: 366–7.
[30] Barthes 1977b: 58–60.
[31] Barthes 1975: 18–20, 261–3.
[32] Bal & Bryson 1991: 203.

of the image in which every detail receives a place. The narrative is emphatically produced by the reader to deal with the image; it produces the story through the processing of a strange image into a familiar mind-set.

This system of codes opens a pathway to an analytical framework based on the multi-stability of signs – a transition fully realised in the work of Jacques Derrida (1930–2004).[33] Derrida reversed structuralism's attempt to move away from the phenomenology of Husserl and Heidegger and reappropriated their work for a new form of deconstruction,[34] feeding off the Peircean model of semiotics.[35] Concentrating on Barthes' primary semiotic level, he argued that the picture plane and its syntactic structure, the combinations of different signs and the mode of their combination, generate meaning, leaving no need to relate the picture to external *signifiers*.[36]

At the same time, Derrida threw open the picture to its surroundings – in the case of two-dimensional panel painting, to what lies beyond its frame. And what surrounds the picture, in his view, is a constituting component of that picture. Pictures are pervasive – or, using the term adopted by another Peircean semiotist, Umberto Eco (1932–2016), they are 'open'.[37] They engage continuously in processes of dissemination, which shape varied social and political frames.[38] But what remains similar to Barthes' work in Derrida's approach is the particular interest in the subversiveness of the picture, the ways in which the depiction deviates from the discourses of its time, its variance from the main thrust of culture – yet, as we have seen, iconology was above all concerned to locate the picture within and as part of this thrust. The focus here is on those elements and aspects of the depiction that do not correlate with the mainstream characteristics of form, theme, and idea, aspects that in Panofsky's iconological model serve as the correctives – as *history of style*, *history of type*, and *history of symbols* – that guide the interpreter through the different levels of analysis.[39]

And yet for a deconstructivist analysis these correctives are just as important as for Panofsky, even if for diametrically opposed reasons: the latter uses them to locate an artefact within the culture to which it pertains; the former has to locate the artefact in a contrasting comparison to its cultural framework in order for the analysis to be informative rather than just a levelling

[33] Derrida's assessment of structuralism was a milestone in this respect: Derrida 1976.
[34] Culler 1982. For Heidegger, see above, pp. 31–4.
[35] Bryson 1983: 85.
[36] Derrida 1976.
[37] Eco coined the phrase 'opera aperta', the open work of art: Eco 1989.
[38] Derrida 1987: 11–3. Cf. Bal & Bryson 1991: 192–3.
[39] See above, pp. 21–3.

tool. By turning its interest almost solely to the *signified*, however, this form of post-structuralist semiotics also propagates a position that markedly destabilises the scaffolding for such correctives, a paradox that presents a considerable challenge for any form of deconstructivist semiotic approach.

Semiotics and art history: style, gaze, and narrative.

Epistemologically, all forms of semiotics are both anti-Kantian, in the sense that they deny an *a priori* connection of mind and world, and anti-existentialist, in that they do not regard humans as the prime movers in establishing meaning. Instead, they understand signs as catalysts for the forging and directing of human perception. Semiotic analysis, with its interest in forms of communication, can underpin other types of analysis, especially those based on discourse models,[40] including frame analysis.[41] It also lends itself to appropriation for specific trajectories of enquiry. For visual culture, those concerned with style, the gaze, and narrative are particularly relevant.[42]

The form and style of an artefact are manifest in its syntax – they are embodied in the arrangement of signs on the surface of the artwork, the composition of these signs, including the distance between individual signs, and the use of light and shadow to highlight individual signs. Stephen Bann has demonstrated how Peirce's sign categories might be applied in order to describe and assess form and style of artworks, including abstract art such as cubism.[43] Bann allocates different formal features to different

[40] Michel Foucault (1926–84), who methodologically operated between structuralism and post-structuralist deconstruction, is generally taken as the most prominent representative of discourse analysis (for example Foucault 1970).

[41] This notion of *framing* is adopted from Erving Goffman's (1922–82) sociological model of Frame Analysis (Goffman 1974). Most prominently, Mieke Bal has adopted it for semiotic analysis (Bal 2002: 133–73; see also Bal & Bryson 1991: 177–81).

[42] Further areas of interest: the semiotics of the aesthetic as presented by the works of Hubert Damisch (1928–) and Louis Marin (1931–92); see Damisch 1996 on the Judgement of Paris; Marin 1980; Marin 1981; Damisch 2005. Marxist takes on semiotic analysis are another important shaper of visual culture studies and emphasise the role of ideology and social and power hierarchies. Marxism, with its concept of historical materialism, explores the connections and relationships of socio-political shifts and changes to cultural conditions, not least art. One of the merits of Marxist theorems is that they put emphasis on the social processes of production, use, and perception and thus facilitate semiotic's investment in exploring the context of the artwork as expressed in the notion of the *open work*. In the semiotic appropriation of Marxism, this *context* then can become a *frame*, based on the notion of a pluralist and mobile system of meaning within which the artwork operates and which is open enough to account for, for example, non-elite forms of reception. See Hatt & Klonk 2006: 120–41.

[43] Bann 1970: esp. 133–8.

sign categories, thereby opening up the possibility of assessing shifts in the relationships of the elements in the different categories in order to characterise the style of the artwork, on which meaningful interpretation can then be based.

The gaze and gazing form a central part of human communication. Both the activity itself and its absence are indicative of the quality of communication.[44] In the area of visual culture interest in the gaze is manifest in reception aesthetics and in reception theory more generally.[45] The gaze is also at the core of discussion in film studies, specifically in analysis of gendered forms of viewing.[46] The approaches in both cases are informed by psycho-analytical theorems, and especially by the work of Jacques Lacan (1901–81) and his concept of the gaze.[47] That social enquiry can be facilitated by this methodological mixture of semiotics, gender, and psychoanalysis is exemplified for the field of art history by the work of Mieke Bal (1946–), in particular by her 1991 study *Reading Rembrandt*.[48]

Bal's work also demonstrates how semiotics can facilitate an analysis of visual art according to narratology, principles of narrative developed for the verbal. Indeed, Bal's initial interest in the visual developed out of her interest in narrative. Her take on a narratology for visual art, presented together with Norman Bryson, rests on a mixture of Barthes' viewer-oriented semiotic coding and Mikhail Bakhtin's (1895–1975) producer-focused hetero-discoursive structuralist model of literature.[49] From that basis emerges a model of visual narrative in which layers of code containing narrative and descriptive elements co-exist and compete with each other to form the overall narrative of the image.

More importantly, they extend this model further by appropriating the narrative category of focalisation, considering narrative modes and the narrator(s), focalisers, and actors, thus establishing a concert of acting and re-acting forces that generates meaning.[50] This type of analysis makes use of

[44] Nöth 1990: 405–6.
[45] For reception theory, see Iser 1978. For reception aesthetics, see Kemp 1998.
[46] Mulvey 1975; Mulvey 1989: esp. 14–26.
[47] Lacan 1977: 1–7; Lacan 1981. Mieke Bal and Norman Bryson have argued that psychoanalysis embodies a semiotic model because it explores the links between the unconscious and its expression (Bal & Bryson 1991: 195–6). For a critique of (Lacanian) psychoanalysis that focuses on visual art see Jay 1993: 493–542; for Freud see Wollheim 1991. For an overview of psychoanalytical approaches in the field of art history see Hatt & Klonk 2006: 174–99.
[48] Bal 1991; Hatt & Klonk 2006: 214–15.
[49] Bal & Bryson 1991: 202–6. Bakhtin 1981. On Bakhtin see Hirschkop & Sheperd 1989; Holquist 1990.
[50] Bal & Bryson 1991: 204–5.

Bal's own theory of literary narrative,[51] which shapes a model based on the assumption that multiple readings for any one image are possible, with potential randomness kept in check by the thresholds generated by the codes in operation.

In all this, two characteristics of semiotics are of particular relevance for the field of art history: its investment in the recipient and its interest in context, or, better, in the framework of the artwork.[52] With regard to the former, semiotics is concerned with acts of individual and collective symbolisation. That concern can extend not just to the viewer, but also to the artist, who produces the syntax of signs on the surface of the artwork – as a viewer and for other viewers. With regard to the latter, semiotics in its Peircean manifestation has the flexibility to be able to map and contrast the dimensions of an artwork and the conditions of its perception. The meaning of the artefact is therefore approached as non-fixed, dependent on the discourses within which the artwork is included – and with its contextual framework contributing to the content thus generated.

Two criticisms have been raised against the applicability of semiotics in art history. The first criticism notes that the method was originally developed for the study of texts, and asks, in particular, whether the relations of pictures to their signified are necessarily arbitrary to the same extent as are those of textual signifier and signified.[53] Even though individual strands of semiotics might make allowances for the visual and implement modifications in order to capture the particular qualities of visual artefacts, the analytical parameters of the method are inevitably biased towards the textual and thus, even if modified, unable to account for visual phenomena.

The second criticism is directed at the a-historicity of semiotics, which, it charges, renders the method useless for the study of art in a historical perspective. This criticism is primarily directed against the Saussurean form of semiotics, with its interest in the systemic aspect of cultural signage as represented by *langue*, which is located outside the historical dimension as it is represented by *parole*. But the criticism is also relevant for post-structuralist versions of semiotics, which can take the form of image-immanent semantics,[54] an exercise that involves simply describing the self-referentiality of pictures without the backing of any external factors; in effect we then have a *semiotic circle*, which also operates outside the parameters of history

51 Bal 1997.
52 Bal puts forward a plea for the notion of 'framework' instead of 'context': Bal 2002: 135; see also below, pp. 158–9 n. 27.
53 Hatt & Klonk 2006: 208.
54 Held & Schneider 2007: 370, 372–80.

Semiotics' strong investment in contextual frameworks, including the discourses around the artefact's reception, goes some way to muting these criticisms. With regard to issues of the visual, deconstructivist forms of semiotics are well suited to accounting for visual communication because they assess its specific forms of meaning production in comparison, and contrast, to meaning production by other media.

This advantage is further supported by the way in which contextual frameworks are included in the interpretation: they are not taken as a stable, fixed package of meaningful elements with which the meaning of the artefact is synchronised, as is the case in iconology, but rather as a fluctuating range of coordinates. This iterative type of experiment enables semiotics to evade the dangers of tautology that Christopher Wood has attested for iconology.[55] And additionally, semiotics, especially in its deconstructivist manifestation, can therefore offer precisely that play of interpretations that Didi-Huberman asked for in order to tackle alienation in art-historical scholarship.[56]

With regard to issues of the historical, Bal and Bryson, among others, have argued that any viewing of an artefact, including that by modern interpreters, adds a new discourse to the image and that this iterative process of reception would make futile any attempt to reconstruct the artefact at a specific point in time. Instead, one should compare constructions of the artefact within different frameworks of viewing, including different points in historical time.[57]

[55] See above, p. 91 n. 14.
[56] See above, pp. 4–5.
[57] Bal & Bryson 1991: 179–80. For an example for iterative art-historical writing, see Clark 2006.

5 | Semiotics in action

The semiotic interpretations here are devised as a three-step process, applying structuralist and post-structuralist elements of semiotic enquiry. At the stage of semantics, the focus is on the relationship of the signs and the things to which they refer, the denotations. At the stage of syntactics, the relationships existing between the signs are under scrutiny, that is, the paradigmatic and syntagmatic aspects of the depictions. The stage of pragmatics, finally, sees the exploration of the relationship between the signs shaping the depiction and those people that make sense of these signs.

1) The Karlsruhe hydria: thresholds of desire, choice, and crisis

Semantics.

Externally, the vase shape and stylistic rendering of the Karlsruhe hydria provide a framework for its use and date.[1] Internally, the two sections of the hydria, the upper picture field and the frieze below, present distinct practices of semiosis: while almost all figures in the upper picture field bear a name label – an index internal to the representation, but external to the figure[2] – those in the frieze below do not. A second gradation sees some figures identified through their attributes as mythological or divine characters,

[1] For a description of the vessel, see above, pp. 10–12; for information on the myth depicted, see above, pp. 37–42. For its potential use, see above, p. 10. With regard to style, the hydria was categorised by John Beazley on the basis of his connoisseurship studies, centred on the identification of artists, and subsequently attributed to the Painter of the Karlsruhe Paris, who was related to the circle of the Meidias Painter, see above, pp. 10–11. The focus on an artist personality produces a specific perspective on the artwork, an approach Beazley developed out of the work of the Italian physician and art historian Giovanni Morelli (1816–91). On the method, its scope, and limitations, see Morelli 1893, Wollheim 1973; Hatt & Klonk 2006: 48–56; Davis 2011: 86–93 (see also Davis 2011: 75 for a differentiation of connoisseurship and formalism); on its application in scholarship on Greek vase-painting see Beazley 1974; see also Kurtz 1983: 68–9. For a more critical perspective see Hoffmann 1979; Neer 1997; Davis 2011: 135–6.

[2] For the use of name labels by the Meidias Painter as a vehicle for allusion and generally as a device to provide additional layers of signification, see Couëlle 1998 (*non vidit ante* 2008);

while others lack such defining features or, rather, display features firmly
anchored in contemporary life outside the picture, raising questions about
their status both in the scene and in relation to the viewer.

One figure's semantic dressing demonstrates such dichotomies to the
full. Eris, the personification of strife, is positioned in the central apex of the
upper picture field (fig. 5.1).[3] Her label, *ERIS*, points to the divinity who in
counsel with Zeus initiated the Trojan War.[4] And yet, her visual appearance
separates her from the gods depicted on the vessel, for whilst the divinities
in the scene – Zeus, Hermes, Hera, and Aphrodite – are distinguished by
wreaths or fillets in their hair and staffs in their hands,[5] Eris in her thin chi-
ton is displayed as similar to the Eutychia personifications in the picture
field, which fits with the fact that her name identifies a divinity whilst also
conveying the qualities of Eris as the personification of strife. More import-
antly, however, Eris resembles the dancing maenads in the lower frieze, and
that similarity is stronger than for any of the other figures in the upper pic-
ture field, not only in terms of dress but also in light of their shared wild and
flowing hairstyles (fig. 5.2).

The figure of Eris thus conjures up a range of competing roles. Dressed as
would be a contemporary female outside the picture[6] and without attributes,
she resembles an Athenian woman, with her unrestricted hairstyle drawing
more parallels with a particular branch of female activity – ritual practice –
beyond normal conventions, and specifically with Dionysian revelling,[7] as
also depicted on the hydria. Yet other elements of her characterisation seem
at odds with these stakes in the contemporary world, positioning her along-
side the personifications (through dress and label) and the gods (through
label alone). These ambiguities with regard to identification, between what
is supported by the external index and what is displayed internally through

cf. also Lorenz 2007: 131–8. For writing on Athenian pottery more generally see Immerwahr
1990: esp. 116–17.

[3] LIMC III 1986 s.v. *Eris* (H. Giroux); Shapiro 1993: 51–61; Borg 2002: 134–5, 145. Eris only
appears three times in scenes of the Judgement: in Karlsruhe, on the calyx-crater by the
Cadmus Painter in St Petersburg (see below, p. 128 n. 30), and on a considerably earlier BF
Attic Cothon: Paris, Musée du Louvre CA 616; from Thebes. C-Painter, *c.* 570 BCE. ABV 58,
122; Para 23; Add² 5.

[4] Cf. above, pp. 40–1 n. 22.

[5] Athena takes an intermediary role, with her spear and helmet both similar to staffs and fillets of
the other gods in the scene, and yet also diverging from them because of their greater specificity
as attributes. Notwithstanding his name label, Helius, on the far right, is also in an ambiguous
position, because he displays none of these divine attributes; their absence could be read as an
index of his role as a personification of the course of time rather than of a specific divine power.

[6] Rössler 1974: esp. 157–61; Williams 1983: 92–7.

[7] Schöne 1987: esp. 129–61; Carpenter 1997: 52–69; Moraw 1998: esp. 29–65. On female ecstasy
specifically see Joyce 1998; cf. also Zeitlin 1982; Bremmer 1984.

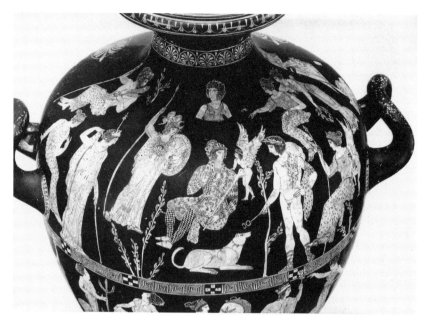

Fig. 5.1 The Karlsruhe hydria: upper picture field. Karlsruhe, Badisches Landesmuseum B36. *c.* 420 BCE.

Eris' appearance, place emphasis not on the underpinning mythological narrative, in which the Judgement was a milestone in the build-up to the Trojan War, but on Eris as bearer of discord and as a woman who is both inside and outside the boundaries of the normal.

This tone set by Eris is in some aspects amplified by the figure of Athena.[8] Athena is rendered similarly in relation to both the realm of myth and the world beyond the picture, albeit by different means. She is shown with highly specialised attributes, helmet, aegis, and shield (fig. 5.1), which leave no doubt about her divine identity. In addition, these attributes fulfil a semantic function profoundly different from that of the attributes that adorn the other two goddesses, the lotus sceptres and fillets. Athena's helmet with its horse protomes and the shield with the drawing of a figure attacking in a rocky landscape reference the statue of Athena Parthenos on the Athenian acropolis.[9] That statue's traces in the world relate this depiction to something that exists in reality, forging an association that is stronger than simply a common iconographic presence. The depiction of Athena is an icon of

[8] The figure of Paris – with his dress symbolic of Eastern forces and iconic of contemporary theatre – adds further elements to the display that blur the boundaries between the realm of myth and the world outside the picture. On Paris' dress, see above, pp. 46–8.

[9] Cf. above, pp. 44–5, with evidence.

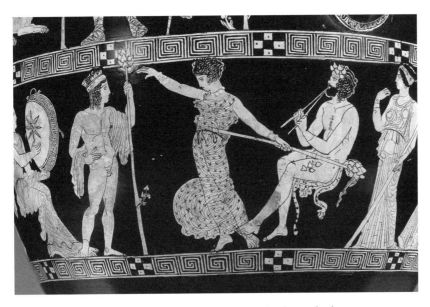

Fig. 5.2 The Karlsruhe hydria: lower picture field. Karlsruhe, Badisches Landesmuseum B36. *c.* 420 BCE.

a particular statue, not merely an iconic symbol of a divinity as in the case of the other two goddesses.

The lower frieze adds to the exploration of, on one hand, the boundaries between the divine and mythological and, on the other, the world outside the picture. But discoveries are made here in light of iconic symbolisations of both the divine and the mundane and are not the result of an intermixing of conflicting external and internal signification. Various attributes, such as tambourine and double-flute, identify the individual characters at the front of the lower frieze as participants of a Dionysian thiasus, with the god himself conclusively identified by the vine-leaf-crowned fillet on his head and the thyrsus in his hand (fig. 5.2).[10]

The representation of other characters is more ambiguous: the tambourine player on the left of the central group is anchored in the real world through her dress and jewellery, yet the fillet on her head and her action, linked to a religious rite, also locate her beyond this world (fig. 0.1).[11] The flute-player has traces in the real world because his instrument links him to

[10] On representations of the god Dionysus in general: LIMC III 1986 s.v. *Dionysos* (C. Gasparri); Hamdorf 1986: 53–8; Carpenter 1997: 85–103; Isler-Kerényi 2007: passim. For Dionysus' role in scenes of the Judgement in Athenian black- and red-figure vase-painting, see below, pp. 186–7, 190–1 n. 20.

[11] On the frameworks of meaning associated with maenads, see Hedreen 1994: 47–54; Moraw 1998: esp. 260–4; Neils 2000: 219–26.

the tambourine player, but his stubby nose, thick beard, and bushy tail iden-
tify him as a satyr and thus as from the realm of myth (fig. 5.2). Similarly,
the presentation of the female groups in the back part of the frieze is gener-
ally entrenched in the contemporary,[12] but the female thyrsus carrier in one of
the groups introduces a more ambiguous note and raises the possibility that
the other three groups of women are to be understood as participating in the
thiasus at the front despite the absence of relevant attributes; she would thus
showcase the all-encompassing power of Dionysiac ritual.[13]

Syntactics.

The syntax of the decoration is shaped by a range of relationships that cut
across layers of signification and create competing vertical and horizontal
hierarchies. First, there is the discrepancy in the use of name labels between
the two picture areas of the vessel. Its divisive impact is somewhat alleviated,
however, by the similarities in the rendering of Eris, above, and the maenads,
below, and also defused by the landscape setting chosen for both picture fields,
a setting that is iconic of a real-world situation: the slopes of the Athenian
acropolis.[14]

In addition, the internal syntax of the landscape fuels concrete indexical
functions. The laurel shrubs separate the upper picture field into zones, dif-
ferentiating the individual characters in the process. Thus, Paris, Eros, and the
dog are screened off by foliage (fig. 5.1), turning Eros and the dog into indices
for the figure of Paris, with the dog accentuating his shepherding role[15] and the
Eros accentuating love.

This process of differentiation is matched by the workings of the dec-
orative design at large, even beyond its signification with regard to the
characteristic branding of the vessels of the Meidian circle (fig. 5.3).[16] The
combination of the lotus-palmette frieze as the upper limit of the picture field

[12] On the depiction of women in comparable boudoir scenes, see Lissarrague 1995: esp. 93–100.
Cf. Burn 1987: 81–5; cf. also Ferrari 2002: 35–60. See Williams 1983; Beard in Robertson &
Beard 1991: 21–35 on the issue of 'everyday' depictions of Athenian women. Ferrari 2003
presents a semioticised engagement with the relationship of myth and everyday in the domain
of visual narrative.

[13] Hamdorf 1986: 15–18; Carpenter 1997: 70–84; Moraw 1998: 66–99.

[14] See above, pp. 44–5.

[15] If the dog is taken to serve as an iconic symbol of Helen (cf. above, pp. 42–4), its significance
escalates.

[16] The overall stylistic portfolio also includes the vase shape, the formal rendering of the figures,
the figures' composition, and the choice of themes. Richard Neer has documented the efforts
of Athenian vase-painters to produce what comes close to corporate branding, particularly
in periods of heightened creativity such as the phase of the pioneers in the late sixth century

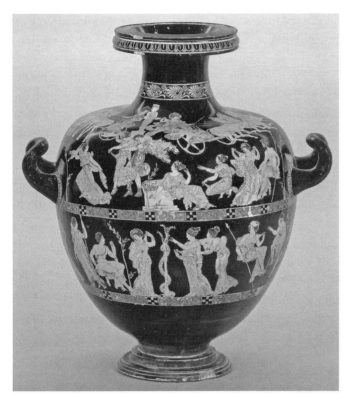

Fig. 5.3 The decorative branding of the Meidian circle. Red-figure hydria by the Meidias Painter. London, British Museum E224. 430/420 BCE.

and the meander-chequerboard band as its lower perimeter conjures up specific sign-value.[17] The blocky meander band exudes separation, underpinned by its repetitive sequencing. At the same time – by virtue of its two conflicting elements, the twisting and turning meander and the balanced and symmetrical chequerboard – it also presents a barrier that, from within, stimulates contemplation and discourse. In contrast, the lotus-palmette frieze is less obtrusive. Its

BCE. See Neer 2002: 87–134. For a similar phenomenon in late classical sculptural production, see Schultz 2007: 165–79. The 'branding' of an individual artist, as a focus of analytic enquiry, follows a trajectory diametrically opposed to that of connoisseurship, notwithstanding the comparable results: while both are interested in the footprint of the artist, connoisseurship searches for traces left unconsciously, while the search for elements of branding, or the artist's trademarks, has to assume they were placed deliberately. For the method of connoisseurship, see above, p. 118 n. 1.

[17] A similar distribution of decorative elements can be found on the name vase of the Meidias Painter (RF Hydria, London, British Museum E224; see above, pp. 10–11 n. 29 (fig. 5.3)) and on his squat-lecythus in Cleveland, see below, p. 128 n. 32. Neils 1983; Burn 1987: 21–2; Lorenz 2007: 139–41). For analyses of the sign value of decorative elements in general, see Flashar & Andreae 1977, comparing the decoration of Geometric vases with

organic structure extends the picture field inconspicuously, not least because the pattern corresponds to the lotus sceptres carried by Hera and Aphrodite.

The decorative bands provide a meaningful framework for the individual pictorial areas. The lower frieze is encased by bands of discursive meander, compressing the frieze as if to ensure the spheres of human and divine whose interrelationship is explored here are brought together more firmly. Meanwhile, the upper picture field, which engages the relationship between what is on display and the world outside, is extended further towards the boundaries of the vase, enhancing its transitional character.[18]

From within the framework established by the landscape and the overall decorative rendering, a range of action schemes emerges. These schemes combine proairetic coding around choosing (intertwined with hermeneutic coding), revelling, and displaying beauty; symbolic code focused on desire, envy, and vengeance; and semic and referential coding as embodied in the iconic dressing of Eris, Athena, Paris, and the setting overall.

In the myth of the Judgement, desire and choice are intricately interwoven. The display on the Karlsruhe hydria cultivates their interrelationship as its primary action scheme by welding together these two aspects in the figure of Paris, with the Trojan prince screened off from the other figures and shown making his decision while being lured by Eros. Simultaneously, the arrangement drives a wedge between the goddesses: those who lose are on the left; victorious Aphrodite is on the right. The splitting of this group, who in previous versions of the Judgement had formed a single entity, adds another layer of contrast, and of conflict.[19]

Homer's use of epithets; in addition, cf. the interpretation put forward for the meander band in the inner tondo of a cup by the Codrus Painter depicting Theseus slaying the Minotaur, which enforces the notion of the labyrinth: RF Cup, London, British Museum E84; from Vulci. Codrus Painter; 440/430 BCE. ARV² 1269.4; Add² 356; Bérard 1989: 13, fig. 7; LIMC VII s.v. *Theseus* no. 46; and cf. RF Cup, Harrow School Museum 1864.52; from Vulci. Phiale Painter, 440/430 BCE. ARV 660; CVA *Harrow, Museum*: 20–2, fig. 1, pls 22.1, 23.1–3, 24.1–2, 25.1–2; RF Cup, Madrid, Museo Arqueologico Nacional L196; Aison, *c.* 420 BCE. ARV² 1685; CVA *Madrid, Museo Arqueologico Nacional* 2: IIID.3–4, pls 1.1–2, 2.1, 3.1–2, 4.1–2, 5.1–2, 15.1. For an interpretation, see Elderkin 1910; Díez de Velasco 1992: 178–80, 182–5.

[18] The decorative structures of the Ceramicus hydria make for an interesting comparison (RF Hydria, Athens, Ceramicus 2712; see above, p. 44 n. 37: although there are similarities between the two vessels, the picture field and the frieze of the Ceramicus hydria are not separated by a meander band but by another, bigger lotus-palmette frieze, thus generating a continuous flow across the decorative boundaries. This supports the content, which is in both sections strongly indexed towards the world outside, above with the boudoir scene of Greek tragic heroines and below with Pentheus' death enrobed in a thiasus, with both instances blurring the line between the mundane and the mythological/divine.

[19] For representations of the three goddesses as an entity, see above, pp. 38–41.

This message is further focused by the orientation of Paris towards the goddess of beauty, which forces the gaze of her competitors not only onto the prince, but also onto her, and by the two Erotes and Eutychias, who emphasise the relationship between Paris and Aphrodite.[20] The lower frieze corroborates this combination of choice and desire through its depictions on the back, where we see the passing of toiletries. That depiction is linked with the theme of revelling and the loss of control as expressed on the front with the scene of the Dionysian thiasus.[21]

The second action scheme on the vessel engages crisis. Its emphasis is not on the process of choosing, quite literally *crisis*, but on its aftermath. The emerging solution, Paris' opting for Aphrodite, is depicted as only the beginning of an even more profound conflict, namely, the Trojan War. Again, the ultimate outcome of this conflict is not directly spelled out, but rather heralded by the polysemic ambiguity that characterises the figure of Eris. This action scheme is also characterised by its engagement of female values. Eris is the only figure in the picture whose external index, the label, generates ambivalence, not greater certitude. Her combined divine and personified role grants her comprehensive powers over the course the story will take. That pivotal role is also stressed in her transitional appearance: while she is hidden behind a hillock, her head turns towards the losers, but her body faces Aphrodite.

The action schemes in operation – desire and choice as well as crisis – fuel a complex narrative structure. The underlining fabula of the Judgement is told in the picture from two narrative perspectives, or by two narrators.[22] Eris organises the Judgement such that it changes global history; she also harnesses the Judgement to rebase the female rites and female revelling as represented in the Dionysian thiasus. In contrast, Paris narrates the story as a confrontation between male and female.

Meanwhile, the hierarchy of these two narrative voices is anything but clear; indeed, the intermixing of primary and secondary narrations

[20] On the actions of these two groups, see above, p. 42.

[21] Music and the revelry depicted in these scenes, especially that by the female dancers in a state of trance, also evoke aspects of the subconscious, expressing uncontrollable desire, a desire in this specific case fuelled by the divine powers of Dionysus. The scene on the frieze shows that these powers have the potential to amalgamate the spheres of mortal and divine. As such, it documents a process structurally comparable to the functioning of the figure of Aphrodite in relation to her consorts in the picture field above, who by virtue of external indices become abstract concepts fleshing out the events on the level of the mythological and divine. On the relationship of Dionysian elements and the Judgement of Paris in general, see Damisch 1996: 116.

[22] For the basic principles of narratology, see Bal 1997:16, 43–74; for the category *fabula* especially: 53–7; cf. De Jong 2004a: 1–10.

generates the unique character of the presentation. That ambiguity is rein-
forced by the continuous oscillating of the identifications of individual
characters, especially for the figures of Eris and Athena. This arrangement
renders the metonymic and the metaphorical interchangeable and locates
these figures both within the realm of myth and the divine and within the
reality outside the picture.[23]

Pragmatics.

Throughout antiquity, and throughout Western civilisation more gener-
ally, the Judgement of Paris has served as a mirror of a set of quintessential
human themes, which include beauty, desire, choice, war, and, not least,
the conflict between Europe and the forces of the East.[24] On the Karlsruhe
hydria, the dominant themes as informed by the action schemes appear to
be (the differing qualities of) women, behaviour outside normative bound-
aries, and crisis, both in its literal sense as *decision* and in its manifestation
as *conflict*.

Propped up by the polysemy of individual characters, the scene therefore
develops discourses that while engaging the mythological narrative also are
relevant for a real event, beyond any connection to a mythological text. But
these discourses are essentially imbued with a mythological kernel. First,
there is the eroticised gender discourse, constituted through the set-up that
sees a male facing a group of women, a set-up in which the mythological
hero Paris is paradigmatically related to the god Dionysus, for while the
former faces the three goddesses, the latter fronts the maenads (fig. 5.1).[25]
Through this arrangement, the male is portrayed in a twofold role: as the
decisive power within the relationship (Paris as arbitrator of desirabil-
ity, Dionysus as gateway to a state of near-divineness) and as an object of
voyeuristic attention. With the eyes of the surrounding women resting on
them, highlighting their own desirability, the men are rendered vulnera-
ble – to female might, in particular female wrath as expressed through Eris,
and to female exuberance.

[23] For similar strategies on the name vase of the Meidias Painter see Lorenz 2007: 136–8. With
 a focus on the name labels exclusively, Couëlle 1998. See Sourvinou-Inwood 1990 for a
 conceptual discussion of a name label in conjunction with the depiction overall on a cup by
 the Codrus Painter; cf. also Sourvinou-Inwood 1991: 3–23.
[24] For a magisterial survey of the employment of the myth in Western art, see Damisch
 1996: 77–310.
[25] Cf. Shapiro 2009b: 250–5 for readings of depictions of both Dionysus and Paris in the later
 fifth century.

The second discourse developed on the vessel is closely interlinked with the showcasing of gender roles and revolves around social behaviour. In his role as a shepherd, Paris represents a bucolic activity associated with youth and normally distinct from military or political activity.[26] This representation therefore instils a tension in the figure of the Trojan prince, between his role as a shepherd and his function in the myth, in which he triggers truly global political and military events.[27] Paris' ambivalent characterisation is evaluated within the scene itself, but without the tension being resolved. The display as shepherd – a role that tells of ideals of leisure and erotic attractiveness – is assessed positively, for it secures him the attention of the three most prominent female Olympians.

But that display is also the springboard for a negative evaluation that targets the inappropriateness of Paris' claiming a stake in divine business, the tragedy of his character's being forced to do so, and the explosiveness of that role, as a catalyst of conflict. The appropriation of Dionysus in the frieze below provides a thoroughly different reading of leisure. The characterisation of Dionysus and Paris in the discourse around social behaviour is in contrast to the way in which their relationship is dressed within the first discourse, around leisure; this change in emphasis underlines the difference between divine and mortal.

The behavioural roles for women are consistent across the whole vessel and are constructed without ambiguity. The most prominent value is modesty: all women are shown in postures or activities of restrained decorum; the exception in the case of the dancing maenads is legitimised by the specific religious context. The goddesses' vanity, an accentuation of their role that can be central in literary versions of the Judgement,[28] is not manifest here.

The third and final discourse played out on the hydria is devoted to the city of Athens and thereby introduces political and religious elements to the presentation. The figure of Athena, and to a lesser extent the figures of Paris and Aphrodite, points to that city, in particular to the acropolis, with its sacro-cultural landscape, and to the theatre, as implied in Paris' dress and amplified by the presence of Dionysus himself.[29] The vase thus merges the world of the recipient outside the image with the pictorial representation, a

[26] Himmelmann 1980: 76–82. For the contradictions in Paris' attire, which is devoid of the explicitly rustic attributes of a shepherd, see Papili 2000: 173.

[27] Neither Stinton nor Gantz regards this discrepancy in roles as problematic: Stinton 1965: 51–62, and esp. 61–2; Gantz 1993: 570.

[28] For the textual versions of the myth, see above, p. 38 n. 9; pp. 40–1 n. 22.

[29] On Paris' dress, see above, pp. 46–8. For the Theatre of Dionysus on the slope of the Athenian acropolis, see Pickard-Cambridge 1946; Gogos & Kampourakis 2008.

process analogous to the blending of the realms of mortal and divine. While the two other discourses have general validity, this last discourse seems specifically targeted at an Athenian audience, for its complexity might otherwise easily be lost.

The three discourses are non-sequential and present essentially distinct, albeit interrelated, readings of the pictorial display, in part informed and distinguished by the different narrative voices in operation across the decoration. Some of the strategies employed here can be found across the oeuvre of the Meidian circle.[30] With its discourse around Athens, however, the Karlsruhe hydria enters entirely unchartered territory. No other versions of the Judgement display any comparable form of external indexing, even if those of the Meidian circle set the scene in a similarly rocky landscape.

But the vessels from the Meidian circle do provide examples of a similar accentuation of other myths.[31] A squat-lecythus by the Meidias Painter that is now in Cleveland serves as a prominent example (fig. 5.4):[32] the vase depicts the Birth of Erichthonius, the first king of Athens, a theme that underlines the autochthony of the Athenian people and their divine roots.[33] In the scene, amidst the very rocks and laurel bushes so popular on the Karlsruhe hydria, Athena receives the baby Erichthonius from the goddess Ge. The city goddess is indexed as such, again resembling the statue of Athena Parthenos, and an amalgamation of mortal and divine is again apparent, with the women in the scene iconic of contemporary women in the world outside the picture, including Ge, who presents her male offspring to the city, thereby producing a strong iconic representation of autochthony.[34]

This comparison shows that the Karlsruhe hydria adheres to the trends of its period, both in reinforcing the branding of the Meidian circle and in its reading of the Judgement overall. But the representation on the vase

[30] For the use of indices to extend the meaning of individual actors in the Judgement, and of the myth as a whole, cf. RF Calyx-crater, St Petersburg, Hermitage St1807; from Kerch. Cadmus Painter, 430 BCE. ARV² 1185,7; Para 460; Add² 341; LIMC VII 1994 s.v. *Paridis Iuridicum* no. 48 (name labels as indices). RF Hydria, once Cancello; see above, p. 42 n. 27 (extended cast of the Judgement, see Lorenz 2007: 121–8). RF Bell-crater, Vienna, Kunsthistorisches Museum IV 1771; see above, p. 42 n. 26 (juxtaposition with other myths (Apollo and Dionysus, and Garden of the Hesperides, respectively)).

[31] Cf. Burn 1987: 10–18, 48.

[32] RF Squat-lecythus, Cleveland Museum of Art 82.142. CVA *Cleveland, Museum of Art* 2: 35–7. Another example for such direct referencing of Athens is the Athenian tribal heroes who appear on the frieze of the name vase of the Meidias Painter, see Lorenz 2007: 131–8.

[33] It is treated to that effect in Euripides' *Ion*; see Walsh 1978; Burn 1987: 21–2; Neils 1983, with identification of the female figures. The myth: LIMC IV 1988 s.v. *Erechtheus* (U. Kron).

[34] Cf. Lorenz 2007: 138–41. For autochthony in Athenian art, see Bérard 1974: 31–8; Loraux 1981: 7–26, 35–73.

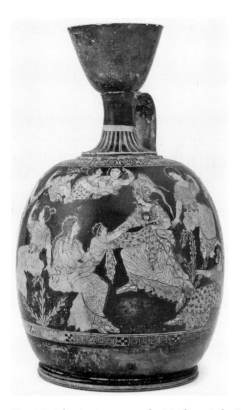

Fig. 5.4 Athenisation across the Meidian circle. Red-figure squat-lecythus. The Cleveland Museum of Art, Leonard C. Hanna, Jr. Fund 1982.142. 420/410 BCE.

also claims a share in the production of a narrative around a mythological core: it puts the concept of desire firmly at its centre and examines its consequences in a comprehensive way, exploring desire's potential to lead to conflict and catastrophe and to probe the limits of mortal and divine. Within this exploration, the discourse around Athens, here uniquely combined with the Judgement, appropriates the content specifically for an Athenian audience and leads its recipients on a multi-layered exploration.

2) The Pergamon frieze: thresholds of being, dominance, and the past

Semantics.

The Great Frieze displays two types of indexical usage, both of which are employed to characterise the gods and the giants explicitly in contrast to

each other,[35] namely, labels and animal features. Whilst labels appear in other depictions of the gigantomachy,[36] here they are particularly necessary because of the exhaustive cast list.[37] For an ancient viewer, a significant proportion of the participants would have been difficult to identify on the basis of the storyline and cultural or iconographic knowledge alone.[38] Rather than linking to a specific account of the gigantomachy, the labels therefore serve a symbolic function, for they anchor the characters in the realm of myth and vouch for their role within the battle. And on another level of symbolism, the positioning of the name labels also literally sets in stone the place of individual cast members in what we might refer to as the cosmos at large: the names of the gods on the cavetto moulding above the frieze and those of the giants on the base moulding below mark the latter as creatures of the earth and the former as creatures of the ether.[39]

Finally, the labels charge the giants with further symbolic meaning by identifying them as personifications of brutal violence and of the forces of nature, with names such as Chthonius (Earth Man) or Molodrus (the Muncher) highlighting their chthonic and uncivilised character.[40] In other versions of the gigantomachy this close tie between the giants and nature's forces is implicit in their actions, for example in their hurling of stones or fighting with branches, and does not appear in their names.[41] Those other

[35] For a semiotic analysis of the Great Altar as a whole, albeit generic, see Queyrel 2005: 148–50, and 123–35 (monarchic reading), 136–47 (civic reading). See also Neumer-Pfau 1983; Schmidt-Dounas 1993; Fehr 1997.

[36] See above, p. 54 n. 81. For the giants' names on the Siphnian treasury, see Brinkmann 1985: 87–105, no. N5 (Tharus); no. N6 (Hyperphas); no. N7 (Ephialtes); no. N8 (Allectus); no. N10 (Erictypus); no. N11 (Biatas); no. N12 (Astarias); no. N14 (Mimon); no. N22 (Porphyrion). For other giant names, see for example LIMC IV 1988 s.v. *Gigantes* (F. Vian & M. B. Moore) no. 105 (Mimus); nos 106, 170–1 (Ephialtes); nos 116, 170 (Enceladus); nos 170–1 (Polybotes).

[37] See above, p. 53–4.

[38] Cf. Schober 1951: 85.

[39] The interpretation of this ordering finds support in the role, physical positioning, and label of Ge, who takes a literally mezzanine role in the arrangement.

[40] On the names of the giants, see Kästner 2004: 126–7, pl. 21.1–4; more generally also Massa-Pairault 2007a: 125–57. The meanings of the giants' names on the Great Frieze: Allectus – *the Unstoppable*; Eurybias – *the Widely Violent*; Maimaches – *Attack Man*; Mimas – *the Ferocious*; Molodrus – *the Muncher*; Obrimus – *the Sledgehammer*; Ochthaius – *the Gruff*; Olyctor – *the Destroyer*, Palamneus – *the Murderer*, Peloreus – *the Monster*; [Sth]enarus – *the Strong*; [Sty]phelu[s] – *the Rough*; Bro[nteas] – *Thunder*; [Char]adreus – *Earth-Fissure*; Chthonius – *Earth Man*; Chthonophylus – *Earth-Born*; Erysichthon – *Earth-Tearer*; [Phar]langeus – *Abyss Man*; Porphyrion – *the Billower*; Oudaius – *the Subterranean*.

[41] This unusual appropriation of natural forces for the personas of the giants here also means that most giant names on the Great Frieze are unknown from other sources. In the case of the

sources report names that reference only the strength of the giants, not nature: Mimas features in Apollodorus;[42] in other sources we encounter Obrimus and Peloreus.[43]

The second type of gradation on the Great Frieze also plays up this characterisation of the giants as creatures of the wild who are set against the gods, distinguished as ruling over nature's forces. On the side of the gods, this distinction is expressed in the animals accompanying them as attributive indices.[44] These animal satellites fulfil two distinct roles. First, when participating in combat, they mark the engagement as particularly fierce. On the south end of the east frieze, Artemis and Hecate both fight accompanied by a Molossian dog (figs 2.11, 2.7); and so too does Asteria, in the east corner of the south frieze (fig. 8.6c).[45] On the north frieze, Ceto/Moira is supported by her satellite, a lion whose paws hold the giant in front of the goddess. Directly adjacent, a giant is attacked by the three satellites of Poseidon: a *ketus*, another sea snake, and one of the hippocampi drawing Poseidon's chariot (fig. 5.5).[46] Similarly, the eagles of Zeus – one next to him (fig. 2.5), one in the west corner of the south frieze (fig. 8.6a), another two in the corners of the frieze on the north and south projection (figs 8.3, 8.4) – emphasise the heat of battle.[47] Second, when the animals are not engaged in battle, their presence underscores the noble sovereignty of the gods. This interpretation applies to the fourth eagle of Zeus, majestically sitting on the thunderbolt in the western corner of the south frieze, and to both Rhea and Eos, in the same vicinity, who are riding a lion and a horse respectively (fig. 8.6a).

The giants are defined not by animal satellites but by virtue of displaying animal features as part of their body. Prominent are the basilisks of their

gods, the situation is different: their names, albeit at times remote, are attested throughout, even if not in all cases related to the gigantomachy. Simon 1975: 50–1 provides a complete list of the two-thirds of gods who on the Great Frieze are included in a gigantomachy for the first time: Oceanus, Thetis, Doris, Nereus, Triton, Pontus, Ceto, Graiai, Moirai, Hesperides, Nyx, Aether, Hemere, Phobus, Phaethon, Heous, Dione, Four Winds, Leto, Hecate, Asteria, Phoibe, Themis, Ouranos, Astraius, Mnemosyne, Eos, Tithonus, Iapetus, Clymene, Semele, Maia, and Nymphai. See also Kähler 1948: 108–9.

[42] Apollod. 1.6. See Fränkel 1890: 65, n. 73a; Smith 1991: 164.

[43] Simon 1975: 41. Obrimus: Fränkel 1890: 65, n. 116 (known from a scholion to Hesiod's *Theogony* 168). Peloreus: Fränkel 1890: 66, n. 70b (known from Nonnus 48.39); Kästner 1994: 132.

[44] Another means of expressing this distinction is the number of victims which surround individual gods; here, Zeus, Artemis, and Triton are singled out specifically: see above, pp. 64–5.

[45] Queyrel 2005: 137 follows Massa-Pairault's (and Carl Robert's) suggestion that these dogs, and the lions of Rhea and Semele, could be icons of star signs (Massa-Pairault 2000: 23–37).

[46] On the composition, see Prignitz 2008: 26; contra: Simon 1975: 9.

[47] Erika Simon assumes that the eagles – as the messengers of Zeus – underline the religious function of the building (Simon 1975: 6).

Fig. 5.5 The Great Frieze, north: Poseidon with his animal satellites. Berlin, Staatliche Museen.

snake legs, which mostly and rather ineffectively attack only the shields of the gods. Other mergers can be found too: on the corner of east and south frieze, Leto's opponent has bird wings and claws; the giant approaching Phoibe has pointed ears and horns with scales;[48] further on the south frieze, the giant wrestling with Aether sports a lion head and paws, and snake legs that support him in combat.[49] Another giant, the largest of all those on the frieze, has a bull's neck and tail.[50] Then, on the south projection, Bronteas ('thunder') wears a panther skin with the head and mouth wrapped around his left arm as if the animal is still roaring – or indeed thundering – against the goddess who attacks the giant from below (fig. 8.4).

The use of animal features and satellites for indexical characterisation functions in the same way as the name labels. They create coherence in the negotiation and anchoring of both gods and giants in the realm of myth by characterising the two parties by the same means. Yet simultaneously they

[48] Kästner 2004: 44.

[49] von Salis discusses the peculiarities of this arrangement at length, connecting it to the Lysippan depiction of Heracles (1912: 85–92).

[50] Because of the size of this giant, he has been frequently referred to as Typhon. See Simon 1975: 38.

contrast the two spheres particularly starkly: the gods have command over the forces of nature while the giants are merely a wild component of nature. Where the satellites portray the gods as distinct from animals and yet also so powerful as to be able to enlist them for their cause, the animal features of the giants underline not their mastery of nature, but their dependency upon it.

The vertical hierarchy instilled by this gradation is contested on the Great Frieze in only two instances. The first case in effect also clearly confirms the norm: the only god who is defeated by a giant, on the north frieze, is depicted wrapped into the snake legs of his opponent. In the moment of his demise, he therefore loses his divine character and finds himself turned into a giant-like halfling.[51]

The second case is more ambiguous: on the north projection, Triton – half man, half hippocamp – shows no structural difference from the giants with snake legs (fig. 2.14). What is more, his appearance on the Great Frieze highlights his hybrid nature, for here he is shown for the first time as an ichthyo-centaur and no longer as human or half-human with fish tail.[52] Yet in his action, Triton is characterised in strong contrast to the giants. He, along with Zeus, is the only participant on the frieze who takes on three opponents. He also shares another feature with Zeus: just as Zeus' aegis merges with the fleece his opponent uses to protect himself,[53] so too Triton's left hand blends into the lion skin with which the giant still standing is attacking him. In the case of Triton, what puts him at odds with the other gods, his hybrid nature and ability to amalgamate other entities, appears to be essentially a sign of superiority shared only with the foremost Olympian.

Syntactics.

Alongside the vertical hierarchies prefigured in the name labels and animal indices, the syntax of the Great Frieze is shaped by its layout according to div-ine family units and spheres of activity: the children of Gaia and Ouranus, split into the Olympians on the east frieze and the south projection, and the Titans on the south frieze; the gods of fate in the middle of the north frieze; the children of Pontus around the north projection; and a tableau of gods of the earth and the sea on the south and north projections respectively.[54] This design

[51] Simon 1975: 25 compares the situation with that of the Laocoon group.
[52] Simon 1975: 52. See LIMC VIII 1997 s.v. *Triton* (N. Icard-Gianolio).
[53] Simon 1975: 18.
[54] Hesiod, *Theog.* 105–7. Allocation according to Simon 1975: 5–6.

emphasises divine order as the organisational principle of what is on display and thereby fulfils an important indexical function. This strategy is corroborated by the eagle of Zeus, which serves as a bracketing device in four locations on the frieze. The animal satellite is both an active participant in the battle and, at the same time, an iconic symbol of the ultimate divine power, namely, Zeus.

The overall tone of the depiction is enhanced by the architectural framework of the Great Frieze and by the way in which the two, the building and the frieze, are intertwined. First, one of Zeus' attributes – the thunderbolt – reoccurs on a capital of the upper colonnade of the Great Altar, indicating that the building as a whole is subject to the principles of divine order that govern the frieze.[55]

Second, the frieze ends where the body of the building gives way to the supra-structure at the end of the stairs. It does so by tapering out, following the elevation of the stairs. This alignment of the narrative with the architectural space, the former giving way to the latter, is further enhanced by the appearance of an eagle in each of the upper corners of the frieze (figs 8.3, 8.4). But because in both cases they are depicted battling away from those corners, the eagles throw movement back into the frieze, thus rendering the action on display perpetual.[56]

This coherent framework of divine relationships and correspondence of building and content is challenged from within by the modes of fighting displayed across the sides of the altar, thereby gaining semantic value. They introduce horizontal hierarchies between the gods,[57] whilst also establishing relationships between some divinities who are not connected by virtue of belonging to the same family group. This phenomenon is noticeable in particular in a comparison of the north and south friezes. The former shows a large number of individual close-combat groups, and specifically gods attacking or having killed a giant with a close-combat weapon, such as a stake or a sword, for example, in the case of Enyo or Stheno. In contrast, the latter displays a considerable number of gods not involved in active combat, or only participating by means of a long-distance weapon or from a riding animal, as in the case of Rhea, Eos, Selene, and Helius (figs 8.6a, 8.6b).

[55] The occurrence of the thunderbolt on the capitals has been taken as evidence that the Great Altar was dedicated to Zeus, but otherwise no strong evidence with regard to the deity worshipped here exists. See above, p. 12.

[56] Quyerel 2005: 136 argues that the appearance of the two eagles is a reference to Delphi and its *omphalus*, its location established by the re-encounter of the two eagles after they have encircled the globe.

[57] For the number of opponents individual gods face as a means of horizontal hierarchisation, see above, pp. 64–5.

The differing rhythms of the combat on the two sides of the frieze are to an extent offset by the fact that both sides depict an instance of multiple gods fighting against one giant, in both cases with the action developing away from the western front of the altar. In the north, Poseidon's opponent is attacked by the god himself and his three satellites (fig. 5.5). In the south, the bull-giant is brought down by three gods: from the left the god with the double-axe (Iapetus?) moves in;[58] from the right, Eos approaches on her horse, probably attacking him with a torch;[59] from underneath, an older god (Tithonus? Cephalus?)[60], forced down on his knees, provides the final blow, ramming his hunting stake with both hands into the giant's torso. This compositional correspondence continues on the north and south projections of the western front of the altar, both of which show combat groups welded around a pyramidal core of a god fighting a giant. This design allows the whole entrance of the altar to appear particularly symmetrical.

Three action schemes emerge from this syntactic framework and establish a narrative. The myth of the gigantomachy is as much about a collective of ingenious combatants, the gods fighting together, as it is about preserving the order of the cosmos.[61] The first action scheme is concerned with both these aspects, and it is constituted by symbolic code as conveyed by the satellites who serve as indices of the gods. This function applies to the animals, and specifically to the eagles, but it also holds true for Nike accompanying Athena and for Eros assisting Aphrodite. These figures all emphasise the results of the divine efforts and point towards power, victory, and conquest. They also confirm the dominance of the divine collective and total destruction as a means of preserving order as central themes of the frieze.

The second action scheme, constituted by proairetic code, corroborates the theme of destruction by unfolding a panorama of different forms of defeat for the giants. This portrayal includes both scenes of conventional warfare and more unconventional encounters. Some giants are attacked with long-distance weapons, such as the wounded giant on the south frieze next to Phoibe (fig. 8.7). Others are battled in traditional pyramidal combat formation, as are the opponents of Phobus and Stheno on the north frieze. Meanwhile, some giants are defeated in ways not seen before in a gigantomachy: Aether's wrestling match against the lion giant on the south frieze has its only parallel in scenes of Heracles fighting Antaius.[62] Similarly

[58] Simon 1975: 37–9.
[59] Fragments of flames are positioned above the neck of the giant. See Simon 1975: 38.
[60] Simon 1975: 39 (Tithonus); Börker 1978: 286–7 (Cephalus).
[61] See above, p. 67.
[62] LIMC I 1981 s.v. *Antaios* I (R. Olmos & L. J. Balmaseda).

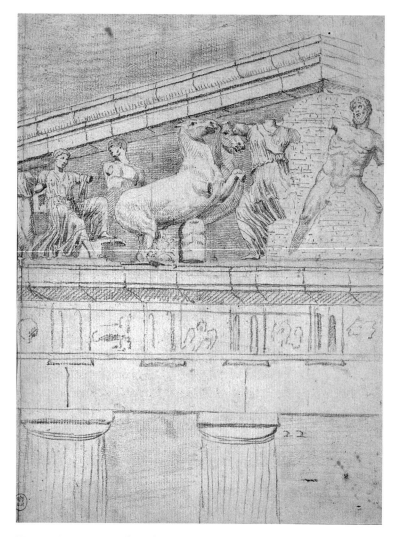

Fig. 5.6 An iconic template: the Parthenon west pediment, drawing by Jacques Carrey (1674). Paris, Bibliothèque Nationale.

exceptional is the way in which Aphrodite is crushing the face of a giant lying already dead on the ground (fig. 2.15). Along with the depictions of the violently contorted bodies of dead giants on the north and east frieze, the spectrum of destruction portrayed here emphasises the relentless annihilation of the giants, and in doing so puts emphasis on the process of keeping the cosmos in balance.

Finally, the third action scheme zooms in again on the theme of dominance, once more confirming the vertical hierarchy of gods and giants. This hierarchisation is achieved by a diversified use of semic and referential codes,

and specifically by employing iconographic templates for individual gods and giants who are charged with iconic meaning. Some giants are shown with traits that in Pergamene art are associated with Gallic warriors,[63] in particular tousled hair, drenched with limewater. While such depiction puts the giants in the same category as a mass of defeated enemies, some gods, by contrast, are rendered tantamount to beacons of cultural superiority, in particular on the east frieze. Here, three gods display elements that have traces in the real world: Zeus and Athena, who refer back to the depictions on the Parthenon west pediment (fig. 5.6);[64] and Apollo, who is depicted in the stance of a Lapith from the south metopes of the Parthenon,[65] or possibly emulating elements of the Apollo of Leochares.[66]

In addition, on this side of the frieze, the figure of Hecate bears reference to another statue group, albeit only indirectly. The three-bodied goddess advances against her enemy with a torch (fig. 2.7).[67] Furthermore, underneath the right arm in front holding the torch, two further arms appear clasping weapons. The arm closest to the relief ground holds a double-edged sword; the corresponding left arm must be that which appears above the shield of the outer Hecate body, holding a sheath forward. The arm in the middle holds a spear. With her six arms milling around her bodies, the Hecate group shows compositional resemblance with the Tyrannicides of Critius and Nesiotes, not least because Hecate's third body is almost entirely hidden, thereby emulating the motif that in the case of the Tyrannicides has been described by Richard Neer as 'with limbs radiating from a static, vertical core'.[68]

The three action schemes in operation on the Great Frieze shape a narrative with a clear structure but which is mainly static in character. A strong base line with horizontal coherence among the gods and vertical hierarchies involving the giants celebrate divine dominance and cosmic order as the status quo. This statement is complemented – through variation, not

[63] See Marszal 2000; Stewart 2000: 40; Mitchell 2003. On the Attalid monuments, see above, pp. 69–70.

[64] See above, pp. 62–3.

[65] Zinserling 1983: 102; Queyrel 2005: 158.

[66] von Salis 1912: 57–60; Kähler 1948: 116–17. Winnefeld 1910: 47 comments critically on the connection, remarking on differences with regard to style and motive: in contrast to the Belvedere statue the Pergamene Apollo was in the process of drawing an arrow from his quiver.

[67] For a detailed account of the composition, see Winnefeld 1910: 41–2. Hecate's tripartite body points back to Attic art: Simon 1975: 29, 53. For Hecate more generally, see LIMC VI 1992 s.v. *Hekate* (H. Sarian).

[68] Neer 2010: 83.

contradiction – by a three-part division of the altar, in which each part has a distinct narrative voice but no one part dominates the others: the frontal area around the projections is a tableau of destruction across different spheres of the world; the scenes on the north and south friezes are a monument to drastic forms of elimination; and the east frieze underwrites the account of divine victory by highlighting the cultural superiority of the gods.[69]

Pragmatics.

In archaic and classical versions of the gigantomachy, the myth serves to confirm a collective in its strengths and values by demonstrating that collective's victory over a group of serious opponents.[70] In the Great Frieze, this trajectory, whilst firmly anchored in the realm of myth throughout, is significantly extended in two respects, for while the theme of dominance is at the core, the frieze also negotiates discourses both around the past and around different states of being and belonging.[71] It is this latter discourse of being and belonging which guides the formulation of the other two, concerned with dominance and the past respectively.

 The exploration of the theme of being and belonging constitutes itself in three ways. The first sub-discourse is concerned with the pervasive display of the giants as chthonic creatures, reflected in their labelling and in their appearance with snake legs. The second sub-discourse negotiates the fluidity of existence, expressed once again in the characterisation of the giants, whose bodies can emulate animal features, but also displayed in those instances where bodies seemingly merge into each other and acquire each other's surface texture, as in the case of Triton and his opponent, or Doris' boot, which blends into the scales of the snake tail of her giant opponent where she touches him.[72] This fluidity is employed to throw into relief both the animalistic nature of the giants and the contrast that is the might of the gods, capable of altering the condition of things.[73]

 A third sub-discourse around existence is devoted to relationships of existence as represented by family unity. Most prominent here is the

[69] On the axial-symmetrical composition in general, see Pfanner 1979: esp. 50–7.
[70] See above, pp. 54–7.
[71] Simon 1975: 29 marks out mortality vs immortality as a central discourse.
[72] Simon 1975: 7. Compare, in contrast, Artemis or Ceto/Moira, whose boots, in a similar situation, do not assimilate the texture of the giants' bodies.
[73] Cf. also the depiction of Athena's magic powers separating Alcyoneus from the earth; see above, p. 52.

emphasis on mothers and sons, as with Semele and Dionysus on the south projection, but fathers and daughters also appear, in Zeus and Athena or Oceanus and Doris, and so do husbands and wives, such as Nereus and Doris.[74] The behavioural roles negotiated in this discourse consistently place firm emphasis on the bond between blood relatives – a bond that does not stop short of the giants themselves, as is evidenced in Ge's pain in the face of the demise of her son Alcyoneus.

The theme of dominance is shaped by this debate around being, existence, and belonging. With divine might displayed as rooted in family unity, this discourse is essentially concerned with social behaviour.[75] Here steely violence is employed to synchronise male and female behavioural roles on the side of the gods. The female divinities on the frieze execute more unusual brutal forms of combat. Whilst the gods are shown wrestling or stabbing their enemies with the usual combat weapons, the goddesses can maim their enemies with torches, let their animal satellites maul them, or simply tread on their bodies and faces. This non-conventional violence helps to situate the goddesses on a par with the gods: with templates of female combat few and far between, the power of the goddesses is here articulated specifically by the mode in which they defeat their enemies.[76]

There is a second layer to this female violence. The clash of gods and giants is a clash of social systems, with the giants an exclusively male entity. In light of these differing social systems presented here the emphasis on female brutality is also a statement confirming the importance of unity between male and female so as to maintain order, in this specific case the cosmic order at large.

Finally, aspects of being and dominance together shape the third discourse negotiated in the Great Frieze, that is, the relationship to the past. The depiction encompasses different aspects of dominance as expressed in the varying actions of the gods, reaching from sheer physical power, as in the case of Aether, to mastery of the magical, as in the case of Athena, and to noble sovereignty, including cultural superiority, as represented by Rhea or the emulations of classical templates, as in the case of Apollo, Zeus, and Athena, and possibly Hecate.

This recycling of iconographic moulds from the peak of Greek civilisation, reflected also in the symbolic code triggered by the choice of myth

[74] Cf. Fehr 1997: 49–50.

[75] Fehr 1997 understands this family discourse as synonymous with a discourse around belonging to a specific *oicus* and polis (esp. Fehr 1997: 59–60).

[76] I am grateful to Susanne Muth for her observations and comments on the matter. See also Neumer-Pfau 1983: esp. 76–9.

itself,[77] underwrites bold claims around cultural sovereignty. This loaning from the past is not without irony considering that the myth of the gigantomachy is in essence about the future and about the destruction of bothersome remnants of the past. Yet again, the cohesive forces that shape the Great Frieze, with the different discourses all intermeshed in order to celebrate the ethereal might of the gods against the chthonic magic of the giants, dissolve a potential ambiguity and turn it into a strong, consistent message.

3) The Louvre sarcophagus: thresholds of loyalty, conflict, and fate

Semantics.

The Louvre sarcophagus is shaped by processes of external and internal semiosis.[78] Externally, the relief is defined by the casket's use as a funerary container and its date based on its overall stylistic appearance.[79] Internally, two types of gradation can be observed, one playing out the relationship between classical Greek and the contemporary Antonine stylistic features characterising the relief, and the other negotiating the spheres of the mythological, the metaphorical, and the everyday.

The first type of gradation is expressed in the dressing of individual characters by means of their coiffeur. The hair of the two demons in the scene on the left is rendered in the 'experimental mannerism' associated with late Antonine art,[80] with deeply cut drill lines creating significant light-and-shadow effects, almost like woodcutting, although the arrangements of their coiffeurs otherwise differ (fig. 5.7, see also fig. 2.22). In contrast, the hair of most of the other characters on the casket, even where it shows traces of the drill, appears in an overall smoothened, more classicising treatment. In both these cases, the hair serves as a symbolic sign, in the sense that it can be related to a specific stylistic convention. The deeply drilled hair of the demons provides them with a certain dynamic,

[77] On the role of the gigantomachy in Athenian state art, see above, pp. 54–5.

[78] For a description of the casket, see above, pp. 14–16; for information about the myth depicted, see above, pp. 72–4.

[79] For its use and potential context, see above, p. 16. Traversari 1968 sees strong links between the deathbed sarcophagi and the Column of Antoninus Pius, assuming the same artist was in charge of the column and some of the sarcophagi. For a discussion of the relationship with contemporary public art, see above, pp. 85–7.

[80] Zanker & Ewald 2012: 249–50; cf. also Traversari 1968: 154–7.

Fig. 5.7 The hair of one of the female demons. The Louvre sarcophagus. Paris, Musée du Louvre MA 539. *c.* 190 CE.

with the light-and-shadow effects appearing to accelerate their actions. It also firmly grounds them within contemporary formal styles.[81] In contrast, characters such as Althaea and Atalanta appear as if part of another world, a *Greek* world.

There are also very subtle, but potentially meaningful, differences in the two appearances of Meleager, even if these do not establish quite such a clear dichotomy as in the case of the demons.[82] As he fights against the Thestiadae in the scene on the far right, his hair is pushed up over his forehead, with the locks a foam-like mass and not separated by as many drill lines as they are in the central scene, and his face appears more rounded (fig. 5.8b). This appearance of the Meleager in the scene with the Thestiadae, whilst displaying elements also present in the portrait of Pertinax in the Capitoline,[83] seems reminiscent of Lysippan

[81] On late Antonine style, see above, p. 85.

[82] For the iconography of Meleager, see also above, p. 72 n. 128.

[83] Type 'Capitoline – Toulouse'. Rome, Museo Capitolino n. 391. 193 CE. Fittschen & Zanker 1985: 90–1 n. 79; Fittschen 1999: 75–7. Fittschen notes the significant differences from Antonine portraiture. Therefore, even if one disagrees about the Lysippan influence, the stylistic difference between the two Meleager depictions on the casket is clear. Particularly interesting is that the carving seems to be coherent across the casket as a whole, i.e. it was all executed by the same hand; my thanks to Mont Allen for kindly sharing this observation.

(a)

Fig. 5.8a Meleager on the bier. The Louvre sarcophagus. Paris, Musée du Louvre MA 539. *c.* 190 CE.

characters.[84] This would throw into relief the character's realism and active and dynamic power by aligning him with representations of other famous mythological heroes such as Heracles.[85] This connection would also underpin his mythological qualities and it would furnish him with specific values more generally associated with Lysippan characters in Roman culture: *veritas* and *pulchritudo*.[86] The hair and face thus serve as symbolic signs, but with notions of iconicity: this representation does not merely follow stylistic conventions, for it points to specific representations – the sculptures of Lysippus – in order to imbue the depiction with contemporary relevance.

In contrast, Meleager's appearance in the central scene is more iconic of a *Zeitgesicht*, a period face, the popular means of rendering oneself in Roman private portraiture (fig. 5.8a).[87] While his hair does not match the contemporary execution of that of the two female demons on the left, it still shows more similarities with the types of coiffeur prevalent in Antonine portraiture than with the hair of the figure of Meleager on the right.[88]

[84] Stewart 1978: 308–12, 473–5; Moreno 1995; Edwards 1996.

[85] For Lysippus' execution of Heracles, see Moreno 1995: 266–77.

[86] Hölscher 2004: 94–7.

[87] For the notion of *Zeitgesicht*, see Kockel 1993: 67; Zanker 1995.

[88] Cf. for example the portrait of Marcus Aurelius in the 'Ufficii – Toulouse type', San Antonio, Museum of Art no. 85.136.1. Fittschen 1999: 22–3 no. B5. For an overview of Antonine portraiture, see Wegner 1939.

(b)

Fig. 5.8b Meleager fighting the Thestiadae. The Louvre sarcophagus. Paris, Musée du Louvre MA 539. *c.* 190 CE.

These two iconicity-infused presentations blur the line between the mythological sphere and the world outside the casket, but they do so in different ways. The figure of Meleager in combat metaphorically conjures up contemporary value sets because of his (Greek) stylistic appearance and because his action is adapted from mythology: the sword makes clear that this is no ordinary hunting adventure, and the boar hide highlights that this is no ordinary sword combat.[89] The hero on the bier, in contrast, enacts contemporary protocols of dying and being mourned, facilitated by the idealised iconicity of his facial appearance, which is similar to the actual portraits that sometimes adorn the bodies of mythological characters on sarcophagus reliefs from the late second century onwards and throughout the first half of the third century.[90]

Other characters add to the exploration of the boundaries between mythological Greek and contemporary Roman spheres. All three demons, two on the left and one on the right, bear attributes that locate them outside the sphere of the normal, but they do so at differing intensities. The demon with wings on her head and thrusting a torch behind the altar is characterised as belonging to the sphere of the mythological (figs 0.3, 2.22).[91] The demon's mythological presence serves as an external indexical sign for

[89] On the weapons of Meleager, see above, pp. 74–5.
[90] Newby 2011, with further bibliography; Zanker & Ewald 2012: 39–44.
[91] For the iconography of the figure, see above, pp. 80–1.

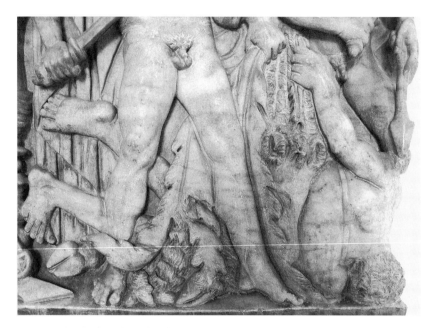

Fig. 5.9 The dead uncle and the boar hide on the Louvre sarcophagus. Paris, Musée du Louvre MA 539. *c.* 190 CE.

Althaea, whose appearance lacks defining attributes other than her action of burning the log on the altar. The demon's mythologically marked appearance also differentiates her from her two companions.

The appearance of the demon on the left and her writing action cannot vouch for her mythological quality (fig. 5.7). Only the wheel on which she has put her foot indicates her stake in another sphere. Such a wheel appears frequently with figures indicating destiny, especially Nemesis.[92] With the wheel as an attribute, this demon therefore has a stake in the metaphorical, impacting both the realm of the normal and the realm of the mythological. The demon on the right has a similar presence (fig. 0.3). The stick in her hand, possibly a scourge, is not strong enough an indicator to place her in the mythological sphere, but with her short hair and with her calm presence seemingly at odds with the brutal fighting around her, she also takes a place in the metaphorical.[93]

One further negotiation of boundaries is served up by the dead uncle on the left. His twisted body is intertwined with the boar hide, turning

[92] For depictions of Nemesis with a wheel in Roman contexts, see LIMC VI s.v. *Nemesis* (F. Rausa).

[93] On other sarcophagi of the deathbed group this character holds a similar implement; on the casket in the Capitoline Museums she has a snake in the other hand; see above, p. 73 n. 133 (4).

each into an index of the other and generating a creature both human and beast at the same time (fig. 5.9). The body of the uncle is thus dehumanised, and he, like the hide, has become a hunting trophy. The tableau of uncle-cum-boar thus also marks the action carried out by Meleager quite literally as a perversion – it is an index legitimising Meleager's assault on the remaining uncle, who also can be regarded as nothing but an animal, and a symbol of Meleager's transgressive powers, for he can turn humans into animals.[94]

Syntactics.

The main drive behind the relief's syntax is the compositional distribution, which groups the characters into three distinct scenes. The central scene with its six figures takes most of the space and features the largest cast; the scenes on either side comprise three characters on the left and four on the right. Each scene is composed in strong diagonal lines, meeting in an apex over the middle of each scene. Each scene also features markers of its location, but in this respect different practices are at play: whilst the location markers in the scene on the left and in the centre – the altar, the stool, and the bier – have indexical value within the scene, specifying the actions on display, the two markers in the scene on the right – the *parapetasma* and the tree – have an iconic function, conjuring up the indoors and the outdoors, respectively.

But the role of the *parapetasma* goes further. It may primarily serve as a partition between the scene in the centre and that on the right, but by virtue of being in the Thestiadae scene, it is also turned into an attribute for the fighting Meleager.[95] It links him with his alter ego on the bier, and also renders him with a strong connection to the domestic context and to civilisation more generally. In turn, the tree that appears to grow out of the fighting uncle relates him to the wild,[96] in an analogy with the indexical meaning of

[94] Some Antonine sarcophagi depicting galatomachies provide a similar visual, in which a Galatian is depicted slipping off his horse with his limbs intertwined with those of the animal, prominently on the Amendola sarcophagus: Rome, Museo Capitolino no. S213. La Rocca & Parisi Presicce 2010: 310–23. The motif reoccurs on a sarcophagus in Rome, Villa Doria Pamphili and another piece in Rome, Museo Nazionale no. 108437. See Andreae 1956: 49–52; Faust 2012: 177–96, esp. 195–6.

[95] Cf. the differing placement of the *parapetasma* on the relief in Museo Capitolino (see above, p. 73 n. 133 (4)) to the Louvre sarcophagus; in the former depiction it clearly concludes the scene around the bier, without overlapping with the Meleager fighting the Thestiadae.

[96] This feature is unique to the Louvre relief: if a tree is depicted in the scene with the Thestiadae, it is on Meleager's side of the quarrel; see the reliefs in Ostia (see above, p. 73 n. 133 (1)) and Wilton House (see above, pp. 73–4 n. 133 (7)); an exception might have been the piece only extant in a Coburgensis drawing (see above, pp. 73–4 n. 133 (15)).

the boar hide for the dead uncle, underscoring the difference between the Thestiadae and Meleager by locating them in distinct spheres of existence.

The *parapetasma* facilitates a relationship between the two Meleagers that cuts across the compositional compartmentalisation and across the differentiation of the two Meleagers by means of their hairstyles.[97] This relationship, then, also helps to highlight the fact that each of the Meleagers conjures up the attention of most of the other characters in his respective scene, thereby marking them both out as action hot spots.

On the opposite side of the central scene this relationship of the two Meleagers is complemented by another relationship that cuts across the compositional partitioning: the connection between Atalanta and Althaea. Theirs is an altogether more unlikely pairing, and it is not established by attributes. They are carved on the same plane, the uppermost relief plane, and in addition, these figures are the only characters across the three scenes who are not turning their faces towards the scene's action. Althaea's glancing away from the action around the altar means that her gaze is directed towards Atalanta (fig. 2.22).

The resulting connection between the two characters is syntagmatic in that they belong to the same myth, but it is also paradigmatic in that both women are shown at the moment of a traumatic encounter that makes them avert their gazes – each in a different way, with one seated statically on her chair and the other performing a dynamic sweeping motion of evasion. Here, then, is a structural difference from the symmetrical arrangement of the two Meleagers. While the men canvas different stages in life, in a temporal tableau, the women display two different facets of negotiating trauma, a qualitative tableau. One further connection cuts across the three-scene composition, that between the three demons, whose relationship, too, is syntagmatic, because together they appear as if the Moirai/Parcae,[98] whilst at the same time they are also connected paradigmatically, because each of them points to a different shade of fate or vengeance. Their presence amalgamates the concepts of Fates and Furies.

From this framework a range of action schemes emerges, driving the narrative by mixing proairetic, symbolic, semic, referential, and hermeneutic

[97] This establishing of relationships across individual scenes can be observed on various sarcophagi from the second half of the second century CE, pointing to the complete abandonment of individual scenes in the reliefs after the late Antonine stylistic change; see the compositional differences between the Louvre sarcophagus and the earliest deathbed sarcophagus in Ostia (see above, p. 73 n. 133 (1)) with its clear separation of scenes, enforced by attributive markers, a wall and a statue of Artemis on a high pedestal.

[98] For the iconographic relationship between the three demons of fate here and depictions of the Moirai, see above, pp. 80–1.

codes.[99] The proairetic coding of the relief shapes a sequence of combat, dying, and mourning, with the symbolic coding highlighting love, despair, anger, and revenge. In addition, the double appearance of Meleager is characterised by semic and referential coding, aligning him with the activities and virtues of a Roman citizen.[100] Other characters display elements of this coding, too, but not to the same extent. A particularly complex case is the figure of Althaea, whose action puts her close to Roman religious practice whilst at the same time the inversion in which it appears here fuels hermeneutic coding.

In the myth of Meleager, Atalanta, and the Calydonian boar, love, envy, and vengeance are the central action schemes. The Louvre sarcophagus emulates these action schemes, separating them into different trajectories and with differing protagonists, one dedicated to love (the scene in the centre), another to a mixture of envy and vengeance (the scene with the Thestiadae), and a third to vengeance and fury (the scene with Althaea at the altar). These action schemes are presented one per scene, yet again a continuous effort is made to interweave their trajectories.

The central scene puts emphasis on love, with a sub-scheme of loss. Love is expressed here at the point of its rupture, in the juxtaposition of the figures of Meleager and Atalanta, who are orientated towards each other but are not interacting. Their mutual failure to connect, albeit for different reasons, underscores the scheme of loss. That theme is elaborated further by a disconnect amongst the informants, with the four mourners all directing their attention to Meleager, whereas Atalanta conjures up only the attention of her dog.

The quintessential power of the action scheme of love on the relief comes also from its driving of a wedge between the action schemes of vengeance furnished by the scenes to its sides. Both these action schemes display vengeance at the point of execution, with the killing of the uncles and the burning of the log constituting in each case an act of retaliation, and do so with a complementary juxtaposition of the genders, with male vengeance on the right, female on the left. Each also provides a causal explanation: on the right, it is envy as expressed in the dead uncle still clutching the boar hide; on the left, it is fury, as personified by the demon behind the altar.

Love might be the dominant action scheme, but a more sinister undercurrent rubs up against that theme, served up by the three demons, the characters who connect the separated scenes of vengeance. Their appearance

[99] For these categories, see above, pp. 112–3.
[100] For a discussion of the virtues depicted in the scenes, see above, pp. 83–4.

on the left and right of the relief provides a framework that threatens to swallow the love scheme, thereby producing a delicate balance between the two themes – a balancing act further enhanced by the fact that Althaea and Atalanta on the left and the two Meleagers on the right have stakes in each other's scenes and action schemes.

The fabula of Meleager on the casket is told from two perspectives. A male voice is constituted in Meleager's action on the right and draws in his otherwise passive alter ego on the bier; this voice organises the myth as a clear sequence of cause and effect, from combat to death, and as a related showcase of virtuous male behaviour. But there are competing female voices, most distinctly, that of Atalanta, who, sandwiched between mother and *nutrix*, serves both as an end point of Althaea's despair and as a starting point for the mourning of Meleager. Her voice organises the myth as a complex web of fate and destiny, from love to anger, and as a showcase of familial grief and despair.[101]

This second narrative voice, that of Atalanta, dominates the first voice because of the number of characters that participate in it and because of the interconnection of the scenes on the left and the right generated by the demons. The scene on the right with its one demon appears as if a satellite of the scene on the left. This bracketing also means that the linearity of the first narrative voice is dissolved in the second, thereby prising apart the sequentiality of that first voice such that it can form additional nodes in the web of fate and destiny.

Pragmatics.

In Roman antiquity at least, the myth of Meleager stood for a strong bond between two capable partners, a man and a woman, as expressed in the relationship of Meleager and Atalanta and in their physical attractiveness that stemmed from their associations with the outdoors. This reading can include notions of *matrimonium*, as manifest in a funerary inscription on the tomb of the freedwoman Allia Potestas from the early second century CE, in which the husband celebrates the physical features of his wife, along

[101] Atalanta's role is supported by the shield next to her and its shield sign: a gorgoneion – a feature shared by all deathbed sarcophagi except for the pieces in Villa Albani and the Torno Collection (see above, pp. 73–4 n. 133 (3, 5)); of the sarcophagi in Paris, Studio Canova and Castel Gandolfo not enough is extant to discern what was depicted there (see above, pp. 73–4 n. 133 (2, 6, 8)). Gorgoneia appear frequently on all types of sarcophagi as an apotropaic element employed to guard the tomb and the dead within, see Koch & Sichtermann 1982: 226–8.

with her qualities as *univira*, the ideal of the Roman matron, by paralleling her with depictions of Atalanta on stage.[102]

The depictions on the Louvre sarcophagus both extend and problematise this conventional reading. Here, the dominant themes as informed by the action schemes are loyalty (in love and within the family) and, intertwined with loyalty, conflict and, finally, fate. These themes shape three discourses, around gender, behavioural roles, and death. Underpinned by the prevalent semic and referential coding of the Louvre sarcophagus, these discourses invite a reading as a real event,[103] with the mythological content freely perused in order to throw into relief contemporary sentiments.

The gender discourse is constituted by the juxtaposition of male activity on the right and female activity on the left and by the central scene and its combined activity of different age groups. Through this arrangement, the younger male as portrayed by Meleager is presented in a twofold role, as guarantor of love and loyalty, because he defends Atalanta's honour, and as destroyer of family bonds, because by killing her brothers he is unfaithful to his mother. On the female side, this ambiguous construct is matched by the figure of the older woman, Althaea, who mirrors Meleager's combined loyalty and unfaithfulness, in her case towards her brothers and against her son. What differentiates the two is that (dis)loyalty performed by combat is displayed as male, while (dis)loyalty performed by sacrificial magic is female.

The ambiguities inherent in the figures of Meleager and Althaea also fuel the second discourse, around behavioural roles, with the Louvre relief essentially serving as a triptych of behavioural roles for the male, the female, and the family. Buttressed by utterances of male and female virtue, articulated in combat and grieving respectively, this discourse is welded together around the theme of loyalty. Generally, on the casket, loyalty finds expression in its negative form as vengeance and in its positive form as empathy. Whilst the former is the preserve of Meleager and Althaea, the latter is confined to the female characters and the old man in the central scene. Interwoven with this theme are discussions of loyalty to a partner and to the family. The first, loyalty to a partner, is expressed in Meleager's assault on the uncles and in

[102] CIL VI 37 965; see Gurlitt 1914–16; Hesberg-Tonn 1983: 183–6, esp. 185. The notion of *matrimonium* is particularly prevalent on mosaics of the high and late empire: Raeck 1992; Muth 1998: 203–5; Muth 1998: esp. 322–4; Muth 1999; Lorenz 2008: 75–8; Zanker & Ewald 2012: esp. 62–70.

[103] This reading as 'real' comes even though the Louvre sarcophagus does not include a 'real' funerary scene, unlike the first deathbed sarcophagus in Ostia: see above, p. 73 n. 133 (1).

Atalanta's grieving – activities that in both cases are problematised by their surroundings: the dead body on the bier and Althaea's sacrificial act.

The second strand, loyalty towards the family, focuses on the relationship of young and old. In a straightforward form, this transgenerational association is shown by the joint effort of young and old mourners at Meleager's bier, with the added edge that here the old are not mourned by the young, as according to the natural course of life, but the young by the old.[104] In a more complicated form, this theme is explored in Althaea's action as she puts an end to her offspring's life.

Yet again, the relief marks out the behaviour of the couple, Meleager and Atalanta, as fundamental for and dominating any discourse around social roles within the family. Their characters serve as hinges of the composition and, in the central scene, are prominently placed on furniture with a clear stake in the real world. Meleager and Atalanta serve as the frame of the family unit in both literal and figurative senses, providing a framework within which other family members move like satellites. This structure turns the family members into indexical informants for the couple, who as a tableau then transmit values of *matrimonium* and *concordia*.

The third discourse, around death, serves as a bracketing device for the other two discourses, on gender and behavioural roles, and provides an explanation for the stark ambiguities that shape the male and female roles depicted on the casket. This discourse is driven by the theme of fate as presented in the three demons of fate and their actions. It functions as a fundamental theme for the depiction as a result of its scaffolding through the distribution of the demons across the scenes.

Death, as shaped by fate, is presented as the great leveller: it connects the boar, Meleager and Atalanta, the uncles and Althaea, and binds together expressions of loyalty and unfaithfulness, virtue and misdemeanour. In this sense, the discourse around death gives the depiction and its content a clear trajectory and provides a foil for the other two discourses.

Some of the strategies employed on the Louvre sarcophagus can be found across the group of deathbed sarcophagi, but none of the other reliefs in this group grants such a decisive framing role to the demons of fate and thus to the discourse of death. Also, no other piece carves out in anything like the same way male and female roles as on the Louvre relief for Althaea/Atalanta and Meleager/Meleager.[105] In its combination of affirmative presentation

[104] Note the difference from the depiction of the Death of Patroclus on the Pianabella relief, where the dead figure on the bier has a beard, whereas the mourners surrounding him are beardless and so depicted as more youthful. For the Pianabella sarcophagus, see above, p. 76.

[105] For an iconographic analysis of the deathbed group, see above, pp. 74–84.

and elements of *consolatio ex negativo*, the relief presents a version of the Meleager myth that easily matches the narrative complexity of Ovid's text with its different narrative perspective, and the relief also provides a two-pronged approach towards what might be regarded as appropriate funerary rhetoric.

6 | Narratives of sign and signification

1) Semiotics as experiment: the results

Semiotics invests in the understanding of cultural utterances in whatever medium, with a focus on the production of meaning from signs. Semiotics postulates that the relationship between sign and meaning is arbitrary, not natural – hence its interest in the processes within which meaning is created. This interest is put into practice by zeroing in on modes of content transmission at play in a picture, breaking the depiction down into a range of vertical and horizontal relationships and assessing their share in meaning production.

At the stage of semantic analysis, the case studies demonstrate three strengths of the semiotic approach. The first is its ability to facilitate a survey of the different media employed in a picture, alongside establishing their individual contributions to the overall content. In the case of the Karlsruhe hydria and the Great Frieze, this approach provides the toolkit for an exploration of the role of the name labels employed in the depictions and their relationship to the figural representation. The labels are a vital feature of the two depictions, since – as becomes clear from a comparison with conventional patterns of display for these two myths – not all representations of the Judgement of Paris and the gigantomachy feature such labelling.

Semiotics' ability to differentiate between the transmission strategies of the individual media as executed here also reveals a crucial difference from the iconological approach. The latter takes a label as merely referential to the depiction,[1] but in semiotic analysis, the relationship of depiction and label is understood to be differential. These approaches lead in turn to distinctly different results, as is particularly obvious in the case of the personification Eris on the Karlsruhe hydria (fig. 5.1): seen through the prism of iconology, the figure forms part of an iconographic change during the latter part of the fifth century and is indicative of a growing interest in the

[1] The iconological analyses of the Karlsruhe hydria and the Great Frieze function without reference to the respective labels.

personal conditions of the individual and the causality of historical events;[2] seen from the viewpoint of semiotics, Eris embodies the discourse around the divine and mortal played out on the vessel, sharing characteristics of both types of depicted figure.[3]

A second strength is found in semiotics' ability to differentiate in a meaningful way between forms of stylistic appearance. On a first level, this aptitude offers a gateway into exploring the branding of an individual depiction, as is the case with the Karlsruhe hydria and the Louvre sarcophagus. On a second level, this capability facilitates the assessment of different formal and stylistic elements within the same picture. Both the Great Frieze and the Louvre sarcophagus offer such examples in emulating different classical and contemporary artistic elements, which convey specific characteristics for individual figures, as seen in the juxtaposition of Lysippan and Antonine Meleager (figs 5.8a and b).[4] In an iconological approach, such stylistic discrepancies are assessed only on the level of pre-iconographic analysis, where they are understood as crucial for establishing the historical context that is tackled in the iconographical analysis, not as defining the picture's strategies in conveying content.

A third strength is semiotics' ability to differentiate between metonymic and metaphorical forms of representation. In the case of mythological images, this ability is realised primarily in assessing the relationships of differing elements – the mythological, the divine, the everyday, the wild, etc. – inherent in individual representations. The iconological model offers the means to track such aspects on the level of iconographic comparison, too, but it regards these aspects as deviations from a conventional template that are to be synthesised, not as elements that purposefully shape relationships within a picture. This capability for differentiation plays a crucial role in all three case studies. For the Karlsruhe hydria and the Louvre sarcophagus, it makes it possible to fan out the shades of meaning embodied by the different personifications, such as Eris or the Moirai/Parcae.[5] For the Great Frieze, it can tease out how the depiction contrasts the giants' share in nature with the gods' command over it.[6]

At the interface of semantics and syntactics, the semiotic approach provides yet another way of reaching into the depiction, once more based on the method's concern for relationships between different types of utterance: by

[2] See above, pp. 45–6.
[3] See above, pp. 119–20.
[4] See above, pp. 141–2.
[5] See above, pp. 119–20, 143–5.
[6] See above, pp. 130–3.

accounting for all types of element within a picture and the ways in which they shape meaning, and not only for figurative elements and their connected attributes, as is the case in iconological analysis. Across the case studies, this feature is of particular importance for the analysis and interpretation of the Karlsruhe hydria, where it facilitates an assessment of the landscape elements within the scene and, more remarkably, of the decorative bands framing the pictorial areas.[7]

Most crucial at the level of syntactics is that semiotics provides the means for an exploration of the connections between the individual elements of a picture – not in the sense of a taxonomy, as is achieved by a compositional analysis, but in establishing the action schemes fuelled by the elements of a picture and their vertical and horizontal relationships. Where iconology at the stage of iconographic analysis produces an understanding of the narrative structures of a picture by means of external prosthetics – that is, through iconographic comparanda – semiotics draws out that understanding from within the picture itself.

This ability of semiotics to zoom in solely on the picture facilitates an assessment of the narrative strategies with regard to the action codes at play and, shaped by them, the narrative voices. Such an assessment provides insight into the way in which individual myths are appropriated in the visual. This functioning of semiotics is particularly noticeable in the case of the Karlsruhe hydria and the Louvre sarcophagus, with the mix of narrative voices thus established for each picture more complex than would conventionally be expected of the respective myths, which are both welded to an individual character, Paris and Meleager respectively.[8]

The action codes are valuable for establishing not only the narrative principles within the picture, but also its relationship to the world outside, thereby putting to good use both Derrida's claim for self-referentiality and Eco's notion of the open artwork. Semic and referential coding is especially valuable here. The more a picture is filled with these two types of code, the better this method can tease out comments on social reality, as the Karlsruhe hydria and the Louvre sarcophagus powerfully exemplify. This focus also helps to draw out that the state monument, the Great Frieze, differs from the two privately commissioned case studies in the way in which all semic and referential coding is interwoven with symbolic coding.[9]

[7] See above, pp. 122–4.
[8] Discussions of the two depictions in scholarship usually focus on these two characters. See above, pp. 37–41, 71–5.
[9] See above, pp. 134–7.

At the level of pragmatics, the semiotic approach identifies the discourses shaped by the depiction. This concludes the assessment of the 'how' of the picture's presentation. By contrast, the final stage of the iconological approach, the synthesis, focuses on the 'why' of the depiction. The strength of semiotics is its drawing out the operational dimension of the individual elements of a depiction, dissecting their formulation rather than what they represent with regard to the underlying myth. This focus is particularly valuable for establishing differing discourses that might be connected to specific uses and functions of a picture – in contexts such as the domestic, as in the case of the Karlsruhe hydria; state religion, as in the case of the Great Frieze; or the funerary sphere, as in the case of the Louvre sarcophagus. This focus also aligns semiotics with the objectives of a *contextual-differentiating* approach, even if semiotics is not actually concerned with the physical context of the picture.

Yet certain challenges for the semiotic approach emerge at the stage of pragmatics. This approach might not be limited by the natural boundaries of the depicted story with regard to the scope of its interpretation, but, on the flipside, this freedom brings with it a certain indifference towards the underlying myth. Whilst semiotics' lack of concern for the natural boundaries of a story might redress the bias of those iconological studies that employ literary sources as the sole key for interpreting visual versions of a myth, it generates problems at the opposite end of the scale. In semiotics, the myth is subsumed within the exploration of the action schemes, which, in turn, are narrowed down towards general human conditions, spanning psychological and emotional states and their relation to social and gender roles, political conditions, and other cultural parameters.

The narratological toolkit offers a corrective here by comparing narrative strategies around one specific myth across different representations and media in a way that resembles iconographic comparison. This practice is noticeable in the assessment of the Great Frieze on the level of pragmatics: here, the use on the frieze of symbolic code in order to emulate the past as a positive value is set against the conventional thrust of the specific myth, the gigantomachy, as celebrating the future by means of wiping out the past.[10]

Another potential corrective is provided by the historical framework of the picture, in the way in which reference to the conventional patterns of display of the gigantomachy myth is a reference to other versions of this myth placed within specific historical contexts. Such historical framing is

[10] See above, p. 139–40.

what Barthes proposes under paradigmatics.[11] It stops the analysis from slipping into mere self-referentiality, notwithstanding the benefits of a syntagmatic assessment. Such 'pure' self-referentiality would be just as detrimental as the tautology inherent in iconological interpretation, even if the two function in diametrically opposed manners: the former is exclusively concerned with the picture, while the latter focuses solely on the culture that surrounds it.

However, the reliance on a historical framework raises another set of challenges, which bring to the fore the paradox inherent in any historical appropriation of a method – in this instance semiotics – that operates intrinsically a-historically. In order to establish a historical framework, a semiotic analysis has to make use of the same tools as employed in the iconological model, namely, iconographic comparison and inclusion of whatever knowledge of the relevant historical period is available. It therefore also encompasses all the shortcomings of the iconological approach,[12] even though Derrida and Eco see the historical framework as reciprocal to the picture, not as subsuming it.

Yet, again, all three case studies demonstrate that the semiotic approach, within the boundaries of such historical framing, can still produce insights different from those elicited by examination through the iconological prism. The focalisation of the semiotic analysis brings to our attention aspects an iconological approach would not point out – specifically, issues around sensual mediation.[13] In the case of the Karlsruhe hydria, one such aspect is seen through comparison with another myth, the Birth of Erichthonius, which as visualised towards the end of the fifth century demonstrated comparable slippage between the spheres of myth and the everyday; in the case of the Pergamon altar, we see how pointers to the past (and to classical masterpieces) are implemented in order to characterise individual figures;[14] in the case of the Louvre sarcophagus, we see the role of age and gender in the rhetoric of mourning.

[11] See above, p. 112. For an appropriation of the concepts 'paradigmatic' and 'syntagmatic' in ancient art scholarship, see Stewart 1983: esp. 67–9.

[12] This predicament stems from semiotics' essential need to locate the signified. In semiotics, the artefact itself is meant to help the interpreter understand the meaning it produces – yet in exemplary semiotic analyses, for example Roland Barthes' interpretations of advertisement (Barthes 1977a: 34), the deduction of the signified is based on the interpreter's direct, intimate knowledge of the cultural framework of the picture – a knowledge not available to us for historical periods such as antiquity.

[13] Jay 1993: 589.

[14] Note here the difference from the way in which the iconological analysis deals with the iconographic reference to Athens; see above, pp. 44 (iconology); 120–1 (semiotics).

2) Semiotics and ancient art scholarship

Semiotics poses significant problems with regard to its mappability in the field of ancient art study. First, a serious complication arises from the absence of a master model of the type that exists for Panofsky's iconology, which could be employed as a reference point, at least for semiotic applications in the area of the visual. Barthes' schema of the five codes is the closest thing we have to such a model.[15] Another inhibitor is that semiotics, which by definition refutes the idea of 'natural' meaning, fights against a powerful undercurrent that shapes the discipline of classical art history to this day, an undercurrent formed by the legacy of nineteenth-century encyclopaedia studies, with their strong belief that 'natural' meaning can be established through close description and classification.[16] Finally, just as iconological elements are used in some studies without express reference to iconology, so too some studies reach for the semiotic toolbox without acknowledging its assistance.[17]

Discussions of the method.

Seminal in its 'pure' engagement with semiotics in the study of ancient art is the 1979 paper *Zeichen*, 'Signs', by Lambert Schneider, Burkhard Fehr, and Klaus-Heinrich Meyer, published in the first number of the journal *Hephaistos*.[18] Grounding itself in the work of Charles Morris (1903–79),[19] and therefore with an approach close to that of Peircean semiotics,[20] the

[15] See above, pp. 112–3.

[16] On this point, see Zanker 2000: 205–6: 'On the other hand, the noticeable reservations and weariness on the part of the archaeologists when it comes to the reconstruction of contexts is connected to the still unbroken, positivist understanding of academic scholarship as the description and classification of individual objects within the framework of an abstract system of typological genres, which emerged at the same time and out of the same spirit as the classification systems of someone such as Linné in the natural sciences.' (trans. author; German original: 'Zum anderen aber hängt die auffällige Zurückhaltung und Skepsis der Archäologen bei der Rekonstruktion von Kontexten mit dem noch immer ungebrochenen positivistischen Verständnis von Wissenschaft als Beschreibung und Klassifizierung des einzelnen Objekts im Rahmen eines abstrakten Gattungssystems zusammen, das zur selben Zeit und aus demselben Geist wie die naturkundlichen Ordnungssysteme eines Linné entstanden ist.')

[17] See above, p. 92.

[18] Zeichen 1979. More recently on the relationship of semiotics and archaeology, see Schneider 2006; generally, for the emergence of semiotic studies in ancient art history especially at Hamburg, see Schneider 2010: 35–40.

[19] Zeichen 1979: 9–11 (with Morris 1938 as main influence).

[20] For Peirce, see above, pp. 107–10.

paper aimed to tackle the fierce criticism faced by sign approaches at the time.[21] The result was a practical guide (including a terminology synchronised with that of other disciplines) to semiotics as a framework for studying communication and interaction, both within the artwork and with regard to its audience. At its core is a plea for an integrative analysis of historical processes,[22] which is married with a particular interest in the recipient.[23]

Despite this emphasis on the practical aspects of the sign process, the paper does not venture into post-structuralist semiotics and its more dynamic understanding of signs, as is apparent in its hesitance to account for different types of signs: its main concern is iconic signs, discussed as dependent upon the historical context of which they form a part.[24] This dependency on the historical and cultural context more generally acts as a corrective, defined as a framework for the enactment of the threefold model of syntactics, semantics, and pragmatics laid out in the paper.[25] However, the methodological basis for the implementation of this corrective is not made explicit. Indeed, the approach seems once more to rest on the traditional correctives of style, type, and iconography – the very correctives that are at the core of iconology.[26]

Current voices within the discipline employ the notion of 'context' as a corrective, understood as any data pertinent to the picture.[27] We see this

[21] Zeichen 1979: 8. These criticisms are mostly in line with those discussed above (see pp. 116–7): non-historicity; over-complicated, formulaic, and mathematical design; conflicting theorems about what the method entails.

[22] Zeichen 1979: 31.

[23] Zeichen 1979: 17–18.

[24] Zeichen 1979: 11–12. This focus on just one sign type demonstrates its limitations when – in the process of explaining denotation and connotation – it is attested that certain connotations of a sign can become denotations, namely when they are so well established that they do not appear to represent abstract meaning anymore (Zeichen 1979: 13). This effectively describes a semiotic *symbol*, thus indirectly proving the usefulness of differentiation between different classes of signs in order to differentiate the processes that generate meaning.

[25] Zeichen 1979: 18.

[26] Cf. Squire's discussion of historical appropriations of semiotic approaches, specifically Baxandall's work, to bring out their reliance on an epistemological framework not unlike that underpinning Panofsky's iconology, along with their overbearing reliance on the textual to explain the visual: Squire 2009: 79–87. Cf. also Sourvinou-Inwood's more personal summary regarding the application of a semiotic framework in classical art-historical study: Sourvinou-Inwood 1991: 3–23. For Baxandall, see also above, p. 33 n. 62.

[27] For a critical discussion of the notion of 'context', see Mieke Bal, who argues against the implicit, non-semiotic reliance on the data surrounding the artefact as embodied by the notion of 'context', and thus speaks in defence of the multi-stability of signs (Bal 2002: 135): 'Context is primarily a noun that refers to something static. It is a *thing*, a collection of data whose factuality is no longer in doubt once its sources are deemed reliable. *Data* means *given*, as if

concept in Junker's elaboration of the hermeneutical spiral,[28] and, similarly, it features in the work of Stansbury-O'Donnell, who proposes that for a semiotics-based approach to be successful at a historical level, contextual information has to act as a corrective that delimits multiple options of interpretation in what he labels a 'post-structuralist synthesis'.[29]

Stansbury-O'Donnell starts from the need to adapt text-centred semiotics for the study of what he labels 'visual language', mixing Saussure and Barthes and also covering aspects of structuralism, post-structuralism, hermeneutics, and communication studies.[30] His establishment of the additional value of a semiotic and structuralist analysis over an iconographic analysis defines two key strengths of the former approach, benefits that have also emerged from the case studies in this chapter: first, its focus on the internal relationships within a picture, and second, its ability to assess pictures that are not clearly of either mythological or normal character.[31]

A historiography of semiotics in ancient art scholarship.

The discussion of iconology in ancient art scholarship has already brought out some points where semiotics and iconology join forces in interpretation.[32] From the wide range of approaches employing semiotic elements, the focus in the following will be on three prominent strands:[33] the first targets the formal aspects of ancient art and, linked to this, issues of cultural

context brings its own meanings. The need to interpret these data, mostly only acknowledged once the need arises, is too easily overlooked.' For Bal, the solution to the context dilemma lies in *framing*, in considering and interpreting the polysemic nature of any type of data encountered in the process of interpreting the picture, be it internal or external to the picture.

[28] Junker 2012: 126–31. In Junker's discussion, semiotic elements are not referenced but inherent in his hermeneutical spiral as a silent partner. See also above, pp. 98–9 for the amalgamation of iconological and semiotic elements.

[29] Stansbury-O'Donnell 2011: 103.

[30] Stansbury-O'Donnell 2011: 73, 79–107. Again, his argument is embodied in application: here he discusses Christine Sourvinou-Inwood's interpretation of scenes of erotic pursuit on Greek vases (Stansbury-O'Donnell 2011: 72–9). See especially Sourvinou-Inwood 1991: 58–98.

[31] Stansbury-O'Donnell 2011: 81–2.

[32] See above, pp. 98–9.

[33] Not included here, but important for understanding the range of semiotic applications across art-historical scholarship, is the work on Greek vase-painting concerned with establishing social realities as conveyed through pictures. The collaborative project *La cité des images* provides the landmark study in this field, mixing elements of structural anthropology and semiotics in order to uncover the social discourses that shaped Athenian vase-painting: Bérard 1989. This approach continues prominently in the work of François Lissarrague (Lissarrague 1990b; Lissarrague 2013; for a methodological discussion, see also Lissarrague 2009). Cf. also Robertson & Beard 1991, for Mary Beard's exemplary semiotic analysis of an Athenian vase, paired with Martin Robertson's connoisseur/iconographic take.

communication; the second is concerned with the gaze in its sexual con-
notations as stimulated by artworks; and the third explores the narrative
structure of pictures.

Semiotics and form.

The semiotic analyses of the case studies make use of form and style as bear-
ers of meaning; they are understood as a facet of the artwork's content, not
merely a corrective for dating purposes.[34] This approach has been well estab-
lished, especially in Roman art scholarship, since Tonio Hölscher's seminal
study *Language of Images in Roman Art*, which appeared in 1987.[35] It is a
type of approach anchored in structuralist semiotics. Within the discipline
itself, it has a diverse pedigree: it displays elements of iconology-infused,
culture-historical pluralism, as represented by Brendel's *Prolegomena*,[36]
as well as an investment in stylistic form, which it shares with studies in
structural formalism as pursued by Guido Kaschnitz von Weinberg and
Bernhardt Schweitzer,[37] but without adopting their interest in purely aes-
thetic meaning.

Hölscher borrows from semiotic linguistics the idea of the 'system' that
organises vocabulary and syntax.[38] This system serves as the communica-
tional framework within which operate the signs, that is, the formal elem-
ents shaping the artwork.[39] Specifically, in this case, it serves to dissect the
emulation of Greek stylistic templates within Roman art and the meanings
that are associated with those templates.[40] Implicit in Hölscher's work are
notions of Saussurean *langue* and *parole*: the *langue*, a typological system
the Romans derive from Greek art, charged with specific meanings of *a pri-
ori* validity; and the *parole*, a Roman period style appropriating these mean-
ings.[41] It is at this point – with the assumption of the stability of the meanings

[34] For form and style in semiotic art history, see above, pp. 114–5.
[35] Hölscher 2004.
[36] Brendel 1953, based in parts on Brendel 1936; for an assessment, see Lorenz 2012: 205–6. For
a discussion of the conceptual background to Hölscher's study, see Elsner 2004; cf. also the
review by Burkhardt Fehr (Fehr 1990).
[37] Kaschnitz-von Weinberg 1944; Schweitzer 1969. For a critical discussion of formal
structuralism in ancient art-historical scholarship, see Wimmer 1997.
[38] Hölscher 2004: 10–22.
[39] Hölscher 2004: 58–69.
[40] Among the examples presented here are battle scenes, which in Roman art are generally
represented by means of Hellenistic style because of its associations with dynamic pathos
(Hölscher 2004: 23–46, 95); scenes of state ceremony are infused with templates of the
classical period, Phidias and Polycleitus, associated with *decor supra verum* (Hölscher
2004: 47–57, 94–8).
[41] Hölscher 2004: 97, 114. For Saussure, see above, pp. 107–10.

of the Greek templates along with the way in which they are appropriated in Roman art – that the semiotic framework of Hölscher's study collapses and aligns itself with non-semiotic models founded on the concept of 'natural' meaning, or stable units of meaning inherent in a depiction.[42]

Whilst Hölscher's model finds correspondence in a range of studies concerned with the ways in which Greek art is emulated in Roman culture,[43] scholarship on Greek art provides examples for a more decisively semioticised approach to stylistic analysis, most prominently in the work of Richard Neer, such as his discussion of the emergence of the classical style.[44] Whilst Neer also adopts a terminology from literary texts for describing the features that characterise the shifts from archaic to classical sculpture, his focus on the aesthetics and more generally the phenomenology of Greek sculpture moves beyond the textual paradigm. Neer differentiates three trajectories contributing to the viewer–object relationship – pose, anatomy, psychology – and in mapping their gradual reconfigurations, his discussion maintains a semiotic framework.

Semiotics and the gaze.

Explorations of the viewer and the *gaze* are concerned with the ways in which social discourses outside the picture interact with those inside.[45] Studies in this field frequently traverse the boundaries of visual art and literature, with more scholars of the latter working on the former than vice versa.[46] These approaches are rooted in phenomenology, with Jacques Lacan's work acting as the primary leading example.[47] They mostly employ

[42] This alignment is criticised by Fehr 1990: 725; for the preference given to textual over visual models by this system, see Squire 2009: 86.

[43] For example Gazda 2002; Perry 2005; Marvin 2008; Anguissola 2012. Sarcophagi studies concerned with the emulation of Greek myth as a means of conveying allegoric messages and their relationship with *Vita Humana/Romana* elements form a distinct branch of this engagement, sitting between formal and narrative analyses. See especially Blome 1978; Blome 1992; Giuliani 1989; Brilliant 1992; Fittschen 1992; cf. also Grassinger 1994; Gessert 2004.

[44] Neer 2010. Cf. also Neer's discussion of connoisseurship in vase-painting scholarship, which rehabilitates the approach as a semioticised, formal assessment: Neer 1997; Neer 2005. On this point, see also Davis 2011: 75.

[45] For the gaze in semiotic art history, see above, pp. 115–6.

[46] See also Squire 2009: 83–5, listing Goldhill 2001, Steiner 2001, and Elsner 1995 as examples of reaching across the boundaries of the literary and the visual. Squire demonstrates how, in praxi, these approaches around the social construction of viewing can treat the visual as mere illustration of – and subject to – interpretations derived from textual evidence, thereby once more generating problems analogous to those faced by iconology.

[47] See above, p. 115.

a post-structuralist, dynamic form of semiotics, and they seek alliances in film and media studies.[48]

The viewers, and specifically who they are and what can be expected of them, have elicited significant debate in classical art-historical scholarship. Early studies with an investment in viewers bypass this problem by continuing to employ an all-knowing, all-seeing viewer similar to the type of viewer who features in Riegl's work,[49] and who features implicitly also in iconology.[50] This position was undercut by Jas Elsner's 1991 paper on the Ara Pacis. Elsner argued against the postulate of 'natural' meaning – a single meaning intended by those commissioning and executing artworks, to be perceived by those viewing them – championing instead an approach that applies a scale of potential viewer responses, encompassing, for example, viewers caught up in activities, such as religious rites, and viewers disinterested or simply ignorant.[51] Elsner's claim, in turn, was challenged by Paul Zanker, who – whilst noting the lack of the viewer as a category in the iconographic-iconological model – rejected Elsner's notion of individual symbolisation and promoted instead a focus only on collective practices, thus implicitly reviving the Rieglian approach.[52]

Alongside the continued dispute around individual and collective symbolisation, two broad strands of enquiry can be differentiated: first, an interest in reception aesthetics and the ways in which the picture itself prefigures

[48] Particularly influential in this area is Laura Mulvey's study of visual pleasure (Mulvey 1975; Mulvey 1989).

[49] For example: Brilliant 1984. The landmark achievement of Riegl's study of Dutch group portraiture, published in 1902 (Riegl 1999), was to demonstrate how the genre of group portraiture in sixteenth- and seventeenth-century Holland was driven by democratic thought: the viewers of these pictures were put in a position to negotiate between those portrayed in the pictures, without the pictures conveying a coherent, hermetic message about their sitters. See Podro 1982: 81–95; for Riegl, see also above, pp. 24–7.

[50] See above, pp. 35–6.

[51] Elsner 1991.

[52] Zanker 1994. For this controversy, see also Bielfeldt 2003: 119–20. This discussion traverses laterally a much wider dispute around the term 'propaganda', and whether Roman state relief deliberately conveys propagandistic (i.e. politically transformative) content. This discourse was triggered by Paul Veyne, who argued that Roman state art fulfilled an important role by means of its decorative presence, but not through its actual content; Veyne used the Column of Trajan as an example that state art might not have been visible to individual viewers and that art has no *telos* and cannot be studied with regard to its objective or what it wants to communicate because, fundamentally, it is a mode of behaviour, not a product (Veyne 1988). Veyne's investment in production aesthetics was prominently countered by Salvatore Settis (Settis 1991; Settis 1992 – discussed again in Veyne 2002: esp. 6–10), who employed an approach based on reception aesthetics that is concerned with the competencies of the authors and the viewers and differentiates between two types of viewing competence: *generic competence*, based on cultural practices and covering aspects such as, in the case of the Column of Trajan, that Roman viewers would have been familiar with depictions of emperors fulfilling specific

how it wants to be seen,[53] and second, an interest in the construction of power discourses. In the latter instance, the concern is to separate out roles within such a discourse by means of identification of the types of viewer role stimulated by a depiction, such as scopophilia (the sexual pleasure that can be derived from looking at things) or voyeurism (the sexually driven act of [secret] looking).[54]

Particularly successful in the field of studying the gaze are those approaches that manage to account for the gaze of both genders.[55] In contrast, studies zeroing in on the male gaze often fall victim to the criticism Bryson advanced against structuralism: a concept, the gaze, popular because of its potential to capture dynamic relationships, is then exercised only on a structuralist level, with the relationship under investigation predefined and failing to account for the potentially polysemic nature of the pictures with which it deals.[56]

Semiotics and narrative.

The semiotic take on visual narrative provides an alternative to the traditional *associative-philological* assessment of mythological depictions, in which the pictures' storytelling is explained through literary sources and any deviations between the two media are explained away as due to the relevant literary models no longer being extant, or as a shortcoming on the part of the visual artists who failed to understand the texts properly.[57] Instead,

duties and rites, essentially Panofsky's iconographic level; and a *specific competence*, unique to a specific monument, its individual viewers, and a moment in time, such as what metropolitan Romans would have known about the Dacian Wars and from where they would have been able to see what of the column's frieze. For a summary of the debate, cf. Ewald & Norena 2010: 33–5. See also below, p. 230.

[53] For example Stansbury-O'Donnell 2005; Lorenz 2007. Cf. also Zanker 1997; Neer 2010: 13, who argues against a focus on a 'viewing experience', and in favour of considering viewing as an interplay of 'possibilities' and 'constraints' triggered by the artwork. For reception aesthetics generally, see above, p. 115.

[54] For example Fredrick 1995, who employs Mulvey's categories of 'fetishist scopophilia' and 'sadistic voyeurism' for the study of pictures of Ariadne in Pompeian houses, concluding that male power is rendered dominant within the domestic context by the way in which the female body and, more rarely, violent attacks on it are presented.

[55] For example Sourvinou-Inwood 1991; Osborne 1994; Bergmann 1996; Stähli 1999. For parallels in media studies, see Fuss 1992; Berenstein 1995; Mayne 1995.

[56] For Bryson, see above, pp. 103–4. On issues around gender discourse in ancient culture, see Wyke 1989; Meyer-Zwiffelhofer 1995; Larmour & Miller & Platter 1997; Hallett & Skinner 1998.

[57] Squire 2009: 15–89 provides a detailed historiography of the dominance of the textual over the visual in art-historical scholarship. For narratology in semiotic art history, see above, pp. 115–6.

approaches in semioticised narratology in the field of ancient art appropriate notions of the viewer alongside categories of literary narratology.[58]

This interest in semioticised narratology results in a range of forms of analytical execution.[59] Two examples should suffice here. Mark Stansbury-O'Donnell's study on Attic vase-painting presents the most comprehensive attempt at scaffolding a semiotic, and here specifically structuralist, framework for the interpretation of ancient visual narrative.[60] Stansbury-O'Donnell separates the study of depictions into two strands, one at a micro-structural level and the other at a macro-structural level,[61] with the two strands together devised to capture the narrative experience as a whole. This differentiation of narrative micro- and macro-structures is adopted from the works of Barthes and Eco.[62] This approach leads to a detailed picture of the operational modes of visual narrative, but – in true semiotic fashion – without any attempt to differentiate any shifts or changes in these modal aggregates within a historical chronology. Notwithstanding Stansbury-O'Donnell's later campaigning for 'post-structuralist synthesis', this earlier take presents a diachronic approach concerned with the phenomena of visual narrative, not with how these phenomena operate within specific historical periods or contexts.

The chronological dimension, in contrast, is at the forefront of Luca Giuliani's study on the development of visual storytelling on Greek vases.[63] Whilst Giuliani develops his methodological framework out of a critical engagement with Gotthold Ephraim Lessing's definition of the abilities of the textual and the visual as presented in the *Laocoon*,[64] his differentiation

58 For an overview of such studies in the field of Greek vase-painting, see Stansbury-O'Donnell 1999: 1–8; see also Sourvinou-Inwood 1991: 3–23.

59 Some studies practise within the semiotic framework the same type of philological-associative approach, with the visual merely explained within the concept of the textual: see Squire 2009: 86–7, discussing Steiner 2007.

60 Stansbury-O'Donnell 1999.

61 Stansbury-O'Donnell divides the micro-structure into nucleus, catalyst, informant, and index (Stansbury-O'Donnell 1999: 21); the macro-structure is structured into viewing process, viewing context, composition, spatial and temporal setting, and form and style (Stansbury-O'Donnell 1999: 54–117).

62 Stansbury-O'Donnell 1999: 13–17, 18, 54. For Barthes and Eco, see above, pp. 111–3.

63 Giuliani 2013. In essence, Giuliani demonstrates how narrative pictures develop from the polychronous to the monochronous (Giuliani 2013: 162–3; cf. Raeck 1984). Stansbury-O'Donnell's review of the German edition (published 2003) gives excellent insight into the viewpoints of the two scholars, with Stansbury-O'Donnell noting the same application of semiotic terminology, but not substance, that Fehr flagged in the review of Hölscher 2004 (Fehr 1990): Stansbury-O'Donnell 2006: esp. 538–9.

64 Stansbury-O'Donnell 1999: 8–9; Giuliani 2013: 1–18. For Lessing's argument, see Mitchell 1986, 95–115; Squire 2009: 97–111.

of two modes of display, *description* and *narrative*,[65] introduces a structural differentiation indicative of a semioticised approach. Those elements are defined as narrative that 'do not correlate to the normal workings of the world'; those elements that are 'normal' are identified as description. *Normal*, in Giuliani's definition, denotes the values and experiences prevalent in the period in which the picture was created. Pictures can consist exclusively of descriptive elements, but those conveying a story – those that consist of narrative elements – always also have to include descriptive elements that flesh out the course of action.[66] Giuliani's categories dissolve the conventional distinction between *myth* and *everyday life* and instead explore these two aspects as an integrated system, an approach that is similar to that for which Giuliani had argued in 1989 with regard to mythological depictions on Roman sarcophagi.[67]

Stansbury-O'Donnell and Giuliani each mix structuralist and poststructuralist analytical elements, in Giuliani's case also infusing them with the notion of an iconological corrective to establish the *normal* and thus map the historical development of the narrative structures. The key difference between the two approaches sits at the level of the viewer. With his interest in the polymodal and polysemic elements of a depiction, Stansbury-O'Donnell targets issues of perception outside the sphere of collective symbolisation, an approach that is in line with Elsner's refutation of natural meaning. In contrast, Giuliani's investment is in exploring acts of collective symbolisation, which are synthesised with historical developments such as the emerging culture of reading towards the end of the fifth century BCE.

3) Conclusions

The range of semiotic applications across classical art-historical scholarship, along with the results from the three case studies, demonstrates that this approach draws out the operational strategies of a picture. Specifically with regard to mythological images, semiotics helps to establish the picture's investment in the mythological alongside other paradigms, in the

[65] Giuliani 1996a: 12–15; Giuliani 2013, passim, esp. 15–18, 247–8.
[66] Giuliani 2013: 244–8.
[67] Giuliani 1989. Giuliani employs concepts from Quintilian's rhetoric in order to capture the transmission potential of this emulation (Giuliani 1989: 38–9); cf. Bielfeldt 2005: esp. 277 n. 810. For a critical assessment, see Lorenz 2011: 305–7.

narrative structures of individual depictions, and, thus, in the picture's contribution to wider social, political, and cultural discourses.

This investment in the different discourses of life renders semiotic approaches particularly popular – and successful – in the study of artistic genres from the private sphere, such as vase-painting or wall-painting. With regard to public art, semiotic forms of analysis are far less widespread, seldom found beyond discussion of the viewer and the Roman appropriation of Greek art, which takes place in both public and private contexts. This reservation exists despite the results that a semiotic approach can elicit in the sphere of state art, as the case study on the Pergamon altar demonstrates.[68]

Among the inhibitors to the application of semiotics to public art are, on the one hand, the traditional investment in 'natural' meaning within the discipline, which reigns particularly strong in what is perceived as the primary fields of classical art history such as state art, for this type of art responds to, sometimes even depicts, historical events. Aligning picture with event therefore seems a natural act. Hence, from this perspective, the use of semiotics seems unnecessary.

And, on the other hand, there is a notable hesitance to cross-examine these public pictures against their historical context: that is, not to carve out any subversive elements within the picture but, instead, simply to align them with the historical context. This practice runs the risk of dissolving any potential discrepancies between the two sides, the historical context and the picture; instead of approaching the artwork as 'open' it closes down its assessment. Here again is the challenge that exists at the stage of iconological synthesis, for both iconology and semiotics need a historical corrective. Regardless, where studies on public art dare to tackle the very evidence used to establish the historical context of their respective pictures, such practice can elicit useful results.[69]

[68] Among other successful applications is Richard Neer's work, especially his analysis of the Tyrannicides (Neer 2010: 78–85). See also the treatments of the Pergamon altar by Neumer-Pfau 1983; Queyrel 2005; Massa-Pairault 2007a.

[69] For a successful example, see Neer 2002. Cf. also Sourvinou-Inwood 1990: esp. 137–8, who applies the historical situation as a 'filter' in order to reconstruct ancient perceptions.

Image studies

7 | Introducing image studies

'In each individual case, what is the object of painting? Does it aim to imitate what is, as it is? Or imitate what appears, as it appears? Is it imitation of appearance, or of truth?'

'Of appearance,' he said.

'In that case, I would imagine, the art of imitation is a far cry from truth. The reason it can make everything, apparently, is that it grasps just a little of each thing – and only an image at that. We say the painter can paint us a shoemaker, for example, or a carpenter, or any of the other craftsmen. He may know nothing of any of these skills, and yet, if he is a good painter, from a distance his picture of a carpenter can fool children and people with no judgement, because it looks like a real carpenter.'

Plato, *Politeia* 598 b–c[1]

In *Republic* 10, Plato presents his charge against imitation.[2] Socrates is shown embarking on a general discussion of the 'mimetic', the imitative arts, touching upon all sorts of visual mimesis. He explains his understanding of imitation by referring to painting, *graphike*, and painters, *zographoi*. Painters imitate objects by copying the visual appearance of particular material manifestations of these objects, not their real, truthful being, their *form*. They capture the surface appearance, *to phainomenon*, but not the qualitative constituents of whatever they depict – not a real carpenter, but his likeness. Their products are therefore, Socrates argues, ghost-like, *phantasmata* or *eidola*, 'at a third remove from the truth', the endpoint in the sequence: form – material manifestation – picture.[3]

[1] Translation: Ferrari & Griffiths 2000: 317. Greek original: 'τοῦτο δὴ αὐτὸ σκόπει· πρὸς πότερον ἡ γραφικὴ πεποίηται περὶ ἕκαστον; πότερα πρὸς τὸ ὄν, ὡς ἔχει, μιμήσασθαι, ἢ πρὸς τὸ φαινόμενον, ὡς φαίνεται, φαντάσματος ἢ ἀληθείας οὖσα μίμησις;', 'φαντάσματος, ἔφη.' πόρρω ἄρα που τοῦ ἀληθοῦς ἡ μιμητική ἐστιν καί, ὡς ἔοικεν, διὰ τοῦτο πάντα ἀπεργάζεται, ὅτι σμικρόν τι ἑκάστου ἐφάπτεται, καὶ τοῦτο εἴδωλον. οἶον ὁ ζωγράφος, φαμέν, ζωγραφήσει ἡμῖν σκυτοτόμον, τέκτονα, τοὺς ἄλλους δημιουργούς, περὶ οὐδενὸς τούτων ἐπαΐων τῶν τεχνῶν· ἀλλ' ὅμως παῖδάς γε καὶ ἄφρονας ἀνθρώπους, εἰ ἀγαθὸς εἴη ζωγράφος, γράψας ἂν τέκτονα καὶ πόρρωθεν ἐπιδεικνὺς ἐξαπατῷ ἂν τῷ δοκεῖν ὡς ἀληθῶς τέκτονα εἶναι.'

[2] See Moss 2007 for *Republic* 10 and its discussion of poetry, with further bibliography. Specifically on imitation and ancient art, see Keuls 1978; Nehamas 1982.

[3] Plato, *Politeia* 599d.

169

As Moss has aptly noted, Plato was concerned to characterise the imitative acts as 'to be compelling and realistic by copying the way things appear, at the cost of misrepresenting the way things are'.[4] This passage has therefore provided an exemplum ex negativo for image studies,[5] whose focus is on precisely what Plato regarded as a deficiency of the visual arts – their removal from truth. Image studies is concerned not with the metaphysics of pictures, their relationship to truth, but with their physics, the way in which they negotiate truth and reality, the stages at a second and third remove from truth.

The passage in the *Republic* also highlights the difference between semiotics and image studies, notwithstanding their shared disinvestment from truth. On the surface, Plato's point is similar to Pliny's point in the anecdote about Zeuxis: Parrhasius fools his fellow painter with precisely the type of imitation described by Plato – a curtain that is a curtain in appearance alone, not in form.[6] By contrast, however, whilst Pliny's story, with its shift in hierarchies of evidence and perception that depends on individual viewers, draws attention to conventions of communication and patterns of display, Plato claims a direct relationship between material manifestation and picture, above and beyond any involvement of viewers. He is concerned with the choices made by the artist and the impact of those choices on the viewers.

In line with Plato, image studies tackles the possibility that pictures are not representations of reality, but modifications. Breaking with Plato, however, image studies takes pictures to be constructive, not mimetic: pictures shape reality; they do not imitate it. The objective of image studies, therefore, is to analyse the functional aspects of pictures evident in the way they produce reality. In short, image studies holds that one needs to be familiar with material functions and the physicality of display if one is to interpret artworks.

1) What is image studies?

The importance of the shift from the history of art to the history of images cannot be overestimated. On the one hand, it means that art historians can no longer rely on a naturalized conception of aesthetic value to establish the parameters of their

[4] Moss 2007: 422.
[5] For Plato's relationship to images more generally, see Belting 2011: 111–14.
[6] See above, pp. 103–5.

discipline. Once it is recognized that there is nothing intrinsic about such value, that it depends on what a culture brings to the work rather than on what the culture finds in it, then it becomes necessary to find other means for defining what is a part of art history and what is not.

<div align="right">Bryson & Holly & Moxey 1994: xv</div>

Image studies leaves behind the aesthetic evaluation of artworks to concentrate instead on functional assessment of all types of visual evidence, including even mental images. This broad scope means that not just one single methodological framework is employed. Instead, various approaches towards pictures are appropriated from a wide range of disciplines. In contrast to semiotics, so concerned with the production of meaning by audiences, in image studies the focus is on the visual, as it is also for iconology. Image studies is driven largely by the notion that the human experience of pictures takes place before language, as the primordial means of communication. Image studies takes the visual to be at the core of human life and activity – the visual is deployed as an anthropological paradigm. Across the domain of image studies, semiotic approaches, with their imbalance in favour of language, are mostly regarded as not suited to dealing with pictures.

Image studies is concerned with the eidetic character of pictures, with their specific visual means of operation. As part of that interrogation, practitioners look at the spectrum of associations that might be made by the artist and by the viewer. To establish the visual modalities of pictures, image studies frequently engages with material not scrutinised in traditional art history, including digital media and computer-generated imagery, and also with seemingly mundane forms of artistic production such as casts and imprints. Whilst the former are of interest because of the possibility of pervasive manipulation, the latter embody quintessential issues around reality in representation.

In practice, image studies, no matter its many permutations, pursues two strands of enquiry, both rooted in iconographic practice. First, image studies considers the contextual dimension of the picture, its physicality within its environment, with 'environment' understood as both the physical context of the picture, including the pictorial space itself, and the picture's ideational context. Second, image studies is concerned with the performative aspects of the picture's iconography. The term 'performative' here is deployed in its widest sense, as an embodiment of all the visual parameters of a picture and not only figural elements or material attributes.

2) Image studies: premises, positions, and problems

Whatever the pictorial turn is, then, it should be clear that it is not a return to naïve mimesis, copy or correspondence theories of representation, or a renewed metaphysics of pictorial 'presence': it is rather a postlinguistic, postsemiotic rediscovery of the picture as a complex interplay between visuality, apparatus, institutions, discourse, bodies, and figurality. It is the realization that spectatorship (the look, the gaze, the glance, the practices of observation, surveillance, and visual pleasure) may be as deep a problem as various forms of reading (decipherment, decoding, interpretation, etc.) and that visual experience or 'visual literacy' might not be fully explicable on the model of textuality. Most important, it is the realization that while the problem of pictorial representation has always been with us, it presses inescapably now, and with unprecedented force, on every level of culture, from the most refined philosophical speculations to the most vulgar productions of the mass media. Traditional strategies of containment no longer seem adequate, and the need for a global critique of visual culture seems inescapable.

Mitchell 1994: 16

Iconology and semiotics claim the universal validity of their respective methodological frameworks. The practices discussed here under the label *image studies* sit between these two methods, with the potential to function as mediator for their opposing epistemological concepts. And image studies can also reconcile by fusing Anglo-American *visual culture studies* and German *Bildwissenschaft*, which are separated not least by the untranslatability of their respective labels.

In German, the wide concept sustained by the term *visual* is inevitably translated and simultaneously condensed to a form containing the term *Bild*, which encompasses both the concrete *picture* and the ideational *image*,[7] as, for example, in the expressions *Bildkultur* (visual culture) and *Bilderwelt* (visual world). Within this process, however, the elements of sight and viewing, also contained in the term *visual*, are relegated to a secondary place, as parameters in some way inherent within the concept *Bild* but not expressed in the disciplinary terminology.

Meanwhile, the translation of the term *Bildwissenschaft* into English has its own challenges. In his review of Hans Belting's book *Bild-Anthropologie* (2001), Christopher Wood used both *disciplines of the image* and *science of the image*.[8] The former option denies one particular remit of

[7] On the relationship of the terms *image* and *picture*, see Mitchell 1986: 9–14.

[8] Wood 2004: 370. Mitchell discusses the problem of translating *Bildwissenschaft* as *image science* with regard to both German and US audiences: Mitchell 2007: 37–8. The recent English

Bildwissenschaft, which is to create a single disciplinary purchase on the *image*; *Bildwissenschaft* does not seek to represent a conglomerate of disciplines occupied with images. The latter option, which emphasises the scientific nature of this approach, is also a misrepresentation, for *Bildwissenschaft* invests in the anthropological dimensions of the image, rather than deem it an object of scientific research. More recently, Matthew Rampley has translated *Bildwissenschaft* with *image theory*,[9] thereby drawing attention towards the methodological ambitions of these new approaches and away from their interest in the practicalities of the image.

The dislocation in terminology is indicative of the differences between these two contemporary approaches to images, between *visual culture studies* and *Bildwissenschaft*. A survey of their individual historiographies will elicit further insight into their essential natures.

Visual culture studies and the pictorial turn.

Contemporary visual culture studies reflects the attempt to reposition art-historical disciplines in order that they might respond to the new forms of mass media information transmission that have emerged since the 1960s.[10] A prominent marker for the emergence of visual culture studies as an analytical framework is the theory of the media presented by Marshall McLuhan (1911–80) in his 1964 *Understanding Media*.[11] McLuhan analysed the relationship of content and the media that deliver that content. He emphasised the social significance of this relationship, thus diverting the focus away from the content itself and towards the means of its transmission and the related processes of perception. His crucial attestation was that the media serve as a prosthetic device of the human body in order to facilitate an understanding of the world.

Influenced by McLuhan's postulate, visual culture studies examines the relationships between the content of a visual representation and the media used for this content's delivery, focusing on the social significance of these relationships and so drawing attention to audiences and audience perception. It therefore frequently features as a companion of – or is emulated in – media studies. The analytical methodology employed by visual culture

translation of Belting's book by Thomas Dunlap, published in 2011, employs the terms 'image studies' (Belting 2011: 2) and 'pictorial theory' (Belting 2011: 9).

[9] Rampley 2012: 121; later he uses 'science of the image': Rampley 2012: 126.

[10] On *Visual Culture Studies*, see Bryson & Holly & Moxey 1994; Mirzoeff 1999; Elkins 2003; Dikovitskaya 2005. For a critical assessment, see Mitchell 2002; Schulz 2005: 86–124; Davis 2011: 3–10.

[11] McLuhan 1964.

studies is based on the fundamental assumptions of semiotics, that is, the production and circulation of signs, and its post-structuralist revision, which embraces the multi-stability of signs and their involvement in processes of recirculation.

The visual culture studies approach has been widely used to analyse mass media and popular culture. A socio-political mission is conspicuous: ideological mechanisms driving both image production and consumption are highlighted, forms of visual representation are targeted as propagandistic, and the ideological implications of media in terms of class, gender, and culture are foregrounded. This wide scope means that analytical perspectives are borrowed as deemed appropriate: formalism, feminism, gender studies, narratology, psychoanalysis, the gaze, post-colonial anthropology, and so on. Many of these approaches are themselves rooted in semiotics.

In parallel with this semiotic purchase, visual culture studies operates at a trans-disciplinary, even supra-disciplinary level.[12] Its practitioners aim to provide a (post-)structural frame for the study of culture as it is visually manifested. Visual culture studies draws attention to social and religious rituals and political practice, to viewing and the relationship between text and picture, and to the reception and emulation of different cultures.

A group of interventions within visual culture studies sits within this general framework, whilst also pointing beyond it. This group constitutes itself around a movement labelled the *pictorial turn* – a term devised in analogy to the *linguistic turn*, famously proclaimed by Richard Rorty in 1967 and devoted to defining 'society as a text'.[13] One of the leading proponents of identification of a pictorial turn in current developments across the humanities is William J. T. Mitchell (1942–),[14] who holds that prevalent systems of thinking are driven by a dominance of visual metaphors but also, on the flipside, by a growing mistrust and fear of the visual.[15]

Mitchell posed the question 'What is an image?'[16] Notwithstanding his own roots in semiotic and post-structuralist enquiry,[17] his attempt to answer this question led him to a critique of the work of, among others, Nelson Goodman and Edmund Burke.[18] He aimed to break out of the

[12] Bal & Bryson 1991: 175.

[13] Rorty 1967.

[14] Mitchell 1984; Mitchell 1986; Mitchell 1994; Mitchell 2005. The work of James Elkins is also to be noted here: Elkins 1998, Elkins 2000.

[15] Mitchell 1994: 11–3.

[16] Mitchell 1984; Mitchell 1986.

[17] Cf. Mitchell 1994: 11–12.

[18] Mitchell 1986: 47–150.

semiotics mould, arguing against semiotics' deep entrenchment in the verbal and textual, which he regarded as rendering it unfit to deal with the visual qualities of pictures.[19]

Mitchell also strove for what he termed a *critical iconology*. To that end he addressed two particular issues that emerge from Panofsky's iconological model.[20] For Mitchell, 'icon' and 'logos' – the two elements that shape iconology – should be understood not as opposing forces, but as two parts of a complementary relationship. A synthesis of the powers of both media can capture human activity, Mitchell believes, recording, 'This move, in my view, takes iconology well beyond the comparative study of verbal and visual art and into the basic construction of the human subject as a being constituted by both language and imaging.'[21]

Whilst Mitchell's critique of Panofsky's model is somewhat exaggerated in the way in which it frames it as a power hierarchy in which the textual evidence has the firm upper hand over the visual,[22] his second criticism is more weighty. Again, it is connected to the icon–logos antinomy and targets iconology's failure to engage with ideology. Mitchell undertook a cross-analysis of Panofsky's approach and Louis Althusser's Marxist critique of ideology that was triggered by their employment of corresponding analogies to explain their respective models: where Panofsky deployed a man who lifts his hat in a gesture of greeting, Althusser utilised a man who knocks on a door.[23] By using a social event to exemplify his understanding of the visual, Mitchell argued, Panofsky showed that he was guided by the ideological maxim that the 'icon' is subsumed under the structuring perspective of the 'logos'. While claiming to be 'a putative science, not just the object of a science', according to Mitchell, iconology remains unaware of its own ideological basis.[24]

From the deconstruction of both semiotics and iconology, Mitchell developed his central ambition: a methodological framework, a *picture theory*, that is not subject to a methodological meta-system, but is concentrated on the pictures themselves – that framework is to be free of the anxiety that Mitchell believes present in modern philosophy when it comes to reflecting

[19] For the criticisms of semiotics as a text-dominated method, see also above, pp. 116–7.

[20] For Panofsky's model, see above, pp. 20–3.

[21] Mitchell 1994: 24.

[22] For the relationship of text and image in the different reworkings of Panofsky's approach, see above, pp. 32–5, 99–100; cf. also Elsner & Lorenz 2012: 495–506.

[23] Mitchell 1994: 25–34.

[24] Mitchell 1994: 20, 30. Cf. also Mitchell 2007: 45: he specifies that both iconology and ideology set out to establish 'knowledge of objects by subjects' but generate 'knowledge of subjects by subjects'.

critically on individual manifestations of visual representation.[25] Mitchell
seeks to study *what pictures want*:[26]

The idea is to make pictures less scrutable, less transparent; also to turn analysis of
pictures toward questions of process, affect, and to put in question the spectator
position: what does the picture want from me or from 'us' or from 'them' or from
whomever? Who or what is the target of the demand/desire/need expressed by the
picture? One can also translate the question: what does this picture lack; what does
it leave out? What is its area of erasure? Its blind spot? Its amorphic blur? What does
the frame or boundary exclude? What does its angle of representation prevent us
from seeing, and prevent it from showing? What does it need or demand from the
beholder to complete its work?

In Mitchell's picture project, the picture itself is the starting point of the
enquiry and directs the analytical and interpretative process. This *pictorial
turn* shares with visual culture studies an interest in unveiling political and
ideological strategies that inform current discourses around pictures, for
example with regard to representations of war and terror.[27] But with his
investment in the picture as a living thing that is not determined by the
viewer, but surprises and dominates its audiences and its creators, Mitchell
reaches beyond visual culture studies.

Where iconology and semiotics present clear-cut systems, Mitchell's
critical, or practical, iconology borrows freely from formalism, traditional
iconography, and intermedia- and reception-focused studies. His frame-
work does not encompass a theory of representation but contains instead
the life of pictures, their biology. His design is not unlike Panofsky's invest-
ment in iconology, but Mitchell's model has also an anthropological dimen-
sion, for it includes the viewer as the bodily processor of visual discourse.
Mitchell's framework also embraces the paradoxical unstructured nature of
pictures and their unpredictability and wild energy, paralleling closely Aby
Warburg's picture project.[28]

Bildwissenschaft and the iconic turn.

By design Mitchell's approach is full of internal contradictions, but his inter-
est in the poetics of pictures, in their way of operating, is non-negotiable.
That commitment puts him close to, and at the same time at odds with,

[25] Mitchell 1994: 33–4, 12.
[26] Mitchell 2005: 48–50.
[27] Mitchell 2002.
[28] Mitchell 2005: esp. 28–56; see Didi-Huberman 2002: 12.

another branch of picture studies: *Bildwissenschaft*, 'picture/image stud-ies'. Pursued primarily in German-language scholarship, *Bildwissenschaft* does not share the post-structuralist political and ideological sense of mis-sion that characterises New Art History and visual culture studies. Instead, *Bildwissenschaft* tackles the hermeneutics of the picture, along with its anthropological dimension.[29]

Around the time Mitchell presented his *Picture Theory*, Gottfried Boehm (1942–) posed the question 'what is an image?' in a different way, drawing on the French classics of visual phenomenology and psychology by Maurice Merleau-Ponty and Jacques Lacan,[30] and on German hermeneutics and work-immanent art history.[31] Boehm proclaimed an *iconic turn*, again in analogy to Rorty, a turn that he classified as a *return of the image*.[32] Like Mitchell, Boehm embarked on his adventure by contrasting his approach with Panofsky's iconology.[33] In Boehm's case, however, that comparison was achieved by subscribing to another analytical model, namely, Max Imdahl's *Ikonik*, originally developed as a critique of Panofsky's iconology.[34]

Max Imdahl (1925–88) proposed a method of *pure viewing*, which he understood as engagement with the artwork from within the work itself: an interpretation that is *work-immanent*. Imdahl was concerned with pictures that seem to fall beyond the grasp of iconology, namely, abstract art.[35] He sought to give voice to a picture by careful description of its formal and stylistic characteristics, but not, he emphasised, in the manner of iconology, which synchronises these features with logocentric concepts external to the picture.[36] In designing the methodological foundations that underpinned his focus on the exclusively aesthetical structure of a picture, Imdahl drew on phenomenology and philosophical aesthetics.

[29] For a general discussion of *Bildwissenschaften*, see Rampley 2012.

[30] For Lacan, see above, p. 115.

[31] Boehm 1994.

[32] Boehm 1994: 13; cf. also Boehm 2007: 33–4. For Rorty, see above, p. 98. *Iconic Turn* provided the label for a research programme of the Burda Foundation: www.iconicturn.de (29.12.2012). See also Maar & Burda 2004; Maar & Burda 2006.

[33] An extensive exchange between Mitchell and Boehm provides a good overview of their differing positions (Mitchell 2007 and Boehm 2007, in Belting 2007: 27–48).

[34] Boehm 1978: 464; Boehm 1994: 36; Boehm 2007: 32, where he also underlines that the concept of *Ikonik* is not related to Peirce's *icon* (see above, p. 109).

[35] Imdahl 1980: esp. 84–5, 99–100; Imdahl 1994.

[36] In their lucid discussion of Boehm's approach, Jutta Held and Norbert Schneider explain Imdahl's work by referring to his analysis of Picasso's *Guernica*, with Imdahl's final verdict: 'The cohering of the incoherent and the coherent is the actual message' (Imdahl 1982: 560; trans.: author). That verdict leaves aside any historical, and especially any political, aspects of the painting; see Held & Schneider 2007: 487, n. 1241.

A second influence on Boehm's approach was provided by the philosoph-ical hermeneutics of Hans-Georg Gadamer (1900–2002). In his 1960 *Truth and Method*, Gadamer argued against a single, unmoveable truth and in favour of a form of hermeneutics that embraces discourse as a basis for extracting argument and meaning.[37] Gadamer's *hermeneutical circle* was based on the assumption that understanding presupposes recognition, which facilitates a new and different understanding.[38] Combining Imdahl and Gadamer, Boehm embarked on a discursive form of picture analysis and interpretation focused on the artwork, not on its possible frameworks.

Both Boehm and Mitchell put the picture at the centre of their consider-ations. The difference between Mitchell's *pictorial turn* and Boehm's *iconic turn* crystallises, however, around their respective treatment of Panofskyan iconology. Where Boehm rejected iconology's historical investment as he zeroed in on the picture, Mitchell revised Panofsky's take on the glo-bal questions tackled by individual pictures. Where Mitchell abolished meta-theoretical structures in order to focus on the questions pictures raise, Boehm replaced Panofsky's analytical model with another similarly hege-monial system in order to concentrate on the answers pictures provide.[39]

Hans Belting (1935–) presents a *Bildwissenschaft* positioned between Mitchell and Boehm. His argument is close to that of Mitchell in emphasis-ing the need to account for the rifts and shifts in the production and con-sumption of the visual and their social and psychological implications,[40] but he also shares with Boehm an interest in the formal features and appearance of pictures. Belting's position is rooted in his 1983 proclamation of the end of art history: that discipline, he argued, was struggling to maintain its grip on a domain – the visual – that was effectively disintegrating into a study of human communication and production, and the discipline was also no longer able to cater for new forms of art and visuality that were replacing the more traditional forms of artistic output.[41] Belting's observations, with

[37] Gadamer 2004. For a comparison of Gadamer's approach with iconology and semiotic enquiry, see also above, pp. 98–9. Gadamer's hermeneutical circle is the template for Klaus Junker's 'hermeneutical spiral', see above, pp. 93–4.

[38] For an introductory assessment of Gadamer's hermeneutics, see Grondin 2002 and Bernstein 2002 in Dostal 2002.

[39] Boehm 2007: 31: 'The critical assessment in my 'turn' is concerned more with images than with ideology' ('Mein "turn" ist eher bild- als ideologiekritisch', trans.: author).

[40] Belting 2011: 11–15; see also Belting 2005 for an earlier exposition of his project in English.

[41] Belting 1983. Belting revised his initial claim in Belting 1995. Cf. Arthur Danto's exposition on the problems posed by modern art for the discipline of art history, where he argued that with a linear formal development of art dissolved in modern art, traditional art history – understood as a developmental history of art – might no longer be required (Danto 1986: 81–115; cf. also Danto 1998, a revised version of his claim about the 'death of art').

their iconoclastic overtones, were informed by his work on medieval art. There he had studied how visual representations can constitute religious ritual and had seen a gradual shift towards regarding such representations as primarily of artistic, not religious, value, as *high art* in the modern sense.[42]

Belting puts the human body as producer and recipient of the visual back into the analytical equation, appropriating McLuhan's media-as-prosthesis axiom.[43] His interest in the body as an indispensable element of the visual takes two forms: with the *body* as perceiver, as in the case of the producers and viewers of images, and with the media as *embodying* images, providing them with a temporary home. The importance of body and embodiment leads him into an approach that he describes as an *anthropological* exploration of the image, an enquiry into the human and media-dependent dimension of the visual:[44] 'The concept of media, in fact, complements that of image and body. It provides the "missing link", as it were, for the medium helps us to see that the image neither equates with living bodies nor with lifeless objects.'

Belting focuses on the relationship of image, body, and media.[45] The analytical scaffolding can be provided, he suggests, by – with reference to Mitchell – a new form of iconology, once more discarding Panofsky's model because of its logocentric design. Similarly, he rejects semiotics because of its assessment of images 'away from the body'.[46] Instead, he argues for an understanding of images in which they are conceptualised as part of a history of the changing deployment of media – with media understood as physical carriers of both pictures and images – and therefore also as carriers of shifting perceptions. With this focus on the historical dimension of the media–body relationship, Belting diverges from Mitchell's path.[47] His overall objective is not a picture theory, but an *image history*. This historically based examination does not follow the linear layout of conventional historiography but is devoted to Aby Warburg's strand of cultural-historical enquiry and the work of the *image historian*.[48]

Because of its lack of linearity this approach has been classified as a-historical.[49] And yet that judgement fails to grasp its full purchase, perhaps

[42] Belting 1997.

[43] Belting 2011: 16–19.

[44] Belting 2011: 11.

[45] For the Karlsruhe research group of the same name, initiated by Belting, see http//graduiertenkolleg.hfg-karlsruhe.de/ (1.1.2012).

[46] Belting 2011: 11–12.

[47] Belting 2011: 12–13.

[48] Belting 2011: 12. For Warburg, see above, pp. 28–31.

[49] For example: Wood 2004: 371. Cf. Elkins 2002, on the relativity of all types of art-historical approach.

in the same way that such criticism only partly accounts for the post-structural semiotic approach.[50] It denies the fact that – as Belting argues, following Sartre – images have a double existence, as a *process* and as a *thing*. They therefore present more than just historical elements that can be pinned down by means of formal and stylistic categorisation. Consequently, what appears to be a-historical might unlock another layer of historical enquiry, not based on external pretexts, but extracted from within the visual framework of the picture itself.

The picture – from metaphysics to physics.

Both *pictorial turn* and *iconic turn* aim to pursue the epistemic meanings elicited by a picture, responding to questions about what the term *picture* means in light of its stake in aesthetics. Their interest in the picture contrasts with visual culture studies' conceptualisation of pictures in terms of audience and transmission. The approaches around the *pictorial turn* and the *iconic turn* both borrow from Panofsky's iconology for their assessment of the visual elements within a picture – figures and objects – in terms of the history of types and styles. Generally, therefore, these approaches attain a more historical perspective than semiotics-based forms of enquiry, including visual culture studies at large. Meanwhile, scholars such as Mitchell, Boehm, and Belting have shifted the emphasis on the picture away from Panofsky's *a priori* meaning, that is, the picture's fundamental nature or metaphysics, and towards issues of production and perception, that is, the physics of the picture.

A flurry of related approaches has emerged in the wake of the two *turns*. They can be mapped between two poles: a concern for pictures as social-cultural processes, as described by Belting;[51] and an understanding of pictures as possessed by some kind of wild magic, as mooted by Warburg. In French philosophy and art criticism strands of interpretation have developed around the latter pole, with borrowings from phenomenology and Heidegger.

Jean-Luc Nancy (1940–) has scrutinised the differences between texts and pictures and the productive tension that emerges from the relationship between these two cultural codes.[52] Régis Debray (1940–) has focused on

[50] See above, pp. 110–4.

[51] This concern can also be found in the work of Horst Bredekamp (1947–). Bredekamp promotes art history as the paradigmatic discipline for the pursuit of *Bildwissenschaft*, which – he argues from a decidedly German perspective – it had already been before 1933. See Bredekamp 2003; Bredekamp 2010. Cf. Belting 2007: 16; see Schulz 2005: 27.

[52] Nancy 2005.

processes of viewing and perception. Concentrating on the ways in which media content is transmitted, he has developed an approach that he termed *mediology*.[53] Debray argued for the existence of a network covering image producers and viewers, internal and external images. This network shapes the organisation of observations, annotations, ideas, ideals, wishes, and values in which producers and audiences immerse themselves consciously and subconsciously. This network operates as a transmission apparatus that generates and distributes knowledge and thus fulfils the functions of a cultural engine.[54]

Georges Didi-Huberman (1953–), a fierce critic of Panofsky,[55] has targeted the magical, irrational aspects of images, explicitly following in the footsteps of Merleau-Ponty, Lacan, Freud, and Warburg. Didi-Huberman, who describes his project as a *meta-psychology* of images,[56] emphasises the dialectics of the image and the viewing process. He focuses on the multiple coding of images, but he too explicitly differentiates this avenue of enquiry from semiotic analysis.[57] His key example for demonstrating the dialectic *surplus value* that pictures generate is minimal art: these artworks are always more than what they represent, notwithstanding any aims on the part of the artist to create a redundant representation.[58]

A showcase for Didi-Huberman's approach is provided by his analysis of the work of Fra Angelico, and in particular his *Annunciation* in the Florentine monastery of San Marco.[59] Key to Didi-Huberman's analysis is the way in which he turns the spatial framework of the fresco, its colouring, and particularly the voids in between the figures into crucial ingredients for the multiple meanings exuded by the image, for he thus highlights what is lost in a conventional iconological analysis with its pre-textual, figure-centred, and synthesising regime. In doing so he anticipates Belting's demand for a combined study of images and their media.

With this focus on the discourse between image and viewer, Didi-Huberman operates close to another method, namely, reception aesthetics, which has developed on the basis of semiotics.[60] Here the surplus value of a picture is explored primarily with a view to the ways pictures and

[53] Debray 1991; see also Debray 1995; Debray 2000.
[54] Debray 2000: 7–8.
[55] See above, pp. 4–5, 33–6.
[56] Didi-Huberman 1992; for Didi-Huberman's epistemological basis, see Held & Schneider 2007: 496–7.
[57] Held & Schneider 2007: 377–8.
[58] Didi-Huberman 1992: 27–36.
[59] Didi-Huberman 2005: 11–52.
[60] See above, p. 115.

viewers can connect with each other. Under the heading 'reception aesthetics' Wolfgang Kemp (1946–), for example, has explored spectator figures in pictures and their engagement of external viewers.[61]

Visual culture studies and *Bildwissenschaft* have a mixed purchase on visual phenomena. Both share an interest in overcoming the traditional limitations of art history, whether by widening the scope of enquiry to include non-Western art or visual phenomena in disciplines such as the natural sciences or by employing novel forms of analysis and interpretation. A common denominator, at least for Mitchell's *Picture Theory* and for *Bildwissenschaft* more generally, is an investment – explicit or implicit – in the pragmatics of the Peircean sign system and a rejection of the Saussurean version of semiotics.[62] Another shared tendency lies in their refutation of Panofsky's iconology and their commitment to Aby Warburg as the founding father of this type of a history of images.[63]

Where iconology strives for an *a priori* truth and semiotics abolishes the idea of truth altogether,[64] the different varieties of *visual culture studies* and *Bildwissenschaft* locate truth as self-constituting within the picture, shaped by the discursive network of image, body, and media. This claim is based on the assumption of a relative truth, that is, a truth relative to human perception, which in turn links in with Edgar Wind's experiment in embodiment,[65] whose approach is reflected in Belting's plea for concentration on the physics of an image, not its metaphysics.[66]

The emerging approaches around visual culture studies and the *pictorial turn* and *iconic turn* have not yet received a comprehensive critique.[67] Most responses have been general and target their interdisciplinary nature, with the wide array of materials and interpretive models seeming to divert attention away from the traditional core business of art-historical scholarship, that is, from formal and stylistic analysis and the study of individual artists.[68]

The dangers highlighted by such criticism are both epistemic and institutional, and the critics' concern is, above all, to prevent the break-up and subsequent disappearance of art-historical disciplines, along with a

[61] Kemp 1992; Kemp 1998. Cf. also Wollheim 1986: 183–6, where Wollheim developed a stronger sense of the boundary-crossing aspects of spectators in pictures.

[62] For summaries of their approaches, see above, pp. 107–10.

[63] See above, pp. 28–31.

[64] See above, pp. 104–6.

[65] See above, pp. 5–6.

[66] Belting 2011: 10.

[67] For an overwiew, see Wood 2004.

[68] Belting 2011: 11–13.

diluting – or, worse, loss – of all discipline-specific skills and knowledge under the wider bracket of culture studies. Interdisciplinarity is always a challenge.[69] Yet perhaps the greatest strength of the approaches around visual culture studies and the pictorial and iconic turns is that they put art-historical disciplines in a position to drive contemporary discourse across the arts and humanities, and indeed beyond, because they are so capable of handling the visual.[70]

[69] For a lucid description of the alleged dangers of interdisciplinarity (and how to turn them into a methodological advantage), see Bal 2002: 3–21; cf. also Mittelstrass 1991: 21.

[70] Belting 2011: 13.

8 | Image studies in action

Image studies interpretations proceed in three stages, devised to capture the functional aspects of the pictures and the logistics of their display. At the stage concerned with spatial design, the focus is on the physical set-up of the picture. In the second stage, which addresses iconography, the physicality of display is under scrutiny, along with how motifs are combined and subsequently experienced. The third stage explores historical dimensions, with a focus on space and perspective as modelled in and shaped by the picture.

1) The Karlsruhe hydria: the pot as spin doctor

The hydria and its spatial design.

The Karlsruhe hydria stands out because of the arrangement of its two pictorial areas, the upper picture field and the lower frieze. This design also characterises two pieces attributed to the Meidias Painter himself, and hence seems indicative of this artistic circle (for example fig. 5.3).[1] More commonly, hydriae are decorated with a picture or frieze on the frontal part of the shoulder, or a picture on the front of the body. A sizeable group of hydriae combine a shoulder frieze with a body picture on the front. Hydriae of the Camirus type display a frontal pictorial field with an all-around animal frieze.[2] The specific composition chosen for the three Meidian hydriae is unparalleled and at the core of the strategies used to generate and transmit meaning here.

The viewer approach required by the Karlsruhe hydria, with its two picture areas, contrasts with that required by hydriae with a frontal shoulder frieze and body picture, a design popular in the later sixth and early fifth centuries BCE. The upper picture field on the Karlsruhe hydria resembles the traditional frontal shoulder frieze-picture of earlier hydriae because it

[1] RF Hydria, London, British Museum E224; see above, pp. 10–11 n. 29; RF Hydria, Athens, Ceramicus 2712; see above, p. 44 n. 37.

184 [2] Diehl 1964: esp. 61–8.

has to be viewed from above. However, the design is modified: the picture field is extended below the side handles of the vessel (fig. 0.1). This trapezoid picture field requires a lower viewpoint. Where the earlier design of a shoulder frieze established a focal point at the centre front of the body of the vessel, here the picture field takes its viewers across the whole horizontal extension of the vessel.

While such extension can also be found on other contemporary hydriae (figs 8.1, 8.2),[3] on the Karlsruhe hydria, the design is extended further, to include a frieze that runs around the whole vessel underneath the upper picture field. As a result of this arrangement, the two pictorial areas are only visible together in a restricted zone at the front comprising ten figures across the two areas (fig. 0.1). To appreciate the decoration fully, viewers have to engage in activity, turning the vessel or shifting their own points of view. And the movement required is not the normal binary action based on the single 180° rotation common for those Greek vases with a picture on each side of the vessel. The Karlsruhe hydria requires not two, but multiple viewpoints – with none of these viewpoints offering a complete view of both picture areas. The design of the vessel is constituted by individual visual clips.

This arrangement has considerable impact on the content transmitted. The picture field is seemingly a static tableau of thirteen figures, but under closer scrutiny reveals a distinct take on the story of the Judgement of Paris (fig. 5.1).[4] First and most notable is that the mathematical centre of the picture field, which in Greek vase-painting commonly features characters indicative of what is on display, in the case of the Karlsruhe hydria raises more questions than it answers. Although the figure of Paris together with Hermes, the Eros, and the dog forms a nucleus, based on interwoven actant-reactant relationships between the four, the group is also noticeably drifting away from the centre, highlighting its interdependency with other elements in the scene.

In addition, the surrounding cast puts pressure on the cohesion of the nucleus, adding contradictory layers of meaning. The circle of figures immediately surrounding the nucleus intermixes goddesses – Hera, Athena, and Aphrodite – with two personifications, Eris and Eutychia, with the latter

[3] Among those portraying the Judgement, cf. RF Hydria, Palermo, Museo Archeologico Regionale 2366; see above, pp. 39–40 n. 19; RF Hydria, Syracuse, Museo Archeologico Regionale Paolo Orsi 38031; see above, p. 42 n. 26; RF Hydria, once Cancello; see above, p. 42 n. 27; RF Hydria, once Berlin, Staatliche Museen F2633; now lost; from Vulci. Cadmus Painter, 420/410 BCE. Gerhard 1845: pl. c; ABV² 1187,32; Add² 341; CVA Berlin, Antiquarium 9: Beilage 16; LIMC VII (1994) s.v. *Paridis Iuridicum* no. 47.

[4] For a summary of the iconographic features of the scene, see above, pp. 10–12, 37–44.

holding the garland towards Paris. With three of these four figures look-
ing towards the nucleus, that grouping is confirmed as the focal point of
the picture. And yet two pairings – a goddess and a personification in each
case – offer diametrically opposed commentaries on the activity taking
place within the nucleus, pointing to the positive (Eutychia and Aphrodite)
and the negative (Eris and Athena) repercussions of Paris' choice. The other
ancillary characters – Clymene, the second Eutychia, Helius, and Zeus –
add to that complexity.[5]

The physicality of the material carrier amplifies these dynamics: the fur-
ther the view drifts to the left, the more the negative consequences beyond
the contest come to the fore; the further to the right, the more Aphrodite's role
is emphasised. The depiction delivers both situative and attributive mean-
ings: the former expressed in the figures belonging to the mythological nar-
rative, the latter in the participation of the personifications. Meanwhile, the
figure of Eris supports both these strands – and thereby directs a particular
understanding of the scene, as a situative representation of the Judgement,
and at the same time an attribute of the Trojan War. The employment of
such a figure as the hinge of the scene confirms multi-stability as central to
the figurative decoration. In this sense, then, movement across the surface
of the vessel turns into pro- or retrogression in narrative time and com-
plexity, fuelled by different narrative voices and perspectives, and narrative
modes. The tableau character of the composition may seem to present a fait
accompli, but the image still contains suspense.

Finally, the frieze below offers yet another extension, once more sup-
ported by the vessel itself. Its content, the Dionysian thiasus and the bou-
doir scenes (fig. 5.2), is generally taken as playing up the characteristics of
the Meidian circle.[6] And yet its role goes beyond a mere reinforcement of
the Meidias brand. The frieze interacts with the display above: the female
activity presented below, maenadic revelling and a more constrained show-
casing of beauty-related activity, provides an attributive enhancement of
the decision being taken above, Paris' scrutinising of female qualities. So,
while the Judgement scene itself pursues the issue of female roles as only
one aspect among several, the frieze highlights that one aspect by means of
comparative extension. Additionally, the distribution of the groups across

[5] On Clymene: LIMC VI 1992 s.v. *Klymene IV* (A. Kossatz-Deissmann): the only occurrence
listed is this instance on the Karlsruhe hydria. On the second Eutychia, see above, p. 39. On
Helius' role, see above, p. 39. Zeus here carries a thunderbolt; on his iconography in general:
LIMC VIII 1997 s.v. *Zeus* (M. Tiverios). The father of the god features first in the Meidian
scenes of the Judgement, cf. Clairmont 1951: 110.

[6] See Burn 1987: 65–8; Robertson 1994: 237–42. See also above, pp. 45–6.

the expanse of the frieze serves up a noteworthy counterpoint to the scene above. While it connects the two types of female activity, it also identifies a correlation of thiasus with the Judgement – but not with the boudoir scenes, which would appear the more obvious choice if the set-up were to enforce the victory of Aphrodite depicted above.

Closer inspection reveals that the figure of Dionysus depicted below converges with the figure of Hermes above, for the figures mirror each other's stance (fig. 0.1). This replication seems more than just a coincidental double use of the same stock figure, not least because Dionysus' thyrsus overlaps the frame of the frieze and reaches into the dividing meander band. The connection thus established appears as if a visual take on the type of narrative transgression exploited by Cratinus in his *Dionysalexandrus*, where Dionysus takes over Paris' role and secures Helen for himself.[7] This extension of content along a medial axis is matched by the lateral widening of content facilitated by the boudoir scenes in the back of the frieze, which are entrenched in a mode of existence that is not necessarily part of the mythological realm.[8] And yet, despite this different setting and despite the separation from the upper pictorial field, the back part of the frieze still successfully crosses contentual and spatial thresholds to serve as an extension of female roles and behaviours as depicted in the Judgement and the thiasus.

In intermixing the parts of the vessel and also the levels of transmission, the vase and its decoration involve the viewer in processes of what could be termed modal metalepsis:[9] by breaking down the boundaries between the narrative and the descriptive and between the mythological and the normal, the design of the vessel reaches towards its audience, immersing them in what is on display. The transmission is not merely a product of image-processing in the mind of the viewer, but is made *corpo-real* on and through the body of the vessel.

Space, design, and content – an iconographic perspective.

The character of this specific form of transmission can be further defined by comparing the design of this vessel with the design of other vessels

[7] See also above, pp. 40–1 n. 22.

[8] On the relationship of mythology and the normal/everyday, see above, pp. 100, 122 n. 12, 164–5.

[9] For the narrative category of metalepsis, see Genette 1980: 33–85, 234–7; Melina 2002; De Jong 2004b: esp. 16; De Jong 2009: esp. 88–93. For its use to describe phenomena of visual storytelling, see Lorenz 2007: 117–21; Lorenz 2013a: esp. 119–20, 142–4. On the categories *narrative* and *descriptive*, see Lorenz 2007: 129–30, with a discussion of Giuliani 2013: 15–18, 132–4, 244–8.

representing the Judgement. The Judgement was popularly depicted in black- and red-figure vase-painting and across different types of pottery. Certain trends emerge.[10] Whilst symposium ware was the preferred habitat for the story, it appears marginally more often in black-figure than in red-figure.[11] Red-figure vase-painting was increasingly likely to be found depicting the Judgement on hydriae and notably less likely to be found on lecythi, but the subject was particularly popular for white-ground black-figure lecythi in the last quarter of the sixth-century.[12]

The Judgement was frequently displayed along with other figure scenes. Perhaps unsurprisingly, the variety of combinations was widest in the second half of the sixth century, the period in which the myth enjoyed greatest popularity on vases. Then, Judgement scenes were most frequently partnered with depictions of generic warriors, including scenes of soldier's farewell,[13] followed by combinations with Dionysian scenes,[14]

[10] Of the 216 occurrences of the myth listed in the Beazley Archive, 149 are black-figure and 67 are red-figure.

[11] 55.6% for black-figure as against 52.1% for red-figure; 'symposium ware' here comprises amphorae, craters, stamni, pouring vessels (oinochoae, pelicae), and drinking vessels (cups, scyphi, and canthari). This overall picture cannot account, however, for the comparative rise of occurrences on either drinking vessels towards the end of the sixth century and in the first half of the fifth or craters in the third and fourth quarter of the fifth.

[12] For the hydriae, 14.74% in black-figure with 19.37% in red-figure; for the lecythi, 16.08% in black-figure (two-thirds of which from the last quarter of the sixth century) with 8.94% in red-figure. For white-ground black-figure lecythi, see Kurtz 1975.

[13] Of the 127 sufficiently preserved depictions of the Judgement in black-figure vase-painting listed in the Beazley Archive (147 in all), about one in six shows a scene with warriors alongside the Judgement. Scenes of warrior farewell: BF Amphora, London, British Museum B171; from Vulci. *c.* 530/520 BCE. CVA *London, British Museum* 3: III.He.6, pl. 31.4A–B; BF Neck-amphora, Tarquinia, Museo Nazionale Tarquinese 630; from Tarquinia. Antimenes Painter, *c.* 520 BCE. ABV 271.76; Burow 1989, no. 99, pl. 98; BF Neck-amphora, Florence, Museo Archeologico Etrusco 3865. Antimenes Painter, *c.* 510 BCE. ABV 278.30; Add² 73; BF Neck-amphora, London, British Museum B326; from Vulci. Group of Würzburg 179, *c.* 520 BCE. ABV 290.2; Para 126; CVA *London, British Museum* 4: III.He.7, pl. 57.4A–B. On the theme more generally, see Spieß 1992; Matheson 2005.

[14] Scenes with Dionysus: BF Neck-amphora, Bochum, Ruhr Universität, Kunstsammlungen S1089. Exekias, 530/520 BCE. CVA *Bochum, Kunstsammlungen der Ruhruniversität* 1: 37–8, Beilage 9.1, fig. 13, pls 26–7; BF Neck-amphora, Oxford, Ashmolean Museum G272. Group of Würzburg 199, 520/510 BCE. ABV 290.2; Add² 75; CVA *Oxford, Ashmolean Museum* 3: 5, pls 12.1–2, 13.1–2; BF Neck-amphora, Brussels, Musées Royaux A 3089. 530/520 BCE. CVA *Brussels, Musées Royaux d'art et d'histoire* 3: III.He.18, pl. 26.2A–C; BF Hydria, Auckland, The Auckland Institute and Museum 12964; from Italy. Group of Faina 75, 530/520 BCE. ABV 327.5; Para 144, 192; Add² 88; CVA *New Zealand Collections* 1: 12–13, pl. 49.1–5; BF Pyxis, Lentini Museum 4640; from Lentini. *c.* 550 BCE. Panvini & Sole 2009: 326, VI/364; BF Hydria, Berlin, Staatliche Museen F1894; from Vulci. Antimenes Painter (Manner of), *c.* 520 BCE. ABV 277.14, 692; Para 122; Add² 72; CVA *Berlin, Antikenmuseum* 7: 27–8, Beilage 5.1 pls 19.3–4, 20.2.4, 48,3; LIMC VII s.v. *Paridis Iuridicum* no. 33; BF Neck-amphora, New York, Gallatin.

and with scenes of the Trojan War, in particular of Troilus and the Recovery of Helen;[15] combinations with Heracles and Athena were also popular,[16] and

Group of Compiegne 988, *c.* 520/510 BCE. ABV 285.5; CVA *Cambridge (MA), Fogg Museum and Gallatin Collections*: 86, pl. 37.2A–B; BF Neck-amphora, Richmond (VA), Museum of Fine Arts 60.27. Antimenes Painter, *c.* 520 BCE. Para 120.6STER; Add² 70; Burow 1989: no. 84, pl. 85. Two vessels include Dionysus within the scene of the Judgement: BF Scyphus, Paris, Cabinet des Médailles I4791; from Corinth. *c.* 500 BCE. CVA *Paris, Bibliothèque Nationale* 2: 51, pl. 70.4.6–8; BF Hydria, Berlin, Staatliche Museen F1894; as above. Combinations of Dionysian character, but without the god: BF Neck-amphora, Purrmann 8763 (Satyrs and Maenads). Tyrrhenian Group, 560/550 BCE. *Aachener Kunstblätter* 44, 1973: 24–5, figs 29–32; BF Neck-amphora, London Market (Maenad and Bull). *c.* 510 BCE. Sotheby, sale catalogue: 9.12.1985, no. 262; BF Amphora, Vatican, Museo Gregoriano Etrusco Profano 39515 (Symposium); from Vulci. Ptoon Painter, 560/550 BCE. ABV 84.3; BF Neck-amphora, Florence, Museo Archeologico Etrusco 70995; see above, p. 39 n. 13 (Symposium). Lydus, 570/560 BCE. ABV 110.32; Para 44; Add² 30.

[15] Combination with scenes from Troy: BF Pyxis, Lille, Musee de Beaux Arts 763 (Achilles and Memnon). C Painter, 570/560 BCE. ABV 681.122BIS; Add² 16; CVA *Lille, Palais des Beaux-Arts-Université Charles de Gaulle*: 25–8, fig. 2, pls 5–7; LIMC VII s.v. *Paridis Iuridicum* no. 5; BF Neck-amphora, London, British Museum B239 (Achilles dragging Patroclus' body); from Vulci. Leagrus Group, *c.* 520/510 BCE. ABV 371.147; Add² 99; CVA *London, British Museum* 4: III.He.7, pl. 58.3A–B; BF Neck-amphora, Hannover, Kestner-Museum 754 (Aeneas); from Etruria. Painter of Munich 1519, *c.* 510 BCE. CVA *Hannover, Kestner-Museum* 1: 25, pls 9.4, 13.1–2, 14.4. Scenes of the Troilos myth: BF Hydria, Berlin, Staatliche Museen F1895; from Vulci. Antimenes Painter, *c.* 510 BCE. ABV 268.31; Add² 70; Burow 1989: no. 63, pl. 63; BF Hydria, Munich, Antikensammlung J136. The recovery of Helen: BF Lecanis, Athens, National Museum, Acropolis Collection 2116; from Acropolis. C P, 570/560 BCE. ABV 58.121; BF Neck-amphora, Boston (MA), Museum of Fine Arts 60.790. Group of Würzburg 199, 520/510 BCE. Para 126.12BIS; Add² 75; CVA *Boston Museum of Fine Arts* 1: 33–4, fig. 37, pl. 45.1–4; BF Neck-amphora, Munich, Antikensammlung 1392. Antimenes Painter, 520/510 BCE. ABV 281.16; Add² 73; CVA *Munich, Museum Antiker Kleinkunst* 1: 20–1, pls 26.2, 27.4, 28.5; LIMC VII s.v. *Paridis Iuridicum* no. 34; BF Neck-amphora, Richmond (VA), Museum of Fine Arts 57.9. Antimenes Painter, *c.* 520 BCE. ABV 271.78, 691; Para 118; Add² 71; Burow 1989: no. 39, pl. 39. On the myth, see LIMC IV 1988 s.v. *Helene* (L. Kahil); Ghali-Kahil 1955: 16–22, 71–113, 190–202; Scherer 1966–67; Hedreen 1996.

[16] Combinations with Heracles: BF Hydria, London, British Museum B312 (Heracles and Triton); from Vulci. Chiusi Painter, 530/520 BCE. CVA *London, British Museum* 6: III.He.5, pls 70.1, 81.3; Ahlberg-Cornell 1984: 136, no. VIII.2; BF Hydria, University of Chicago, D. & A. Smart Gallery 1889.15 (Heracles and Triton); from Cerveteri. Leagrus Group, 510/500 BCE. ABV 673; Para 164; Add² 148; LIMC VII s.v. *Paridis Iuridicum* no. 16; BF Amphora, Paris, Musée du Louvre F31 (Heracles and Cycnus). Witt Painter, third quarter of the sixth century BCE. ABV 313.1; CVA *Paris, Louvre* 3: II.He.10, III.He.13, pls 11.6.9, 17.2; Zardini 2009: 272, 516, figs 6, 110A; BF Hydria, NYMC (Heracles and the Lion). Antimenes Painter, *c.* 510 BCE. ABV 277.13; Add² 72; CVA *Northampton, Castle Ashby*: 13, pl. 21.1–4. Combinations with Heracles and Athena: BF Loutrophorus, Athens, National Museum, Acropolis Collection 1.1174; from Acropolis. *c.* 530/520 BCE. Graef & Langlotz 1925: pl. 68.1151A; BF Hydria, London, Market. Third quarter of the sixth century BCE. Christie, Manson and Wood sales catalogue 28.4.1964, no. 64, pl. 9; BF Neck-amphora, London, British Museum 1847.8–6.27. Eye-Siren Group, *c.* 520/510 BCE. ABV 286.3; Add² 74; CVA *London, British Museum* 4: III.He.7, pl. 58.1A–B; BF Scyphus, Athens, National Museum 12626. Krokotus Group, *c.* 510 BCE. CVA *Athens, National Museum* 4: 44–5, fig. 10.2, pls 33.1–4, 33.3–4. Birth of Athena: BF Pyxis, Paris, Musée du Louvre CA616; from Thebes. C Painter, 570/560 BCE. ABV 58.122; Para 23; Add² 16; LIMC

joint depictions with Theseus and the Minotaur, Apollo, and the gigantoma-
chy were also found.[17]

From the end of the sixth century onwards, however, the Judgement more
often than not appeared as the only theme on its material carrier, rather than
in combination with other scenes. In part, this shift can be explained by the
types of vessel now employed for depiction of the myth, which provided space
for only a sole picture field: the lecythus and the calpis-type hydriae become
more prominent while the amphorae disappear from the Judgement portfolio.
And the combinations that still occur set a different emphasis: whilst no new
subjects are introduced, the partnering with warrior scenes and with scenes
of Heracles and Athena ceases,[18] and scenes of the Trojan War that still occur
in combination with the Judgement focus on Helen.[19] Combinations with
Dionysian scenes continue, on occasion intermixed with the appearance of
Apollo.[20]

This shift towards the Judgement as sole content and away from previously
popular combination topics coincided with changes in the iconographical
reach of the figure of Paris. In black-figure vase-painting, the Judgement is

VII s.v. *Paridis Iuridicum* no. 6; BF Neck-amphora, Munich, Antikensammlung J101; from
Vulci. Leagrus Group, *c.* 510 BCE. CVA *Munich, Museum Antiker Kleinkunst* 8: 85–6, Beilage
F8, pls 424.4, 427.1, 430.4; BF Pyxis, Athens, Ceramicus 21290; from Ceramicus. Kunze-Götte
et al. 1999: pl. 40.1.8, 2–5, Beilage 5. Athena in chariot: BF Neck-amphora, Vatican, Museo
Gregoriano Etrusco Vaticano 399; from Vulci. Group of Copenhagen 114, 530/520 BCE.
ABV 395.7.

[17] Combinations with Theseus: BF Amphora, Brussels, Musées Royaux R306. Class of Louvre
F215BIS, 530/520 BCE. Para 138; CVA *Musées Royaux d'art et d'histoire* 1: III.He.4, pl.
11.2A.2B; BF Neck-amphora, Munich, Antikensammlung J107; from Vulci. Antimenes
Painter, *c.* 510 BCE. ABV 278.31; Add² 73; CVA *Munich, Museum Antiker Kleinkunst* 8: 80–1,
Beilage F4, pls 419.4, 423.1–2, 430.1. Apollo: BF Neck-amphora, London, British Museum
B238; from Vulci. Nicoxenos Painter, last quarter of the sixth century BCE. ABV 392.9; Para
172; Add² 103; CVA London, British Museum 4, III.He.7, pl. 58.2A–B; LIMC VII s.v. *Paridis
Iuridicum* no. 1. Gigantomachy: BF Neck-amphora, New York, Metropolitan Museum 98.9.11.

[18] Instead, a combination with an amazonomachy occurs: RF Pelike, Malibu, The J. Paul Getty
Museum 83.AE.10. Marsyas Painter, 330/320 BCE. LIMC VII s.v. *Paridis Iuridicum* no. 52A.

[19] RF Cup, Paris, Musée du Louvre G151 (Paris returning to Priam and Hecuba); from Cerveteri.
Brygos, *c.* 480 BCE. ARV² 406.8; Para 371; Add² 232; LIMC VII s.v. *Paridis Iuridicum* no. 35;
RF Cup, Berlin, Staatliche Museen F2291 (Paris and Helen); from Vulci. Makron, 490/480
BCE. ARV² 459.4, 481, 1385, 1654; Para 377; Add² 244; CVA *Berlin, Antiquarium* 2: 33–4, pls
84; Kunisch 1997: no. 295; LIMC VII s.v. *Paridis Iuridicum* no. 36; RF Cup, Berlin, Staatliche
Museen F2536 (Helen and Menelaus); from Nola. Painter of Berlin 2536, *c.* 440 BCE. ARV²
1287.1, 1689; Add² 358; CVA *Berlin, Antiquarium* 3: 17, pls 117.2–4, 118.1–2, 133.2.4.9; LIMC
VII s.v. *Paridis Iuridicum* no. 39.

[20] RF Stamnus, London, British Museum E445 (Poseidon, Nike, Dionysus); from Vulci. Painter
of London E445, *c.* 470 BCE. ARV² 217.1; CVA *London, British Museum* 3: III.Ic.9, pl. 21.4A–
D; LIMC VII s.v. *Paridis Iuridicum* no. 21; RF Stamnus, Berlin, Staatliche Museen F2182; from
Tarquinia. Syleus Painter, 480/470 BCE. ARV² 251.32; LIMC VII s.v. *Paridis Iuridicum* no. 104;
RF Amphora, London, British Museum E257; from Vulci. Niobid Painter, 460/450 BCE. ARV²

the Trojan prince's sole iconographic presence, some appearances as a partici-
pant in the Trojan War aside.[21] In red-figure vase-painting, his iconographic
portfolio diversified to include scenes of romantic encounter with Helen,[22]
frequently in the presence of Aphrodite.[23] Scenes displaying Paris as a warrior
were discontinued.

These changes in compositional layout, thematic juxtaposition, and inter-
nal iconography[24] were not all synchronous. They should be understood as
indicators of gradual shifts in the appropriation of the Judgement. Over time,
they would shape the Judgement iconographically such that the scenes from
the later fifth century look considerably different from those of a century ear-
lier. But notwithstanding the seemingly uncoordinated nature of the changes,
together they establish a clear trajectory in the characterisation of the indi-
vidual participants and in the depiction of their relationships.

The scenes of the sixth century put great emphasis on the goddesses and
on the homogeneity of their group (fig. 2.1). The Judgement here is not so
much about mortal arbitration as about divine force,[25] an interpretation sup-
ported by the absence of Paris or his fleeing from the scene. In addition, the
processional character of the scenes encourages their interpretation in light of
ritual activities, such as wedding processions.[26] The Judgement then marks a
stage in life and the power of the gods in orchestrating its course.[27] To a lesser

604.50; Add² 267; CVA *London, British Museum* 3: III.Ic.5, pl. 7.2A–B; Prange 1989: N65, pl.
24; RF Bell-crater, Sarajevo, National Museum 33 (Satyr and Maenad). 440/430 BCE. CVA
Sarajevo, Musée National de la Republique Socialiste de Bosnie-Herzegovine: 49–50, pls 46.1–3,
48.1–2; RF Hydria, Karlsruhe, Badisches Landesmuseum 259; RF Calyx-crater, St Petersburg,
Hermitage Museum ST1807 (Dionysus and Apollo); see above, p. 128 n. 30; RF Pelike, Athens,
National Museum CC1855. Marsyas Painter, 350/340 BCE. ARV² 1475.5; Para 495; LIMC
VII s.v. *Paridis Iuridicum* no. 53; RF Calyx-crater, Athens, National Museum N1106 (Satyrs
and Maenads). LC Group, *c.* 330 BCE. ARV² 1457.11, 1461, 1694; Add² 380; LIMC VII s.v.
Paridis Iuridicum no. 54. Combinations with Apollo: RF Cup, Paris, Musée du Louvre G151;
see above, p. 190 n. 19; RF Hydria, Berlin, Staatliche Museen F2633 (Apollo and Leto in the
Judgement scene); see above, p. 185 n. 3; RF Bell-crater, Vienna, Kunsthistorisches Museum
1771 (Apollo and Leto); see above, p. 42 n. 26.

[21] LIMC I 1981 s.v. *Alexandros* nos 71, 74, 78 (R. Hampe); see above, pp. 39–41.

[22] For these scenes, see above, pp. 43–4.

[23] On the relationship between heroine and goddess in these scenes, see Bron 1996; cf. Shapiro
2005: 54–60; Meyer 2009: 90–3.

[24] For the iconographic development of the individual characters, see above, pp. 37–44.

[25] The Judgement seems to be appropriated in this way in those cases where it is combined with
scenes of Heracles and Theseus, see above, pp. 189–90 nn. 16–7.

[26] See above, pp. 38–41; cf. also Dodson-Robinson 2010 on Sappho's version of the Judgement
and connections to wedding ritual. On wedding depictions more generally, see Oakley & Sinos
2002.

[27] This notion is strongest in those cases where the Judgement is combined with scenes of the
Birth of Athena, but might reverberate also in combinations with the recovery of Helen, and
with Troilus (for examples see above, p. 189 n. 15).

extent, consecutive narratives across an individual vessel were also deployed during this period, with the Judgement depicted along with scenes of the Trojan War, which would follow.[28]

The emphasis on the goddesses as a group is redirected in the last quarter of the sixth century, first with the growing individualisation of the goddesses, then with Paris' continuous presence in the scene. From here, the Judgement was no longer about the three goddesses as a ritualised, powerful unit, but rather increasingly about the relationship between the Trojan prince and the individual qualities embodied by each of the goddesses. This shift was most pronounced from the second quarter of the fifth century, when the goddesses, having arrived on Mount Ida, were depicted surrounding Paris, and the prince was shown choosing between them (fig. 2.2).[29]

Space and narrative towards the end of the fifth century.

The focus on the relationship(s) between the individual actors offered an opportunity for the story to reach beyond its immediate mythological and contentual framework. The Judgement could still be employed as an important episode in the Trojan War or, indeed, as a marker for a stage in life,[30] but the zooming in on the characters and, in particular, on the power of Paris facilitated a step change: with the all-encompassing, formidable power of the divine trinity discontinued in the scene, the behaviour of the individual participants in the Judgement and the consequences of their actions for the course of (mythological) history were carved out more and more within the scene itself.[31] Whilst earlier the juxtaposition of the Judgement with other scenes had facilitated an extension of the story, these later depictions, and those from the last decades of the fifth century in particular, negotiate such extension within the Judgement scene itself, and to this end a flurry of personifications and other mythological characters is introduced.[32]

This reworking of the story in favour of greater emphasis on relationships and on the power of Paris is found in the scene on the Karlsruhe hydria, and indeed on the other examples of the Judgement from the wider circle of the Meidias Painter (fig. 8.1, 8.2).[33] And on a number

[28] See above, pp. 40–1, 119–20.

[29] For the iconographic development, see above, pp. 38–9.

[30] As is the case when the Judgement is combined with the subject of Paris and Helen: RF Cup, Berlin, Staatliche Museen F2291; see above, p. 190 n. 19.

[31] Other additions to the Judgement scene in the later fifth century include Priam and Hecuba, for example: RF Hydria, Palermo, Museo Archeologico Regionale 2366; see above, pp. 39–40 n. 19.

[32] See above, p. 39.

[33] RF Hydria, Karlsruhe, Badisches Landesmusum 259; RF Hydria, Berlin, Staatliche Museen F2633, see above, p. 185 n. 3; RF Calyx-crater, St Petersburg, Hermitage ST1807; see

of vessels from this group, including the Karlsruhe hydria, the visual exploration of the internal relationships that shape the Judgement are taken even further, a development that is particularly evident when the Karlsruhe hydria is compared with the calyx-crater by the Cadmus Painter.[34] Whilst personifications are employed in both scenes, the latter presents these extending characters in a register above and separate from the core cast.[35] On the crater, the viewer is confronted with a static juxtaposition – on the one hand the myth, on the other the consequences – and because of the physicality of the material carrier, both elements are in view together.[36]

The situation on the hydria is not as straightforward. Different permutations of its content depending on the position of the viewer could be encountered, a method that feeds off and maximises the impact of the more complex hydria shape. This technique was also adopted for a group of other hydriae representing the Judgement.[37] Two pieces in particular provide insight into aspects explored in this period. Figures such as Priam, Hecuba, and Oinone were included on a piece by the Nicias Painter such that the further along the sides the viewer's scrutiny falls, the more the Judgement is explored in light of family relationships (fig. 8.2).[38] A hydria by the Cadmus Painter shows the Judgement from an entirely different angle, quite literally (fig. 8.1):[39] Aphrodite takes up the centre of the composition here,

above, p. 128 n. 30; RF Hydria, once Cancello; see above, p. 42 n. 27; RF Hydria, Palermo, Museo Archeologico Regionale 2366; see above, pp. 39–40 n. 19; RF Hydria, Syracuse, Museo Archeologico Paolo Orsi 38031; see above, p. 42 n. 26; RF Bell-crater, Vienna, Kunsthistorisches Museum; see above, p. 42 n. 26.

[34] RF Calyx-crater, St Petersburg, Hermitage ST1807; see above, p. 128 n. 30.

[35] In addition to Eris, the crater also features Themis; and on the crater Helius' role in providing the scene with a temporal framework is appropriated by Selene and Eos, standing either side of Themis and Eris in their carriages. For Themis, see LIMC VIII 1997 s.v. *Themis* (P. Karanastassi); Clairmont 1951: 112; Shapiro 1993: 216–26; Borg 2002: 131, 145; see also Davies 1988b: 31, 5–11. On the bell-crater in Vienna depicting the Judgement, Helius and Selene are combined to instil a temporal dimension: Bell-crater, Vienna, Kunsthistorisches Museum IV 1771; see above, p. 42 n. 26.

[36] One could indeed argue that the crater in St Petersburg translates the new iconographic shape of the Judgement into the presentational framework of the mid-sixth century, given that it represents a scene of Apollo and Dionysus on the reverse. On the relationship of Apollo and Dionysus, see Mitchell-Boyask 2008: 107–9.

[37] RF Hydria, Berlin, Staatliche Museen F2633, now lost; see above, p. 185 n. 3; RF Hydria, once Cancello; see above, p. 42 n. 27; RF Hydria, Palermo, Museo Archeologico Regionale 2366; see above, pp. 39–40 n. 19; RF Hydria, Syracuse, Museo Archeologico Paolo Orsi 38031; see above, p. 42 n. 26.

[38] RF Hydria, once Cancello; see above, p. 42 n. 27. Complexity is added because the additional figures can bear dual identifications, see Lorenz 2007: 121–8. This family aspect is also championed by Euripides in his *Hecuba* (premièred before 423 BCE), see Mossman 1995.

[39] RF Hydria, Berlin, Staatliche Museen F2633, now lost; see above, p. 185 n. 3.

Fig. 8.1 Aphrodite in the centre of the Judgement of Paris. Red-figure hydria by the Cadmus Painter; from Vulci. Berlin, Staatliche Museen F2633 (now lost). 420/410 BCE.

accompanied by Pothus;[40] Paris and Hermes, on the left, and the other two goddesses, on the right, only come into view when the viewer glances side-ways.[41] This breaking down of the scene into individual frames, in terms of both location and content, puts emphasis on the theme of love and desire, but by the same token generates anticipation about the story the scene will

[40] Pothus is the personification of desire: LIMC VII 1994 s.v. *Pothos I* (J. Bažant); Shapiro 1993: 121–4. Other personnel include Himerus and a boy on a dolphin, both rendered in parallel to Pothus. On Himerus: see above, p. 43 n. 32. The dolphin boy is interpreted as Taras by Clairmont 1951: 113; on this figure, see LIMC 1997 VIII s.v. *Taras I* (R. Vollkommer). Taras is one of Sparta's allies on Sicily (Thuc. 6.34.4; 44.2), which raises the question whether the Eros figures here supply a subcutaneous political commentary. Similar personnel can be found on the name vase of the Cadmus Painter, also in Berlin, which depicts a scene with Cadmus and Athena: RF Hydria, Berlin, Staatliche Museen F2634; from Vulci. Cadmus Painter, 420/410 BCE. CVA *Berlin, Antikensammlung* 9: 59–64 fig.16 pls 34–9, 58.11, Beilage 9.1; LIMC V 1990 s.v. *Kadmos* I no. 19.

[41] The placement of the figures in a w-shape across the curved surface of the hydria's shoulder enhances this fragmentation: Paris, Aphrodite, and Hera are laid out across the edge of the curve, well visible from an elevated viewpoint; Hermes and Athena, placed in the intervals between the three, are positioned further below and can therefore best be seen from a lower viewpoint. In addition, behind the handle attachments, stand a woman with burning torch and bow (on the right) and a man with wreath and laurel staff (on the left). They bear no name labels, unlike most other figures in this scene, but their attributes suggest that they represent Leto and Apollo.

Fig. 8.2 The Judgement with extended entourage. Red-figure hydria by the Nicias Painter; from Suessula. Once Cancello. 420/410 BCE.

yield. It thereby restructures the Judgement, selecting one aspect of its outcome for particular attention, in this case the fulfilment of Paris' desire.

On the Karlsruhe hydria, the same techniques are employed, with characters extending the core content and their placement across the vessel fuelling the narrative. But perhaps more pronouncedly than on the other examples, the arrangement here emphasises how the activity required of the viewer, both physical and intellectual, results in continuous interchanges in modes of transmission, not least because from a certain angle the hydria partners the Judgement with the Dionysian scene, within a single visual field. The hydria therefore serves as the 'body of narrative', taking the role of an extradiegetic or primary agent of narrative that guides the viewers,[42] a body of narrative with the potential to determine the content and dissolve the boundaries between reality and virtuality.

In this way, then, the design of vessels such as the Karlsruhe hydria surmounts one of the essential problems of visual storytelling: that is, how to guide or control the recipient's gaze.[43] That problem is solved by creating individual frames of transmission, visible only from distinct viewpoints. Not all of these frames provide content of their own, and yet the overall content is shaped by their interplay, with thresholds of meaning continuously renegotiated and challenged.[44] The vessel conveys content while mapping both the individual perspectives that mould that content and the interstices between those perspectives.

Here we can capture the genuinely innovative thrust of this type of visual design, and of late fifth-century vase-painting more generally. Many of the strategies employed on these vessels stem from the standard corpus of storytelling in Greek vase-painting; some are even rather old-fashioned, for

[42] On the terms extradiegetic and/or primary, see De Jong 2004a: 1.
[43] Giuliani 2013: 248–9.
[44] On the impact of individual frames on meaning production, see Friedberg 2006: 196.

example the employment of polychronous and proleptic features such as the combination of the Judgement with elements pointing to the imminent war.[45] But these earlier examples lacked the same integration of the material carrier. In the later fifth century, the shape of the vessel – its corporealisation – was newly discovered as a narrative engine, something it certainly had always been, but without being exploited to the same extent. These innovations resulted in the vessel's surface appearing as if a holographic foil – a surface that constantly evolves as the viewer glances over it – supported by the shape of the hydria, which called for movement to the sides as well as up and down.

The notion prevalent in scholarship that these vessels are free of narrative cannot be upheld.[46] The distributed narrative created on these vessels must be understood as their particular strength in transmitting content,[47] and not as evidence of their creators' inability to shape a story or as a symptom of the imminent decline of Athenian vase-painting in the fourth century. Decorations on vessels such as the Karlsruhe hydria consist of individual units, or frames, that demand activity – and not simply reaction – from their viewers if meaning is to be generated, whether those viewers are to reposition either themselves or the vessel, or to select from sets of possible relationships and levels of meaning – the mythological, the allegorical, and the normal. The vase becomes a sphere of virtual discourse. It provides not an escapist gateway into a dream world,[48] but an interface that blurs levels of existence.

Overall, then, vessels from the end of the fifth century such as the Karlsruhe hydria document an increase in awareness of issues of the visual during this period[49] and were engaged in particular with the essential problem of how to direct viewers – concerns that will become increasingly prominent in vase-painting throughout the following century. They explore designs that demonstrate a concern for strictly visual ways

[45] Polychronous storytelling, with cataphoric or proleptic reference to events to come, can be found in vase-painting throughout the sixth and fifth centuries, see Snodgrass 1982 (contra Wickhoff 1900: 13–16); Giuliani 2013: 134–5; cf. Lorenz 2007: 128–31.

[46] Hahland 1930; Real 1973: 62–3, 71. For a more diversified analysis, see Isler-Kerényi 1985; Burn 1987: 95; Borbein 1995: 445–6; Schmidt 2005: 287–8.

[47] Cf. the notion of narrative described by Mieke Bal and Norman Bryson (Bal & Bryson 1991: 205): 'What this view of narrative suggests, then, is that the act of looking at a narrative painting is a dynamic process. The viewer moves about the surface to anchor his or her look at a variety of positions. These positions are not just alternatives, as a pluralistic view would have it, but are interrelated and embedded.'

[48] The vase was interpreted in this sense in earlier scholarship: Burn 1987: 21. Contra Lorenz 2007: 138–41; and above, pp. 48–51.

[49] Cf. Borbein 1973: 174–8; Borbein 1995: 443–8.

of transmission and catered for audiences not accustomed to the newly developing culture of reading.[50] The type of storytelling practised on these vases is characterised by the simultaneousness of modes of transmission and media (visual and textual); the storytelling is fed by communicative choices usually employed in the construction of a text, but those choices here are subordinated to the physical framework of the vessel and therefore organised in distinctive ways. Thus, the Judgement of Paris on the Karlsruhe hydria does not operate on the basis of a dichotomy of text and image; rather it dissolves that dichotomy. The painter has achieved that end by exploiting the most basic device of his trade, the vessel itself. The pictures overcome the limitations of their two-dimensional, static surface and force the recipients to turn the vessel. Quite literally, these depictions establish a pictorial turn.

2) The Pergamon frieze: myth outside the box

The Great Altar and its spatial design.

Its Π-shape distinguished the Great Altar from earlier altars (fig. 0.2).[51] The architectural shape in concert with the positioning on the altar terrace – the east side, the altar's back, faced the entrance to the *temenus*, a situation similar to that of the Parthenon – meant that visitors were exposed to the outside of the altar and the Great Frieze adorning it for as long as possible, for they had to make their way around the building and up the stairs towards the upper courtyard.[52]

In another way, too, the Great Frieze was clearly designed for extensive interaction. The figures were carved in extremely high relief and therefore jut into the space occupied by the viewers. This effect is enhanced by the blank background, with the absence of any illusionistic rendering of depth behind the figures. In addition, the dark blue colour that the background

[50] Contra: Giuliani 2002: 338–9; Giuliani 2013: 195–224. For the culture of reading in general: Harris 1989: 43–115. For the relationship between literature and art more generally: Robert 1881: esp. 5–11; Snodgrass 1982; Hedreen 1996: 153–6; Small 2003: 21–36; Giuliani 2013: 1–18.

[51] For the architecture of the Great Altar, see Stähler 1978; Hoepfner 1989; Hoepfner 1993; Linfert 1995; Scholl 2009; 2011. Jim Coulton refers to the upper storey as '[Ionian] stoa with wings'. Coulton 1976: 81–5; cf. Scholl 2009: 257.

[52] The Great Altar is the only building known from antiquity completely surrounded by a gigantomachy: Kähler 1948: 108–9.

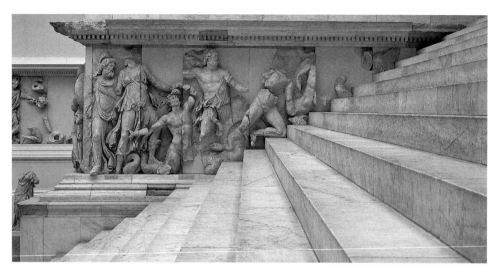

Fig. 8.3 The Great Frieze, north projection: the two giants on the stairs. Berlin, Staatliche Museen.

was painted would have made the figures appear yet closer to the space in front of the picture.[53]

Another technique was also employed on the Great Frieze in order to break down the boundary between viewer and picture. In the section of the frieze on the inner flanks of the projections lining the staircase, the bodies of three giants along with their snake legs spill out of the space of the frieze and onto the stairs (figs 8.3, 8.4). In the south, the giant Bronteas has broken down, his knee on the stairs. His body is facing the viewer, but his head is turned to the right and faces down the stairs, where his opponent is approaching (fig. 8.4). His right leg ends in a snake body that spirals up the stairs to the left to attack Zeus' eagle, who has seized the jaw of the reptile with his claws.

In the north, the two opponents of Thetis and Oceanus are also placed on the stairs (fig. 8.3, cf. also 2.13). The one in front is a fully humanoid giant. He is shown frontally as he attempts to escape up the stairs. No longer standing, he kneels on the stairs, with his weight on his left knee. With his left hand he is grasping a rock, again placed on the stairs, possibly intending to throw it at Oceanus. His comrade is seen from the back, sitting further up on the stairs and depicted in a futile attempt to protect himself with his shield. The snake body of his left leg reaches out next to Oceanus, but shows no sign of resistance. Perhaps his right leg-snake planned to fight against

[53] For the relationship of space and figure on the Great Frieze, see Kähler 1948: 88–96. Cf. Queyrel 2005: 173–4.

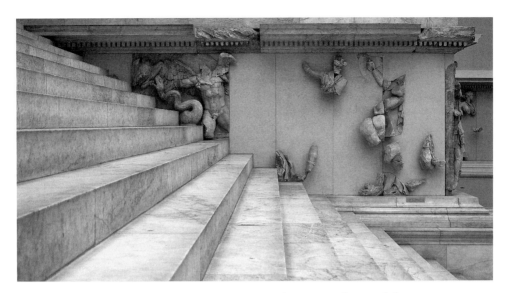

Fig. 8.4 The Great Frieze, south projection: Bronteas on the stairs. Berlin, Staatliche Museen.

the eagle up in the corner of the frieze, just as Bronteas, on the opposite side, fought against the other eagle.

In their original condition, these figures spilling out of the frieze and onto the stairs must have had an impact even stronger than today for they were painted and had been set in front of a dark background, which acted as a barrier. The stairs, by contrast, were probably of white marble. The difference between coloured frieze and external marble architectural features would have enhanced the act of boundary crossing undertaken by the giants – with the giants thrown into relief by being thrown out of the relief and into the sphere of the viewers.

The composition in the part of the frieze that runs along the stairs follows the composition of the sides. The battle of gods and giants surging around the altar is frozen in time, as if a snapshot. Meanwhile, a noticeable concern of the arrangement is to guide the viewer past the combat groups and, especially, around the corners.[54] By moving to the south Hecate, who appears at the south end of the east frieze, guides visitors towards the corner and onto the adjacent south frieze (fig. 2.7). On the south frieze in turn, Phoibe takes up the baton to lead visitors further westwards and to the stairs of the altar (fig. 8.6c). A similar progression can be found on the projections: Triton, in the north (fig. 2.14), and Semele, in the south, are both pointing the viewer

[54] Winnefeld 1910: 139, 142; Kähler 1948: 109, 113–14; Pfanner 1979: 52.

towards the stairs. On the inside of the north projection, Nereus and Doris complete these efforts (fig. 2.13).

In light of these compositional dynamics, the sidestepping giants by the stairs can be seen as amplifiers: they augment the way in which the composition of the frieze overall guides visitors towards the upper courtyard of the Great Altar. They do so by throwing into sharp relief the fierceness of the fight taking place in the approach to the upper courtyard – a fierceness that is expressed in the fact that for these giants their only means of countering the onslaught is to exit the frieze. That exit, in turn, seals their destruction. But above all, that exit underlines the all-encompassing power of the gods – a power that enables them to annihilate the physical boundaries of the frieze and expel the giants from the pictorial space.

Still, one might argue that the giants' spilling out of the frieze is nothing more than a formal consequence of the pairing of an unusual architectural layout with exceptionally high-relief carving:[55] as the lower standing line of the frieze disappears in this part of the frieze, it is inevitable that some figures end up on the steps (figs 8.3, 8.4). But it is noteworthy that only the giants, and not the gods, feature on the steps. Therefore, rather than see a mere coincidence that stems from the formal conditions of the frieze, one could take this situation as an attempt to situate the giants within the sphere of the viewers as a means of raising pity, or even compassion, for their fate.[56]

Yet it is surely more likely that an entirely different emotional charge is intended here. The set-up allows the viewers to step into the role of the gods and tread with gusto on the bodies of the giants – just as Doris does on the projection (fig. 2.13) and just as Artemis and Aphrodite do on the east and north friezes respectively (fig. 2.11, 2.15). With this invitation to join the battle, the viewers become allies of the gods. That extra involvement both increases the reality of what is on display and causes a rapture, for with the giants entering the sphere of the viewers, the latter are elevated into the realm of the gods.

When the Great Frieze is compared with another representation of the gigantomachy on a building, this complicity of gods and viewers – along with the divinisation this complicity might yield for the viewers – is revealed as a particularly potent feature. The situation on the north frieze of the Siphnian Treasury in Delphi is in general similar to that on the Great Frieze: name labels are used for identification, and the main axis of the

[55] See for example Kähler 1948: 84–9 with a detailed discussion of the claims for reality established by the high relief.

[56] An understanding analogous to Tonio Hölscher's interpretation of the Large Attalid anathema: Hölscher 1985; for the monument more generally, see Schalles 1985: 68–103.

composition, from east to west, invites the viewers to follow the depiction up the Sacred Way and towards the entrance to the Treasury.[57]

But where viewers of the Great Frieze become divine accomplices when they turn towards the stairs, viewers of the Siphnian Treasury remain mere followers, an audience of the divine. The battle on the Siphnian Frieze is self-contained. As is characteristic of hoplite warfare, opposing lines move against each other, a practice that excludes viewers from participation.

The exclusion of the audience is manifest in particular when we zoom in on the one element on the north frieze of the Siphnian Treasury that displays a physical anomaly that has parallels on the Great Frieze. One giant is attacked by the two lions drawing Cybele's chariot, her animal satellites. Both lions hold the giant with their paws; the one in front is biting into the opponent's cuirass. The giant in turn is making attempts, albeit futile, to wrestle himself free.

In this section of the frieze the profile view, characteristic for the remainder of the depiction, is suspended. The face of the lion in front is presented frontally, as is that of the giant, albeit almost completely covered by his Corinthian helmet. This arrangement, too, might bring these two figures closer to the spectators, but instead it primarily emphasises the fierceness of the battle in which they are ensconced – so fierce that these two figures break out of the orderly hoplite ranks in order to end their confrontation. The scene thus generates a particularly bold image of war, but it does not integrate the viewer. The message it conveys – about the power of the gods – is similar to that in the presentation on the Great Frieze, and that message is also conveyed similarly, by displaying the demise of the giants. However, on the Siphnian Treasury frieze this message is put on display, but not put into practice – not put into practice as it is on the stairs of the Great Altar, where the viewers are invited into the fight, and into direct participation.

Space, design, and content – the Great Frieze, from a distance and close up.

The cityscape of Hellenistic Pergamon was shaped by impressive visual axes that connected buildings and monuments by cutting across the terraces of the citadel.[58] The Great Altar was intricately involved in these strategies: its position on a dedicated terrace rendered it highly visible from a distance, its visibility further enhanced by the gleaming white of its marble shell, which

[57] For the Siphnian Treasury, see Simon 1984; Neer 2001. For the inscriptions, see Brinkmann 1985: esp. 87–105, 121–30 for the inscriptions on the north frieze.

[58] Radt 1988; Rheidt 1992; Stähler 1978; Scholl 2009. Cf. La Rocca 1998: 8–13.

distinguished it clearly from the surrounding structural walls of the altar ter-race.[59] At the same time, the altar appeared relatively isolated from some of the constitutive dynamics of the acropolis:[60] whilst it provided the backdrop to the panegyric festivals that took place in the theatre, its position excluded it from a role in any of the related processions, and indeed cut it off from the rituals taking place in the Sanctuary of Athena Nikephorus on the terrace above.[61]

Various axes for viewing the frieze would have opened – and closed – as individuals approached and then surrounded the Great Altar. Each of these axes emphasised a different aspect of the monument and of the gigantoma-chy that surrounded it. Viewers approaching the city from the south-west would have seen the Great Altar itself as a discrete element of the acropo-lis.[62] From a distance, the entrance facade of the Great Altar would have been visible, along with the west side of the gigantomachy, the two fronts of the projections. Essentially, these two sections provided a condensed, well-integrated version of the battle.[63] The composition of these sections is symmetrical,[64] presenting in both cases an extended pyramidal arrange-ment with a divinity left and right fighting towards the centre. In both cases the movement from the outside towards the stairs of the altar takes up a large proportion of the space.[65] This compositional symmetry is comple-mented by the choice of figures: in the north, the gods of the sea – Triton to the left, Amphitrite to the right (fig. 2.14) – engage the giants;[66] in the south it is the gods of the land, Dionysus and Semele.[67]

This tableau combines clear-cut messages.[68] The pyramidal composition on display here was traditionally chosen for battle groups. The depictions of sea and land can be taken as shorthand for a description of the gigantomachy

[59] Scholl 2009: 73.

[60] Massa-Pairault 2007a: 2–3 (cf. Coarelli 1995): she links this phenomenon to the dual character of Pergamon as both a polis and a kingdom.

[61] Queyrel 2005: 138–47 analyses the relationship of the gods depicted in the gigantomachy and their sanctuaries across Pergamon; cf. also Schefold 1981: 115.

[62] Schraudolph 2007: 198. The extent to which the detail of the Great Frieze was visible from this distance is not clear.

[63] On the west frieze, see Schmidt-Dounas 1992; Massa-Pairault 2007a: 38–48.

[64] Pfanner 1979: 47.

[65] Kähler 1948: 110. Kähler also points out that the lion attacking on the south projection is matched by the lion skin the giant uses on the north projection as protection against Triton (1948: 110).

[66] On Triton, see LIMC VIII 1997 s.v. *Triton* (N. Icard-Gianolio); on Triton's depiction as a sea centaur, first recorded in Lycophron's *Alexandra* (34), see Massa-Pairault 2007a: 44–6. On Amphitrite, see LIMC I (1981) s.v. *Amphitrite* (S. Kempf-Dimitriadou).

[67] For a comprehensive description, see Winnefeld 1910: 13–17 nos 1–2, 83–6 no. 29; cf. Pfanner 1979: 46–8.

[68] For a discussion of the similarities between the two sections, see Kähler 1948: 109–11.

as a battle spanning the whole globe. Finally, the choice of gods continues this theme of global threat, with both male and female gods, generations, as expressed by the two pairs of divine mothers and sons,[69] and families. And the intertwinement of these gods goes further: both divine families depicted here have a share in the thiasus; Dionysus has a close relationship to the sea.[70] The bold and simple structure of the composition in this part of the frieze might have been discernible even from afar, especially when painted. Those approaching might then have been placed in a mind-set fuelled by expectations generated by battle scenes inspired by classical Greek art.

Viewers climbing up the road onto the acropolis would have experienced a different perspective when they reached the Upper Agora, from *c.* 220/210 onwards the civic centre of Pergamon.[71] Seen from here, the Great Altar no longer appears as an autonomous monument, but rather as if the foundation for the Temple of Athena Nikephorus, positioned above and beyond on the terrace of the Athena Sanctuary (fig. 8.5).[72] The Great Altar also formed an integrated element of the Upper Agora in another respect. The key features of the marketplace were the Temple of Zeus Soter, founded by Attalus I,[73] and a set of dedications by the royal family, celebrating their military successes.[74] When these elements of the Upper Agora were paired with the altar and the Sanctuary of Athena Nikephorus, 'the victory bringer', together these three aspects of the acropolis served to emphasise victoriousness as an essential element of Attalid state ideology.[75]

The Great Altar, however, was not merely an architecturally impressive basis for the Athena Temple above.[76] The south side of the altar was only some 50 metres away from the dedications on the Upper Agora, which

[69] This aspect has been understood as a reference to Pergamene politics and the special relationship Eumenes II and Attalus had to their mother Apollonis; see Schmidt-Dounas 1992: 299–300; cf. also Massa-Pairault 1981/2; Schmidt 1990: 150–2; Massa-Pairault 2007a: 185–205.

[70] Barbara Schmidt-Dounas has convincingly argued for this last point; see Schmidt-Dounas 1992: esp. 297–9.

[71] For the restructuring of the Upper Agora under Eumenes II, see Rheidt 1992: esp. 266–9. Cf. La Rocca 1998: 8–13; Massa-Pairault 2007a: 3–6.

[72] A composition comparable to that of the Athena Sanctuary on Lindos, see Hoepfner 1989: 622–4.

[73] Schrammen 1906: 93–118, esp. 108–18; Radt 1996; Radt 1999: 92–3; Massa-Pairault 2007a: 3–4.

[74] This explanation of the purpose of the dedications is based on the interpretation of an inscription possibly celebrating the victories of Attalus I, see Fränkel 1890, n. 41. The three foundations for monuments in the west section of the Upper Agora are likely to be connected with this.

[75] Cf. Massa-Pairault 2007a: 4.

[76] Webb 1998: esp. 244–54; Ridgway 2000: 23–5.

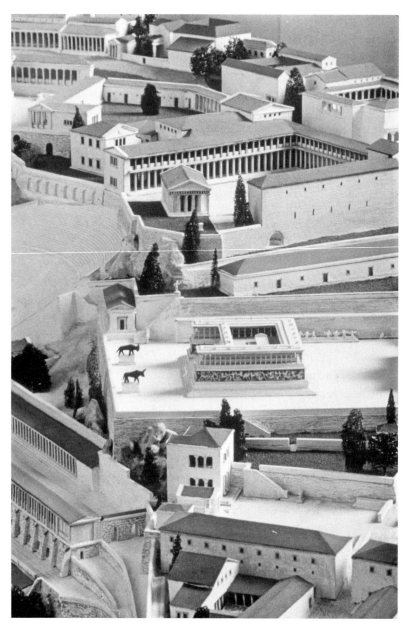

Fig. 8.5 The acropolis of Pergamon: Upper Agora, Great Altar, and the Sanctuary of Athena Nikephorus. Model by Hans Schleiff. Berlin, Staatliche Museen.

in turn were around 170 metres away from the Temple of Athena Polias. The frieze on the south features a type of composition that would have been visible from the Upper Agora, for that composition is characterised by centralised arresting elements and by elements that guide the viewer on (fig. 0.2). In the east section of the south frieze, figures such Phoibe,

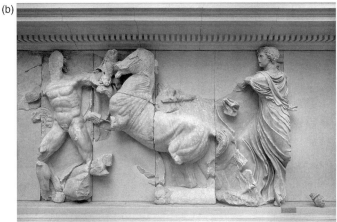

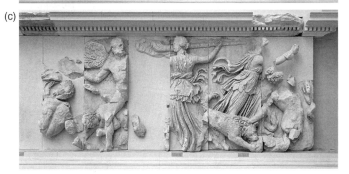

Fig. 8.6 (a) The Great Frieze, south: Rhea on the lion. Berlin, Staatliche Museen. (b) The Great Frieze, south: Helius in his chariot. Berlin, Staatliche Museen. (c) The Great Frieze, south: Phoibe. Berlin, Staatliche Museen.

encountered above, clearly push towards the west (fig. 8.6c). And further to the west, the gods riding animals take this movement up: Selene and Helius in the middle of the frieze (fig. 8.6b), and Rhea and Eos in the west (figs 8.6a, 0.2).

Yet again, dynamic features are intermixed with more static scenes.[77] In the east section, Phoibe's movement is countered by Themis, who fights towards the east, and the two combat groups involving Ouranus and Aether absorb the momentum. Selene introduces a new dynamic towards the west, only to be muted by the combat group featuring Thea. After reinvigoration by Helius, the movement westwards is brought to a full halt by Eos, who rides into the group with the bull giant with its strong eastward momentum. This combination of compositional elements on the south frieze means that from a distance the gods riding on animals – Rhea, Eos, Helius, and Selene – are presented as if spot lit. Each takes up a relatively large amount of space, and if the god faces an opponent at all, then that figure is a significant distance away. More generally, the emphasis on these gods takes attention away from the battle and directs it instead towards the divine sovereignty on display here.

This depiction serves as a stage in the relay that runs from the Upper Agora, with its focus on Attalid victory, to the Temple of Athena Nikephorus, and its celebration of divine support. Thus, when viewed from a distance and in connection with the two other areas of the acropolis, these gods – Rhea, Eos, Helius, and Selene – seem removed from their narrative context in the gigantomachy and reappropriated to underpin the Temple of Athena Nikephorus, prefiguring the course of the day in a way similar to that found in the pediment decoration of classical temples, as in the Parthenon east pediment.[78] The Temple of Athena Nikephorus thus gains in the Great Altar an attribute that positions it in reference to Athenian art of the classical period, an objective also present in other monuments within its *temenus*.[79] That attribute provides the Temple of Athena Nikephorus with a place within divine order and also a place within history.

Viewed close up, the Great Frieze offers further messages to its viewers. Because of the frieze's position on the building, a viewer would have experienced it primarily from a low angle.[80] At the same time, the high relief and background rendering bring the figures forward. That apparent positioning

[77] Ever since the discovery of the Great Frieze scholars have recognised that it does not follow the principles of centralised composition: Brunn 1884: 50, 53–4; cf. also Pfanner 1979.

[78] For the Parthenon east pediment, see Berger 1974: 15–16, 19–21; with a new reconstruction, Palagia 1993: 28–30.

[79] Conversely, from the terrace of the Athena sanctuary, the view opens onto the distinctly paratactical combat groups of the north frieze. For the architectural layout of the terraces, see Schrammen 1906: 88–90. Junker sets the specificity of the Athena Nikephorus sanctuary balustrades against the generic nature of the Great Altar, see Junker 2003: 432–3. For the furnishings of the sanctuary, see above, pp. 68–70.

[80] The frieze sections lining the staircase are an exception.

is supported by the dynamic composition more generally:[81] the contours of the figures seldom follow clear lines and instead appear broken and asymmetrical; the movement within the composition diverges and breaks off. A notable predilection for exaggerated contrapposto depictions and body torsion is also evident, with limbs and objects projecting out from the relief ground, such as Artemis' quiver, Aphrodite's arm, or the pot with snakes.

Overall, this rendering of the relief makes the depictions reach into the space occupied by the viewer. In particular, the bodies and faces of the dying giants, contorted with pain, are positioned to catch the viewer's eye.[82] On the east frieze, Apollo's opponent would have stared directly at those approaching from the north-east. Artemis' opponent, who is fighting the Molossian dog, was turned towards viewers coming from the south-west. On the south frieze, the giant next to Phoibe, who is shown trying to pull an arrow out of his breast, would have appeared to be veering towards those walking towards him from the south-east (fig. 8.7). On the north frieze, the face of the dead opponent of Aphrodite would have greeted viewers coming from the north-east corner; further down that side, the giant fighting the Moirai would have faced those coming from the same direction.

In addition, and as also in the gigantomachy on the Siphnian Treasury from the archaic period,[83] on the Great Frieze not only the giants but also the animal satellites of the gods are depicted as facing the viewer. This description applies to Hecate's dog on the east frieze, chewing on the snake leg of a giant (fig. 2.7), and equally to the dog on the south frieze, who supports Phoibe and Asteria. This looking out of the frieze is an act of metalepsis and establishes a relay with viewers,[84] who are drawn into the sphere of the picture, strengthening the frieze's claim to be real. With the application of this strategy to the giants, viewers are again put in the role of divine allies: here is another invitation to enter battle, and at the same time an assurance that this adventure will be victorious. The interaction with the divine satellites supports this interpretation: in directing their attention to

[81] It was noted early on in scholarship that the irregular rhythm of the Great Frieze sets it apart from classical frieze depictions. For a comprehensive assessment, see von Salis 1912: 38–40; Kähler 1948. Equally, it was argued that this exceptional character could not be explained merely by way of a response to the architectural physicality of the monument demanding such an unbalanced arrangement, see Winnefeld 1910: 232–3; contra Brunn 1905: 483–4.

[82] Contra Kähler 1948: 93 (cf. also Prignitz 2008: 36): Kähler is correct that there is no direct eye contact, but the orientation of faces and bodies still creates a rapport between figure and viewer.

[83] For the Siphnian Treasury, see above, p. 54 n. 81.

[84] For metalepsis as a device of storytelling, see above, p. 187.

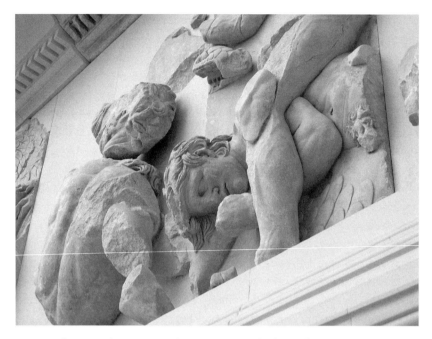

Fig. 8.7 The viewers' perspective: the giant next to Phoibe on the Great Frieze, south. Berlin, Staatliche Museen.

the outside, these satellites connect with viewers, who are thus once more put on a par with the gods.

Space and narrative in the Hellenistic world.

The design of the Great Altar, and especially the fact that visitors to the monument had to go around the building in order to reach the stairs to the altar proper, grants the depictions a diegetic function: while orchestrating the movement around the building, the depictions also guide through the narrative. But they are not a single narrative voice. The multi-directionality of the frieze, which contrasts with friezes such as the Parthenon frieze, allows for bilateral movement as well as movement back and forth at the relief ground. Viewers do not have to simply proceed past the frieze, but can enter into zones of deep contact, and not just on the stairs. The narrative on display can therefore be explored through a multitude of trajectories.

Distance also defines the narrative. The content of the frieze would have depended on whether it was viewed from the valley, from the Upper Agora, or from its immediate vicinity. The messages of that content then range from generic victoriousness to celebration of Athenian heritage and the

power of the gods; they also tell of putting viewers in the role of gods, a message related to the way in which individual parts of the frieze draw the viewer into the action.

The Great Frieze is evidence that viewing was understood as a process, for a comprehensive understanding of its scenes required synthesis of varied viewing experiences. As such, the Great Frieze replicates characteristics of multi-viewpoint sculpture of the third century BCE. The Ludovisi Gaul and the Farnesian Bull, for example, not only were positioned in space, but also demanded distinctly spatial perception.[85] These sculpture groups were not to be assessed from a single viewpoint; they required their viewers to move around the whole monument, frequently assaulting them with contradictory viewing experiences and deliberately hiding aspects.[86] In addition, the sculpture of the high Hellenistic period became more closely integrated into its spatial context, becoming an actual part of that space.[87]

As if the principles of this type of sculpture have been mapped onto a relief on a square monument, viewers' movement through space around the Great Altar is also a journey across layers of narrative and conceptual frameworks. The sculpture functions as a body of narrative. Narrative diegesis is accomplished here in space and by means of space: contact zones between narrative levels and between the narrative and the sphere of the viewers are established in the physical space around the sculpture. Their tangibility, in turn, grants the scenes greater presence and increases their *enargeia*.[88] Thus, the zone of interaction between monument and viewer is turned into an area of pervasive virtuality.

At Pergamon, the result of such design was a viewing of the Great Frieze that took those synthesising what was on display on a journey in which they first acted as an audience for the display of Attalid power and Athenian heritage, then became witnesses of divine exploits, and finally turned

[85] For the Ludovisi Gaul, see Kunze 2002: 40–3; see also Hansen 1937; Marvin 2002. For the Farnesian Bull, see Kunze 1998; Kunze 2002: 25–38.

[86] For the first and still most influential discussions of the composition of Hellenistic sculpture groups, see Krahmer 1923/4; Krahmer 1925; and also Künzl 1968. For a critical discussion, see Stewart 1993; Kunze 2002: 12–20, 229–38. For the relationship of sculptural composition and forms of narrative in the literature of the same period, see Zanker 2004: 72–103.

[87] Kunze 2002: 232–9. Various examples of sculpture as if acting in the space of the viewer appear in Hellenistic literature, throughout emphasising the strong claims for reality such sculpture makes. The most vivid description is by Herodas, of the visit of two women to a sanctuary and its sculptural display: Herod. 4, esp. 4.27–38; see Zanker 2009: 98–113. On this phenomenon in Hellenistic literature, see Zanker 1987: 39–112; Manakidou 1993; Kunze 2002: 233–4; Lorenz 2013a: 125–6.

[88] Hölscher 1980: 354–5; Zanker 1987.

themselves into divine accomplices. The approach to and the movement around the Pergamon altar were intended to trigger a transformative process for the viewer not unlike that of the Via Crucis, the stations of the cross, in Christian churches – with the objective that, eventually, the viewer would become one with the divine.

Again the Great Altar is at odds with the Athenian Parthenon. The exterior decoration of the Parthenon, with its metopes and the frieze, prepared those viewing and moving around the building for an encounter with the resident divinity in the sense that by synthesising the combined display of Athenian youths and pan-Hellenic myths as they approached, the viewers were weaving a virtual peplos – a fabric of the city state of the type depicted over the entrance to the Parthenon – ready to be handed over to Athena. At Pergamon, in contrast, the process of viewing and synthesising turned those approaching into more than just devotees bringing gifts to the gods, for they were to share in the divine sphere in an explicitly physical way. That promise on the part of the Pergamene monument also sat well with its global aspirations, which were so much greater than those of its Athenian predecessor.[89]

3) The Louvre sarcophagus: facing Atalanta

The sarcophagus and its spatial design.

While Ovid's account of the myth moves from the hunt to the killing of the Thestiadae, then to Althaea's burning of the log, and finally to Meleager's death, the Louvre sarcophagus renders Meleager's death as the pivotal point in the narrative, framed by the episodes with the Thestiadae and Althaea. These two scenes to the sides of the deathbed take place before the death scene (fig. 0.3), but their sequential relationship is not at all clear. According to Ovid, the episode with the Thestiadae occurs before Althaea burns the log, but, again in Ovid, the Moirai/Parcae are only present at the point in the myth when Althaea decides to keep the log, after Meleager's birth, and not when she burns it; then, she only summons them, and not as Fates, but Furies.[90]

On the Louvre sarcophagus, the presence of the demons of fate and fury in the scene on the left suggests that the scene conflates two episodes in

[89] See above, pp. 60–3.

[90] Ovid *Met.* 8.451–7 and 8.488–90; see also above, pp. 80–1 with a discussion of the iconography of the three demons.

the narrative of Meleager, conveying at the same time his rescue and his damnation at the hands of his mother. Drawing out Althaea's conflict in this way heightens the general drama of the scene, but it also puts it both before and after events with the Thestiadae on the right. The two scenes to the side seem arranged to form a narrative loop, presenting at the same time cause and result. The scenes' reciprocal relationship is supported by the deployment of the female demons, whose trinity is distributed across these two scenes, with two on the left and one on the right.

This compositional arrangement has no parallels in other versions of the deathbed group: in those cases where two scenes of Althaea and the Thestiadae appear, they follow on from each other, with each marking the beginning or the end; they are not shown in this ring composition.[91] On the Louvre sarcophagus, such a reciprocal relationship is underpinned by another structuring feature, in the distribution of figures across the three scenes. The two scenes to the sides each comprise three standing figures arranged in a pyramidal composition, but each time differently: in the scene on the left the apex of the pyramid is at the top of the scene, constituted by the head of the demon behind the altar (fig. 2.22); in the scene on the right the apex is at the bottom, at the point where Meleager's left foot joins with the boar hide.

The centre scene is not composed in pyramidal form and follows instead two competing strategies: within the scene, and at the mathematical centre of the casket's front, the shield with gorgoneion is placed frontally looking out of the picture (fig. 0.3);[92] at the same time, the figures of Meleager and Atalanta act as two magnetic poles, stretching the scene out and away from a central point, a notion enhanced by the presence towards the right of the scene of three mourners moving towards Meleager. More competing forces are also at play across the composition. The relief may be divided into three individual scenes but these open up to each other at the seams: on the left,

[91] The earlier sarcophagi seem to favour the Althaea episode's preceding that of the Thestiadae; the later caskets reverse that sequence: on the sarcophagi in the Capitoline Museums and in the Torno Collection, Althaea (in the latter depicted on the side panel) precedes the Thestiadae, with the narrative sequence developing from right to left (see above, pp. 73–4 n. 133 (4, 5)). On the sarcophagi in Wilton House and Castle Gandolfo (see above, pp. 73–4 n. 133 (7, 8)), the narrative sequence develops from left to right, and the Thestiadae precede Althaea, followed by Meleager's death. The scenes depicting the demons of fate leave room for interpretation, for they may be set at the point of Meleager's birth or after his killing the uncles: on the casket in Museo Capitolino, that scene comes before the scene with the Thestiadae; on the casket in Wilton House after; see above, pp. 73–4 n. 133 (4, 7). For an iconographic summary of the group of sarcophagi depicting Meleager's death, see above, pp. 72–80.

[92] For gorgoneia in funerary scenes, see above, p. 79 n. 153, 148 n. 101.

Althaea turns towards Atalanta (fig. 2.22);[93] on the right the *parapetasma* screens the two Meleager figures and thereby combines them;[94] additionally, the spear under Meleager's bier points to the scene of the killing of the Thestiadae (fig. 0.3).

Offsetting these competing directions in movement is the compositional arrangement around the edges of the relief, which facilitates a viewing from the front of the casket and thus connects up with the compositional structure established by the gorgoneion shield: the lion-bodied Sphinxes depicted in profile on each side panel stride to the front, with two figures moving around the side corners and into the front of the relief. These conflicting forces – the centralised composition competing with the looping scenes to the sides – confronts the viewers with a complex visual offering, drawing them towards certain points whilst also creating multiple relationships across the casket.

In the Tomba della Medusa, the frontally composed sarcophagus was at the centre of a three-casket set-up, with the two coffins to the sides displaying complex, non-centralised compositions.[95] The original context of the Louvre sarcophagus is lost, however,[96] and so we cannot know whether its composition also answered to the way in which it was displayed within its tomb. We can assume that these reliefs were not viewed exclusively within the tomb, for their viewing context would have included the rituals and practices leading up to and during the burial.[97] The enjambment of individual scenes could be found on sarcophagi since the Hadrianic period, even if the non-linear arrangement of individual episodes of a myth was not the norm on mythological sarcophagi reliefs,[98] and, as outlined, at least unusual in the deathbed group.

Comparable in its juxtaposing of specific and generalised scenes is the composition of the reliefs on the Column of Marcus Aurelius: although the sequence appears linear, the scenes that make up that sequence are arranged so as to create a recurrent pattern. They do not recount a consecutive narrative, but rather emphasise one specific message: the Roman army is highly efficacious.[99] Whilst the frameworks of the column and the casket

[93] See also above, pp. 147–8.

[94] See also above, pp. 147–8.

[95] For the set-up and a discussion of the relationship between the three sarcophagi in that tomb, see Bielfeldt 2003: 136–49.

[96] The casket was previously part of the Borghese collection and so likely comes originally from a tomb in Rome or its surroundings.

[97] Zanker & Ewald 2012: 25–7; Borg 2013: 213–40.

[98] Rodenwaldt saw in this break-up of a linear narrative sequence a sign of the dawn of late antiquity: Rodenwaldt 1935: 5.

[99] So Faust 2012: 116–20. With a different interpretation, but comparable in the assumption that the composition on the Column of Marcus Aurelius is meaningful, see Griebel 2013: 200.

are different, the two forms share a common concern to produce essential visuals out of a seemingly consecutive visual narrative. The analogy with the column suggests that the Louvre sarcophagus might be regarded as depicting in the scenes to the sides cases of *superbia*, which has to be punished: on the right of the Thestiadae, on the left of Meleager. That punishment demonstrates the power of the demons of fate and their ultimate corrective, death, which is represented in the centre.

Space, design, and content – story and sequence.

On the Louvre sarcophagus the adjustment of the narrative sequence ties the two scenes to the sides closely together. It also puts a spotlight on the scene in the centre.[100] What is depicted here differs once more from other portrayals of Meleager's death across the deathbed group. In the early versions of this event, Meleager on his bier forms the centre of the scene (fig. 8.8).[101] On the piece in Wilton House dated to 180 CE, the bier with Meleager has been moved further to the right and in the centre is the figure of Althaea at the altar, with a frontally facing shield with gorgoneion to her side – the same type of shield that also appears on the Louvre sarcophagus and on a now-lost piece.[102] What makes the Louvre sarcophagus along with this now-lost piece stand out from the rest of the group is that in these examples in the centre of the casket is neither Meleager nor Althaea but Atalanta, sitting facing the bier. In the earliest version in Ostia, Atalanta is not part of the scene (fig. 8.8). In versions in Wilton House, Paris, and Castel Gandolfo, she is facing away to the far right.[103] Only in the pieces in the Capitoline Museum and Milan does she face the bier, and even then she is sat to the far left of the scene (fig. 8.9).

On the Louvre sarcophagus, Atalanta may not be at the physical centre of the relief but by being close to, indeed by overlapping, the actual centre held by the Gorgo shield, her figure becomes the focus. Across the whole group of deathbed sarcophagi, she is in the guise of Artemis,[104] and so here her

[100] On the importance of elements that rub up against other versions of the depicted myth on sarcophagi, see Bielfeldt 2003: 120–3.

[101] Ostia; Rome, Capitoline; Wilton House; see above, pp. 73–4 n. 133 (4, 7).

[102] For the now lost piece once in Rome, see above, pp. 73–4 n. 133 (15).

[103] See above, pp. 73–4 n. 133 (7, 2, 8).

[104] On the Paris fragment she appears differently, in a long tunic, with delicate sandals and a portrait-style coiffeur; only the quiver on her back and the rock on which she sits recall her usual characterisation (see above, p. 73 n. 133). Note also that Atalanta can be shown in different guises of mourning. On the piece in Wilton House she stands in front of an archway in profile view and has covered her face completely with her right (see above, pp. 73–4 n. 133

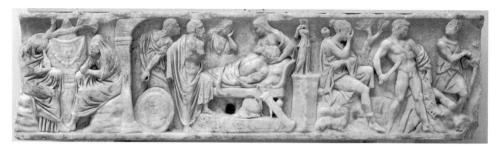

Fig. 8.8 The earliest depiction of Meleager on his deathbed on Roman sarcophagi. Ostia, Museo Archeologico 101; from Ostia. 160 CE.

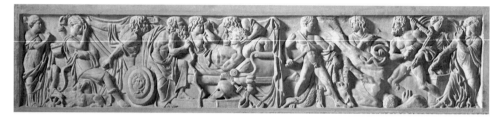

Fig. 8.9 Meleager on his deathbed in combination with Althaea and the demons of fate. Rome, Museo Capitolino 623. 170 CE.

appearance ensures that the scene is firmly placed in a hunting context,[105] notwithstanding the attributes surrounding Meleager, which furnish a wider spectrum of associations.[106] Her decisive role is enhanced by the fact that she is the tallest figure on the frieze. If she stood up, she would burst

(7, 8)); in the version in Castel Gandolfo she is seen in three-quarter view, standing opposite a tree (see above, pp. 73–4 n. 133 (8)). On the depictions in Ostia, the Paris fragment, and Villa Albani Atalanta sits weeping, with her back to the deathbed (see above, p. 73 n. 133 (1, 2, 3)). In three versions, including the Louvre sarcophagus, Atalanta sits opposite Meleager's bed, with her face cradled in her hand (see above, pp. 73–4 n. 133 (5, 6)). While her hand covers her face completely on the sarcophagus in Milan, on those in Paris and Rome she has moved her right hand so far to the left part of her face that her right profile remains fully visible. Across all the different groups of sarcophagi depicting Meleager and Atalanta, her characterisation in the guise of Artemis remains constant; only on a sarcophagus in Florence one of her shoulder straps has slipped off in a motif, which is characteristic for depictions of Aphrodite: Florence, Galleria degli Uffizi 135. H 0.56 L 2.10 D 0.56. Early third century CE. Koch 1975 no. 21 pl. 29b. Outside the funerary sphere, Atalanta's appearance oscillates more often between the characteristics of Artemis and Aphrodite, see Lorenz 2008: 55–83, Lorenz 2011: 324–7.

[105] An additional possible pointer towards her life in the outdoors is a piece of rock that appears between Atalanta's leg and the stool. The rock is a puzzling feature in a scene set indoors. It has previously been explained as a mistake by the artist, who had copied wrongly from a model book: Koch 1975: 39–40, 121; Ewald, in Zanker & Ewald 2012: 365.

[106] For an iconographic analysis of Meleager and his attributes, see above, pp. 74–7.

through the upper edge of the relief. In this, she is matched only by the figure of Meleager fighting on the far right, who, if he stood fully upright, would have a similar effect.

Atalanta stands out in another way, once more differentiating the Louvre version from the others across the deathbed group. Her grief is visualised by means of an odd, unnatural motif: she covers the left part of her face with her right hand. This awkward gesture means that the viewers of the sarcophagus have an excellent snapshot of her face, which would not have been available if she had – more naturally – covered the right side of her face, as she does on some of the other sarcophagi in this group.[107] Instead, in the Louvre sarcophagus the shielding arm works almost like a frame, highlighting her facial features.

Atalanta is here designed to attract the gaze, a function underlined by her dog's looking up towards her and the positioning of the shield with the gorgoneion – the epitome of gaze-attracting devices – directly next to her.[108] Atalanta herself, however, is not actively seeking to establish contact. The way in which she shuts herself off from the action on the frieze opens her to the audience. She is not simply a figure who can offer consolation to a mourning female viewer, which is how she has been principally interpreted.[109] Rather, she functions as a gateway into the image as a whole, and the fact that she is taller than the space provided by the relief is suggestive of her relation to the sphere outside the image.

One final feature underlines Atalanta's central role in the frieze: she occupies the topmost relief layer, the layer closest to the viewer's own sphere. Towards the right, she dominates a hierarchy of relief layers that reaches down to the fighting uncle on the very right. That figure is partly covered by the body of his dead brother, in front of which Meleager is positioned, thus dominating the relief arrangement of this scene. In the central scene, in which Atalanta is the dominant figure, Meleager's bed overlaps the fighting Meleager, thus positioning the deathbed scene hierarchically above the scene on the right and turning Atalanta into the figure controlling the whole frieze on her right.

On the left of Atalanta, the arrangement is less clear-cut. The huntress overlaps in part with Althaea, but not wholly: they appear to share a relief plane, which could explain the need for the deeply drilled vertical ridge

[107] On the two early pieces in Ostia and Milan, Atalanta covers her face completely: Ostia, Museo Archeologico 101; see above, p. 73 n. 133 (1); Milan, Torno Collection, see above, pp. 73–4 n. 133 (5).

[108] For the gorgoneion, see above, pp. 79 n. 153, 148 n. 101.

[109] Zanker & Ewald 2012: 62–70, esp. 64–5.

that separates their garments from each other. The figure with the torch is located on a plane further to the rear, while the Moira on the far left could occupy the same relief layer as Althaea and Atalanta.

The staggered arrangement that characterises the frieze in parts supports a modular system of representation, facilitated by the sarcophagus as a material object. The result is a very specific take on the story: Atalanta serves as the hook for the construction of this visual and thematic system, based on the compositional emphasis her figure receives. The appropriation of Atalanta as a gateway figure and narrative voice has an important effect on viewing the sarcophagus, for she provides a distinctly female perspective on Meleager's life and on the display of male virtues. That female perspective explains the appropriation of visual templates not employed elsewhere to present this particular myth.[110]

Atalanta's role as a gateway cannot change the basic descriptive content of the *conclamatio* scene around the deathbed: a young man associated through his weapons with the war and the hunt is dying. That death appears premature, to judge by the grief of old and young who surround him.[111] Perhaps here is a straightforward *allegoria apertis permixta*:[112] a depiction that includes elements that refer directly to the reality outside the image, to bereavement and a corpse newly buried inside the sarcophagus.

But Atalanta's role as gateway adds two further layers of meaning. First, it triggers an understanding that this is not a *Vita Romana* scene but a mythological scene. She is the only figure in the *conclamatio* scene characterised by elements that suggest a location outside the normal – her hunting attire, the rock and the dog at her feet, and the Gorgo shield. With her narrative baggage, she vouches for the mythological pedigree of the rest of the scene, only helped by the Corinthian helmet underneath Meleager's bed, which would not have been part of the equipment of a soldier in a *Vita Romana* scene.

And yet, because Atalanta has become part of this descriptive setting and herself sports features that belong in the sphere of the normal – the stool on which she sits and her being touched by the nurse – the distinction between the mythological sphere and the *everyday* world is blurred, and blurred precisely in the figure of Atalanta: viewers are invited into the picture by a mythological character, which clearly locates the scene in the mythological world of dreams and wishes, but what the audience then encounters is not so different from the normal world outside the picture. Atalanta's presence creates grounds

[110] For an iconographic analysis of the relief, see above, pp. 14–16, 71–84.
[111] For *conclamatio* scenes on sarcophagi, see above, pp. 79–80.
[112] For this category, see Giuliani 1989: 38–9; Bielfeldt 2005: esp. 277 n. 810; also Zanker & Ewald 2012: 47–8 (referring to it as 'bridge-building'). Cf. Lorenz 2011: 306–7.

for a mythological interpretation while at the same time denying that mytho-
logical interpretation by showing that the myth reflects real-life mourning.

Secondly, with Atalanta as starting point for the experience of the cen-
tral scene, the grief of the extended family, of siblings, nurse, and teacher,
which takes up most of the space in that scene, is clearly channelled and
subordinated to the sorrow of the wife and lover. Atalanta's exposed posi-
tion highlights that while death is a family affair and orchestrated by poign-
ant collective grief, the real and perennial grief, so grave that it cannot be
part of the general mourning, is that of the faithful partner.

Atalanta's impact as a lens is even greater in the scene on the right. Seen
through her eyes, Meleager's fight is unfettered by any ethical ambivalence
about killing members of one's family or treating the dead without mercy.
Meleager is not an overly emotional hero, blinded by love and acting in the heat
of the moment, nor does he simply represent a select image of generic fight-
ing prowess and virtue. From Atalanta's perspective, Meleager is a man who
protects and who fights with all his might for the claims of his lover and wife.
He is turned into a visual exemplum of deep and unconditional marital love.

Taking Atalanta's point of view has a destabilising effect on the categor-
ies of the narrative and the descriptive,[113] and on the clear differentiation
between what belongs to the myth and what is part of an *allegoria apertis
permixta*. This destabilisation is enhanced by another feature, for the tower-
ing size of Atalanta in the central scene and of Meleager in the scene on the
right and the elements of *non-normal* mythology that characterise them – in
case of Atalanta her attire, in the case of Meleager the arrangement around
a boar hide and a dead body – link the two figures across the two scenes.
They support each other in their mythological roles and provide a narra-
tive framework for the *conclamatio* scene around the bier, which otherwise
would veer towards the non-mythological. On the one hand, then, this por-
trayal of Atalanta and Meleager has the potential to turn description into
mythological narrative and elevate the suffering on display to a heroic level.

On the other hand, however, as the fighting Meleager on the right
becomes a model of virtue in the perspective enabled by Atalanta, he is
turned into a descriptive attribute for what is on display in the centre of the
frieze, the mourning of a formidable warrior, and he is exploited specifically
as a descriptive attribute to explain the state of sorrow in which Atalanta is
depicted, having been loyally devoted to her partner, who went as far as kill-
ing members of his family to secure her claim for the boar's hide. Meleager's

[113] These categories are here employed as defined by Luca Giuliani: Giuliani 2013: 15–17
(narrative); 16–17 (descriptive); 244–8 (both).

mythological pedigree is then once more dissolved, in order to be function-alised as an explanation for the depth of grief felt by the huntress and the extended family.

Atalanta not only serves as a relay that enables the external viewer to con-nect with the relief, but also links two stages of the mythological narrative – the love between the two hunters as manifested in Meleager's fight against his uncles on the one hand and his death on the other – and she does so by relating these stages to female emotion. With this doubled metaleptic function,[114] that is, in enabling the thresholds between viewers and picture and between dif-ferent stages of the narrative to be crossed, the figure of Atalanta turns what is labelled the *Death of Meleager* into a tableau of female sorrow, a contem-plation of both the causes and the results of that death.

For the scene on the left, the huntress is a gateway figure of minor import-ance, evident not least in her sharing a relief plane with Althaea. The mix-ture of allegorically and mythologically charged figures shaping this scene matches the significative quality of the scene on the right, and together these scenes provide a framework for the central *conclamatio* scene, which on its own would lean towards a representation of a human life (rather than mythological) event. And yet, even though Atalanta's impact on the left scene is more limited, her figure still brings instability into the narra-tive and descriptive categories for this part of the imagery. With Althaea and Atalanta on the same relief plane and with both depicted in poses of distress – the former outwardly trying to fend off fate, the latter inwardly grappling with it – the focus is directed towards an intimation of female attitudes of piety. This group of two becomes a visual sign of the mourning of sons, brothers, and husbands, and of sacrificing for these men.[115]

In all, then, Atalanta's function on the frieze is two-fold, both descriptive and narrative. Her figure delivers a descriptive visual image of mourning that is enriched by the two scenes on the right, which showcase the qualities of the lover she has lost. In this way, the scene on the far right, a narrative rendering of Meleager's fight against the uncles, can also be understood as an allegorical paradigm for *Vita Romana*. At the same time, the huntress also serves as the root and cause of the events that unfold on the right, which makes her an element of the narrative: she provides the narrative voice to guide the viewer through these events, first the death itself, and then the events that led to this death. Atalanta enfolds the figure of Althaea in the same ambivalent narrative-cum-descriptive power, providing the grounds for Althaea's state,

[114] For metalepsis as a phenomenon of visual narrative cf. Lorenz 2007; Lorenz 2013a: 119–20.
[115] Cf. above, pp. 81–2.

while offering a parallel visual of mourning. The only figures on the frieze that are not exposed to shifting narrative and descriptive values are the demons of fate and vengeance.[116] While anything else on the frieze is up for debate, the framing provided by the demons of fate and vengeance is consistent, and tells of a constant progression to an ultimate fate, and that ultimate fate is death.

Space and narrative towards the end of the second century CE.

The Louvre sarcophagus features a dual system of content transmission. The frontally composed Gorgo shield in concert with the side panels and the demons of fate and vengeance corroborates an unmitigated message about the generic powers of death already inherent in the sarcophagus as an object. The remainder of the frieze encourages viewers to reflect on the intersection of myth and everyday life. For these two forms of transmission, allegories and ideals form only one element within a vibrant set of stimulants. The key to the sarcophagus monument lies in unravelling interwoven strands of question and explanation.

The Louvre sarcophagus stands out from the other versions of the death of Meleager produced in the last quarter of the second and the early third centuries CE because of the way in which it functionalises Atalanta as a gateway figure and as a narrative voice for the experience it represents, welding around her figure an exploration at that interface of mythological and everyday content. In its engagement with the permeability of the categories of the mythological and the real, the Louvre sarcophagus moves away from the rhetorical concept of the *allegoria apertis permixta*, a shift linked primarily to the figure of Atalanta. In doing so, the sarcophagus continues strategies of display that could already be found about a century earlier in representations of the story of Meleager and Atalanta on the walls of Pompeii. In the Casa della Venere in Conchiglia, for example, it is also Atalanta who – with a period face and contemporary clothing – makes direct advances to the viewers, turning from a mythological character into a descriptive character (fig. 8.10).[117]

The homology of the depiction of the mythological episode and the experiential framework of death is emphasised by the personalisation of the former. An *interpretatio Romana* is made possible by bringing into that depiction of the myth an aspect of *Vita Romana*, the idealised version of Roman everyday life.[118] At the same time, the mythological cachet of

[116] See above, pp. 147–8.
[117] Lorenz 2008: 64–6.
[118] Reinsberg 2006: 17; cf. above, pp. 79–80.

Fig. 8.10 Exploring myth and the everyday: Meleager and Atalanta in the Casa della Venere in Conchiglia in Pompeii (II 3,3). 60/70 CE.

Atalanta not only is a catalyst for such an 'abstract viewing',[119] but also adds content derived from her mythological persona. The image must therefore be assessed with regard to its character as both a 'real event', a scene of everyday life, and an 'artificial event', a myth.

In contrast to representations like that in Pompeii and on some other sarcophagi, on the Louvre sarcophagus the mythological and everyday spheres are not simply combined in order to trigger a discourse about the mythological and the real; they are amalgamated in order to generate a novel narrative force: with Atalanta as a gateway, the mythological story is personalised in its entirety. The modular narrative structure allows the viewers to immerse themselves fully in both the mythological world and real *conclamatio*, with each trajectory amplifying the other. The result, a mediated reality of sorts, differs significantly from the juxtaposition of the mythological and the real on

[119] For this concept, see Koortbojian 1995: 9–15; Bielfeldt 2005: 22; Zanker & Ewald 2012: 47–8; cf. also Blome 1992; Brilliant 1992; Fittschen 1992.

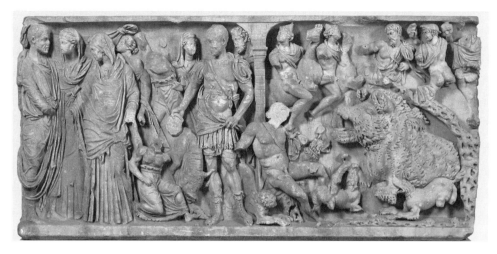

Fig. 8.11 Depicting myth alongside the everyday: the Rinuccini sarcophagus. Berlin, Staatliche Museen 1987,2; from Florence, Villa Rinuccini. 200/210 CE.

sarcophagi such as that with the earliest relief in the deathbed group in Ostia (fig. 8.8),[120] or the unique representation on the near-contemporary Rinuccini sarcophagus, where two scenes from the repertoire of the 'commander' sarcophagi are represented alongside the death of Adonis (fig. 8.11).[121]

The narrative voice constructed around Atalanta is not just testimony to the strategies of selection that characterised the Romans' use of myth in which certain elements from individual myths were employed while others were discarded in order to generate distinct Roman messages,[122] nor does it simply represent a move from classicising symbolism to *interpretatio Romana*, which Peter Blome attests for the late Antonine period,[123] and against which Bielfeldt convincingly argues,[124] but it is not merely a mixture of myth and allegorical paradigm either. The Louvre sarcophagus is clearly concerned with the allegorical and emotional content that mythological scenes are capable of transmitting and has been designed around the assumption that its viewers would be willing and able to engage in acts of 'abstract viewing', by selecting specific aspects of mythological knowledge while ignoring others in order to make sense of this particular representation and grasp its allegorical meanings.

[120] See above, p. 73 n. 133 (1).
[121] Berlin, Staatliche Museen 1987,2; from Florence, Villa Rinuccini. 200/210 CE. L 2.15 H 1.01 B 0.99. Grassinger 1999 no. 59; Reinsberg 2006 no. 6; see also Zanker & Ewald 2012: 44. For the 'commander' sarcophagi, see above, p. 83.
[122] See Zanker 1999; Zanker & Ewald 2012: 245–62. Cf. also Giuliani 1989; Koortbojian 1995: 120–6; Bielfeldt 2005: esp. 321–8.
[123] Blome 1992: 1071–2.
[124] Bielfeldt 2005: 22.

But the sarcophagus' significance does not stop there: it is not just a reference to something else in an iconological sense; it does not just present Greek myths in order to generate and transmit behavioural ideals and allegorical messages related to death and to the religious rites at the tomb; it does not present a paradigmatic narrative only. Rather, it offers a pervasive narrative experience that feeds off the specific characteristics of its two constitutive components, the mythological and the everyday. As such, it invites the viewers to a reading of the myth very different from the known textual versions of the story, while by means of the modular set-up, the individual scenes can constantly generate their own narrative scenarios, adding to or countering Atalanta's perspective.

These different voices are facilitated by the material carrier, the sarcophagus, which provides narrative space, but at the same time filters those voices through its funerary function. As a body of narrative, the Louvre sarcophagus demonstrates that a multitude of perspectives and the ambivalence of the relationship between the descriptive and the narrative do not cause a breakdown in the way pictures can direct their viewers. While such ambiguities are usually regarded as a crucial problem of visual narrative,[125] on the relief surface of the Louvre sarcophagus these features help realise the potential of visual narrative. This coffin demonstrates that descriptive and narrative elements can be immanent in one and the same visual form, waiting for the viewers to unlock their workings in order to provide them with a story and, at the same time, also a counter-reading.

These strategies of modular, shuffled narrative, breaking with a linear pattern of storytelling, are a brilliant means of enticing the complexities out of a story, as the viewer is invited to revisit and rethink previous assumptions about the development of the storyline. But these multilayered strategies are not extended to all the figures depicted, facilitating a particularly subtle transmission. The Fates/Furies, who belong to an allegorical realm somewhere between mythological narrative and everyday life, are not affected by multiple interpretations: their meaning and their role on the frieze remain unchanged in that they point to the inescapability of fate and the inevitability of death. This stability is also manifested on the side panels of the Louvre sarcophagus, which show two Sphinxes striding towards the frontal frieze. The Fates/Furies and the Sphinxes together have an apotropaic significance that is matched by the Gorgon shield in the centre of the front, and together they provide a robust, clearly focused framework that enfolds the mythologically articulated world of female sorrow and grieving.

[125] Cf. Mitchell 1986: 95–115 and his discussion of Lessing; also Giuliani 2013: 1–18.

Unlike earlier combinations of myth and *Vita Romana* in Roman imperial art as found on the walls of Pompeii and on other sarcophagi, reliefs like the Louvre sarcophagus no longer present a state of distress either simply or straightforwardly. The relief shows no indication that it was designed to facilitate forms of 'abstract viewing' of the type observed on sarcophagi of the early third century, notably the casket depicting Achilles and Penthesilea in the Vatican, with the episode on the casket arranged so as to lead viewers to pick up on an ulterior message triggered by specific, emphatic details not necessarily representative of the mythological story at large.[126] Instead, the Louvre relief engages in a cunning balancing act, with mythological narrative and ulterior messages crossing paths and supporting – and competing with – each other to provide the viewers with consolation as much as with guidance regarding the challenges of life. This multifold intent explains why these reliefs are designed to absorb their viewers into the pictorial sphere, with only the certainty of death delimiting this process of immersion.

The vitality of such images and their participation in an intense discourse about virtuality and about the power and versatility of visual narrative started earlier than the stylistic changes that can be observed on sarcophagi during the late Antonine period, but the evidence of monuments such as the Louvre sarcophagus throw light on the search for new ways to develop visual expression at the end of the second century CE.[127] These qualities were lost in the course of the third century CE, when more explicit and less discursive forms of representation appeared on sarcophagi, reflecting interests that eventually led to the abandonment of mythological stories altogether.

[126]　Zanker & Ewald 2012: 47–9.
[127]　For Antonine art see above, pp. 84–8.

1) Image studies as experiment: the results

Image studies focuses on a picture's share in negotiating – and shaping – reality, that is, on its functional aspects and the logistics of its display. At the stage of spatial analysis, the case studies demonstrate the strength of image studies in its scrutiny of the compositional design of a picture by highlighting certain features from specific viewpoints, which creates varying perspectives on the picture as an artefact. In combining elements of the syntactic assessment of semiotics with iconology's iconography, this stage appropriates these elements in a new way. While semioticised syntactics is concerned with the internal structure of a picture, and iconological iconographics with the external connection between individual motifs within the picture and other such motifs in other pictures, image studies occupies a middle ground with its consideration of the internal structures of a picture as shaped by their perception.

At this stage, everything in and around the picture is under scrutiny: the elements that make the depiction as well as the empty spaces around them, both within the picture and within its immediate environment.[1] That approach is firmly rooted in semioticised reception aesthetics, and in narratology more generally. Additionally, it emulates those interpretive mechanisms in a spatio-physical approach within which the focus is on the performativity of the picture and on what is on display at different points in the picture's use: the 'what' of the picture as presented through the 'how' of its physical display.

In the case of the Karlsruhe hydria, this approach reveals any blind spots created by the heterogeneous arrangement of the two pictorial areas and considers how these areas would have been perceived whilst the pot was lifted, tilted, or turned. It also highlights the visual connections established across the two pictorial zones. With regard to the Pergamon altar, it throws into relief the compositional arrangement of the Great Frieze along the

[1] Cf. Didi-Huberman's analysis of Fra Angelico's *Annunciation* in the Florentine Monastery of San Marco (Didi-Huberman 2005: 11–52), see above, p. 181.

stairs and reveals the display as the endpoint of the various compositional strategies that have been devised to anchor the depiction within the sphere of its audience and that serve to create a pervasive experience of the narrative as a whole. Similarly, for the Louvre sarcophagus, the focus on spatial design establishes a specific take on narrative sequence as played out on the casket.

At the second stage, the combined application of syntactics and iconographics is extended to consider the logistics of the picture with regard to what surrounds it. As the case studies demonstrate, such an approach will take different forms, depending on the character of the picture under scrutiny. This approach meets the picture's own requirements, fulfilling Tom Mitchell's demand that analysis takes seriously 'what pictures want'.[2] With regard to both its internal and external logistics, the picture is opened up to scrutiny that is not part of either iconology or semiotics. The physical manifestation of the picture is recognised as a corrective for its interpretation, while ignored by these other two methods.

This concern for the physical elicits insights into the pictures along chronological, temporal, and spatial axes. In the case of the Karlsruhe hydria, the chronological is assessed in light of the lateral iconographics of the vessel, through a chronological study of how in vase-painting the Judgement is combined with other stories, and on what material carriers. This approach assesses the interplay of the two pictorial zones on the pot and investigates the aspects of the myth highlighted at different points throughout the sixth and fifth centuries BCE.

In the case of the Pergamon altar, for which information about its actual physical environment is available, the spatial and temporal are scrutinised together. The logistics of movement around the Pergamene acropolis would have led to a fragmentation of the continuous frieze narrative that would have been accompanied by a series of iterative appropriations within and for the urban image at large. In the case of the Louvre sarcophagus, an internal aspect of spatiality and temporality has been explored here: namely, Atalanta's contribution as the dominant narrative voice within the frieze composition and her impact on the sequence of the story and the distribution of roles.

In considering the chronological, temporal, and spatial logistics of the pictures' display, image studies champions the pictures themselves as a corrective for their own interpretation. Still, as in iconology and semiotics, image studies too requires an external historical corrective to functionalise

[2] See above, pp. 174–6.

its method when it comes to historical insights. Yet image studies again goes it alone, for while semiotics has its 'post-structuralist synthesis', which is related to iconological 'historical synthesis', image studies employs an unrelated historical corrective. As that corrective is shaped by the previous stages of analysis, it has a unique purchase. It poses three questions: how does a picture negotiate spatiality as an artefact, a 'body of narrative'?; how does this negotiation of spatiality relate the picture to other representations?; and what historical understanding can the respective takes on space and perspective provide? In all three case studies this approach to the picture's logistics provides insight into the creation of virtual storyscapes and the negotiation of the boundaries between viewer and object.

Image studies considers a picture to be an object and a social process, combining the respective trajectories of iconology and semiotics. It overcomes the epistemological differences between these other methods by appropriating the physical logistics of a picture. While iconology caters for the *what* and semiotics for the *how* of the picture's role within a communicative system, image studies provides the means to study both the *what* and the *how*. It can avoid the pitfalls of an *associative-philological* or *generalising* approach and facilitates instead a *differentiating* approach, which accounts for the picture as an artefact within a flexible framework delimited by the logistics of space and perception.

2) Image studies and ancient art scholarship

The terms *Bildwissenschaft* and *visual culture studies* are pervasive across classical art-historical scholarship,[3] and across classical studies more broadly. Their use describes a wide range of practices, focusing on different media and working with different methods. The lowest common denominator is that visuality is tackled, even if understood in the widest sense.[4] The

[3] It could be argued, as it has been in the case of art history more generally (Bredekamp 2003; see also above, p. 180 n. 51), that the study of ancient art has always had an investment in image studies (cf. Juwig & Kost 2010: 13) because ancient art scholarship deals with pictures of all types as 'artefacts' in the full sense – not just with pictures classified as 'fine art' and with examination zeroing in purely on the pictorial surface. The case for such longstanding analysis of ancient art is strengthened by the fact that antiquity presents us with 'pictures before the age of art' (for this concept, see Belting 1997).

[4] One only has to take from among recent studies those explicitly using these terms in their titles to get an idea of this spectrum, reaching from the discussion of philosophical notions of ancient perception (for example, Sinisgalli 2012: *Perspective in the Visual Culture of Classical Antiquity*) to the gaze in literature (for example Lovatt 2013: *The Epic Gaze: Vision, Gender and*

unique purchase of approaches of the type examined in this study under the heading 'image studies' has awaited elucidation.

As is also the case for semiotics, for image studies such significant scope generates great flexibility with regard to both corroborating evidence and method. This latitude can stand in the way of a comparison of approaches within the scholarly field. It also encourages a proliferation of scholarly work that readily adopts (fashionable) banners whilst continuing to work within the traditional confines of iconographic study, an unjustified appropriation that iconology and semiotics have also suffered.[5]

Assessments of the workings and the impact of *Bildwissenschaft* and *visual culture studies* are still desiderata for the field of classical art history. The coming years will reveal the extent to which *image studies* is capable of bringing together these two concepts and reinvigorating the study of Greek and Roman art. Meanwhile, interventions in the field have provided pointers to a possible future analytical framework for image studies in classical art-historical scholarship, to the questions that might be on its agenda, and, indeed, to the answers those questions might receive. These interventions fall into two interconnected categories that were also explored in the case studies: first, the physics and the performativity of perception (including matters of context) and second, mediality.

Physicality and performativity.

The first category takes its inspiration from (semiotic) reception aesthetics, specifically Wolfgang Iser's concept of the reader.[6] That notion is intermixed with the idea of the hyper-alert, reflective, moving *flaneur* as developed by Charles Baudelaire and Walter Benjamin and, somewhat contradictorily, with its polar opposite, a notion of the fleeting, disinterested viewer.[7]

Narrative in Ancient Epic), and within the field of ancient art study from the study of Roman humour (Clarke 2007: *Looking at Laughter: Humor, Power, and Transgression in Roman Visual Culture*) to Christian religion (Elsner 2007a: *Viewing the Gods: The Origins of the Icon in the Visual Culture of the Roman East*). See Samida 2010 on the lack of explicit engagement with the toolboxes of *Bildwissenschaft* and visual culture studies, and the iconic turn more broadly, across the archaeological disciplines.

[5] This practice applies specifically to the use of the term 'media'. It is often employed as a fashionable replacement for the more traditional terms 'genre' or 'work of art', but without honouring its stake in the concept of embodiment (for an outside perspective on the *media*-centrism specifically in German academia, see Wood 2004: 371). The discrepancy between the media of art and the picture as media needs to be addressed in order to reach a truly visual interpretation of a picture. See Belting 2011: 18–19.

[6] Iser 1978; see above, p. 115.

[7] For the concept of the *flaneur*, see Buck-Morss 1991; Benjamin 2002. For the concept of the fleeting viewer, see Veyne 1988 and Veyne 2002 (the latter in response to Zanker 2000); Settis

Traditionally, the spaces of ancient art are approached as if containers for objects. The objects within these containers are catalogued, but no consideration is given to the relationship between object and space – space within this traditional framework is a static component, an 'in vitro' context.[8] But the *flaneur*-inspired approach considers space and objects together as part of a process of staging: space and objects do not exist as absolute values, but are constituted in ever-new iterations by virtue of their performativity – that is, the ways in which they shape, orchestrate, and are influenced by different situations.[9] In turn, these 'images' are regarded as an expression of culture. Any changes in their performativity, their appearance and functioning, are therefore indicative and serve as historical evidence.

This interest in the flexibility of space and in its physicality and performative character, and, reciprocally, the interest in the changing physical and psychological/emotional viewpoints of its users and viewers, take 'context' as 'in vivo', not 'in vitro'. What differentiates the 'in vitro' container space from the 'in vivo' space as performance is what helps this strand of image studies to reach beyond the determinative contextual studies described by Mieke Bal,[10] in which contextual data is regarded as fixed; here, in contrast, all parts of the equation are variable.

The concept of the 'in vivo' context is prominently applied in studies devoted to the 'urban image' of ancient sites, most notably in Diane Favro's 1996 landmark publication on Augustan Rome.[11] Favro employs an iterative approach – specific viewers move through the same urban spaces at differing times and their experiences are recorded – in order to capture the urban image as an entity developing in historical time.

The interest in 'in vivo' contexts might be wrapped around the notion of fluidity and flexibility, but it finds a corrective in the parameters of the physical space – distance, angles, light, etc. This investment in spatial logistics,

1991 and Settis 1992 (responding to Veyne 1988). Cf. also Elsner 1991; Elsner 1995: esp. 220–1. For a discussion of these two types of viewer, see Zanker 2000: passim. Cf. also above, pp. 162–3 n. 52.

[8] On the concept of space as a container, based on a pre-relativity worldview, see Lorenz 2008: 14–15.

[9] See Zanker 2000: 205–6 for a succinct assessment of the differences between these two concepts and how scholars have engaged them. Examples of studies following a static 'container' concept of space are Manderscheid 1981, on the decoration of Roman baths, and Fuchs 1987, on Roman theatres. In contrast, Neudecker 1988 demonstrates more decisively an interest in the 'stage' of the Roman villa as shaped by its sculptural decoration (see Neudecker 1998 for his approach in an English version); cf. also Bartman 1991.

[10] See above, p. 159 n. 28.

[11] Favro 1996. The ongoing Berlin research hub Topoi has produced a couple of publications in this field, see for example Wulff-Rheidt & Kurapkat 2014.

and with it in the logistics of viewing, is what sets this approach apart from the traditional semiotic interest in the viewer;[12] yet, again this approach cultivates a thoroughly semiotic notion: it does so by way of its investment in comparative viewing, for the viewers' experiences are generated by comparing and contrasting information from the performative stages through which they move.

This concern with ambulation and performative viewing as gateways for the appropriation of perception and experience as objects for historical scrutiny is not confined to the study of urban landscapes, but finds application also in the study of other spatial settings. A good example for the scope of this approach is the 1999 study on ancient spectacle edited by Bettina Bergmann and Christine Kondoleon, which tackled the visuality of a diverse range of physical and conceptual spaces such as cityscapes, tombs, and domestic architecture, primarily derived from the archaeological record, and also looked at theatre performance, mourning, and dining, primarily based on literary evidence.[13]

Bettina Bergmann's most important contribution is concerned with the performative aspects of interior decoration in the Roman domestic sphere because she demonstrated how interior decoration shaped the lives of those living within those walls.[14] Bergmann's approach has been extended and diversified, specifically with regard to the way in which mythological depictions generated storyscapes across Roman houses, providing entertainment but also orchestrating life by means of specific statements about social and cultural values and ideals.[15] In recent years, the Roman funerary sphere has become the focus of studies concerned with the performative aspects of burial and tomb visiting. Whilst work on the tomb contexts of Roman mythological sarcophagi is somewhat constrained by the availability of evidence,[16] studies dealing with the tomb more generally are illuminating for our understanding of how Roman funerary art was related to its audience.[17]

[12] For semiotics and the viewer in ancient art-historical scholarship, see above, pp. 161–3.

[13] Bergmann & Kondoleon 1999. See now also O'Sullivan 2011 on walking in Roman culture; cf. also the collation of case studies in Scott 2012.

[14] Bergmann 1994; for a discussion of this approach and its use of Quintilian's rhetorical manual, see Lorenz 2014: 183–8.

[15] This expansion encompasses Bergmann's own work (Bergmann 1996; Bergmann 1999) and the studies by Clarke, which include many contextual discussions of interior decorations; for Pompeian painting see also Lorenz 2008; Lorenz 2013b. For the high and late empire, Susanne Muth's study on the mythological mosaics of Spain and Northern Africa sets an impressive standard for a contextual discussion of Roman myth in the domestic context (Muth 1998; cf. also her work on the Villa of Piazza Armerina, Muth 1999).

[16] Bielfeldt 2003 is an important case study; see also Meinecke 2012.

[17] See now Borg 2013 for a comprehensive assessment of imperial funerary culture.

Exploration of the physics of the visual for the Greek world poses significantly more challenges than for the Roman world simply because few Greek contexts provide the density of information available from sites such as metropolitan Rome, Pompeii, or Ostia.[18] However, examined under the headings 'cultural poetics' and, more specifically, 'ritual analysis',[19] Greek sanctuaries have opened up to studies of this type, proving particularly helpful in revealing how visitors experienced their architecture and architectural decoration during religious practices and rites.

Robin Osborne's 1987 paper on how the Parthenon metopes would have been visible to those moving past in a procession was an early intervention in this field; this work predates Settis' argument against Veyne's position on the possibilities of viewing in Roman state relief, but pursues a similar line of argument.[20] Richard Neer's discussion of the Siphnian Treasury at Delphi develops such approaches further.[21] Neer also harnesses changes in the spatiality of art as a component of formal analysis in an exciting expansion of conventional understandings of form and style.[22]

Finally, interest in spatial performativity is not confined to actual physical spaces, for it can just as well be pursued in figurative space, such as the space within a representation. Studies devoted to Athenian sympotic culture and the domestic context have erected the scaffolding for a promising line of enquiry,[23] with Nikolaus Dietrich's 2010 book on landscape markers in archaic vase-painting a particularly stimulating appropriation of the concept.[24]

Mediality.

This second strand of activity also takes its cue from semiotics, specifically in its concern for reception aesthetics, viewer response, and materiality. The mediality of the artefact has many facets, including the ways in which the

[18] For a discussion of aspects of spatial performativity, see Stansbury-O'Donnell 2011 in his sections on viewer response (pp. 101–3), context (pp. 133–48), and agency (pp. 149–54).

[19] For these terms, see Stansbury-O'Donnell 2011: 154–63.

[20] Osborne 1987; for a similar approach, cf. Marconi 2007. For the positions of Veyne and Settis, see above, pp. 162–3 n. 52.

[21] Neer 2001.

[22] Neer 2010; cf. above, pp. 160–1.

[23] Here, the French tradition of semiotic cultural study seamlessly leads into image studies (cf. above, p. 159 n. 33), with Lissarrague 1990 and Lissarrague 2001 the most prominent examples. For the Greek domestic context, see Nevett 1999; cf. also Nevett 2010.

[24] Dietrich 2010. The volume is published in a series that is entirely devoted to the exploration of aspects of spatial performativity: De Gruyter's Image & Context series, edited by Francois Lissarrague, Rolf Michael Schneider, and Bert Smith. The series's mission statement reads: 'At

human body can function as a processing device for visual experience[25] and the spatial logistics of an artefact, which dovetails with the strand of activity just discussed, concerning physicality and performativity.[26]

One other facet of mediality concerns the relationship of text and image. Scholarship on ancient art has passed through two stages in defining this relationship: the associative-philological approach, discussed above,[27] and finally combined media analysis. This final method, which has gained popularity in recent years, employs approaches adopted from contemporary media studies and is moving away from the dominance of the textual over the visual that shapes the associative-philological approaches.

Michael Squire's work on the Tabulae Iliacae provides an indicative example of this media approach. In an earlier work Squire had acutely described the ways in which the dominance of the textual in art-historical analysis, and specifically in classical art-historical interpretation, is a by-product of an anti-iconic attitude shaped by the Reformation but with lasting effects.[28] In his analysis and interpretation of the narrative structure and content of the Tabulae Iliacae, small tablets dated to the Roman imperial period which are decorated with miniature images and primarily Homeric texts, Squire began a campaign for an approach with the interplay of media at its heart, to replace an approach that proposed one media's supremacy over the other.

Squire's analysis of the tablets brought out the slippage between text and image – the interstices of cultural discourse – and in so doing demonstrated the sophistication of leisure communication, along with its cataclysmic powers, in the early imperial period.[29] This approach explores a particularly rich vein for cultural understanding because deep historical insights are best achieved at points of rapture, here by capturing the scope of what was considered possible and appropriate at one time in terms of content transmission across the media.

the core of the series are the questions of how and by whom images were shaped and perceived, and how images functioned within and contributed to a specific cultural context. The series aims to stimulate new discussion about the visual cultures of the ancient world and new approaches towards a history of the image.'

[25] For example Osborne 2011; Squire 2011a. Cf. also Belting 2011: esp. 15–16 (pp. 106–11 with a comment on ancient Greek art).

[26] This interdependency is demonstrated in the case study of the Pergamon altar: see above, pp. 201–8.

[27] See above, pp. 8–9.

[28] Squire 2009: 15–89.

[29] Squire 2011b. Previous attempts at explaining the iconotexts of the Tabulae Iliacae took these objects only to demonstrate the hierarchical relationship between text and image, with the former leading the latter: Horsfall 1979 provides a primary example for an associative-philological approach, cf. also Valenzuela Montenegro 2004.

The slippage between text and image was not confined to Roman culture. Recent work on the combined powers of artefact and inscription in the Greek religious context has elicited new understandings of the practices of religious ritual, revealing the vividness of the religious experience. Jonathan Day's work on ritual iconotexts has opened new ground here. His assessment of the Manticlus Apollo acutely demonstrates that to read the inscription written as a boustrophedon on the legs of the statuette, the reader had to ambulate from leg to leg and back again, thereby enacting the movement of those legs and making the statue seem to move.[30] This observation is in line with Neer's reflections on perception of archaic funerary markers,[31] and with recent epigraphic studies' consideration of inscriptions within 'in vivo' contexts, in which meaning impacts through and is impacted by what happens around it.[32]

Scholarship addressing south Italian vase-painting provides another example of the benefits of a cross-media approach, even if largely ex negativo. This field is torn between the 'philodramatics', those who regard vase-paintings that depict myths also featured in tragedy as mere illustrations of theatre plays, and the 'iconocentrics', who take the pots as independent of the plays.[33] Luca Giuliani's recent study demonstrates what could be gained from abandoning these camps to analyse vase pictures for the insights they provide into the perception mechanisms at play across a culture, for both the textual and the visual.[34]

Another facet of an artefact's mediality is its materiality. Whilst the description and categorisation of an artefact's make, its material and colour qualities, have always been at the core of art-historical analytical efforts, what is at stake here is the way in which the material qualities of the artefact impacted and enhanced its performativity and thus its content, not its place within a formal taxonomy.

This engagement with materiality can roughly be divided into three branches. The first of these branches looks at how materiality enhances the object. Neer's concern with marble, noting in particular that its translucent qualities contributed to the *thauma*, 'wonder', of archaic and classical Greek statues, provides a recent example.[35] Documenting the roots of this

[30] Most recent: Day 2010: 33–47. For an overview discussion of art and inscription in archaic sculpture, see Muth & Petrovic 2012: 291–306; cf. also Lorenz 2010.
[31] Cf. above, p. 161.
[32] Bing 2014.
[33] For an assessment, see Taplin 2007: 23, who belongs to the philodramatics (cf. also Taplin 1993); Giuliani 1996b: 74–5 for an iconocentric's view.
[34] Giuliani 2013.
[35] Neer 2010: passim.

approach in the formalist tradition as much as in semioticised iconology, Rolf Michael Schneider's 1986 study of Roman depictions of barbarians demonstrated how coloured marbles could facilitate complex statements that merge seeming contrasts – the ethnicity of those depicted, their prosperity, as well as their status – into powerful ideological messages enhancing the prestige of those who commissioned these pieces.[36]

Underpinning this first branch, a second branch of the study of materiality is devoted to reconstructing the colour appearance of artefacts and the interplay of the colour and qualities of the material from which the artefact is made, as, for example, in the case of marble's translucency. We saw such interplay on the Great Frieze of the Pergamon altar, where figures would have stood out against the dark background colour, enhancing the effect of the high relief.[37] This branch includes the analysis of elements in painting that extend the content of the depiction, as in studies of the Sciarra Amazon[38] and of the Copenhagen garland sarcophagus, where colour analysis traced bucolic landscape elements that had only been painted and not sculpted.[39]

A third branch in the analysis of materiality is concerned with the effects of specific materialities on the atmosphere within which artefacts are perceived. Bettina Bergmann's work on the Casa del Poeta Tragico's mythological decoration exemplifies this approach: Bergmann does not simply consider what the mythological panels show and where they are situated, but brings the dominant colours within the rooms and their interplay with natural light and axes of viewing into the discussion.[40] This rubric encompasses also examination of the agency of pictures and consideration of those who made these pictures and their impact on the pictures' capabilities and authority in negotiating reality. How, we could ponder for example, might a particular artisan have resolved a particular artistic problem – one such question is answered by the Roman tendency to appropriate the works of Lysippus and Pheidias in different contexts. As this branch also recognises, a picture might sport an artist's signature in order to stimulate discourse with its audience, not simply as a means of branding that artefact.[41]

[36] Schneider 1986.

[37] See above, p. 199.

[38] Ostergaard 2010.

[39] Sargent 2011.

[40] Bergmann 1994; see also above, p. 229.

[41] This line of enquiry must be separated from studies in ancient masters and from connoisseurship. See Neer 2002 and Squire 2013 for discussions with regard to the playful nature of artists' signatures in Greek and Roman art.

3) Conclusions

Image studies is concerned with the picture as embodiment, with the logistics of the artefact, its display, and perception. Where semiotics deals with the internal operational structures of the picture and iconology places the picture within the external world, image studies is invested in the internal and external implications of the picture's physical presence.

For mythological pictures, image studies opens a window onto performativity. This approach asks questions about how narratives are shaped through the audience's engagement with a picture, an engagement guided by the composition and its spatial display, enacted in movement, and able to forge connections between storylines when more than one story is depicted, as is the case with the Karlsruhe hydria, or when a picture presents intertwined storylines, as on the Louvre sarcophagus. Image studies then brings insight into the ability of individual pictures to orchestrate life within varied settings, and to shape social, political, and cultural discourses.

The concern with physicality and spatiality renders image studies particularly suitable for tackling pictures within architectural settings – public squares, the domestic context, the funerary sphere, and urban landscapes at large, for example. The results are clearly evident in our case study of the Pergamon altar. Meanwhile, as the Karlsruhe hydria and Louvre sarcophagus demonstrate, the reach of image studies is not limited to pictures with a physical context. The physicality of the picture is constituted first and foremost through the picture itself, which means that two-dimensional pictures with their 'pictorial space' can be examined according to the methods of image studies just as well as three-dimensional monuments.

With the picture itself at the core of its analysis, and analytical tools selected according to the character of that picture, image studies can function for all artistic genres (including non-figural art) and modes, public and private. Image studies is therefore also insulated against ideological leanings, which push iconology towards state or religious art, and semiotics towards artistic genres located in the private sphere.

Critics of image studies in the field of ancient art highlight one concern in particular: the way in which the logistics of pictures are studied – and how viewers allegedly processed these pictures – is a modern construct and not a reflection of ancient reality. However, this reproach misjudges the pervasiveness of construction and reconstruction in ancient art scholarship, no matter the methodological background. As Paul Zanker has correctly

recognised:[42] 'The classical archaeologist has a great deal to do with pictures and images, he classifies and interprets pictures, and in a certain sense he himself produces images because he continuously employs his imagination in order to generate images of past life out of its scattered remains.'

Image studies is not a threat to the academic nature of the discipline, to its 'scientific' pedigree. The reconstruction of history as a physical network of dependencies and correctives as facilitated by image studies – the engagement with the 'fabric' of the past – promises reliable results. By design, image studies performs a continuous balancing of heterogeneous data from varied sources. Such differential functioning sets image studies off in a positive way from the 'aporia of hermeneutics'.[43]

[42] Zanker 2006: 165 ('Der Klassische Archäologe hat viel mit Bildern zu tun, er ordnet und deutet Bilder, ja er ist in gewisser Weise selbst ein Bildermacher, muss er doch ständig seine Fantasie benutzen, um aus den spärlichen Resten des Überkommenen Bilder der einstigen Lebenswelt zu entwerfen', trans.: author). See also Hölscher 2000b: esp. 157; Hölscher 2007; cf. also Schneider 2010: 41–2.

[43] Schneider 2010: 42.

10 | The study of mythological images as threesome – assessing the experiment

Where painting continues to galvanise writing, that writing is both more and less than painting's supplement. If supplement is that which completes, fulfils, terminates, it is a word that cannot apply to the uncurtailable activity of recognition. If supplement is addition over and beyond an existing boundary, the image is unbounded, and least of all by the four walls of the frame. Writing is the trace of an encounter which will never know the object in absolute terms, but which will continue for as long as the image can circulate within society; for as long as the image remains alive.

Bryson 1983: 85–6

Everyone knows that images are, unfortunately, too valuable, and that is why they need to be put down. Mere images dominate the world. They seem to simulate everything, and therefore they must be exposed as mere nothings. How is this paradoxical magic/nonmagic of the image produced? What happens to an image when it is the focus of both over- and underestimation, when it has some form of 'surplus value'? How do images accrue values that seem so out of proportion to their real importance? What kind of critical practice might produce a true estimation of images?

Mitchell 2005: 76

The authors of the analytical models sketched out at the beginning (Sedlmayr, Bauch, and Panofsky) define their own scholarly habitat only indirectly. They assume a universal validity of their models and therefore do not specially position themselves within academic discourse. Since the 1970s, rigorous scholarly work is increasingly expected to reflect upon its own, implicit theoretical habitat and to expatiate upon it. This – mostly still only implied – imperative already alleges that no single theory can lay claim to providing the one single truth, and that instead a plurality of scholarly models exists which all can claim equal feasibility. This means on the side of the object, the artefact to be interpreted, that its semantic potential is turned into a function of the conditions of its reception. By means of its analysis, it might be refreshed, or (in parts) remain arcane. In order to fight the interpretive arbitrariness that

might arise from this, it is paramount always to assess the historical pertinence, an assessment with regard to the 'emission level' of the work of art, its intentions and the options of its reception for the primary communicative community.

Held & Schneider 2007: 396–7[1]

The experiment conducted over the previous pages was concerned with the ways in which we can approach pictures, especially mythological pictures, that is, pictures conveying stories. The study explored three methods commonly applied to the study of imagery – iconology, semiotics, and image studies – testing their respective abilities and limitations by means of an iterative cross-examination welded around the study of three individual objects depicting myths.

This experimental design was chosen to facilitate engagement with what is perhaps best called the 'source code' of art-historical study: that is, the operational practices of pictures and our methods of extracting and assessing the pictures' meaning This lateral approach, a study of three means of interpreting pictures alongside each other, was explicitly not concerned with *a priori* truths, but instead sought to map the differences between and dependencies of the individual methods that provide the analytical tools we might employ in establishing meaning production.

This set-up sought to overcome the 'impoverished sense of its own possibilities' that constrains art-historical study,[2] especially in the fields of Greek and Roman art, and to do so by making full use of those art-historical 'possibilities' to open up pathways of enquiry – not in order to demonstrate that any particular analytical model holds the key to unlocking the full complexity of meaning in a picture, but in order to showcase that an iterative approach can be an asset for analysis. If the semantic potential of a picture is

[1] German original: 'Die Autoren der eingangs skizzierten Analysemodelle (Sedlmayr, Bauch und Panofsky) bestimmen ihren eigenen wissenschaftlichen Standort nur mittelbar. Sie gingen von der universellen Gültigkeit ihrer Entwürfe aus und positionierten sich daher nicht eigens im Wissenschaftssystem. Seit den 1970er Jahren wird es von anspruchsvollen wissenschaftlichen Arbeiten jedoch zunehmend verlangt, die eigene implizite wissenschaftstheoretische Position mit zu reflektieren und zu explizieren. Dieses (meist noch unausgesprochene) Gebot unterstellt bereits, dass keine Theorie Anspruch auf die eine Wahrheit erheben kann, dass vielmehr eine Vielzahl wissenschaftlicher Analyseverfahren möglich ist. Das bedeutet für die Objektseite, das zu interpretierende Artefakt, dass sein semantisches Potenzial auch eine Funktion der Rezeptionsbedingungen ist. Es kann analytisch aktualisiert werden oder aber (partiell) verborgen bleiben. Um der interpretativen Willkür, die daraus folgen könnte, zu wehren, gilt es, stets die historische Angemessenheit, die Überprüfung an dem "Emissionsniveau" eines Werks, den Intentionen und Rezeptionsmöglichkeiten der primären Kommunikationsgemeinschaften zu überprüfen.'

[2] See above, p. 3.

approached as 'a function of the conditions of its reception', as described by Jutta Held and Norbert Schneider,[3] then the application of different methods for analysis and interpretation to a single artefact, as here, acts as a feasibility study.

1) The methods and their trajectories

The experiment followed a dual strategy in order to address the reciprocal relationship of art theory and art history and possible interdependencies of method and knowledge, scrutinising both pictures and methods to establish their impact on one other. Its challenge was to determine how we might approach mythological imagery analytically and how the meaning we elicit is related to the tools we use.

The three sections devoted to individual methods have brought out the ideological remits that underpin each approach when it comes to studying pictures that convey narrative as a form of historical evidence. We sought to establish how each of these methods responds to processes of meaning production in the visual: some of these responses complement or extend each other; some overlap; some are contradictory. Such cross-examination makes apparent the benefits and shortcomings of each of the methods, along with their interdependencies.

For each method, we can extrapolate characteristic trajectories of enquiry. Broadly speaking, iconology is concerned with the historical context; image studies with the physical context; and semiotics with reaching into the presentation itself. Viewed more specifically, the three methods can be differentiated by their response to fragmentation, common to all types of ancient artefact, including mythological images. Each method has its own solution, but in constructing its own perspective on the relevant object, each method also adds another level of fragmentation, a secondary level that entails a loss of information for certain aspects.

Iconology is the method most concerned with rectifying the state of fragmentation. It aims to generate a comprehensive data set, established by means of iconographic comparison and in order to reconstruct the picture within its historical context as accurately as possible. Whilst based on a close autopsy of the artefact, this practice diverts attention away from the object itself and onto the object's comparative relationship with other objects.

[3] Held & Schneider 2007: 397.

Iconology is underpinned by the notion that the picture can be established as one irrefutable truth. This method is not impeded by the fragmentation of data for a single artefact because it aggregates (indirect) data about that artefact by comparison with other artefacts, in what might best be labelled a 'linked-data' approach. Iconology can therefore be applied virtually anywhere, with the extent of its success dependent on how 'thin' or 'thick' the network of comparative data is, as the scaffolding around the picture.

Semiotics overcomes the state of fragmentation in a structurally comparable way. It also directs its focus onto a network of data, but in this instance that network exists not between artefacts but within the artefact itself. Semiotics, too, is therefore applicable virtually anywhere – but where iconology introduces a new level of fragmentation in respect of the artefact itself, which is explained only through its relationship with other pictures, semiotics also proves neglectful, not of the picture itself, but of what surrounds the picture, its iconographic and historical dimensions.

Image studies can be described as an attempt to overcome the flattening effects of the linked-data set-up of iconology and semiotics with regard to the picture itself as well as to what surrounds that picture. It does so by forcing the interpreter to concentrate not on a network of linked data, but on the ways in which a picture conveys data about itself, serves as an agent for different actions, and generally establishes relationships with other data.

2) The objects through the methods

The methodological trajectories have an impact on the objects under scrutiny that in turn throws into sharper relief the analytical qualities of each individual method. Generally, the study has demonstrated that pictures with a high level of ideological content, as found in public art, and pictures that serve specific functions, such as funerary representations, will always be receptive of analytical means that can uncover the ideational character and content of a representation within its historical dimension. These requirements are particularly well met by the iconological approach, but both semiotics and image studies also offer means of tackling ideational discourses and when married with a historical corrective can unearth significant insights.

In turn, highly heterogeneous depictions – depictions that employ different styles alongside each other, or different types of figures, or different modes of transmission – lend themselves to the semiotic approach, which

has the means to reach into the representation and grasp, and map, its internal differences. While iconology and image studies can track aspects of such heterogeneity, neither approach is invested in turning such observed differences into meaningful interpretation, preferring to synthesise, rather than diversify, its data.

Finally, pictures with a certain spatial complexity – either within the representation itself or regarding its setting – will always benefit from an image studies approach, which takes account of the physicality of the representation in a way not facilitated by either of the other two methods.

The Karlsruhe hydria.

Each method's analysis of the Karlsruhe hydria concentrates on the process of judgement depicted in the scene, along with Paris' desire (figs 0.1, 5.1). Yet that analysis in each case takes a different form.

Iconology focuses on the iconographic characterisation of the individual figures and their compositional arrangement by drawing on a network of comparisons that includes other depictions of the episode in text and image, the locale of the Athenian acropolis, and the practices of Athenian theatre. These foci lead to an interpretation that accentuates religious and political aspects, along with the role of the gods, and intimisation and individualisation in the portrayal of the individual characters. The interpretation centres on the role of the Oriental in Athenian society and politics and on Athenian stakes in the Peloponnesian War, the most decisive event of the period.

Iconology is an appropriate tool for enabling understanding of the pot as a product of a period of crisis – contrary to some criticism of the method, it does indeed provide the means to interrogate the artefact in light of general historical knowledge, and without synthesising away the characteristics of the artefact. Iconology is not suited, however, for examination of the relationship of the picture fields on the pot, or the pot's potential functions.

Semiotics draws attention to the modes of presentation across the vessel, including the mythological and non-mythological along with the figural and non-figural. This focus on the internal syntax of the vessel identifies Eris as a protagonist alongside and in addition to Paris. This differing emphasis leads semiotic interpretation also to a different interpretation overall, an interpretation that highlights choice and crisis. It also draws out differences between male and female behaviours, based on a comparison of action schemes as depicted on the hydria itself and of trends across other depictions of the Meidian circle.

Overall, the semiotic interpretation concentrates on artistic branding and exposes how the depicted discourse about behaviour undertaken within and outside normative boundaries propagates certain role models. Semiotics can deal much better with the combination of myths on the pot than can iconology; it might also offer insight into the use of the pot, whose display of male and female action schemes was indeed suited to both the *gynaikeion* and the symposium. Meanwhile, semiotics' reading of the vessel as representative of crisis and conflict also adds to a historical understanding of the period in which the pot was produced.

Image studies' concern with the physicality of the artefact and the conditions of its viewing leads to an iconographic comparison of the juxtaposition of Judgement scenes with other topics on Athenian vessels. The interpretation draws out the presentation of Paris' desire as a process. In so doing, it also engages in an argument about the presentation of the story as evidence of viewer guidance at play in later fifth-century Athenian culture, and as a sign of the emergence of a new visuality rather than as corroboration of a decline of the genre of vase-painting brought about by political and economic upheavals in the wake of the Peloponnesian War. In this way, image studies responds to all three challenges – related to content, function, and historical horizon – posed by this specific object.

A look at two figures in the depiction, Paris and Athena, exemplifies how the shifting focus across the three methods impacts understanding of individual characters. From an iconological perspective, Paris is the anchor figure of the scene, with an emphasis on matters of personal responsibility. The other figures are assessed in relation to the Trojan prince, an evaluation that includes Athena, whose rendering in parallel to Athenian state art is brought out by the iconographic assessment. With regard to the judgement scene itself, however, Athena is considered as secondary to Aphrodite, whose relationship with Paris takes centre stage in the analysis. Meanwhile, Athena is seen instead as locating the scene within an Athenian context and as a foil for Paris' Oriental appearance.

In semiotic interpretation the focus shifts to include both picture fields in the discussion. Paris is no longer regarded as the sole anchor of the scene; instead, Eris' role in the depicted narrative is brought under investigation and with it also the paradigmatic relationship between Eris and other female characters in the scene, and between Paris and Dionysus. Like iconology, semiotics highlights Athena's function in locating the scene within the city of Athens, but with its focus on modes of depiction, semiotics also throws into relief how this role locates the figure of Athena outside the realm of

myth, and the extent to which other figures in the scene, such as Eris or the women in the lower frieze, share similar characteristics.

When the Karlsruhe hydria is approached from the vantage point of image studies, consideration of the roles of the individual characters is pushed back in favour of exploration of the way in which relationships between individual figures can change in the process of viewing. Paris features here for the way in which his character connects with the lower frieze, including the figure of Dionysus; Athena is explored in light of her relationship with Paris, which is set against Aphrodite's relationship with him.

The Pergamon frieze.

In the case of the Pergamon altar, all three methods consider elements of the divine and its dominance as portrayed in the representation (fig. 0.2). Again, however, distinct pathways are taken through such common ground. Iconology's focus on the characterisation of individual figures brings out the extent to which the gigantomachy depicted here differs from previous renderings of the myth, and the nature of the Great Frieze's celebration of the power of the gods. This approach leads to an interpretation that emphasises the Pergamene depiction's emulation of an earlier Athenian template in order to engage in a sophisticated competition with its predecessor and role model. The iconological approach seeks to master the challenges that are raised by the ideological use of myth and inherent in the relationship of form and meaning, especially regarding potential Athenian links; it is not concerned with the spatial display of the myth.

Semiotics zooms in on the means of differentiation employed across the Great Frieze, exposing a discourse of destruction and defeat of cosmic dimensions. Like iconology, semiotics engages with the way in which the depiction relates to the past, throwing particular light on how, here, artistic templates of famous statues are functionalised; in so doing it also fleshes out the parameters of the divine discourse depicted on the Great Frieze. This method too tackles ideological display and the relationship of form and meaning, and it too has little to say about spatial display.

In contrast to both iconology and semiotics, image studies' concern with the physicality of display draws attention to the design of the Great Frieze in the wider context of the Pergamene acropolis. Image studies compares the frieze with other Greek religious buildings, and its exploration of the frieze's divinisation of the viewer uncovers a significant shift from the way earlier sacral buildings such as the Athenian Parthenon had engaged their visitors. Through its focus on the spatial display, image studies also addresses those

challenges around the ideological use of myth and the meaningful use of artistic form.

In the case of the Great Frieze, the figures of Athena and the giant Bronteas provide good examples for demonstrating the differing impact of each analytical method. From the vantage point adopted by iconology, the depiction of Athena articulates the pervasive power of the gods portrayed here and also expresses the Great Frieze's complex relationship with Athenian art, specifically the Parthenon. Meanwhile, the depiction of Bronteas confirms that on the Great Frieze a hitherto unseen iconography has been chosen for the giants: that is, their characterisation as hybrid creatures, with animal features such as snake legs, or wings on their backs.

The semiotic perspective, with its interest in modes of depiction, focuses on Athena's role as daughter and as a reference to the Parthenon, and it also considers Athena's extrication of her opponent from his allocated sphere, the earth, not least in order to explore the display of female violence on the Great Frieze. In turn, the figure of Bronteas is representative of the semiotic approach's dissection of the merging of the giants, as animal hybrids, with the wild forces of nature, an investigation that highlights the giants' juxtaposition with the gods and their divine command over nature.

Finally, the emphasis on the performative iconography of the frieze pursued by image studies draws out how the figure of Athena in her role as a reference to Athenian state art is supported by the design of the wider spatial context of the altar. And image studies' analysis of the locating of Bronteas' body in part on the stairs of the building leads to a deeper understanding of the display of divine power and of the invitation to the viewer to enter into the actions of the gods.

The Louvre sarcophagus.

For the Louvre sarcophagus, all three approaches bring insight into the depiction's comments on the course of life and, therefore, all three show concern for the function of the object (fig. 0.3). The iconological perspective focuses on the figure of Meleager, along with his weaponry, in order to explore the relationship between the depictions on the relief, other versions of the episode in text and image, and depictions of hunting and war across Roman art, including sarcophagi and state relief. The resulting interpretation highlights the depiction's combination of elements of consolation and commemoration as a means of rendering personal effort. With its investment in iconographic comparison, the iconological approach has a particular challenge in tackling the evidence of public art, a challenge it takes up

through a cross-examination that avoids levelling the differences between the sarcophagus and other material evidence.

In turn, semiotics draws out the differentiation of individual groups of figures in the scene, facilitated by the two occurrences of Meleager and by the stylistic rendering more generally, including the deployment of non-figural elements. The interpretation focuses on the negotiations of sets of emotional pairings on the casket (love and envy, loyalty and vengeance), resulting in an assessment of the relief as debating death in light of age and gender.

Meanwhile, image studies considers the sequencing of the three individual scenes that make up the relief, exploring how their non-sequential arrangement highlights particular relationships between individual characters and brings out the themes of pride and punishment. This approach tackles in particular the depiction's navigation of the realms of myth and of the sphere beyond the picture as the image seeks to involve its viewers.

The mechanisms of the individual methods are best brought out by observing the changing focus on the figures of Atalanta and Althaea. Viewed through the lens of iconology, both figures are part of a network of data that grounds the presentation of Meleager, ensuring his correct identification, and they also contribute *pietas* to the scene. In contrast, the semiotic lens is turned in particular on the respective roles of these two women, looking at Althaea's affiliation with the Fates – she forms a group and is aligned in her action with the Fates, yet she also resists them – and also at her complex relationship with Atalanta, who by virtue of the carving is presented simultaneously as connected with and cut off from Althaea. Image studies increases the focus on the role of Atalanta and explores her function as a gateway for the depiction overall. This emphasis, then, also facilitates a detailed analysis of the role of Althaea and the pyre scene within the depiction overall.

3) Mythological images and iterative analysis: a conclusion

The insights into the operational modes of each method gained here provide a basis for an exploration of how these individual methods can be brought into interaction with each other, in addition to improving understanding of the individual objects under investigation. Indeed, the cross-examination makes the strengths of each method quite clear – and also brings out how they might be aligned and even combined in order to reach a deeper

understanding of the individual pictures, notwithstanding the fact that the individual trajectories of the three methods are distinct.

A few examples will suffice to demonstrate how such a virtuous methodological circle might be generated. In the case of the Louvre sarcophagus, Meleager's sword, identified by the iconological approach as peculiar for a hunter's iconography, when scrutinised according to a semiotics approach enables insight into the differentiation of the various actors on the casket and their characterisation by means of attributes, in particular for the demon of fate with the torch, who displays a similarly non-standard iconography.

Meanwhile, a semiotic study of the Karlsruhe hydria brings out the importance of the figure of Eris in representing crisis and decision-making. When that perception is followed up by means of iconology, further insights regarding the deployment of personifications in Greek vase-painting are revealed, specifically their increased narrative importance in the later fifth century. From the perspective of image studies, then, Eris' twisted pose can be studied as symptomatic of the centrifugal forces shaping the vessel's composition overall.

Finally, in the case of the Pergamon frieze, an image studies approach turns the bodies of the giants on the stairs into an aspect worth of study, but, its significance established, this feature also lends itself extremely well to iconological and semiotic analysis: the former tackles how representative such composition is, and indeed how it sets off the Pergamene monument from its predecessors, especially the Athenian Parthenon; the latter provides the means for assessing how the giants' presence outside the frieze relates to their characterisation at large, specifically in contrast to the gods.

These examples show how iterative analysis can guide us through the evidence and facilitate deep understanding. Such analysis is well suited to tackling the challenges posed in particular by mythological images with their unique cocktail of conventional pictorial formulae and genuine narrative innovations – and to tackling these challenges in light of the primary evidence itself. But the applicability of such approach reaches far beyond mythological imagery alone and should serve visual representation of all types. On a more general level, the iterative experiment also demonstrates what we have to lose if we opt for method exclusivity and fail to make full use of the analytical tools at our disposal. Here the present study ends, with a plea for a multilateral, multi-method approach to pictures – in the study of ancient mythological imagery, and of images at large.

Bibliography

ABV – Beazley, J. D. (1956) *Attic Black-Figure Vase-Painters*. Oxford.

Add² (1989) *Beazley Addenda*, eds T. H. Carpenter et al. Oxford.

Ahlberg-Cornell, G. (1984) *Heracles and the Sea-Monster in Attic Black-Figure Vase-Painting*. Stockholm.

Allen, R. E. (1983) *The Attalid Kingdom: A Constitutional History*. Oxford.

Alpers, S. (1979) 'Style is what you make it: The visual arts once again', in *The Concept of Style*, ed. B. Lang. Philadelphia, PA: 137–62.

Altekamp, S. (2008) 'Klassische Archäologie', in *Kulturwissenschaften und Nationalsozialismus*, eds J. Ewert and J. Nielsen-Sikora. Stuttgart: 167–209.

Amedick, R. (1991) *Die Sarkophage mit Darstellungen aus dem Menschenleben*. Vita Privata, Antike Sarkophagreliefs I 4. Mainz.

Andreae, B. (1956) *Motivgeschichtliche Untersuchungen zu den römischen Schlachtsarkophagen*. Mainz.

Andreae, B. (1980) *Die römischen Jagdsarkophage: Antike Sarkophagreliefs I 2*. Berlin.

Andreae, B. (1985) *Die Symbolik der Löwenjagd*. Opladen.

Angelicoussis, E. (1984) 'The panel reliefs of Marcus Aurelius', *RM* 91: 141–205.

Anguissola, A. (2012) *'Difficillima imitatio': Immagine e lessico delle copie tra Grecia e Roma*. Rome.

Argan, G. C. (1975) 'Ideology and iconology', *Critical Inquiry* 2: 297–305.

Arnulf, A. (2002) 'Das Bild als Rätsel: Zur Vorstellung der versteckten und mehrfachen Bildbedeutung von der Antike bis zum 17. Jahrhundert', *Münchner Jahrbuch der bildenden Kunst* 53: 103–62.

ARV – Beazley, J. D. (1963) *Attic Red-Figure Vase-Painters*. Oxford.

ARV² – Beazley, J. D. (1984) *Attic Red-Figure Vase-Painters*. 2nd edition. Oxford.

Assmann, J. (1995) 'Collective memory and cultural identity', *New German Critique* 65: 125–33.

Bakhtin, M. (1981) *The Dialogic Imagination: Four Essays*. Austin, TX.

Bal, M. (1997) *Narratology: Introduction to the Theory of Narrative*. Toronto.

Bal, M. (2002) *Travelling Concepts in the Humanities: A Rough Guide*. Toronto.

Bal, M. and Bryson, N. (1991) 'Semiotics and art history', *ArtB* 73: 174–208.

Bally, C. and Sechehaye, A. (eds) (1916) *Cours de linguistique générale (de Ferdinand de Saussure)*. Geneva.

Bann, S. (1970) *Experimental Painting: Construction, Abstraction, Destruction, Reduction*. London.

Bann, S. (1989) *The True Vine: On Visual Representation and Western Tradition.* Cambridge.

Baratte, F. and Metzger, C. (eds) (1985) *Musée du Louvre: Catalogues des sarcophages en pierre d'époque romaine et paléochretienne.* Paris.

Barrett, J. F. (1979) *Monumental Evidence for the History of the Alcmaeonids* (PhD Chapel Hill). Ann Arbor, MI.

Barthes, R. (1967) *The Fashion System.* New York [trans. of *Système de la mode.* Paris (1967) by M. Ward and R. Howard].

Barthes, R. (1972) *Mythologies.* New York [trans. of *Mythologies.* Paris (1957) by A. Lavers].

Barthes, R. (1975) *S/Z: An Essay.* New York [trans. of *S/Z.* Paris (1970) by R. Miller].

Barthes, R. (1977a) *Image, Music, Text.* London.

Barthes, R. (1977b) *Elements of Semiology.* New York [trans. of *Éléments de sémiologie.* Paris (1964) by A. Lavers and C. Smith].

Barthes, R. (1982) 'The reality effect', in *French Literary Theory Today: A Reader*, ed. T. Todorov. Cambridge: 11–17.

Bartman, E. (1991) 'Sculptural collecting and display in the private realm', in *Roman Art in the Private Sphere*, ed. E. Gazda. Ann Arbor, MI: 71–88.

Baxandall, M. (1972) *Painting and Experience in Fifteenth Century Italy.* Oxford.

Baxandall, M. (1985) *Patterns of Intention: On the Historical Explanation of Pictures.* New Haven, CT.

Bayer, T. (2001) *Cassirer's Metaphysics of Symbolic Forms: A Philosophical Commentary.* New Haven, CT.

Beazley, J. D. (1925) *Attische Vasenmaler.* Tübingen.

Beazley, J. D. (1974) *The Berlin Painter.* Mainz [trans. of *Der Berliner Maler.* Berlin (1930) by P. Jacobsthal].

Becatti, G. (1947) *Un manierista antico.* Rome.

Beckmann, M. (2011) *The Column of Marcus Aurelius.* Chapel Hill, NC.

Bedaux, J. B. (1990) *The Reality of Symbols: Studies in the Iconology of Netherlandish Art 1400–1800.* The Hague.

Belting, H. (1983) *Das Ende der Kunstgeschichte?* Munich.

Belting, H. (1995) *Das Ende der Kunstgeschichte: Eine Revision nach zehn Jahren.* Munich.

Belting, H. (1997) *Likeness and Presence: History of the Image before the Era of Art.* Chicago, IL [trans. of *Bild und Kult.* Munich (1994) by E. Jephcott].

Belting, H. (2005) 'Image, medium, body: A new approach to iconology', *Critical Inquiry* 31.2: 302–19.

Belting, H. (ed.) (2007) *Bilderfragen: Die Bildwissenschaften im Aufbruch.* Munich.

Belting, H. (2011) *An Anthropology of Images: Picture, Medium, Body.* Princeton, NJ [trans. of *Bild-Anthropologie: Entwürfe für eine Bildwissenschaft.* Munich (2001) by T. Dunlap].

Benjamin, W. (2002) *The Arcades Project.* Cambridge, MA.

Bérard, C. (1974) *Anodoi: Essai sur l'imagerie des passages chthoniens.* Rome.

Bérard, C. (ed.) (1989) *A City of Images: Iconography and Society in Ancient Greece.* Princeton, NJ [trans. of *La cité des images: Religion et société en Grèce antique.* Paris (1984) by D. Lyons].

Berenstein, R. J. (1995) 'Spectatorship-as-drag: The act of viewing and classical horror cinema', in *Viewing Positions: Ways of Seeing Film*, ed. L. Williams. Newark, NJ: 231–69.

Bergemann, J. (1997) *Demos und Thanatos: Untersuchungen zum Wertsystem der Polis im Spiegel der attischen Grabreliefs des 4. Jhs. v. Chr. und zur Funktion der gleichzeitigen Grabbauten.* Munich.

Berger, E. (1974) *Die Geburt der Athena im Ostgiebel des Parthenon.* Basel.

Bergmann, B. (1994) 'The Roman house as a memory theatre: The House of the Tragic Poet in Pompeii', *ArtB* 76: 225–56.

Bergmann, B. (1996) 'The pregnant moment: Tragic wives in the Roman interior', in *Sexuality in Ancient Art*, ed. N. Kampen. Cambridge: 199–218.

Bergmann, B. (1999) 'Rhythms of recognition: Mythological encounters in Roman landscape painting', in *Im Spiegel des Mythos: Bilderwelt und Lebenswelt*, eds F. de Angelis and S. Muth. Wiesbaden: 81–107.

Bergmann, B. and Kondoleon, C. (eds) (1999) *The Art of Ancient Spectacle.* New Haven, CT.

Bernstein, R. J. (2002) 'The constellation of hermeneutics, critical theory and deconstruction', in *The Cambridge Companion to Gadamer*, ed. R. J. Dostal. Cambridge: 267–82.

Beschi, L. (1967–8) 'Contributi di topografia ateniese', *ASAtene* NS 29–30: 381–436.

Bianchi-Bandinelli, R. (1970) *Rome: The Centre of Power.* London.

Bieber, M. (1961) *The Sculpture of the Hellenistic Age.* New York.

Bielfeldt, R. (2003) 'Orest im Medusengrab: Ein Versuch zum Betrachter', *RM* 110: 117–50.

Bielfeldt, R. (2005) *Orestes auf römischen Sarkophagen.* Berlin.

Bing, P. (2014) 'Inscribed epigrams in and out of sequence', in *Hellenistic Poetry in Context*, eds A. Harder and R. Regtuit. *Hellenistica Groningana* 20: 1–24.

Bloch, E. (2000) *The Spirit of Utopia.* Stanford, CA [trans. of *Geist der Utopie.* Munich (1918) by A. A. Nassar].

Blome, P. (1978) 'Zur Umgestaltung griechischer Mythen in der römischen Sepulkralkunst: Alkestis-, Protesilaos- und Proserpinasarkophage', *RM* 85: 435–57.

Blome, P. (1992) 'Funerärsymbolische Collagen auf mythologischen Sarkophagreliefs', *StIt* 10: 1061–73.

Boardman, J. (2005) 'Composition and content on classical murals and vases', in *Periklean Athens and its Legacy: Problems and Perspectives*, ed. J. M. Barringer. Austin, TX: 63–72.

Boehm, G. (1978) 'Zu einer Hermeneutik des Bildes', in *Die Hermeneutik und die Wissenschaften*, eds H. G. Gadamer and idem. Frankfurt am Main: 444–71.

Boehm, G. (ed.) (1994) *Was ist ein Bild?* Munich.

Boehm, G. (2007) 'Iconic turn: Ein Brief', in *Bilderfragen: Die Bildwissenschaften im Aufbruch*, ed. H. Belting. Munich: 27–36.

Böhr, E. (1982) *Der Schaukelmaler*. Mainz.

Böhr, E. (2000) 'Ἀφροσύνη', *AA* 109–15.

Borbein, A. H. (1973) 'Die griechische Statue des 4. Jahrhunderts v. Chr.: Formanalytische Untersuchungen zur Kunst der Nachklassik', *JdI* 88: 43–212.

Borbein, A. H. (1995) 'Die bildende Kunst Athens im 5. und 4. Jahrhundert v. Chr.', in *Die athenische Demokratie im 4. Jahrhundert v. Chr.*, ed. W. Eder. Stuttgart: 430–67.

Borg, B. (2002) *Der Logos des Mythos: Allegorien und Personifikationen in der frühen griechischen Kunst*. Munich.

Borg, B. (2013) *Crisis and Ambition: Tombs and Burial Customs in Third-Century CE Rome*. Oxford.

Börker, C. (1978) 'Ein Linkshänder im Gigantenkampf', *AA* 282–7.

Bothmer, D. von (1957) *Amazons in Greek Art*. Oxford.

Bouquet, S. and Engler, R. (2006) *Writings in General Linguistics (by Ferdinand de Saussure)*. Oxford.

Bourdieu, P. (1970) *La Reproduction: Éléments pour une théorie du système d'enseignement*. Paris.

Bourdieu, P. (1984) *Distinction: A Social Critique of the Judgment of Taste*. Cambridge, MA [trans. of *La distinction: Critique sociale du jugement*. Paris (1979) by R. Nice].

Braun, L. (1982) 'Die schöne Helena, wie Gorgias und Isokrates sie sehen', *Hermes* 110: 158–74.

Bredekamp, H. (1995) 'Words, images, ellipses', in *Meaning in the Visual Arts: Views from the Outside. A Centennial Commemoration of Erwin Panofsky*, ed. I. Lavin. Princeton, NJ: 363–71.

Bredekamp, H. (1998) 'Falsche Skischwünge', in *Edgar Wind: Kunsthistoriker und Philosoph*, eds idem and B. Buschendorf. Berlin: 207–26.

Bredekamp, H. (2003) 'A neglected tradition? Art history as *Bildwissenschaft*', *Critical Inquiry* 29.3: 418–28.

Bredekamp, H. (2010) *Theorie des Bildakts*. Frankfurt/M.

Bredekamp, H., Diers, M., and Schoell-Glass, C. (eds) (1991) *Aby Warburg*. Akten des internationalen Symposions Hamburg 1990. Weinheim.

Bremmer, J. (1984) 'Greek menadism reconsidered', *ZPE* 55: 267–86.

Brendel, O. (1930) 'Immolatio boum', *RM* 45: 196–226.

Brendel, O. (1936) 'Gli studi Germanici sue rilievi storici Romani', *Studi Romani nel Mondo* 3: 122–44.

Brendel, O. (1953) 'Prolegomena to a book of Roman art', *MAAR* 21: 9–73 [revised as *Prolegomena to a Study of Roman Art*. New Haven, CT (1979)].

Brendel, O. (1958) 'Review of: *Pandora's Box. The Changing Aspects of a Mythical Symbol* by F. Panofsky and D. Panofsky', *Gnomon* 30.5: 386–92.

Brendel, O. (1977) *Symbolism of the Sphere*. Leiden [trans. of 'Symbolik der Kugel: Archäologische Untersuchungen zur Geschichte der älteren griechischen Philosophie', *RM* 51 (1936) 1–95 by M. Weigert].

Brilliant, R. (1984) *Visual Narratives: Storytelling in Etruscan and Roman Art*. Ithaca, NY.

Brilliant, R. (1992) 'Roman myth / Greek myth: Reciprocity and appropriation on a Roman sarcophagus in Berlin', *StIt* 10: 1030–45.

Bringmann, K. (2000) *Schenkungen hellenistischer Herrscher an griechische Städte und Heiligtümer 2.1: Geben und Nehmen: Monarchische Wohltätigkeit und Selbstdarstellung im Zeitalter des Hellenismus*. Berlin.

Bringmann, K. et al. (eds) (1995) *Schenkungen hellenistischer Herrscher an griechische Städte und Heiligtümer 1: Zeugnisse und Kommentare*. Berlin.

Brinkmann, V. (1985) 'Die aufgemalten Namensbeischriften an Nord- und Ostfries des Siphnierschatzhauses', *BCH* 109: 77–130.

Bron, C. (1996) 'Hélène sur les vases attiques: Esclave ou double d'Aphrodite', *Kernos* 9: 297–310.

Broneer, O. (1932) 'Eros and Aphrodite on the north slope of the acropolis in Athens', *Hesperia* 1: 321–417.

Brouskari, M. (1989) 'Aus dem Giebelschmuck des Athena-Nike-Tempels', in *Festschrift N. Himmelmann: Beiträge zur Ikonographie und Hermeneutik*, eds D. Salzmann et al. Mainz: 115–18.

Brunn, H. (1884) *Über die kunstgeschichtliche Stellung der pergamenischen Gigantomachie*. Berlin.

Brunn, H. (1905) *Kleine Schriften II*. Leipzig.

Bryson, N. (1983) *Vision and Painting: The Logic of the Gaze*. New Haven, CT.

Bryson, N., Holly, M. A., and Moxey, K. (eds) (1994) *Visual Culture: Images and Interpretations*. Middletown, CT.

Buck-Morss, S. (1991) *The Dialectics of Seeing: Walter Benjamin and the Arcades Project*. Cambridge, MA.

Burn, L. (1987) *The Meidias Painter*. Oxford.

Burn, L. (1989) 'The art of the state in late 5th century Athens', in *Images of Authority*, Papers presented to Joyce Reynolds, eds M. M. Mackenzie and C. Roueché. *Papers of the Cambridge Philological Society Suppl.* 16: 62–81.

Burn, L. (1991) 'Later fifth-century red-figure', in *Looking at Greek Vases*, eds T. Rasmussen and N. Spivey. Cambridge: 118–30.

Burow, J. (1989) *Der Antimenesmaler*. Mainz.

Cain, H. U. (1985) *Römische Marmorkandelaber*. Mainz.

Callaghan, P. J. (1981) 'On the date of the Great Altar of Zeus at Pergamon', *BICS* 28: 115–21.

Camponetti, G. (2007) 'L'hydria londinese di Meidias: Mito e attualità storica ad Atene durante la guerra del Peloponneso', in *Il vasaio e le sue storie: Giornata di studi sulla ceramica attica in onore di Mario Torelli per i suoi settanta anni*, eds S. Angiolillo and M. Guiman. Cagliari: 17–45.

Carpenter, T. H. (1997) *Dionysian Imagery in Fifth-Century Athens*. Oxford.

Carpenter, T. H. (2006) 'The native market for red-figure vases in Apulia', *MAAR* 48: 1–24.

Carter, C. F. (1979) 'Sculpture of the Sanctuary of Athena Polias at Priene', in *Studies in Classical Art and Archaeology*, ed. idem. London: 139–51.

Cassidy, B. (ed.) (1993) *Iconography at the Crossroads*. Princeton, NJ.

Cassirer, E. (1944) *An Essay on Man: An Introduction to the Philosophy of Human Culture*. New York, NY.

Cassirer, E. (1955) *The Philosophy of Symbolic Forms*. New Haven, CT [trans. of *Philosophie der symbolischen Formen*. Berlin (1923–9) by R. Mannheim and C. W. Handel].

Cassirer, E. (2000) *The Logic of the Cultural Sciences: Five Studies*. New Haven, CT [trans. of *Zur Logik der Kulturwissenschaften: Fünf Studien*. Darmstadt (1942) by S. G. Lofts].

Castriota, D. (1992) *Myth, Ethos, and Actuality: Official Art in Fifth-Century B.C. Athens*. Madison, WI.

Castriota, D. (2005) 'Feminizing the barbarian and barbarianizing the feminine: Amazons, Trojans and Persians in the Stoa Poikile', in *Periklean Athens and its Legacy: Problems and Perspectives*, ed. J. M. Barringer. Austin, TX: 89–102.

Cawkwell, G. L. (1997) *Thucydides and the Peloponnesian War*. London.

Childs, W. A. P. (1993) 'Herodotos, archaic chronology, and the temple of Apollo at Delphi', *JdI* 108: 399–441.

Clairmont, C. W. (1951) *Das Parisurteil in der antiken Kunst*. Zurich.

Clairmont, C. W. (1970) *Gravestone and Epigram: Greek Memorials from the Archaic and Classical Period*. Mainz.

Clairmont, C. W. (1993) *Classical Attic Tombstones: Introductory Volume*. Kilchberg.

Clark, T. J. (2006) *The Sight of Death: An Experiment in Art Writing*. New Haven, CT.

Clarke, J. R. (2007) *Looking at Laughter: Humor, Power, and Transgression in Roman Visual Culture, 100 B.C. – A.D. 250*. Berkeley, CA.

Coarelli, F. (1995) *Da Pergamo a Roma: I Galati nella citta degli Attalidi*. Rome.

Couëlle, C. (1998) 'Dire en toutes lettres? Allusions et sous-entendus chez le Peintre de Meidias', *Metis* 13: 135–58.

Coulton, J. J. (1976) *The Architectural Development of the Greek Stoa*. Oxford.

Cozzoli, A.-T. (2009) 'Il "Meleagro" di Euripide', in *La tragedia greca: Testimonianze archeologiche e iconografiche*, eds A. Martina and A.-T. Cozzoli. Atti del convegno, Roma, 14–16 ottobre 2004. Rome: 151–81.

Crowther, P. (2002) *The Transhistorical Image: Philosophizing Art and its History*. Cambridge.

Culler, J. (1976) *Saussure*. Glasgow.

Culler, J. (1982) *On Deconstruction: Theory and Criticism after Structuralism*. Ithaca, NY.

D'Ambra, E. (1988) 'A myth for a smith: A Meleager sarcophagus from a tomb in Ostia', *AJA* 92: 85–99.

Damisch, H. (1996) *The Judgement of Paris.* Chicago, IL [trans. of *Le jugement de Pâris: Iconographie analytique* 1. Paris (1992) by J. Goodman].

Damisch, H. (2005) 'Eight theses for (or against?) a semiology of painting', *Oxford Art Journal* 28: 257–67.

Danto, A. H. (1986) *The Philosophical Disenfranchisement of Art.* New York, NY.

Danto, A. H. (1998) *After the End of Art: Contemporary Art and the Pale of History.* Princeton, NJ.

Davies, M. (1988a) 'The judgement of Paris and Iliad Book XXIV', *JHS* 101: 56–62.

Davies, M. (1988b) *Epicorum Graecorum Fragmenta.* Göttingen.

Davies, M. (1991) *Poetarum Melicorum Graecorum Fragmenta I: Alcman Stesichorus Ibycus.* Oxford.

Davies, M. (2003) 'The judgement of Paris and Salomon', *CQ* 53.1: 32–4.

Davis, W. (2011) *A General Theory of Visual Culture.* Princeton, NJ.

Day, J. W. (2010) *Archaic Greek Epigram and Dedication: Representation and Performance.* Cambridge.

De Jong, I. (2004a) 'Introduction', in *Narrators, Narratees, and Narratives in Ancient Greek Literature: Studies in Ancient Greek Narrative I*, eds eadem, R. Nünlist, and A. Bowie. Leiden: 1–10.

De Jong, I. (2004b) 'Homer', in *Narrators, Narratees, and Narratives in Ancient Greek Literature: Studies in Ancient Greek Narrative I*, eds eadem, R. Nünlist, and A. Bowie. Leiden: 13–24.

De Jong, I. (2009) 'Metalepsis in ancient Greek literature', in *Narratology and Interpretation: The Content of Narrative Form in Ancient Literature*, eds J. Grethlein and A. Rengakos. Berlin: 87–116.

Debray, R. (1991) *Course de médiologie générale.* Paris.

Debray, R. (1995) *Vie et mort de l'image: Une histoire du regard en Occident.* Paris.

Debray, R. (2000) *Transmitting Culture.* New York, NY.

Delivorrias, A. (1978) 'Das Original der sitzenden Aphrodite-Olympias', *AM* 93: 1–23.

Derrida, J. (1976) *Of Grammatology.* Baltimore, MD [trans. of *De la grammatologie.* Paris (1967) by G. C. Spivak].

Derrida, J. (1987) *The Truth in Painting.* Chicago, IL [trans. of *La vérité en peinture.* Paris (1978) by G. Bennington and I. MacLeod].

Despinis, G. (1974) 'Τα γλυπτά των αετωμάτων του ναού της Αθηνάς Νίκης', *ArchDelt* 29.1: 2–24.

DeVries, K. (2000) 'The nearly other: The Attic vision of Phrygians and Lydians', in *Not the Classical Ideal: Athens and the Construction of the Other in Greek Art*, ed. B. Cohen. Leiden: 338–63.

Didi-Huberman, G. (1992) *Ce que nous voyons, ce qui nous regarde.* Paris.

Didi-Huberman, G. (2002) *L'image survivante: Histoire de l'art et temps des fantômes selon Aby Warburg.* Paris.

Didi-Huberman, G. (2005) *Confronting Images: Questioning the Ends of a Certain History of Art.* Philadelphia, PA [trans. of *Devant l'image: Question posée aux fins d'une histoire de l'art.* Paris (1990) by J. Goodman].

Diehl, E. (1964) *Die Hydria: Formgeschichte und Verwendung im Kult des Altertums.* Mainz.

Dietrich, N. (2010) *Figur ohne Raum? Bäume und Felsen in der attischen Vasenmalerei des 6. und 5. Jahrhunderts v.Chr.* Berlin.

Díez de Velasco, F. (1992) 'Anotaciones a la iconografía y el símbolismo del laberinto en el mundo griego: El espacio de la iniciación', in *Coloquio sobre Teseo y la copa de Aisón*, ed. R. Olmos. Madrid, 29–30 octubre 1990. Madrid: 175–200.

Dikovitskaya, M. (2005) *The Study of the Visual after the Cultural Turn.* Cambridge, MA.

Dimas, S. (1998) *Untersuchungen zur Themenwahl und Bildgestaltung auf römischen Kindersarkophagen.* Münster.

Dittenberger, W. (1905) *Orientis Graeci Inscriptiones Selectae* 2. Leipzig.

Dodson-Robinson, E. (2010) 'Helen's "Judgment of Paris" and Greek marriage ritual in Sappho', *Arethusa* 43.1: 1–20.

Dostal, R. J. (ed.) (2002) *The Cambridge Companion to Gadamer.* Cambridge.

Dreyfus, R. and Schraudolph, E. (eds) (1996–7) *Pergamon: The Telephos Frieze from the Great Altar* 1–2. San Francisco, CA.

Ducati, P. (1909) 'I vasi dipinti nello stile del ceramista Midia', *Memorie della Accademia Lincei*, ser. V 14.

Duhn, F. von (1887) 'La necropoli di *Suessula*', *RM* 2: 235–75.

Dyson, S. (1998) *Ancient Marbles to American Shores: Classical Archaeology in the United States.* Philadelphia, PA.

Ebert, J. (1978) 'Das Parisurteil in der Hypothesis zum Dionysalexandros des Kratinos', *Philologus* 122: 177–82.

Eco, U. (1968) *La struttura assente.* Milan.

Eco, U. (1989) *The Open Work.* Boston, MA [trans. of *Opera aperta*. Rome (1962) by A. Cancogni].

Edwards, C. M. (1996) 'Lysippos', in *Personal Styles in Greek Sculpture*, ed. O. Palagia. Cambridge: 130–53.

Ehling, K. (2000) 'Zum Gigantenschild mit dem zwölfstrahligen Stern am Ostfries des Pergamonaltars', *AA* 273–8.

Elderkin, G. W. (1910) 'Meander or labyrinths', *AJA* 14: 185–90.

Elkins, J. (1998) *On Pictures and the Words that Fail Them.* Cambridge.

Elkins, J. (2000) *Our Beautiful, Dry and Distant Texts: Art History as Writing.* London.

Elkins, J. (2002) *Stories of Art.* London.

Elkins, J. (2003) *Visual Studies: A Sceptical Introduction.* New York, NY.

Elsner, J. (1991) 'Cult and sculpture: sacrifice in the Ara Pacis Augustae', *JRS* 81: 50–61.

Elsner, J. (1995) *Art and the Roman Viewer.* Cambridge.

Elsner, J. (2000) 'Frontality in the Column of Marcus Aurelius', in *Autour de la colonne aurélienne: Geste et image sur la colonne de Marc Aurèle à Rome*, eds J. Scheid and V. Huet. Turnhout: 251–64.

Elsner, J. (2004) 'Foreword', in *The Language of Images in Roman Art*, by T. Hölscher. Cambridge: xv–xxxi.

Elsner, J. (2006) 'From empirical evidence to the Big Picture: Some reflections on Riegl's concept of *Kunstwollen*', *Critical Inquiry* 32: 741–66.

Elsner, J. (2007a) 'Viewing the gods: The origins of the icon in the visual culture of the Roman East', in *Roman Eyes: Visuality and Subjectivity in Art and Text*, ed. idem. Princeton, NJ: 225–52 [revised version of 'The origins of the icon: Pilgrimage, religion, and visual culture in the Roman East as resistance to the centre', in *The Roman Empire in the East*, ed. S. E. Alcock. Oxford (1997) 178–99].

Elsner, J. (2007b) 'Archéologie classique et histoire de l'art en Grande-Bretagne', *Perspective. La revue de l'Institut national d'histoire de l'art* 2: 231–42.

Elsner, J. and Lorenz, K. (2012) 'The genesis of iconology', *Critical Inquiry* 38.3: 483–512.

Engels, J. (1998) *Funerum sepulcrorumque magnificentia: Begräbnis- und Grabluxusgesetze in der griechisch-römischen Welt mit einigen Ausblicken auf Einschränkungen des funeralen und sepulkralen Luxus im Mittelalter und in der Neuzeit*. Stuttgart.

Engemann, J. (1997) *Deutung und Bedeutung frühchristlicher Bildwerke*. Darmstadt.

Engemann, J. (2007) 'Aktuelle Fragen zu Methoden der Bildinterpretation', *JAC* 50: 199–215.

Erskine, A. W. (2001) 'Trojans in Athenian society: Public rhetoric and private life', in *Gab es das griechische Wunder? Griechenland zwischen dem Ende des 6. und der Mitte des 5. Jahrhunderts v. Chr.*, eds D. Papenfuss and V. M. Strocka. Mainz: 113–25.

Esteve-Forriol, J. (1962) *Die Trauer- und Trostgedichte in der römischen Literatur untersucht nach ihrer Topik und ihrem Motivschatz*. Munich.

Ewald, B. C. and Norena, C. F. (eds) (2010) *The Emperor and Rome: Space, Representation, and Ritual*. Cambridge.

Faust, S. (2012) *Schlachtbilder der römischen Kaiserzeit: Erzählerische Darstellungskonzepte in der Reliefkunst von Traian bis Septimius Severus*. Tübingen.

Favro, D. (1996) *The Urban Image of Augustan Rome*. Cambridge.

Fehr, B. (1990) 'Review of: Tonio Hölscher, *Bildsprache als semantisches System* (Heidelberg, 1987)', *Gnomon* 62: 722–9.

Fehr, B. (1997) 'Society, consanguinity and the fertility of women: The community of deities on the great frieze of the Pergamum altar as a paradigm of cross-cultural ideas', in *Conventional Values of the Hellenistic Greeks*, ed. P. Bilde. Aarhus: 48–66.

Fendt, A. (2011) 'Die Erstpräsentation der pergamenischen Funde im Alten Museum', in *Pergamon: Panorama der antiken Metropole*. Exhibition catalogue Berlin 2011/12, eds R. Grüssinger, V. Kästner, and A. Scholl. Petersberg: 378–80.

Ferrari, G. (2002) *Figures of Speech: Men and Maidens in Ancient Greece*. Chicago, IL.

Ferrari, G. (2003) 'Myth and genre on Athenian vases', *ClAnt* 22: 37–54.

Ferrari, G. R. F. and Griffiths, T. (2000) *Plato: The Republic*. Cambridge.

Ferretti, S. (1989) *Cassirer, Panofsky and Warburg: Symbol, Art, and History*. New Haven, CT.

Fittschen, K. (1975) *Meleager Sarkophag*. Frankfurt am Main.

Fittschen, K. (1992) 'Der Tod der Kreusa und der Niobiden: Überlegungen zur Deutung griechischer Mythen auf römischen Sarkophagen', *StIt* 10: 1046–59.

Fittschen, K. (1999) *Prinzenbildnisse antoninischer Zeit*. Mainz.

Fittschen, K. and Zanker, P. (1985) *Katalog der römischen Portraits in den Capitolinischen Museen und den anderen kommunalen Sammlungen der Stadt Rom I*. Mainz.

Flashar, H. and Andreae, B. (1977) 'Strukturäquivalenzen zwischen den homerischen Epen und der frühgriechischen Vasenkunst', *Poetica* 9: 217–65.

Foucault, M. (1970) *The Order of Things: An Archaeology of the Human Sciences*. London [trans. of *Les mots et les choses: Une archéologie des sciences humaines*. Paris (1966)].

Fränkel, M. (1890) *Die Inschriften von Pergamon 1: Bis zum Ende der Königszeit*. Altertümer von Pergamon VIII.1. Berlin.

Fredrick, D. (1995) 'Beyond the atrium to Ariadne: Erotic painting and visual pleasure in the Roman house', *ClAnt* 14: 266–87.

Friedberg, A. (2006) *The Virtual Window: From Alberti to Microsoft*. Cambridge, MA.

Friedman, M. (2000) *A Parting of the Ways: Carnap, Cassirer, and Heidegger*. Chicago, IL.

Fuchs, M. (1987) *Untersuchungen zur Ausstattung römischer Theater*. Mainz.

Furtwängler, A. and Reichhold, K. (1904) *Griechische Vasenmalerei I*. Munich.

Fuss, D. (1992) 'The homospectatorial gaze', *Critical Inquiry* 18.4: 713–37.

Gadaleta, G. (2002) *La tomba delle Danzatrici di Ruvo di Puglia*. Naples.

Gadamer, H.-G. (2004) *Truth and Method*. London [trans. of *Wahrheit und Methode*. Tübingen (1960) by W. Glen-Doepl, J. Weinsheimer, and D. G. Marshall].

Gaehtgens, T. W. (1996) 'The Museum Island in Berlin', in *The Formation of National Collections of Art and Archaeology*, ed. G. Wright. Washington, DC: 53–77.

Gaifman, M. (2009) 'The Libation of Oinomaos', in *Antike Mythen, Medien, Transformationen, Konstruktionen*, eds U. Dill and C. Walde. Berlin: 576–98.

Gallina, A. (1993) 'Il sarcofago di Pianabella', *Archeologia Laziale* 11: 149–54.

Gantz, T. (1993) *Early Greek Myth: A Guide to Literary and Artistic Sources*. Baltimore, MD.

Garland, R. (1992) *Introducing New Gods: The Politics of Athenian Religion*. London.

Gattinoni, F. L. (1997) *Duride di Samo*. Rome.

Gazda, E. (ed.) (2002) *The Ancient Art of Emulation: Studies in Artistic Originality and Tradition from the Present to Classical Antiquity. Memoirs of the American Academy in Rome, Supplementary* 1. Ann Arbor, MI.

Genette, G. (1980) *Narrative Discourse*. New York, NY.

George, M. (2000) 'Family and *familia* on Roman biographical sarcophagi', *RM* 107: 191–207.

Gerhard, E. (1839) 'Über die Vase des Midias', *Abhandlungen der Königlichen Akademie der Wissenschaften zu Berlin*.

Gerhard, E. (1845) *Apulische Vasenbilder des königlichen Museums zu Berlin*. Berlin.

Gessert, G. (2004) 'Myth as consolatio: Medea on Roman sarcophagi', *GaR* 51: 217–49.

Geyer, A. (1978) 'Ikonographische Bemerkungen zum Neapler Brüdersarkophag', *JdI* 93: 369–93.

Ghali-Kahil, L. B. (1955) *Les enlèvements et le retour d'Hélène dans les textes et les documents figurés*. Paris.

Giannoulis, M. (2010) *Die Moiren: Tradition und Wandel des Motivs der Schicksalsgöttinnen in der antiken und byzantinischen Kunst*. Münster.

Giraud, D. (1994) *Μελέτη αποκαταστάσεως του ναου της Αθηνας Νικης*. Athens.

Giuliani, L. (1989) 'Achill-Sarkophage in Ost und West: Genese einer Ikonographie', *JBerlMus* 31: 25–39.

Giuliani, L. (1996a) 'Laokoon in der Höhle des Polyphem: Zur einfachen Form des Erzählens in Bild und Text', *Poetica* 28: 1–47.

Giuliani, L. (1996b) 'Rhesus between dream and death: On the relation of image to literature in Apulian vase-painting', *BICS* 41: 71–86.

Giuliani, L. (2000) 'Die Giganten als Gegenbilder der attischen Bürger im 6. und 5. Jahrhundert v. Chr.', in *Gegenwelten zu den Kulturen Griechenlands und Roms in der Antike*, ed. T. Hölscher. Munich and Leipzig: 263–86.

Giuliani, L. (2002) 'Bilder für Hörer und Bilder für Leser', in *Die griechische Klassik: Idee oder Wirklichkeit*, Exhibition. Berlin: 338–43.

Giuliani, L. (2013) *Image and Myth: A History of Pictorial Narration in Greek Art*. Chicago, IL [trans. of *Bild und Mythos*. Munich (2003) by J. O'Donnell].

Goffman, E. (1974) *Frame Analysis: An Essay in the Organization of Experience*. Boston, MA.

Gogos, S. and Kampourakis, G. (2008) *Das Dionysostheater von Athen: Architektonische Gestalt und Funktion. Mit einem Beitrag zur Akustik des Theaters*. Vienna.

Goldhill, S. (2001) 'The erotic eye: Visual stimulation and cultural conflict', in *Being Greek under Rome: Cultural Identity, the Second Sophistic, and the Development of Empire*, ed. idem. Cambridge: 154–95.

Gombrich, E. H. (1960) *Art and Illusion: A Study in the Psychology of Pictorial Representation*. London.

Gombrich, E. H. (1970) *Aby Warburg: An Intellectual Biography*. London.

Goodman, N. (1976) *Languages of Art: An Approach to a Theory of Symbols*. Indianapolis, IN.

Graef, B. and Langlotz, E. (1925) *Die antiken Vasen von der Akropolis zu Athen*. Berlin.

Grassinger, D. (1991) *Römische Marmorkratere*. Mainz.

Grassinger, D. (1994) 'The meanings of myth on Roman sarcophagi', in *Myth and Allusion: Meanings and Uses of Myth in Ancient Greek and Roman Society*. Boston, MA: 91–107.

Grassinger, D. (1999) *Die mythologischen Sarkophage: Achill, Adonis, Aeneas, Aktaion, Alkestis, Amazonen. Die antiken Sarkophagreliefs XII 1*. Mainz.

Greifenhagen, A. (1966) 'Der Tod des Pentheus: Eine rotfigurige Hydria', *Berliner Museen* 16: 2–6.

Griebel, J. (2013) *Der Kaiser im Krieg: Die Bilder der Säule des Marc Aurel*. Berlin.

Grondin, J. (2002) 'Gadamer's basic understanding of understanding', in *The Cambridge Companion to Gadamer*, ed. R. J. Dostal. Cambridge: 36–51.

Gruen, E. S. (2000) 'Culture as policy: The Attalids of Pergamon', in *From Pergamon to Sperlonga: Sculpture and Context*, eds N. Grummond and B. S. Ridgway. Berkeley, CA: 17–31.

Gubser, M. (2006) *Time's Visible Surface: Alois Riegl and the Discourse on History and Temporality in Fin-de-Siècle Vienna*. Detroit, MI.

Gurlitt, L. (1914–16) 'Die Allia Inschrift', *Philologus* 73: 289–301.

Guyer, P. (ed.) (2010) *The Cambridge Companion to Kant's Critique of Pure Reason*. Cambridge.

Habermas, J. (1997) *Ernst Cassirer und die Bibliothek Warburg*. Berlin.

Habicht, C. (1956) 'Über die Kriege zwischen Pergamon und Bithynien', *Hermes* 84: 90–110.

Hadzisteliou-Price, T. (1971) 'Double and multiple representations in Greek art and religious thought', *JHS* 91: 48–69.

Hafner, G. (1990) 'Cessavit deinde ars', *RdA* 14: 29–34.

Hahland, W. (1930) *Vasen um Meidias*. Berlin.

Hall, E. (1989) *Inventing the Barbarian: Greek Self-Definition through Tragedy*. Oxford.

Hallett, J. and Skinner, M. (eds) (1998) *Roman Sexualities*. Princeton, NJ.

Hamberg, P. G. (1945) *Studies in Roman Imperial Art*. Copenhagen.

Hamdorf, F. W. (1986) *Dionysos, Bacchus, Kult und Wandlungen des Weingottes*. Munich.

Hampe, R. (1954) 'Das Parisurteil auf dem Elfenbeinkamm aus Sparta', in *Neue Beiträge zur Klassischen Altertumswissenschaft*. Festschrift B. Schweitzer, ed. R. Lullies. Stuttgart: 77–86.

Hannestad, N. (1988) *Roman Art and Imperial Policy*. Aarhus.

Hansen, E. V. (1937) 'The great victory monument of Attalus I', *AJA* 41.1: 52–5.

Hansen, E. V. (1971) *The Attalids of Pergamon*. Ithaca, NY.

Harbison, C. (1989) 'Religious imagination and art-historical method: A reply to Barbara Lane's "Sacred versus Profane"', *Simiolus* 19: 198–205.

Hardwick, L. (1996) 'Ancient amazons: Heroes, outsiders or women?', in *Women in Antiquity*, eds I. McAuslan and P. Walcot. Oxford: 158–76.

Harris, W. V. (1989) *Ancient Literacy*. Cambridge, MA.

Harrison, E. B. (1966) 'The composition of the amazonomachy on the shield of Athena Parthenos', *Hesperia* 35.2: 107–33.

Harrison, E. B. (1981) 'Motifs of the city-siege on the shield of Athena Parthenos', *AJA* 85.3: 281–317.

Harrison, E. B. (1997) 'The glories of the Athenians: Observations on the program of the frieze of the temple of Athena Nike', in *The Interpretation of Architectural Sculpture in Greece and Rome*, ed. D. Buitron-Oliver. Washington, DC: 108–25.

Harrison, J. E. (1886) 'The Judgement of Paris: Two unpublished vases in the Graeco-Etruscan museum at Florence', *JHS* 7: 196–219.

Hart, J. (1993) 'Erwin Panofsky and Karl Mannheim: A dialogue on interpretation', *Critical Inquiry* 19: 534–66.

Hasenmueller, C. (1978) 'Panofsky, iconography and semiotics', *Journal of Aesthetics and Art Criticism* 36: 289–301.

Hatt, M. and Klonk, C. (2006) *Art History: A Critical Introduction to its Methods.* Manchester.

Heath, M. (2004) *Menander: A Rhetor in Context.* Oxford.

Hedreen, G. (1994) 'Silens, nymphs, and maenads', *JHS* 114: 47–69.

Hedreen, G. (1996) 'Image, text and story in the recovery of Helen', *ClAnt* 15: 152–84.

Hedreen, G. (2007) 'Involved spectatorship in Archaic Greek art', *ArtH* 30: 217–46.

Heidegger, M. (1962) *Kant and the Problem of Metaphysics.* Bloomington, IN [trans. of *Kant und das Problem der Metaphysik.* Frankfurt am Main (1929) by R. Taft].

Held, J. and Schneider, N. (2007) *Grundzüge der Kunstwissenschaft: Gegenstandsbereiche – Institutionen – Problemfelder.* Cologne.

Heres, H. (1997) 'Der Telephosmythos in Pergamon', in *Der Pergamonaltar*, ed. W.-D. Heilmeyer. Berlin: 99–120.

Heres, H. and Kästner, V. (2004) *Der Pergamonaltar.* Berlin.

Hesberg-Tonn, B. (1983) *Coniunx Carissima.* Cologne.

Himmelmann, N. (1980) *Über Hirten-Genre in der antiken Kunst.* Opladen.

Hinks, R. P. (1939) *Myth and Allegory in Ancient Art.* Studies of the Warburg Institute 6. London.

Hirschkop, K. and Sheperd, D. (eds) (1989) *Bakhtin and Cultural Theory.* Manchester.

Hjelmslev, L. (1953) *Prolegomena to a Theory of Language.* Baltimore, MD.

Hoepfner, W. (1989) 'Zu den grossen Altären von Magnesia und Pergamon', *AA*: 601–34.

Hoepfner, W. (1993) 'Siegestempel und Siegesaltäre: Der Pergamonaltar als Siegesmonument', in *Die griechische Polis: Architektur und Politik*, eds idem and G. Zimmer. Tübingen: 111–25.

Hoepfner, W. (2002) 'Die Bibliothek Eumenes' II: In Pergamon', in *Antike Bibliotheken*, ed. idem. Mainz: 120–36.

Hoffmann, H. (1979) 'In the wake of Beazley: Prolegomena to an anthropological study of Greek vase-painting', *Hephaistos* 1: 61–70.

Hofmann, W., Syamken, G., and Warnke, M. (eds) (1980) *Die Menschenrechte des Auges: Über Aby Warburg.* Frankfurt am Main.

Holly, M. A. (1984) *Panofsky and the Foundations of Art History.* Ithaca, NY.

Holly, M. A. (1993) 'Unwriting iconology', in *Iconography at the Crossroads*, ed. B. Cassidy. Princeton, NJ: 17–25.

Holquist, M. (1990) *Dialogism: Bakhtin and His World.* London.

Hölscher, T. (1967) *Victoria Romana: Archäologische Untersuchungen zur Geschichte und Wesensart der römischen Siegesgöttin von den Anfängen bis zum Ende des 3. Jhs. n. Chr.* Mainz.

Hölscher, T. (1980) 'Römische Siegesdenkmäler der späten Republik', in *Tainia: Roland Hampe zum 70. Geburtstag*, ed. H. A. Cain. Mainz: 351–71.

Hölscher, T. (1985) 'Die Geschlagenen und Ausgelieferten in der Kunst des Hellenismus', *AntK* 28: 120–36.

Hölscher, T. (2000a) 'Feindwelten – Glückswelten: Perser, Kentauren und Amazonen', in *Gegenwelten zu den Kulturen Griechenlands und Roms in der Antike*, ed. idem. Leipzig: 287–304.

Hölscher, T. (2000b) 'Bildwerke, Darstellungen, Funktionen, Botschaften', in *Klassische Archäologie: Eine Einführung*, eds A. H. Borbein, idem, and P. Zanker. Berlin: 147–65.

Hölscher, T. (2000c) 'Die Säule des Marcus Aurelius: Narrative Struktur und ideologische Botschaft', *Autour de la colonne aurélienne: Geste et image sur la colonne de Marc Aurèle à Rome*, eds J. Scheid and V. Huet. Turnhout: 89–106.

Hölscher, T. (2004) *The Language of Images in Roman Art*. Cambridge [trans. of *Römische Bildsprache als semantisches System*. Heidelberg (1987) by A. Snodgrass and A. Künzl-Snodgrass].

Hölscher, T. (2007) 'Fromme Frauen um Augustus: Konvergenzen zwischen Bilderwelt und Lebenswelt', in *Römische Bilderwelten: Von der Wirklichkeit zum Bild und zurück*, eds F. Hölscher and T. Hölscher. Heidelberg: 111–31.

Holtzmann, B. (2003) *L'Acropole d'Athènes: Monuments, cultes et histoire de l'art*. Paris.

Hornblower, S. (2002) *The Greek World: 479–323 BC*. London.

Horsfall, N. (1979) 'Stesichorus at Bovillae?', *JHS* 99: 26–48.

Howe, T. P. (1954) 'The origin and function of the Gorgo head', *AJA* 58: 134–49.

Hurwit, J. M. (2004) *The Acropolis in the Age of Pericles*. Cambridge.

Huskinson, J. (1996) *Roman Children's Sarcophagi: Their Decoration and its Social Significance*. Oxford.

Huskinson, J. (2011) 'Habent sua fata: Writing life histories on Roman sarcophagi', in *Life, Death and Representation: Some New Work on Roman Sarcophagi*, eds J. Elsner and J. Huskinson. Cambridge: 55–82.

Imdahl, M. (1980) *Giotto. Arenafresken. Ikonographie – Ikonologie – Ikonik*. Munich.

Imdahl, M. (1982) 'Zu Picassos "Guernica": Inkohärenz und Kohärenz in moderner Bildlichkeit', in *Lyrik und Malerei der Avantgarde*, eds R. Warning and W. Wehle. Munich: 521–65.

Imdahl, M. (1994) 'Ikonik: Bilder und ihre Anschauung', in *Was ist ein Bild?*, ed. G. Boehm. Munich: 300–24.

Immerwahr, H. (1990) *Attic Script: A Survey*. Oxford.

Innis, R. E. (ed.) (1985) *Semiotics: An Introductory Anthology*. Bloomington, IN.

Isager, J. (1991) *Pliny on Art and Society: The Elder Pliny's Chapters on the History of Art*. Odense.

Iser, W. (1978) *The Implied Reader: Patterns of Communication in Prose Fiction from Bunyan to Beckett*. Baltimore, MD.

Isler-Kerényi, C. (1985) 'La felicità e lo strazio: Un cratere a calice non attico di età classica', *Numismatica e antichità classiche: quaderni ticinesi* 14: 97–125.

Isler-Kerényi, C. (2007) *Dionysos in Archaic Greece: An Understanding through Images.* Leiden and Boston, MA.

Ivanchik, A. I. (2005) 'Who were the Scythian archers on archaic Attic vases?', in *Scythians and Greeks: Cultural Interactions in Scythia, Athens and the Early Roman Empire, Sixth Century B.C. – First Century A.D.*, ed. D. Braund. Exeter: 100–13.

Iversen, M. (1988) 'Saussure v. Peirce: Models for a semiotics of visual art', in *The New Art History*, eds A. L. Rees and F. Borzello. Atlantic Highlands, NJ: 82–94.

Iversen, M. (1993) *Alois Riegl: Art History and Theory.* Cambridge, MA.

Iversen, M. and Melville, S. (2010) *Writing Art History: Disciplinary Departures.* Chicago, IL.

Jay, M. (1993) *Downcast Eyes: The Denigration of Vision in Twentieth-Century French Thought.* Berkeley, CA.

Joyce, L. B. (1998) *Maenads and Bacchantes: Images of Female Ecstasy in Greek and Roman Art.* Ann Arbor, MI.

Jung, H. (1984) 'Zur Vorgeschichte des spätantoninischen Stilwandels', *MarbWPr*: 59–103.

Junker, K. (2003) 'Meerwesen in Pergamon: Zur Deutung des Grossen Frieses', *IstMitt* 53: 425–43.

Junker, K. (2006) 'Römische mythologische Sarkophage: Zur Entstehung eines Denkmaltyps', *RM* 112: 163–88.

Junker, K. (2012) *Interpreting the Images of Greek Myths.* Cambridge [trans. of *Griechische Mythenbilder: Eine Einführung in ihre Interpretation.* Stuttgart (2005) by A. Snodgrass and A. Künzl-Snodgrass].

Juwig, C. and Kost, C. (2010) 'Bilder in der Archäologie, eine Archäologie der Bilder? Einleitende Bemerkungen', in *Bilder in der Archäologie, eine Archäologie der Bilder*, eds C. Juwig and C. Kost. Münster: 13–32.

Kagan, D. (1969) *The Outbreak of the Peloponnesian War.* Ithaca, NY.

Kagan, D. (1974) *The Archidamian War.* Ithaca, NY.

Kagan, D. (1981) *The Peace of Nicias and the Sicilian Expedition.* Ithaca, NY.

Kagan, D. (1987) *The Fall of the Athenian Empire.* Ithaca, NY.

Kähler, H. (1948) *Der grosse Fries von Pergamon.* Berlin.

Kalkanis, E. (2013) 'The "Meidias" hydria: A visual and textual journey of a Greek vase in the history of art of antiquity (c. 1770s–1840s)', *Journal of Art Historiography* 9: 1–36.

Kampen, N. B. (1981) 'Biographical narration and Roman funerary art', *AJA* 85: 47–58.

Kampen, N. B. (2003) 'On writing histories of Roman art', *ArtB* 77: 371–86.

Kaschnitz-von Weinberg, G. (1944) 'Vergleichende Studien zur italisch-römischen Struktur', *RM* 59: 89–128.

Kästner, U. (2011) '"Ein Werk, so groß und herrlich … war der Welt wiederge-schenkt!": Geschichte der Ausgrabungen in Pergamon bis 1900', in *Pergamon:*

Panorama der antiken Metropole. Exhibition catalogue Berlin 2011/12, eds R. Grüssinger, V. Kästner, and A. Scholl. Petersberg: 36–44.

Kästner, V. (1994) 'Gigantennamen', *IstMitt* 44: 125–34.

Kästner, V. (1997) 'Die Architektur des Pergamonaltars und der Telephosfries', in *Der Pergamonaltar*, ed. W.-D. Heilmeyer. Berlin: 56–66.

Kästner, V. (2003) 'Neues vom Gigantenfries: Ergebnisse des Restaurierungsprojektes der Antikensammlung', *JPKB* 40: 163–81.

Kästner, V. (2004) 'Klassisches Vorbild und hellenistische Form: Die Rekonstruktion des Athena-Nikephoros Propylons auf der Pergamenischen Burg', in *Macht der Architektur: Architektur der Macht*, eds W. Schwandner and K. Rheidt. Berlin: 132–43.

Kästner, V. (2011a) 'Die Altarterrasse', in *Pergamon: Panorama der antiken Metropole.* Exhibition catalogue Berlin 2011/12, eds R. Grüssinger, V. Kästner, and A. Scholl. Petersberg: 198–211.

Kästner, V. (2011b) 'Schrankenrelief: Gigantomachie', in *Pergamon: Panorama der antiken Metropole.* Exhibition catalogue Berlin 2011/12, eds R. Grüssinger, V. Kästner, and A. Scholl. Petersberg: 537–8, no. 6.24.

Kelperi, E. (2007) 'Die Götter auf dem Parthenonfries', in Μουσειον: *Beiträge zur antiken Plastik, Festschrift für Peter Cornelis Bol*, eds H. von Steuben et al. Möhnesee: 217.

Kemp, W. (1973) 'Walter Benjamin und die Kunstgeschichte, Teil 1: Benjamins Beziehung zur Wiener Schule', *Kritische Berichte* 1: 30–50.

Kemp, W. (1978) 'Fernbilder: Benjamin und die Kunstwissenschaft', in *Links hatte noch alles sich zu enträtseln: Walter Benjamin im Kontext*, ed. B. Lindner. Frankfurt am Main: 224–45.

Kemp, W. (1992) *Der Betrachter ist im Bild: Kunstwissenschaft und Rezeptionsästhetik.* Berlin.

Kemp, W. (1998) 'The work of art and its beholder: The methodology of the aesthetic of reception', in *The Subjects of Art History*, ed. M. Cheetham. New York, NY: 180–96.

Kennedy, G. A. (1963) *The Art of Persuasion in Greece.* Princeton, NJ.

Keuls, E. (1978) *Plato and Greek Painting.* Leiden.

Knell, H. (1990) *Mythos und Polis.* Darmstadt.

Koch, G. (1974) 'Zum Eberjagdsarkophag der Sammlung Ludwig', *AA*: 614–30.

Koch, G. (1975) *Die mythologischen Sarkophage: Meleager.* Antike Sarkophagreliefs XII 6. Mainz.

Koch, G. (1983) 'Der Achillsarkophag in Berlin', *JBerlMus* 25: 5–25.

Koch, G. and Sichtermann, H. (1982) *Römische Sarkophage: Handbuch der Archäologie.* Munich.

Kockel, V. (1993) *Porträtreliefs stadtrömischer Grabbauten.* Mainz.

Koester, H. (ed.) (1998) *Pergamon: Citadel of the Gods.* Philadelphia, PA.

Kohl, M. (2007) 'Architecture, sculpture, espace: Essai de caractérisation de l'aménagement du cadre urbain hellénistique. Mont Athos, Alexandrie,

Pergame', in *Images et modernité hellénistiques: Appropriation et représentation du monde d'Alexandre à César*, eds F.-H. Massa-Pairault and G. Sauron. Rome: 113–26.

Koortbojian, M. (1995) *Myth, Meaning and Memory on Roman Sarcophagi*. Berkeley, CA.

Kovacs, D. (1984) 'On the Alexandros of Euripides', *HSCP* 88: 47–70.

Krahmer, G. (1923/4) 'Stilphasen der hellenistischen Plastik', *RM* 38/39: 138–84.

Krahmer, G. (1925) 'Nachahmungen des 5. Jahrhunderts in Pergamenischen Statuen', *AM* 40: 67–106.

Kraiker, W. (1950) 'Das Kentaurenbild des Zeuxis', *BWPr* 106. Berlin.

Krois, J. M. (1998) 'Kunst und Wissenschaft in Edgar Winds Philosophie der Verkörperung', in *Edgar Wind: Kunsthistoriker und Philosoph*, eds H. Bredekamp and B. Buschendorf. Berlin: 181–205.

Kunze, C. (1998) *Der Farnesische Stier und die Dirkegruppe des Apollonios und Tauriskos*. Berlin.

Kunze, C. (2002) *Zum Greifen Nah: Stilphänomene in der hellenistischen Skulptur und ihre inhaltliche Interpretation*. Munich.

Kunze, M. (ed.) (1986) *'Wir haben eine ganze Kunstepoche gefunden': Ein Jahrhundert Forschungen zum Pergamonaltar*. Exhibition catalogue Berlin 1986/87. Berlin.

Kunze, M. (1996) 'Parthenon und Pergamonaltar: Das Bildprogramm am Pergamonaltar als Rückgriff auf den Parthenon?', *Thetis* 3: 71–80.

Kunze-Götte, E. et al. (1999) *Die Nekropole von der Mitte des 6. bis zum Ende des 5. Jahrhunderts. Kerameikos VII.2. Munich.*

Künzl, E. (1968) *Frühhellenistische Gruppen*. Cologne.

Kurke, L. (1992) 'The politics of abrosyne in Archaic Greece', *ClAnt* 11: 91–120.

Kurtz, D. C. (1975) *Athenian White Lekythos: Patterns and Painters*. Oxford.

Kurtz, D. C. (1983) *The Berlin Painter*. Oxford.

La Rocca, E. (1998) 'Die Zwölf Götter, Hera und die Verherrlichung der Attaliden am grossen Altar von Pergamon', *JBerlMus* 40: 7–30.

La Rocca, E. and Parisi Presicce, C. (eds) (2010) *Musei Capitolini: Le sculture del Palazzo Nuovo*. Rome.

Lacan, J. (1977) *Écrits: A Selection*. New York, NY and London [trans. by A. Sheridan].

Lacan, J. (1981) *The Four Fundamental Concepts of Psychoanalysis*. New York, NY [trans. of *Les quatre concepts fondamentaux de la psychanalyse*. Paris (1973) by A. Sheridan].

Landwehr, C. (1998) 'Konzeptfiguren: Ein neuer Zugang zur römischen Idealplastik', *JdI* 113: 139–94.

Langlotz, E. (1954) *Aphrodite in den Gärten*. Heidelberg.

Larmour, D., Miller, P. A., and Platter, C. (eds) (1997) *Rethinking Sexuality: Foucault and Classical Antiquity*. Princeton, NJ.

Lattimore, R. (1942) *Themes in Greek and Latin Epitaphs*. Urbana, IL.

Laube, I. (2006) *Thorakophoroi: Gestalt und Semantik des Brustpanzers in der Darstellung des 4.–1. Jhs. v. Chr.* Tübingen.

Lawton, C. L. (2009) 'Attic votive reliefs and the Peloponnesian War', in *Art in Athens during the Peloponnesian War*, ed. O. Palagia. Cambridge: 66–93.

Leipen, N. (1971) *Athena Parthenos: A Reconstruction*. Toronto.

Leland, L., Davies, G., and Llewellyn Jones, L. (eds) (2007) *Greek and Roman Dress from A to Z*. London.

Lemos, A. A. (2009) 'Iconographical divergencies in late Athenian black-figure: The Judgement of Paris', in *Athenian Potters and Painters II*, eds J. H. Oakley and O. Palagia. Oxford: 134–46.

Lévi-Strauss, C. (1963) *Structural Anthropology*. New York, NY [trans. of *Anthropologie structurale*. Paris (1958) by C. Jacobson and B. Grundfest Schopf].

LIMC (1981–99) *Lexicon Iconographicum Mythologiae Classicae*, 10 vols. Munich and Zurich.

Linfert, A. (1995) 'Prunkaltäre', in *Stadtbild und Bürgerbild im Hellenismus*, eds M. Wörrle and P. Zanker. Munich: 131–46.

Lissarrague, F. (1990a) *L'autre guerrier: Archers, peltastes, cavaliers dans l'imagerie attique*. Paris.

Lissarrague, F. (1990b) *The Aesthetics of the Greek Banquet: Images of Wine and Ritual*. Princeton, NJ [trans. of *Un flot d'images: Une esthétique du banquet grec*. Paris (1987) by A. Szegedy-Maszak].

Lissarrague, F. (1995) 'Women, boxes, containers: Some signs and metaphors', in *Pandora: Women in Classical Greece*, ed. E. Reeder. Princeton, NJ: 91–101.

Lissarrague, F. (2001) *Greek Vases: The Athenians and their Images*. New York, NY.

Lissarrague, F. (2009) 'Reading images, looking at pictures, and after', in *Hermeneutik der Bilder: Beiträge zur Ikonographie und Interpretation griechischer Vasenmalerei*, eds S. Schmidt and J. H. Oakley. Munich: 15–22.

Lissarrague, F. (2013) *La cité des satyres: Une anthropologie ludique (Athènes, VIe – Ve siècle avant J.-C.)*. Paris.

Loraux, N. (1981) *Les enfants d'Athéna*. Paris.

Loraux, N. (1989) *Les experiences de Tirésias: Le feminine et l'homme grec*. Paris.

Lorenz, K. (2006) 'Im Sog der Bilder: Bilddesign und Theaterdramaturgie im späten 5. Jahrhundert v. Chr.', in *Kulturen des Bildes*, eds B. Mersmann and M. Schulz. Berlin: 243–58.

Lorenz, K. (2007) 'The anatomy of metalepsis: Visuality turns around on late fifth-century pots', in *Debating the Athenian Cultural Revolution: Art, Literature, Philosophy and Politics 430–380 B.C.*, ed. R. Osborne. Cambridge: 116–43.

Lorenz, K. (2008) *Bilder machen Räume: Mythenbilder in pompeianischen Häusern*. Berlin.

Lorenz, K. (2010) '"Dialectics at a Standstill": Archaic kouroi-cum-epigram as I-box', in *Archaic and Classical Greek Epigram*, eds A. Petrovic, I. Petrovic, and M. Baumbach. Cambridge: 131–48.

Lorenz, K. (2011) 'Image in distress? The death of Meleager on Roman sarcophagi', in *Life, Death and Representation: Some New Work on Roman Sarcophagi*, eds J. Elsner and J. Huskinson. Cambridge: 305–32.

Lorenz, K. (2012) 'Otto Brendel 1901–1973: Fragmente und Frakturen', in *Lebensbilder I: Klassische Archäologen und der Nationalsozialismus*, eds G. Brands and M. Maischberger. Rahden: 193–206.

Lorenz, K. (2013a) 'Der Grosse Fries des Pergamon-Altars: Das Stilmittel Metalepse und die Analyse von Erzählung in der Flächenkunst', in *Über die Grenze: Metalepse in Text- und Bildmedien des Altertums*, eds U. Eisen and P. von Möllendorff. Berlin: 119–47.

Lorenz, K. (2013b) 'Neronian wall-painting: A matter of perspective', in *A Companion to the Neronian Age*, eds M. Dinter and E. Buckley. Malden, MA: 363–81.

Lorenz, K. (2014) 'The Casa del Menandro in Pompeii: Rhetoric and the topology of Roman wall-painting', in *Art and Rhetoric in Roman Culture*, eds J. Elsner and M. Meyer. Cambridge: 183–210.

Lorenz, K. and Bligh, B. (2013) 'Vorsprung durch Technik: Multi-display learning spaces and art-historical method', *CHart Yearbook*: www.chart.ac.uk/chart2010/papers/bligh-and-lorenz-paper.pdf [last access: 18 November 2013].

Lorenz, K. and Elsner, J. (2008) 'Erwin Panofsky's *On art theory and art history*. Translation and commentary', *Critical Inquiry* 34.4: 33–71.

Lovatt, H. (2013) *The Epic Gaze: Vision, Gender and Narrative in Ancient Epic*. Cambridge.

Lugauer, M. (1967) *Untersuchungen zur Symbolik des Apfels in der Antike*. Erlangen.

Luhmann, N. (1995) *Social Systems*. Stanford, CA [trans. of *Soziale Systeme*. Frankfurt am Main (1984) by E. M. Knodt].

Luhmann, N. (2000) *Art as a Social System*. Stanford, CA [trans. of *Die Kunst der Gesellschaft*. Frankfurt am Main (1997) by E. M. Knodt].

Maar, C. and Burda, H. (eds) (2004) *Iconic Turn: Die neue Macht der Bilder*. Munich.

Maar, C. and Burda, H. (eds) (2006) *Iconic Worlds: Neue Bilderwelten und Wissensräume*. Munich.

MacDowell, D. M. (1999) *Gorgias: Encomium of Helen*. Bristol.

Mack, R. (2002) 'Facing down Medusa (an aetiology of the gaze)', *ArtH* 25: 571–604.

Maderna, C. (2008) 'Der Pergamonaltar und der Mythos der Gigantomachie', in *Die Rückkehr der Götter: Berlins verborgener Olymp*, ed. D. Grassinger. Regensburg: 383–401.

Maderna-Lauter, C. (2000) 'Unordnung als Bedrohung: Der Kampf der Giganten gegen die Götter in der Bildkunst der hellenistischen und römischen Zeit', in *Gegenwelten zu den Kulturen Griechenlands und Roms in der Antike*, ed. T. Hölscher. Munich and Leipzig: 435–66.

Maischberger, M. (2001) 'L'archeologia classica tedesca dal 1945 ad oggi: Linee generali, personaggi, contesti istituzionali', www.bibar.unisi.it/sites/www.bibar.unisi.it/files/testi/testiqds/q49-50/05.pdf [last access: 18 November 2013].

Manakidou, F. (1993) *Beschreibungen von Kunstwerken in der hellenistischen Dichtung*. Munich.

Manderscheid, H. (1981) *Die Skulpturenausstattung der kaiserzeitlichen Thermenanlagen*. Mainz.

Mannheim, K. (1971) 'On the interpretation of Weltanschauung', in *From Karl Mannheim*, ed. K. H. Wolff. New York, NY: 136–86 [trans. of 'Beiträge zur Theorie der Weltanschauungsinterpretation', *Jahrbuch für Kunstgeschichte* 1.15 (1923) 236–74].

Marconi, C. (2007) *Temple Decoration and Cultural Identity in the Archaic Greek World: The Metopes of Selinus*. Cambridge.

Marin, L. (1980) 'Towards a theory of reading in the visual arts: Poussin's The Arcadian Shepherds', in *The Reader in the Text: Essays on Audience and Interpretation*, ed. S. Rubin Suleiman. Princeton, NJ: 293–324.

Marin, L. (1981) *Détruiere la peinture*. Paris.

Mark, I. S. (1993) *The Sanctuary of Athena Nike in Athens: Architectural Stages and Chronology*. Princeton, NJ.

Marszal, J. R. (2000) 'Ubiquitous barbarians: Representations of the Gauls at Pergamon and elsewhere', in *From Pergamon to Sperlonga: Sculpture and Context*, eds N. Grummond and B. S. Ridgway. Berkeley, CA: 191–234.

Martini, W. (2003) *Sachwörterbuch der Klassischen Archäologie*. Stuttgart.

Marvin, M. (2002) 'The Ludovisi barbarians: The grand manner', in *The Ancient Art of Emulation: Studies in Artistic Originality and Tradition from the Present to Classical Antiquity*, ed. E. K. Gazda. Ann Arbor, MI: 205–23.

Marvin, M. (2008) *The Language of the Muses: The Dialogue Between Greek and Roman Sculpture*. Los Angeles, CA.

Massa-Pairault, F.-H. (1981/2) 'Il problema degli stylopinakia del tempio di Apollonis a Cizico: Alcune considerazioni', *Annali della Facoltà di lettere e filosofia, Università degli studi di Perugia*, 1. Studi classici 19: 147–219.

Massa-Pairault, F.-H. (2000) 'Sur quelques motifs de la frise de la Gigantomachie: Définition et interprétation', in *Pergame, histoire et archéologie*, ed. M. Kohl. Lille: 23–37.

Massa-Pairault, F.-H. (2007a) *La Gigantomachie de Pergame ou l'image du monde*. Athens.

Massa-Pairault, F.-H. (2007b) 'L'interprétation des frises du Grand Autel de Pergame et des stylopinakia de Cyzique: Quelques problèmes', in *Images et modernité hellénistiques: Appropriation et représentation du monde d'Alexandre à César*, eds eadem and G. Sauron. Rome: 205–21.

Massa-Pairault, F.-H. (2010) *Pergamo e la filosofia*. Rome.

Matheson, S. B. (2005) 'A farewell with arms: Departing warriors on Athenian vases', in *Periklean Athens and its Legacy: Problems and Perspectives*, ed. J. M. Barringer. Austin, TX: 23–35.

Mathys, M. et al. (eds) (2011) *Das Gymnasion: Architektur, Nutzung und Bildwerke*. Petersberg.

Mayne, J. (1995) 'Paradoxes of spectatorship', in *Viewing Positions: Ways of Seeing Film*, ed. L. Williams. Newark, NJ: 155–83.

McLuhan, M. (1964) *Understanding Media: The Extensions of Man*. New York, NY.

Meinecke, K. (2012) 'Invisible sarcophagi: Coffin and viewer in the late imperial age', in *Patrons and Viewers in Late Antiquity*, eds S. Birk and B. Poulsen. Aarhus: 83–105.

Melina, D. (2002) *Breaking the Frame: Metalepsis and the Construction of the Subject.* Columbus, OH.

Meltzer, G. S. (1994) '"Where is glory of Troy?" Kleos in Euripides' Helen', *ClAnt* 13: 234–55.

Mertens, J. (2010) *How to Read Greek Vases.* New York, NY.

Meyer, K.-H. (1979) 'Semiotik, Kommunikationswissenschaft und Kunstgeschichte', *Hephaistos* 1: 42–60.

Meyer, M. (2009) 'Bilder aphrodisischen Wirkens', in *Aiakeion: Beiträge zur Klassischen Altertumswissenschaft zu Ehren von Florens Felten*, eds C. Reinholdt et al. Vienna: 85–97.

Meyer-Zwiffelhoffer, E. (1995) *Im Zeichen des Phallus: Die Ordnung des Geschlechtslebens im antiken Rom.* Frankfurt am Main.

Michels, C. (2003) *Der Pergamonaltar als Staatsmonument der Attaliden: Zur Rolle des historischen Kontextes in den Diskussionen über Datierung und Interpretation der Bildfriese.* Berlin.

Michels, K. (2007) *Aby Warburg: Im Bannkreis der Ideen.* Munich.

Mielsch, H. (1995) 'Die Bibliothek und die Kunstsammlung der Könige von Pergamon', *AA* 765–79.

Miller, M. C. (1989) 'The ependytes in Classical Athens', *Hesperia* 58: 313–29.

Miller, M. C. (1997) *Athens and Persia in the Fifth Century B.C.: A Study in Cultural Reception.* Cambridge.

Mirzoeff, N. (1999) *An Introduction to Visual Culture.* London.

Misak, C. (ed.) (2004) *The Cambridge Companion to Peirce.* Cambridge.

Mitchell, S. (2003) 'The Galatians: Representation and reality', in *A Companion to the Hellenistic World*, ed. A. Erskine. Oxford: 280–93.

Mitchell, W. J. T. (1984) 'The politics of genre: Space and time in Lessing's Laocoon', *Representations* 6: 98–115.

Mitchell, W. J. T. (1986) *Iconology.* Chicago, IL.

Mitchell, W. J. T. (1994) *Picture Theory: Essays on Verbal and Visual Representation.* Chicago, IL.

Mitchell, W. J. T. (2002) 'Showing seeing: A critique of visual culture', *Journal of Visual Culture* 1: 165–81.

Mitchell, W. J. T. (2005) *What Do Pictures Want? The Loves and Lives of Images.* Chicago, IL.

Mitchell, W. J. T. (2007) 'Pictorial Turn: Eine Antwort', in *Bilderfragen: Die Bildwissenschaften im Aufbruch*, ed. H. Belting. Munich: 37–48.

Mitchell-Boyask, R. (2008) *Plague and the Athenian Imagination: Drama, History, and the Cult of Asclepius.* Cambridge.

Mittelstrass, J. (1991) 'Einheit und Transdisziplinarität: Eine Einleitung', in *Forschungsbericht 4: Einheit der Wissenschaften*, Akademie der Wissenschaften zu Berlin. Berlin: 12–22.

Montanaro, A. C. (2007) *Ruvo di Puglia e il suo territorio: Le necropolis. I corredi funerari tra la documentazione del XIX secolo e gli scavi moderni*. Rome.

Moore, M. B. (1979) 'Lydos and the gigantomachy', *AJA* 83: 79–99.

Moore, M. B. (1995) 'The central group in the gigantomachy of the Old Athena Temple on the Acropolis', *AJA* 99: 633–9.

Moraw, S. (1998) *Die Mänade in der attischen Vasenmalerei des 6. und 5. Jahrhunderts v. Chr.* Mainz.

Morelli, G. (1893) *Italian Masters in German Galleries: A Critical Essay on the Italian Pictures in the Galleries of Munich, Dresden and Berlin*. London [trans. of *Die Werke italienischer Meister in den Galerien von München, Dresden und Berlin: Ein kritischer Versuch [von Ivan Lermolieff, aus dem Russischen übersetzt von Dr Johannes Schwarze]*. Leipzig (1880) by L. M. Richter].

Moreno, P. (1994) *Scultura ellenistica*. Rome.

Moreno, P. (1995) *Lisippo: L'arte e la fortuna*. Rome.

Morris, C. W. (1938) *Foundations of the Theory of Signs*. Chicago, IL.

Morris, D. et al. (eds) (1979) *Gestures: Their Origin and Distribution*. London.

Moss, J. (2007) 'What is imitative poetry and why is it bad?', in *The Cambridge Companion to Plato's Republic*, ed. G. R. F. Ferrari. Cambridge: 415–44.

Mossman, J. (1995) *Wild Justice: A Study of Euripides' Hecuba*. Oxford.

Moxey, K. (1993) 'The politics of iconology', in *Iconography at the Crossroads*, ed. B. Cassidy. Princeton, NJ: 27–31.

Mulvey, L. (1975) 'Visual pleasure and narrative cinema', *Screen* 16: 6–18.

Mulvey, L. (1989) *Visual and Other Pleasures*. London.

Muth, S. (1998) *Erleben von Raum: Leben im Raum*. Heidelberg.

Muth, S. (1999) 'Hylas oder "Der ergriffene Mann": Zur Eigenständigkeit der Mythenrezeption in der Bildkunst', in *Im Spiegel des Mythos: Bilderwelt und Lebenswelt / Lo specchio del mito: Immaginario e realtà*, eds F. de Angelis and Susanne Muth. Wiesbaden: 109–29.

Muth, S. (2004) 'Drei statt vier: Zur Deutung der Feldherrnsarkophage', *AA* 263–74.

Muth, S. (2008) *Gewalt im Bild: Das Phänomen der medialen Gewalt im Athen des 6. und 5. Jahrhunderts v. Chr.* Berlin.

Muth, S. and Petrovic, I. (2012) 'Medientheorie als Chance: Überlegungen zur historischen Interpretation von Texten und Bildern', in *Ansehenssache: Formen von Prestige in Kulturen des Altertums*, eds B. Christiansen and U. Thaler. Munich: 281–318.

Nancy, J.-L. (2005) *The Ground of the Image*. New York, NY [trans. *of Au fond des images*. Paris (2003) by J. Fort].

Napoli, M. (1970) *La tomba del tuffatore: La scoperta della grande pittura Greca*. Bari.

Neer, R. (1997) 'Beazley and the language of connoisseurship', *Hephaistos* 15: 7–30.

Neer, R. (2001) 'Framing the gift: The politics of the Siphnian treasury at Delphi', *ClAnt* 20: 273–336.

Neer, R. (2002) *Style and Politics in Athenian Vase-Painting: The Craft of Democracy 530–460 B.C.* Cambridge.

Neer, R. (2005) 'Connoisseurship and the stakes of style', *Critical Inquiry* 32: 1–26.

Neer, R. (2010) *The Emergence of the Classical Style*. Chicago, IL.

Nehamas, A. (1982) 'Plato on imitation and poetry in Republic 10', in *Plato on Beauty, Wisdom, and the Arts*, eds J. M. E. Moravcsik and P. Temko. Totowa, NJ: 47–78.

Neher, A. (2004) 'The concept of Kunstwollen, neo-Kantianism, and Erwin Panofsky's early art theoretical essays', *Word and Image* 20.1: 41–51.

Neils, J. (1983) 'A Greek nativity by the Meidias Painter', *BClevMus* 70.7: 274–89.

Neils, J. (2000) 'Others within the other: An intimate look at hetairai and Maenads', in *Not the Classical Ideal: Athens and the Construction of the Other in Greek Art*, ed. B. Cohen. Leiden: 203–26.

Neudecker, R. (1988) *Die Skulpturenausstattung römischer Villen in Italien*. Mainz.

Neudecker, R. (1998) 'The Roman villa as a locus for art collections', in *The Roman Villa: Villa Urbana*, ed. A. Frazer. Philadelphia, PA: 77–91.

Neumer-Pfau, W. (1983) 'Die kämpfenden Göttinnen vom grossen Fries des Pergamonaltars', in *Representations of Gods*, ed. H. Kippenberg. Leiden: 75–90.

Nevett, L. (1999) *House and Society in the Ancient Greek World*. Cambridge.

Nevett, L. (2010) *Domestic Space in Classical Antiquity*. Cambridge.

Newby, Z. (2007) 'Art at the crossroads? Themes and styles in Severan art', in *Severan Culture*, eds S. Swain, S. Harrison, and J. Elsner. Cambridge: 201–49.

Newby, Z. (2011) 'In the guise of gods and heroes: Portrait heads on Roman mythological sarcophagi', in *Life, Death and Representation: Some New Work on Roman Sarcophagi*, eds J. Elsner and J. Huskinson. Cambridge: 189–227.

Nicole, G. (1908) *Meidias et le style fleuri dans la céramique attique*. Geneva.

Nöth, W. (1990) *Handbook of Semiotics*. Bloomington, IN.

O'Sullivan, T. (2011) *Walking in Roman Culture* . Cambridge.

Oakley, J. H. and Sinos, R. H. (2002) *The Wedding in Ancient Athens*. Madison, WI.

Ohly, D. (1977) *Glyptothek München: Griechische und römische Skulptur*. Munich.

Olin, M. R. (1992) *Forms of Representation in Alois Riegl's Theory of Art*. University Park, PA.

Oranje, H. (1984) *Euripides' Bacchae: The Play and its Audience*. Leiden.

Osada, T. (1993) *Stilentwicklung hellenistischer Relieffriese*. Frankfurt am Main.

Osborne, R. (1987) 'The viewing and obscuring of the Parthenon frieze', *JHS* 107: 98–105.

Osborne, R. (1994) 'Looking on Greek style: Does the sculpted girl speak to women too?', in *Classical Greece: Ancient Histories and Modern Archaeologies*, ed. I. Morris. Cambridge: 81–96.

Osborne, R. (2000) 'The art of personification on Athenian red-figure pottery', *Apollo* 152: 9–14.

Osborne, R. (2004) 'The anatomy of a mobile culture: The Greeks, their pots and their myths in Etruria', in *Mobility and Travel in the Mediterranean from Antiquity to the Middle Ages*, eds R. Schlesier and U. Zellmann. Münster: 23–36.

Osborne, R. (ed.) (2007) *Debating the Athenian Cultural Revolution: Art, Literature, Philosophy and Politics 430–380 B.C.* Cambridge.

Osborne, R. (2011) *A History Written on the Classical Body.* Cambridge.

Ostergaard, J. S. (2010) 'The Sciarra Amazon investigation: Some archaeological comments', in www.glyptoteket.com/sites/default/files/tracking-colour_report02_2010.pdf: 50–60 [last access: 18 November 2013].

Pächt, O. (1963) 'Art historians and art critics VI: Alois Riegl', *Burlington Magazine* 105: 188–93.

Palagia, O. (1993) *The Pediments of the Parthenon.* Leiden.

Panofsky, E. (1915a) *Dürers Kunsttheorie, vornehmlich in ihrem Verhältnis zur Kunsttheorie der Italiener.* Berlin.

Panofsky, E. (1915b) 'Das Problem des Stils in der bildenden Kunst', *Zeitschrift für Ästhetik und Allgemeine Kunstwissenschaft* 10: 460–7.

Panofsky, E. (1930) *Hercules am Scheideweg und andere antike Bildstoffe in der neueren Kunst.* Leipzig.

Panofsky, E. (1939) *Studies in Iconology: Humanistic Themes in the Art of the Renaissance.* Princeton, NJ.

Panofsky, E. (1953) *Early Netherlandish Painting.* Cambridge, MA.

Panofsky, E. (1955) *Meaning in the Visual Arts.* Garden City, NY.

Panofsky, E. (1981) 'The concept of artistic volition', *Critical Inquiry* 8.1: 17–33 [trans. of 'Der Begriff des Kunstwollens', *Zeitschrift für Ästhetik und Allgemeine Kunstwissenschaft* 14 (1920) 321–39 by K. J. Northcott and J. Snyder].

Panofsky, E. (2008) 'On the relationship of art history and art theory: Towards the possibility of a fundamental system of concepts for a science of art', *Critical Inquiry* 35.1: 43–71 [trans. of 'Über das Verhältnis der Kunstgeschichte zur Kunsttheorie', *Zeitschrift für Ästhetik und allgemeine Kunstwissenschaft* 18 (1925) 129–61 by K. Lorenz and J. Elsner].

Panofsky, E. (2012) 'On the problem of describing and interpreting works of the visual arts', *Critical Inquiry* 38.3: 467–82 [trans. of 'Zum Problem der Beschreibung und Inhaltsdeutung von Werken der bildenden Kunst', *Logos* 21 (1932) 103–19 by K. Lorenz and J. Elsner].

Panofsky, E. and Saxl, F. (1964) *Saturn and Melancholy: Studies in the History of Natural Philosophy, Religion and Art.* London [trans. of *Dürers Melancholia I: Eine quellen- und typengeschichtliche Untersuchung.* Leipzig (1923) by R. Klibansky].

Panvini, R. and Sole, L. (eds) (2009) *La Sicilia in eta arcaica.* Palermo.

Papili, M. (2000) 'Wearing an other hat: Workmen in town and country', in *Not the Classical Ideal: Athens and the Construction of the Other in Greek Art*, ed. B. Cohen. Leiden: 150–79.

Para – J. D. Beazley (1971) *Paralipomena.* Oxford.

Paribeni, E. (1996) *La Collezione Casuccini, Ceramica Attica, Ceramica Etrusca, Ceramica Falisca.* Rome.

Parker, R. (1996) *Athenian Religion: A History.* Oxford.

Paul-Zinserling, V. (1994) *Der Jena-Maler und sein Kreis: Zur Ikonologie einer attischen Schalenwerkstatt um 400 v. Chr.* Mainz.

Payne, A. (2008) 'Portable ruins: The Pergamon altar, Heinrich Wölfflin, and German art history at the fin de siècle', *Res* 53–4: 169–89.

Peirce, C. S. (1977) *Semiotics and Significs*, ed. C. Hardwick. Bloomington, IN.

Pekridou-Gorecki, A. (1989) *Mode im antiken Griechenland.* Munich.

Perry, E. (ed.) (2005) *The Aesthetics of Emulation in the Visual Arts of Ancient Rome.* Cambridge.

Pfanner, M. (1979) 'Bemerkungen zur Komposition und Interpretation des grossen Frieses von Pergamon', *AA* 46–57.

Picard, C. and de la Coste-Messelières, P. (1931) *Monuments figurés, sculpture: Art archaique (fin): Sculptures des temples. Fouilles de Delphes* 4 3. Paris.

Pickard-Cambridge, A. W. (1946) *The Theatre of Dionysus in Athens.* Oxford.

Pickard-Cambridge, A. W. (1988) *The Dramatic Festivals of Athens.* Oxford [2nd edition, revised by J. Gould and D. M. Lewis].

Pirson, F. (1996) 'Style and message on the column of Marcus Aurelius', *PBSR* 64: 139–79.

Podro, M. (1982) *The Critical Historians of Art.* New Haven, CT.

Pollitt, J. J. (1972) *Art and Experience in Classical Greece.* Cambridge and New York, NY.

Pollitt, J. J. (1986) *Art in the Hellenistic Age.* Cambridge.

Porter, J. I. (1992) 'Hermeneutic lines and circles: Aristarchus and Crates on the exegesis of Homer', in *Homer's Ancient Readers*, eds R. Lamberton and J. J. Keaney. Princeton, NJ: 67–114.

Porter, J. I. (1993) 'The seductions of Gorgias', *ClAnt* 12: 267–99.

Potts, A. (2003) 'Sign', in *Critical Terms for Art History*, eds R. S. Nelson and R. Shiff. Chicago, IL: 20–34.

Preziosi, D. (1989) *Rethinking Art History: Meditations on a Coy Science.* New Haven, CT and London.

Prignitz, S. (2008) *Der Pergamonaltar und die pergamenische Gelehrtenschule.* Berlin.

Puchstein, O. (1888) 'Zur pergamenischen Gigantomachie', *Sitzungsberichte der preussischen Akademie der Wissenschaften, Phil.Hist. Klasse* 47: 1231–49.

Puchstein, O. (1889) 'Zur pergamenischen Gigantomachie', *Sitzungsberichte der preussischen Akademie der Wissenschaften, Phil.Hist. Klasse* 21: 323–45.

Puchstein, O. (1902) *Beschreibung der Skulpturen aus Pergamon, 1: Gigantomachie.* Berlin.

Queyrel, F. (2002) 'La fonction du Grand Autel de Pergame', *Revue des études grecques* 115: 561–90.

Queyrel, F. (2005) *L'Autel de Pergame: Images et pouvoir en Grèce d'Asie.* Paris.

Raab, I. (1972) *Zu den Darstellungen des Parisurteils in der griechischen Kunst.* Frankfurt am Main.

Radt, W. (1988) *Pergamon, Geschichte und Bauten: Funde und Erforschung einer antiken Metropole.* Cologne.

Radt, W. (1996) 'Pergamon: Vorbericht über die Kampagne 1995', *AA* 443–54.

Radt, W. (1999) *Pergamon: Geschichte und Bauten einer antiken Metropole.* Darmstadt.

Radt, W. (2011) '"Die lustigen Zeiten sind dahin!": Die Grabungen des 20. Jahrhunderts', in *Pergamon: Panorama der antiken Metropole.* Exhibition catalogue Berlin 2011/12, eds R. Grüssinger, V. Kästner, and A. Scholl. Petersberg: 50–7.

Radt, W. and De Luca, G. (1999) *Sondagen im Fundament des Großen Altars.* Pergamenische Forschungen 12, Berlin.

Raeck, W. (1981) *Zum Barbarenbild in der Kunst Athens im 6. und 5. Jhr. v. Chr.* Bonn.

Raeck, W. (1984) 'Zur Erzählweise archaischer und klassischer Mythenbilder', *JdI* 99: 1–25.

Raeck, W. (1992) *Modernisierte Mythen.* Stuttgart.

Raeck, W. (2010) 'Der Pergamonaltar: Hellenistischer Erinnerungsort zwischen Wissenschaft und Politik', in *Die griechische Welt: Erinnerungsorte der Antike,* eds E. Stein-Hölkeskamp and H.-J. Hölkeskamp. Munich: 280–97.

Rampley, M. (2012) 'Bildwissenschaft: Theories of the image in German-language scholarship', in *Art History and Visual Studies in Europe: A Critical Guide,* eds idem et al. Leiden: 119–34.

Rampley, M. (2013) *The Vienna School of Art History: Empire and the Politics of Scholarship, 1847–1918.* Philadelphia, PA.

Raulff, U. (1997) 'Von der Privatbibliothek des Gelehrten zum Forschungsinstitut: Aby Warburg, Ernst Cassirer und die neue Kulturwissenschaft', *Geschichte und Gesellschaft* 23.1: 28–43.

Real, W. (1973) *Studien zur Entwicklung der Vasenmalerei im ausgehenden 5. Jhr.* Münster.

Reichenberger, A. (2003) *Riegls 'Kunstwollen': Versuch einer Neubetrachtung.* Sankt Augustin.

Reifferscheid, A. (1881/2) *Pergamon.* Wroclaw.

Reinhardt, K. (1938) *Das Parisurteil.* Frankfurt am Main.

Reinsberg, C. (2006) *Die Sarkophage mit Darstellungen aus dem Menschenleben: Vita romana.* Die antiken Sarkophagreliefs I 3. Berlin.

Reusser, C. (2002) *Vasen für Etrurien: Verbreitung und Funktionen attischer Keramik im Etrurien des 6. und 5. Jahrhunderts vor Christus.* Kilchberg.

Reusser, C. and Bentz, M. (eds) (2004) *Attische Vasen in etruskischem Kontext: Funde aus Häusern und Heiligtümern.* Munich.

Rheidt, K. (1992) 'Die Obere Agora: Zur Entwicklung des hellenistischen Stadtzentrums von Pergamon', *IstMitt* 42: 235–85.

Ridgway, B. S. (2000) *Hellenistic Sculpture II: The Styles of c. 200–100 B.C.* Madison, WI.

Riegl, A. (1985) *Late Roman Art Industry.* Rome [trans. of *Spätrömische Kunstindustrie.* Vienna (1901) by R. Winkes].

Riegl, A. (1992) *Problems of Style: Foundations for a History of Ornament.* Princeton, NJ [trans. of *Stilfragen: Grundlegungen zu einer Geschichte der Ornamentik.* Berlin (1893) by E. H. Kain].

Riegl, A. (1999) *The Group Portraiture of Holland*. Los Angeles, CA [trans. of 'Das holländische Gruppenporträt', *Jahrbuch der kunsthistorischen Sammlungen des allerhöchsten Kaiserhauses* 23.3–4 (1902) 71–278 by E. H. Kain and D. Britt].

Riegl, A. (2000) 'The place of the Vapheio cups in the history of art', in *The Vienna School Reader: Politics and Art Historical Method in the 1930s*, ed. C. Wood. New York, NY: 105–29 [trans. of 'Die kunsthistorische Stellung der Becher von Vafio', *JÖAI* 9 (1906) 1–19 by T. Becker].

Ritter, S. (1997) 'Athenas Helme: Zur Ikonographie der Athena in der klassischen Bildkunst Athens', *JdI* 112: 21–57.

Robert, C. (1881) *Bild und Lied: Archäologische Beiträge zur griechischen Heldensage*. Berlin.

Robert, C. (1892) *Die Nekyia des Polygnot, HallWPr* 16. Halle.

Robert, C. (1893) *Die Iliupersis des Polygnot, HallWPr* 17. Halle.

Robert, C. (1904) *Einzelmythen: Hippolytos – Meleager*. Die antiken Sarkophagreliefs *III.2*. Berlin.

Robert, C. (1911) 'Die Götter in der pergamenischen Gigantomachie', *Hermes* 46: 217–53.

Robert, C. (1919a) *Archäologische Hermeneutik: Anleitung zur Deutung klassischer Bildwerke*. Berlin.

Robert, C. (1919b) *Niobiden – Triptolemos ungedeutet*. Die antiken Sarkophagreliefs *III.3*. Berlin.

Robertson, M. (1994) *The Art of Vase-Painting in Classical Athens*. Cambridge.

Robertson, M. and Beard, M. (1991) 'Adopting an approach I & II', in *Looking at Greek Vases*, eds T. Rasmussen and N. Spivey. Cambridge: 1–35.

Rodenwaldt, G. (1916) 'Zur begrifflichen und geschichtlichen Bedeutung des Klassischen in der bildenden Kunst: Eine kunstgeschichtsphilosophische Studie', *Zeitschrift für Ästhetik und Allgemeine Kunstwissenschaft* 11: 113–31.

Rodenwaldt, G. (1935) 'Über den Stilwandel in der antoninischen Kunst', *Abhandlungen der Preussischen Akademie der Wissenschaften, philosophisch-historische Klasse* 3. Berlin.

Rodenwaldt, G. (1939) 'The transition to late-classical art', in *The Cambridge Ancient History* 12: *The Imperial Crisis and Recovery A.D. 193–324*. Cambridge: 544–70.

Rodenwaldt, G. (1940) 'Römische Reliefs: Vorstufen zur Spätantike', *JdI* 55: 12–43.

Rodenwaldt, G. (1943) 'Sarkophag-Probleme', *RM* 58: 1–26.

Rohde, E. (1961) *Pergamon: Burgberg und Altar*. Berlin.

Rorty, R. (1967) *The Linguistic Turn: Recent Essays in Philosophical Method*. Chicago, IL.

Rorty, R. (1979) *Philosophy and the Mirror of Nature*. Princeton, NJ.

Rosenzweig, R. (2004) *Worshipping Aphrodite: Art and Cult in Classical Athens*. Ann Arbor, MI.

Rössler, D. (1974) 'Gab es Modetendenzen in der griechischen Tracht am Ende des 5. und im 4. Jahrhundert v.u.Z.?', in *Hellenische Poleis III*, ed. E. C. Welskopf. Berlin: 1539–69.

Rouveret, A. (1989) *Histoire et imaginaire de la peinture ancienne: Ve siècle av. J.C. – Ier siècle ap. J.C.* Paris.

Russell, M. A. (2007) *Between Tradition and Modernity: Aby Warburg and the Public Purposes of Art in Hamburg, 1896–1918.* New York, NY and Oxford.

Russenberger, C. (2011) 'Pathos und Repräsentation: Zum veränderten Umgang mit Mythen auf stadtrömischen Sarkophagen in severischer Zeit', in *Repräsentationsformen in severischer Zeit*, eds S. Faust and F. Leitmeir. Berlin: 146–79.

Salis, A. von (1912) *Der Altar von Pergamon: Ein Beitrag zur Erklärung des hellenistischen Barockstils in Kleinasien.* Berlin.

Samida, S. (2010) 'Nach dem iconic turn: Aspekte einer bildwissenschaftlichen Programmatik in der Archäologie', in *Bilder in der Archäologie, eine Archäologie der Bilder*, eds C. Juwig and C. Kost. Münster: 95–109.

Sargent, M. L. (2011) 'Recent investigation of the polychromy of a metropolitan Roman garland sarcophagus', www.glyptoteket.dk/sites/default/files/tracking-colour-3_final_2.pdf: 14–34 [last access: 18 November 2013].

Schäfer, H.-M. (2003) *Die kulturwissenschaftliche Bibliothek Warburg: Geschichte und Persönlichkeit der Bibliothek Warburg mit Berücksichtigung der Bibliothekslandschaft und der Stadtsituation der Freien u. Hansestadt Hamburg zu Beginn des 20. Jahrhunderts.* Berlin.

Schäfer, T. (1997) *Andres Agathoi: Studien zum Realitätsgehalt der Bewaffnung attischer Krieger auf Denkmälern klassischer Zeit.* Munich.

Schalles, H.-J. (1985) *Untersuchungen zur Kulturpolitik der pergamenischen Herrscher im 3. Jhr. v. Chr.* Tübingen.

Schalles, H.-J. (2011) '"Wohltaten und Geschenke": Die Kulturpolitik der pergamenischen Herrscher', in *Pergamon: Panorama der antiken Metropole.* Exhibition catalogue, Berlin 2011/12, eds R. Grüssinger, V. Kästner, and A. Scholl. Petersberg: 118–21.

Schauenburg, K. (1962) 'Gestirnbilder in Athen und Unteritalien', *AK* 5: 51–64.

Schauenburg, K. (1975) 'Eurymedon eimi', *AM* 90: 97–121.

Schefold, K. (1981) *Die Göttersage in der klassischen und hellenistischen Kunst.* Munich.

Scherer, M. R. (1966–7) 'Helen of Troy', *Bulletin of the Metropolitan Museum* 25: 368–83.

Schmidt, P. (1993) *Aby Warburg und die Ikonologie.* Wiesbaden.

Schmidt, S. (2005) *Rhetorische Bilder auf attischen Vasen: Visuelle Kommunikation im 5. Jahrhundert v. Chr.* Berlin.

Schmidt, T. M. (1990) 'Der späte Beginn und der vorzeitige Abbruch der Arbeiten am Pergamonaltar: Archäologische Indizien. Ikonographische Spezifika. Historische, dynastische und theologische Dimensionen', in *Phyromachos-Probleme: Mit einem Anhang zur Datierung des Grossen Altares von Pergamon*, ed. B. Andreae. Mainz: 141–62.

Schmidt-Dounas, B. (1992) 'Zur Westseite des Pergamonaltares', *AM* 107: 295–301.

Schmidt-Dounas, B. (1993) 'Anklänge an altorientalische Mischwesen im Gigantomachiefries des Pergamonaltares', *Boreas* 16: 5–17.

Schmidt-Dounas, B. (2000) *Schenkungen hellenistischer Herrscher an griechische Städte und Heiligtümer 2.2: Geschenke erhalten die Freundschaft. Politik und Selbstdarstellung im Spiegel der Monumente.* Berlin.

Schmitz, N. (2000) 'Bewegung als symbolische Form: die Ikonologie und der Kunstbegriff der Medienwissenschaften', in *Über Bilder sprechen: Positionen und Perspektiven der Medienwissenschaft*, eds H.-B. Heller et al. Marburg and Schuren: 79–95.

Schneider, L. (2006) 'Zeichen, Spur, Gedächtnis: Der semiotische Blick und die Fachwissenschaft Archäologie', *Zeitschrift für Semiotik* 28.1: 7–52.

Schneider, L. (2010) 'Theoriegeschichtlicher Rückblick auf archäologische Bildwissenschaft in Hamburg', in *Bilder in der Archäologie: Eine Archäologie der Bilder?*, eds C. Juwig and C. Kost. Tübingen: 33–48.

Schneider, R. M. (1986) *Bunte Barbaren: Orientalenstatuen aus farbigem Marmor in der römischen Repräsentationskunst.* Worms.

Schober, A. (1951) *Die Kunst von Pergamon.* Innsbruck.

Scholl, A. (2009) 'Olympiou endothen aule: Zur Deutung des Pergamonaltars als Palast des Zeus', *JdI* 124: 251–78.

Scholl, A. (2011) 'Der Pergamonaltar: Ein Zeuspalast mit homerischen Zügen', in *Pergamon: Panorama der antiken Metropole.* Exhibition catalogue, Berlin 2011/12, eds R. Grüssinger, V. Kästner, and A. Scholl. Petersberg: 212–18.

Schöne, A. (1987) *Der Thiasos: Eine ikonographische Untersuchung über das Gefolge des Dionysos in der attischen Vasenmalerei des 6. und 5. Jhs. v. Chr.* Gothenborg.

Schöne, A. (1990) 'Die Hydria des Meidias Malers im Kerameikos', *AM* 105: 163–78.

Schrammen, J. (1906) *Der grosse Altar, der obere Markt.* Altertümer von Pergamon III.1. Berlin.

Schraudolph, E. (2007) 'Beispiele hellenistischer Plastik der Zeit zwischen 190 und 160 v. Chr.', in *Die Geschichte der antiken Bildhauerkunst 3: Hellenistische Plastik*, ed. P. C. Bol. Mainz: 189–239.

Schuchhardt, W.-H. (1925) *Die Meister des großen Frieses von Pergamon.* Berlin.

Schuchhardt, W.-H. (1963) 'Athena Parthenos', *AntP* II: 31–53.

Schultz, P. (2007) 'Style and agency in an age of transition', in *Debating the Athenian Cultural Revolution: Art, Literature, Philosophy and Politics 430–380 B.C.*, ed. R. Osborne. Cambridge: 144–87.

Schultz, P. (2009) 'The north frieze of the temple of Athena Nike', in *Art in Athens during the Peloponnesian War*, ed. O. Palagia. Cambridge: 128–67.

Schulz, M. (2005) *Ordnungen der Bilder: Eine Einführung in die Bildwissenschaft.* Munich.

Schulze, H. (1998) *Ammen und Pädagogen: Sklavinnen und Sklaven als Erzieher in der antiken Kunst der Gesellschaft.* Mainz.

Schwartz, F. (2005) *Blind Spots: Critical Theory and the History of Art in Twentieth-Century Germany.* New Haven, CT.

Schweitzer, B. (1969) 'Zur Strukturforschung', in *Grundlagen der Archäologie: Handbuch der Archäologie*, ed. U. Haussmann. Munich: 163–206.

Scott, M. (2012) *Space and Society in the Greek and Roman Worlds*. Cambridge.

Sedlmayer, H. (2001) 'The quintessence of Riegl's thought', in *Framing Formalism: Riegl's Work*, ed. R. Woodfield. Amsterdam: 11–31 [trans. of 'Die Quintessenz der Lehren Riegls', in *Gesammelte Aufsätze*, ed. A. Riegl. Augsburg (1929) xii–xxxiv by M. Rampley].

Segal, C. (1997) *Dionysiac Poetics and Euripides' Bacchae*. Princeton, NJ.

Seidensticker, B. (1995) 'Dichtung und Gesellschaft im 4. Jahrhundert, Versuch eines Überblicks', in *Die athenische Demokratie im 4. Jahrhundert v. Chr.*, ed. W. Eder. Stuttgart: 175–98.

Seidensticker, B. et al. (eds) (1999) *Das griechische Satyrspiel*. Darmstadt.

Semon, R. (1920) *Die Mneme als erhaltenes Prinzip im Wechsel des organischen Geschehens*. Leipzig.

Settis, S. (1991) 'La colonne Trajane: L'empereur et son public', *RA* N.S. 1: 186–98.

Settis, S. (1992) 'Die Trajanssäule', in *Die Lesbarkeit der Kunst: Zur Geistes-Gegenwart der Ikonologie*, ed. A. Beyer. Berlin: 40–52.

Shapiro, H. A. (1981) 'Courtship-scenes in Attic vase-painting', *AJA* 85: 133–43.

Shapiro, H. A. (1983) 'Amazons, Thracians, and Scythians', *GRBS* 24: 105–14.

Shapiro, H. A. (1989) *Art and Culture under the Tyrants in Athens*. Mainz.

Shapiro, H. A. (1993) *Personifications in Greek Art: The Representation of Abstract Concepts 600–400 B.C.* Zurich.

Shapiro, H. A. (2005) 'The judgement of Helen in Athenian art', in *Periklean Athens and its Legacy: Problems and Perspectives*, ed. J. M. Barringer. Austin, TX: 47–62.

Shapiro, H. A. (2009a) 'Topographies of cult and Athenian civic identity on two masterpieces of Attic red-figure', in *Athenian Potters and Painters II*, eds J. H. Oakley and O. Palagia. Oxford: 261–9.

Shapiro, H. A. (2009b) 'Alcibiades: The politics of personal style', in *Art in Athens during the Peloponnesian War*, ed. O. Palagia. Cambridge: 236–64.

Short, T. L. (2004) 'The development of Peirce's theory of signs', in *The Cambridge Companion to Peirce*, ed. C. Misak. Cambridge: 214–40.

Simon, E. (1975) *Pergamon und Hesiod*. Mainz.

Simon, E. (1984) 'Ikonographie und Epigraphik: Zum Bauschmuck des Siphnierschatzhauses in Delphi', *ZPE* 57: 1–22.

Sinisgalli, R. (2012) *Perspective in the Visual Culture of Classical Antiquity*. Cambridge.

Skidelsky, E. (2008) *Ernst Cassirer: The Last Philosopher of Culture*. Princeton, NJ.

Small, J. P. (2003) *The Parallel Worlds of Art and Text in Classical Antiquity*. Cambridge.

Smith, A. H. (1900) *A Catalogue of the Sculpture at Woburn Abbey*. London.

Smith, R. R. R. (1991) *Hellenistic Sculpture*. London.

Snell, B. (1937) *Euripides Alexandros*. Hermes Einzelschriften 5. Berlin.

Snodgrass, A. (1982) *Narration and Allusion in Archaic Greek Art*. Oxford.

Soffel, J. (1974) *Die Regeln des Menanders für die Leichenrede*. Meisenheim.

Sourvinou-Inwood, C. (1990) 'The cup Bologna PU 273: A reading', *Metis* 5: 137–55.

Sourvinou-Inwood, C. (1991) *Reading Greek Culture: Texts and Images, Rituals and Myths*. Oxford.

Sourvinou-Inwood, C. (1997) 'Medea at a shifting distance: Images and Euripidean tragedy', in *Medea: Essays on Medea in Myth, Literature, Philosophy and Art*, eds J. Clauss and S. I. Johnston. Princeton, NJ: 253–96.

Spieß, A. B. (1992) *Der Kriegerabschied auf attischen Vasen der archaischen Zeit*. Frankfurt am Main.

Squire, M. (2009) *Image and Text in Graeco-Roman Antiquity*. Cambridge.

Squire, M. (2011a) *The Art of the Body: Antiquity and its Legacy*. Oxford.

Squire, M. (2011b) *The Iliad in a Nutshell: Visualising Epic on the Tabulae Iliacae*. Oxford.

Squire, M. (2013) 'Ars in their I's: Authority and authorship in Graeco-Roman visual culture', in *The Author's Voice in Classical and Late Antiquity*, eds A. Marmodro and J. Hill. Oxford: 357–414.

Stähler, K. (1966) *Das Unklassische im Telephosfries: Die Friese des Pergamonaltares im Rahmen der hellenistischen Plastik*. Münster.

Stähler, K. (1978) 'Überlegungen zur architektonischen Gestalt des Pergamonaltares', in *Studien zur Religion und Kultur Kleinasiens*, eds S. Sahin, E. Schwertheim, and J. Wagner. Leiden: 838–67.

Stähli, A. (1999) *Die Verweigerung der Lüste*. Berlin.

Stansbury-O'Donnell, M. D. (1999) *Pictorial Narrative in Ancient Greek Art*. Cambridge.

Stansbury-O'Donnell, M. D. (2006) 'Review of: Luca Giuliani: *Bild und Mythos* (Munich (2003))', *Gnomon* 78: 536–39.

Stansbury-O'Donnell, M. D. (2005) 'The painting program in the Stoa Poikile', in *Periklean Athens and its Legacy: Problems and Perspectives*, ed. J. M. Barringer. Austin, TX: 73–87.

Stansbury-O'Donnell, M. D. (2011) *Looking at Greek Art*. Cambridge.

Steiner, A. (2007) *Reading Greek Vases*. Cambridge.

Steiner, D. T. (2001) *Images in Mind: Statues in Archaic and Classical Greek Literature and Thought*. Princeton, NJ and Oxford.

Stewart, A. (1978) 'Lysippan studies 1, 2', *AJA* 82: 163–71, 301–13.

Stewart, A. (1983) 'Stesichoros and the Francois vase', in *Ancient Greek Art and Iconography*, ed. W. G. Moon. Madison, WI: 53–74.

Stewart, A. (1993) 'Narration and allusion in the Hellenistic Baroque', in *Narrative and Event in Ancient Art*, ed. P. J. Holliday. Cambridge: 130–74.

Stewart, A. (1996) 'A hero's quest: Narrative and the Telephos frieze', in *Pergamon: The Telephos Frieze from the Great Altar* 1, eds R. Dreyfus and E. Schraudolph. San Francisco, CA: 39–52.

Stewart, A. (2000) 'Pergamo ara marmorea magna: On the date, reconstruction, and functions of the great altar of Pergamon', in *From Pergamon to*

Sperlonga: Sculpture and Context, eds N. Grummond and B. S. Ridgway. Berkeley, CA: 32–57.

Stewart, A. (2004) *Attalos, Athens and the Akropolis*. Cambridge and New York, NY.

Stinton, T. C. W. (1965) *Euripides and the Judgement of Paris*. London.

Stockhausen, T. von (1992) *Die Kulturwissenschaftliche Bibliothek Warburg: Architektur, Einrichtung und Organisation*. Hamburg.

Strauss, B. (1997) 'The problem of periodization: The case of the Peloponnesian War', in *Inventing Ancient Culture: Historicism, Periodization, and the Ancient World*, eds M. Golden and P. Toohey. London: 165–75.

Strobel, K. (1993) *Das Imperium Romanum im 3. Jahrhundert. Modell einer historischen Krise?* Stuttgart.

Strobel, K. (1996) *Die Galater: Geschichte und Eigenart der keltischen Staatenbildung auf dem Boden des hellenistischen Kleinasiens. Untersuchungen zur Geschichte und historischen Geographie des hellenistischen und römischen Kleinasiens 1*. Berlin.

Strocka, V. M. (1967) *Piräusreliefs und Parthenosschild: Versuch einer Wiederherstellung der Amazonomachie des Phidias*. Bochum.

Strocka, V. M. (1982) 'Das Schildrelief: Zum Stand der Forschung', in *Parthenon Kongreß Basel*, ed. E. Berger. Basel: 188–96.

Strocka, V. M. (2000) 'Noch einmal zur Bibliothek von Pergamon', *AA* 155–65.

Sullivan, F. A. (1936) *Ideas of Afterlife in the Latin Verse Inscriptions*. PhD. Baltimore, MD.

Sullivan, S. D. (2000) *Euripides' Use of Psychological Terminology*. Montreal.

Tanner, J. (2003) *The Sociology of Art: A Reader*. London.

Tanner, J. (2006) *The Invention of Art History in Ancient Greece: Religion, Society and Artistic Rationalisation*. Cambridge.

Taplin, O. (1993) *Comic Angels and Other Approaches to Greek Drama through Vase-Painting*. Oxford.

Taplin, O. (2007) *Pots and Plays: Interactions between Tragedy and Greek Vase-Painting of the Fourth Century B.C.* Los Angeles, CA.

Taplin, O. and Wyles, R. (eds) (2010) *The Pronomos Vase and its Context*. Oxford.

Toynbee, J. M. C. (1985) *Death and Burial in the Roman World*. Baltimore, MD.

Traversari, G. (1968) 'Sarcofagi con la morte di Meleagro nell'influsso artistico della Colonna Aureliana', *RM* 75: 154–62.

Tsitsiou, C. (1990) *Ovid Metamorphosen Buch VIII: Narrative Technik und literarischer Kontext*. Frankfurt am Main.

Tugusheva, O. V. (2009) 'The Meidias Painter and the Jena Painter revisited', in *Athenian Potters and Painters II*, eds J. H. Oakley and O. Palagia. Oxford: 291–6.

Tyrrell, W. B. (1984) *Amazons: A Study in Athenian Mythmaking*. Baltimore, MD.

Valenzuela Montenegro, N. (2004) *Die Tabulae Iliacae: Mythos und Geschichte im Spiegel einer Gruppe frühkaiserzeitlicher Miniaturreliefs*. Berlin.

Vermeule, C. C. (1971) 'Dated monuments of Hellenistic and Graeco-Roman popular art in Asia Minor: Pontus through Mysia', in *Studies Presented to G. M. A. Hanfmann*, eds D. G. Mitten et al. Mainz: 169–76.

Veyne, P. (1988) 'Conduites sans croyance et oeuvres d'art sans spectateur', *Diogène* 143: 2–22.

Veyne, P. (2002) 'Lisibilité des images, propagande et apparat monarchique dans l'Empire romain', *Revue historique* 621.1: 3–30.

Vian, F. (1951) *Répertoire des gigantomachies figures dans l'art grec et romain*. Paris.

Vian, F. (1952) *La guerre des géants: Le mythe avant l'epoque hellénistique*. Paris.

Vischer, F. T. (1887) 'Das Symbol', in *Philosophische Aufsätze zu Eduard Zellers fünf-zigjährigem Doktorjubiläum*. Leipzig.

Voelke, P. (1996) 'Beauté d'Hélène et rituels féminins dans l'*Hélène* d'Euripide', *Kernos* 9: 281–96.

Vogel, L. (1973) *The Column of Antoninus Pius*. Cambridge, MA.

Vos, M. F. (1963) *Scythian Archers in Archaic Attic Vase-Painting*. Groningen.

Wachsmuth, C. (1860) *De Cratete Mallota*. Leipzig.

Walsh, G. B. (1978) 'Rhetoric of birthright and race in Euripides' Ion', *Hermes* 106: 301–15.

Warburg, A. M. (1893) 'Sandro Botticellis *Geburt der Venus* und *Frühling*' (doctorate, Bonn (1893)), in *Gesammelte Schriften I*. Leipzig (1932).

Warburg, A. M. (1999a) *The Renewal of Pagan Antiquity: Contributions to the Cultural History of the European Renaissance*, eds D. Britt and K. W. Forster. Los Angeles, CA [trans. of *Die Erneuerung der heidnischen Antike: Kulturwissenschaftliche Beiträge zur Geschichte der europäischen Renaissance*. Leipzig and Berlin (1932) by D. Britt].

Warburg, A. M. (1999b) 'Dürer and Italian antiquity', in *Aby Warburg: The Renewal of Pagan Antiquity: Contributions to the Cultural History of the European Renaissance*, eds D. Britt and K. W. Forster. Los Angeles, CA: 729–30 [trans. of 'Dürer und die italienische Antike', *Verhandlungen der 48. Versammlung deutscher Philologen und Schulmänner in Hamburg*, Oktober 1905. Leipzig (1906) by D. Britt].

Warburg, A. M. (1999c) 'Italian art and international astrology in the Palazzo Schifanoia in Ferrara', in *Aby Warburg: The Renewal of Pagan Antiquity: Contributions to the Cultural History of the European Renaissance*, eds D. Britt and K. W. Forster. Los Angeles, CA: 563–92 [trans. of 'Italienische Kunst und internationale Astrologie im Palazzo Schifanoja zu Ferrara', *Atti del X. Congresso Internazionale di Storia dell'Arte in Roma, L'Italia e l'Arte Straniera*. Rome (1922) 179–83 by D. Britt].

Warburg, A. M. (2003) *Der Bilderatlas Mnemosyne*, ed. M. Warnke. Berlin.

Webb, P. A. (1998) 'The functions of the sanctuary of Athena and the Pergamon altar (the heroon of Telephos) in the Attalid building program', in Στεφανος: *Studies in honor of Brunilde Sismondo Ridgway*, eds K. J. Hartswick and M. C. Sturgeon. Philadelphia, PA: 241–54.

Weber, M. (1993) 'Zur Überlieferung der Goldelfenbeinstatue des Phidias', *JdI* 108: 83–122.

Wegner, M. (1931) 'Die kunstgeschichtliche Stellung der Markussäule', *JdI* 46: 61–174.

Wegner, M. (1939) *Die Herrscherbildnisse in antoninischer Zeit*. Das römische Herrscherbild II 4. Berlin.

Wellbery, D. (ed.) (2001) *Positionen der Literaturwissenschaft: Acht Modellanalysen am Beispiel von Kleists 'Das Erdbeben in Chili'*. Munich.

West, M. L. (1985) *The Hesiodic Catalogue of Women*. Oxford.

Whitehead, J. K. (1986) *Biography and Formula in Roman Sarcophagi*. Ann Arbor, MI (PhD Yale).

Wickhoff, F. (1900) *Roman Art: Some of its Principles and their Application to Early Christian Painting*. London [trans. of *Die Wiener Genesis*. Vienna (1895) by E. Strong].

Wickkiser, B. (2009) 'Banishing plague: Asklepios, Athens, and the Great Plague reconsidered', in *Aspects of Ancient Greek Cult: Context, Ritual and Iconography*, eds G. Hinge et al. Aarhus: 55–65.

Wilamowitz-Moellendorff, U. von (1881) *Antigonos von Karystos*. Berlin.

Williams, D. (1983) 'Women on Athenian vases: Problems of interpretation', in *Images of Women in Antiquity*, eds A. Cameron and A. Kuhrt. London and Canberra: 92–106.

Wimmer, H. (1997) *Die Strukturforschung in der Klassischen Archäologie*. Bern.

Wind, E. (1931) 'Warburgs Begriff der Kunstwissenschaft und seine Bedeutung für die Ästhetik', *Zeitschrift für Ästhetik und allgemeine Kunstwissenschaft* 25: 163–79.

Wind, E. (2001) *Experiment and Metaphysics: Towards a Resolution of the Cosmological Antinomies*. Oxford [trans. of *Das Experiment und die Metaphysik. Zur Auflösung der kosmologischen Antinomien*. Berlin (1934) by C. Edwards].

Winnefeld, H. (1910) *Die Friese des grossen Altars*. Altertümer von Pergamon *III.2*. Berlin.

Wölfflin, H. (1932) *Principles of Art History: The Problem of the Development of Style in Later Art*. New York, NY [trans. of *Kunstgeschichtliche Grundbegriffe: Das Problem der Stilentwicklung in der neuren Kunst*. Munich (1915) by M. D. Hottinger].

Wölfflin, H. (1964) *Renaissance and Baroque*. London [trans. of *Renaissance und Barock: Eine Untersuchung über Wesen und Entstehung des Barockstils in Italien*. Munich (1888) by K. Simon and P. Murray].

Wollheim, R. (1973) 'Giovanni Morelli and the origins of scientific connoisseurship', in *On Art and the Mind: Essays and Lectures*. London: 177–201.

Wollheim, R. (1986) *Painting as an Art*. Princeton, NJ.

Wollheim, R. (1991) *Freud*. London.

Wolter von dem Knesebeck, H. (1995) 'Zur Ausstattung und Funktion des Hauptsaals der Bibliothek von Pergamon', *Boreas* 18: 45–56.

Wood, C. S. (1997) *Erwin Panofsky: Perspective as Symbolic Form*. New York, NY.

Wood, C. S. (2000) *The Vienna School Reader: Politics and Art Historical Method in the 1930s*. New York, NY.

Wood, C. S. (2004) 'Review of *Bild-Anthropologie* by H. Belting', *ArtB* 86.2: 370–3.

Wood, S. (1993) 'Alcestis on Roman sarcophagi', in *Roman Art in Context: An Anthology*, ed. E. D'Ambra. Englewood Cliffs, NJ: 84–103.

Woodford, S. (2003) *Images of Myth in Classical Antiquity*. Cambridge.

Wrede, H. (1981) *Consecratio in formam deorum: Vergöttlichte Privatpersonen in der römischen Kaiserzeit*. Mainz.

Wrede, H. (2001) *Senatorische Sarkophage Roms: Der Beitrag des Senatorenstandes zur römischen Kunst der hohen und späten Kaiserzeit*. Mainz.

Wulff-Rheidt, U. and Kurapakat, D. (eds) (2014) *Die Architektur des Weges: Gestaltete Bewegung im gebauten Raum*. Berlin.

Wyke, M. (1989) 'Mistress and metaphor in Augustan elegy', *Helios* 16: 25–47.

Wyles, R. (2010) 'The tragic costumes', in *The Pronomos Vase and its Context*, eds O. Taplin and R. Wyles. Oxford: 231–54.

Zanker, G. (1987) *Realism in Alexandrian Poetry: A Literature and its Audience*. London.

Zanker, G. (2004) *Modes of Viewing in Hellenistic Poetry and Art*. Madison, WI.

Zanker, G. (2009) *Herodas: Miniambs*. Oxford.

Zanker, P. (1988) *The Power of Images in the Age of Augustus*. Ann Arbor, MI [trans. of *Augustus und die Macht der Bilder*. Munich (1987) by H. A. Shapiro].

Zanker, P. (1994) 'Nouvelles orientations de la recherche en iconographie. Commanditaires et spectateurs', *RA* 281–93.

Zanker, P. (1995) 'Individuum und Typus: Zur Bedeutung des realistischen Individualporträts der späten Republik', *AA* 473–81.

Zanker, P. (1997) 'In search of the Roman viewer', in *The Interpretation of Architectural Sculpture in Greece and Rome*, ed. D. Buitron-Oliver. Hanover: 179–91.

Zanker, P. (1999) 'Phaidras Trauer und Hippolytos Tod', in *Im Spiegel des Mythos: Bilderwelt und Lebenswelt / Lo specchio del mito: Immaginario e realtà*, eds F. de Angelis and Susanne Muth. Wiesbaden: 131–42.

Zanker, P. (2000) 'Bild-Räume und Betrachter im kaiserzeitlichen Rom', in *Klassische Archäologie: Eine Einführung*, eds A. H. Borbein, T. Hölscher, and idem. Berlin: 205–26.

Zanker, P. (2005) 'Ikonographie und Mentalität: Zur Veränderung mythologischer Bildthemen auf den kaiserzeitlichen Sarkophagen aus der Stadt Rom', in *Lebenswelten: Bilder und Räume in der römischen Stadt der Kaiserzeit*, eds R. Neudecker and P. Zanker. Wiesbaden: 243–52.

Zanker, P. (2006) 'Das Feste und das Flüchtige: Wie Bilder das Selbstverständnis einer Gesellschaft modellieren', in *Iconic Worlds: Neue Bilderwelten und Wissensräume*, eds C. Maar and H. Burda. Munich: 165–84.

Zanker, P. and Ewald, B. C. (2012) *Living with Myths*. Oxford [trans. of *Mit Mythen leben*. Munich (2004) by J. Slater].

Zardini, F. (2009) *The Myth of Herakles and Kyknos: A Study in Greek Vase-Painting and Literature*. Verona.

Zeichen (1979) Schneider, L., Fehr, B., and Meyer, K.-H., 'Zeichen – Kommunikation – Interaktion: Zur Bedeutung von Zeichen-, Kommunikations- und Interaktionstheorie für die Klassische Archäologie', *Hephaistos* 1: 7–41.

Zeitlin, F. I. (1982) 'Cultic models of the female: Rites of Dionysos and Demeter', *Arethusa* 15: 129–57.

Zinserling, G. (1983) 'Parthenon – Pergamonaltar – Augusteische Repräsentationskunst: Problem des Klassizimus als formales und inhaltliches Phänomen', in *Concilium Eirene XVI*, eds P. Oliva and A. Frolikova. Prague: 100–5.

Index

Key sections are highlighted in **bold**.